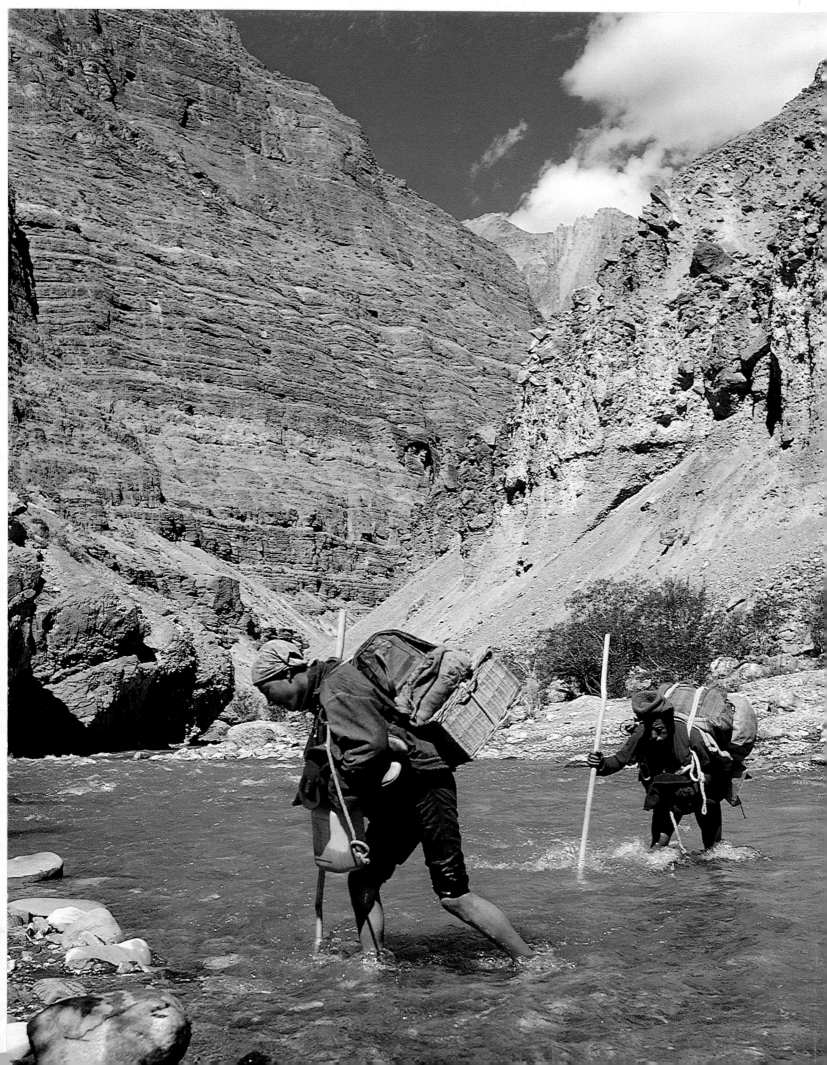

# MICHEL PEISSEL

# TIBET

## THE SECRET CONTINENT

CASSELL
ILLUSTRATED

# Contents

# Introduction

TIBET IS MUCH THE SAME AS the proverbial elephant described by blind people – everyone grasps a different aspect, but no one gets the whole picture. For centuries Tibet has fascinated the world for different reasons: some are amazed by its religion and complex philosophy; others admire its architecture or are enchanted by its colourfully varied inhabitants. What is certain is that Tibet is not like any other land – it is more than a country, it is a complex and unique civilization, a world apart with its own language and dialects, a vast literature and sophisticated customs. It is a world that stands upon a high geological plateau where it constitutes an 'island' looking down on the rest of our planet and forming a true 'continent' within Asia.

If Tibet remains today partly shrouded in mystery, this is due to its having been for so long a secret and inaccessible place, hidden behind the geographical obstacle formed by the world's tallest mountains and impressive barriers of political restrictions erected by China, Nepal, India and Pakistan. These constraints upon travel to Tibet were set up in part to conceal the fact that these four states have over the years each siezed a portion of Tibet. Today the plunder is total, to the extent that the once vast domains of the kings of Tibet have no legal identity of their own. One talks now of Chinese Tibet, Indian Ladakh, Nepal's Mustang district, Indian Sikkim, independent Bhutan and Pakistan's province of Baltistan, often forgetting that these names refer to territories of what once constituted a single, great nation.

In spite of these opportunistic annexations and the clever redrawing of the maps, this book will hopefully demonstrate that Tibetans still constitute a dynamic and united people – a nation that still inhabits the entire extent of that 'secret continent' set in the heart of Asia, a territory four times the size of Texas or France. This 'continent', based on the geographical

Tibetan plateau and which I will call Greater Tibet, is a high-altitude 'world within a world', with its own particular language, customs and a unique Buddhist culture, its own climate and unusual flora and fauna. This is a world that has little time for the pretentions of mapmakers and the ambitions of foreign politicians. It is a nation awaiting an opportunity to rise again and claim its right to autonomy.

This book is an endeavour to reveal the cultural unity of this Greater Tibet and the true dimensions of a great nation. It is a task made easier through photographs, which betray the subtle similarities of Tibetan architecture and art across far-flung regions.

In dealing with Tibet, one must distinguish between the realm of the Dalai Lamas and Tibet itself – a distinction that has often been blurred. The Dalai Lamas are relative newcomers to the Tibetan political scene. They ruled over only one-third of the Tibetan world, although their religious prestige extended far beyond their political domains. Prior to the eighteenth century Tibet was governed by kings and princes, many of whom retained their power right up until the Chinese takeover and the recent abolition of their titles and functions in Sikkim and Ladakh by the Indian government.

It has taken me many years to be able to understand Tibet and what it is that makes it so genuinely unique. After forty years I can at last appreciate that beyond the uniting bonds of Tibetan Buddhism there exists a national identity that is deeply rooted in the hearts and characters of all Tibetans, be they Buddhist, Bonpo, Muslim or simply agnostic.

Few foreigners have been allowed to travel as extensively all over Tibet as it has been my good fortune to do so. Over the past four decades I have made many long journeys and wandered countless trails, meeting and

talking with hundreds of Tibetans, both important and ordinary. I have learned that although Tibet may not be a modern, political entity with well-defined frontiers under a central government, it is nonetheless a strong cultural entity – the product of its long history and unique environment.

Tibet's inhabitants are particularly endearing, an observation proclaimed by people as diverse as Jesuit missionaries, British colonial officers, vagabond philosophers, mountaineers and adventurers, all of whom have remarked on the exceptional good nature and wit of the Tibetan people.

In the course of thirty exploratory expeditions I have travelled more than 12,000 miles (19,000 km) on foot and horseback in search of unvisited regions or on a quest for rare plants and breeds of animal. Frequently I have had to battle Indian, Chinese or Nepalese bureaucracy in order to cross (at times in disguise) the borders which today divide Greater Tibet. As a result, I have been banned twice from India and declared *persona non grata* by both China and Nepal.

From the age of eighteen I had been fascinated by Tibet because it seemed to have escaped what appeared to be the universal trappings of Westernization. As a Frenchman raised in England, while still very young I dreamt of lost horizons. After the Second World War, just as most of my peers were settling down to face decades of peace, I yearned for the exotic. While living as a student in Paris, it was by chance that I read *The Three Faces of Tibet* written by Fosco Maraini. A few weeks later, out of casual curiosity, I purchased an old copy of Sir Charles Bell's *Grammar of Colloquial Tibetan*. To impress my friends I began learning such empire-building phrases as 'The mule gun is on the yak' and 'Shine all brass ornaments', and suddenly I yearned to go to Tibet to discover for myself whether, as my grammar book stated, 'All monks are lazy'.

Alas, at the time (1954) Tibet was more inaccessible than ever before, having just been invaded in 1950 by the Chinese and had its 'doors' double-locked by the aggressor. There seemed no hope that I would ever get there, and I might have given up had I not discovered in my atlas the small smudge of land marked Bhutan. Bhutan means 'land of the Bhot or Bhotias', the name given to Tibetans. To my amazement I discovered that Bhutan featured on all sorts of globes and in countless maps, however small; yet there was not a single motor route into the kingdom, no airstrip and no embassies to issue visas. Suddenly, forbidden Bhutan appeared to me as the true 'lost horizon' I had so long dreamt of exploring. I swore to myself that I would enter Bhutan come what may. Thus began what was to prove a long, long journey – one that eventually took me, at the slow pace of yaks and ponies, to the far corners of that 'continent' called Tibet.

It was a world I soon came to consider my own as I learnt the language, and several of its dialects, and developed a taste for Tibetan butter tea and beer. My friends answered to the names of Tsering and Nima and I even began to dream in Tibetan, talking out loud in my sleep – so I was told – in that beautiful, strange language from 'the roof of the world'. As the years went by I found myself ever closer to understanding what made Tibet truly distinct. It was not, as I had thought, the monks and their teachings, nor was it the exotic aspects of daily life. It was the broad-mindedness of the Tibetan people whose spirit is in tune with the immensity of their horizons. It is this unique spirit and frame of mind that I wish to illustrate here by drawing the reader in my wake across the more interesting trails that web the Tibetan plateau. Before meeting the people and trying to understand them, it is essential to appreciate the special character of the land itself.

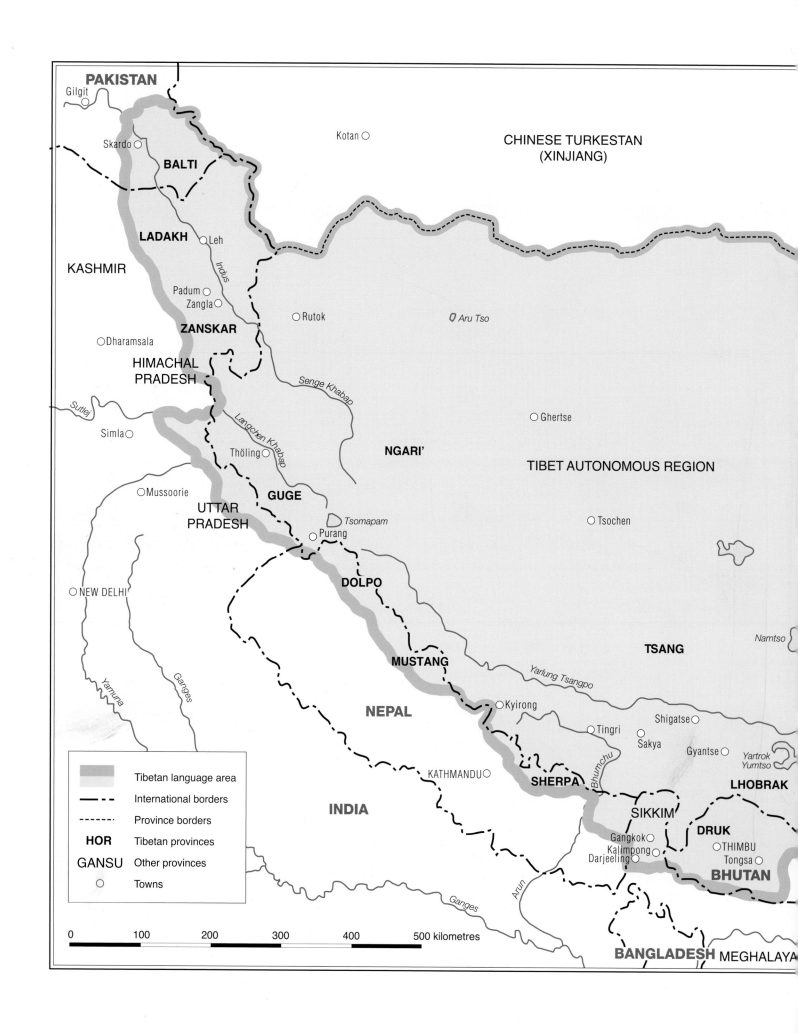

PAKISTAN
Gilgit

Skardo

BALTI

LADAKH
Leh

KASHMIR

Indus

Padum
Zangla

ZANSKAR

Dharamsala

HIMACHAL
PRADESH

Sutlej

Simla

Thöling

Langchen Khabap

GUGE

Mussoorie

UTTAR
PRADESH

Tsomapam

Purang

NEW DELHI

Yamuna

Ganges

DOLPO

MUSTANG

NEPAL

KATHMANDU

INDIA

Ganges

Arun

CHINESE TURKESTAN
(XINJIANG)

Kotan

Rutok

Aru Tso

Senge Khabap

Ghertse

NGARI'

TIBET AUTONOMOUS REGION

Tsochen

Namtso

TSANG

Yarlung Tsangpo

Kyirong

Tingri
Sakya

Shigatse

Gyantse

Yartrok
Yumtso

Bhumchu

SHERPA

LHOBRAK

SIKKIM

DRUK

Gangkok
Kalimpong
Darjeeling

THIMBU
Tongsa

BHUTAN

BANGLADESH  MEGHALAYA

| | Tibetan language area |
| --- | --- |
| | International borders |
| | Province borders |
| **HOR** | Tibetan provinces |
| GANSU | Other provinces |
| ○ | Towns |

0    100    200    300    400    500 kilometres

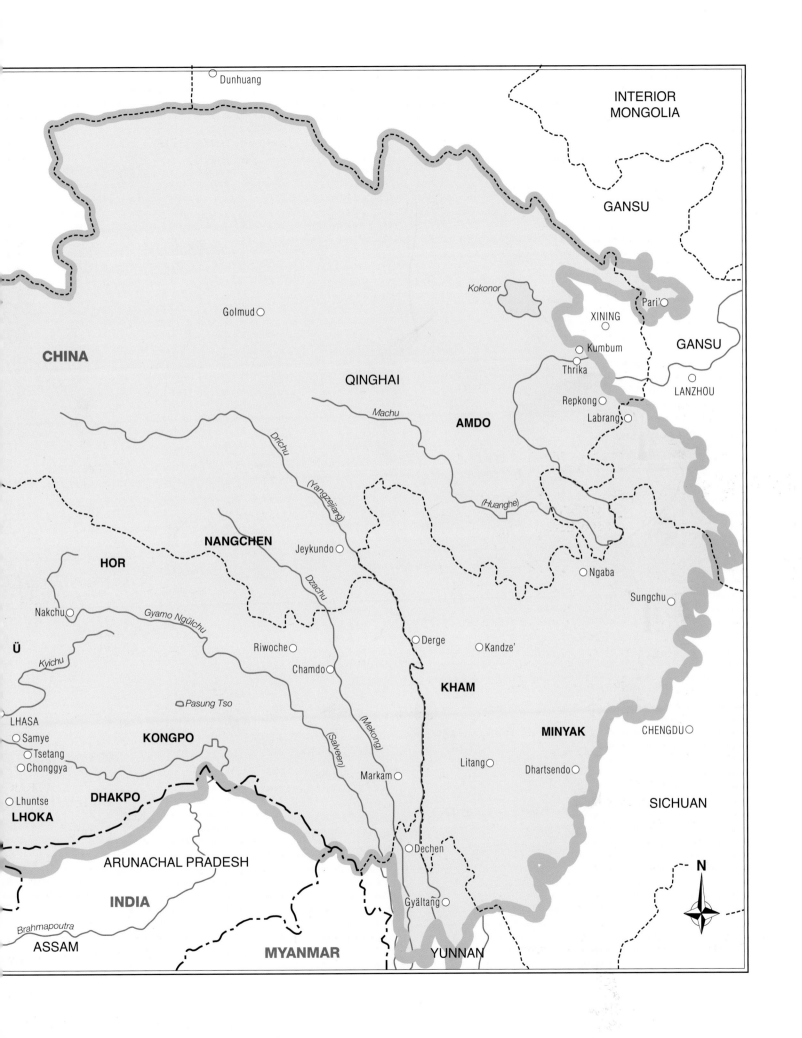

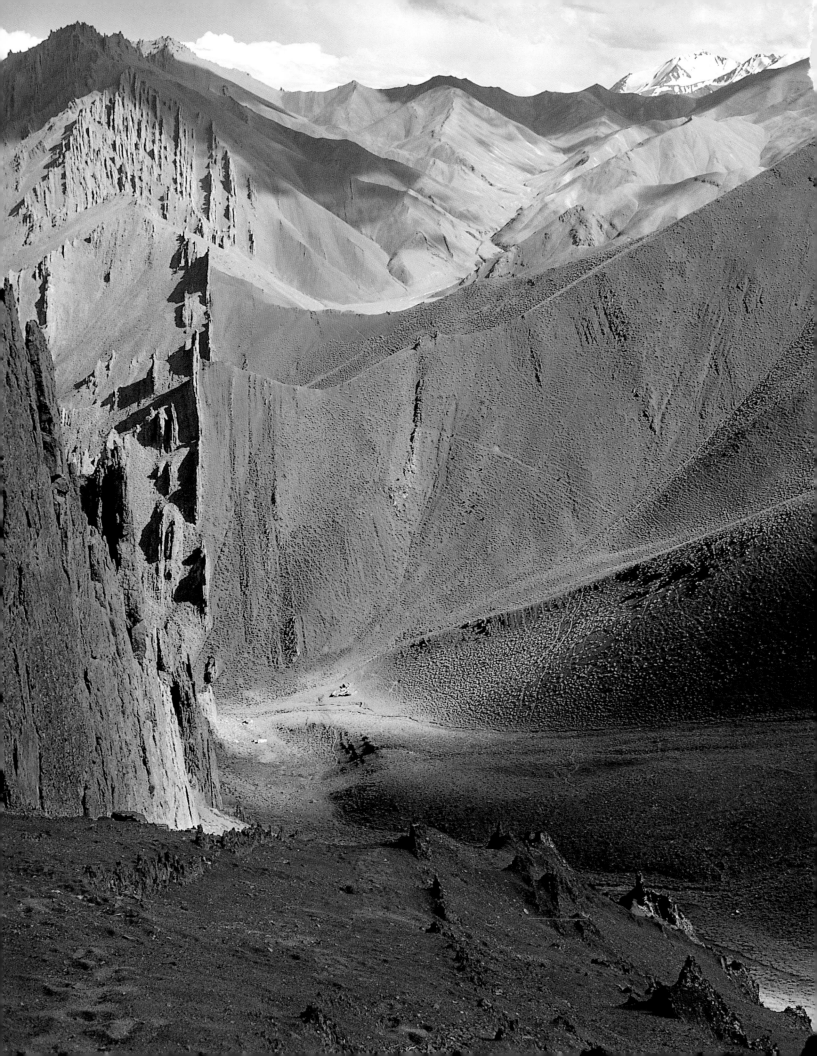

# 1 The Land

*These vertical rock formations attest to the forces unleashed during the prehistoric clash between the two continents that created the Tibetan highlands.*

SITUATED IN THE HEART of Asia, the Tibetan world covers the entire extent of the great Tibetan plateau, extending from the southern face of the Himalayas northwards to the Kuen Lung range that borders the Taklamakan Desert of Chinese Turkestan, and from east to west it ranges from the hills of Sichuan to the Hindu Kush.

Located between the ancient civilizations of India and China, the landlocked area we can historically define as being Tibetan – ethnically, culturally and linguistically – is centred on the high Tibetan plateau. From here it extended northwestwards to the territories of the Uighur peoples (now the autonomous region of Xinjiang), and northeastwards through the scrubby plateau grassland of the Changtang region and across the meandering upper reaches of the Yellow River towards the steppes of Inner Mongolia. To the east, in Kham, Tibetan-populated lands reach far along the Yangtze River and its tributaries into the confines of mainland China. In the west, 'cultural Tibet' extends to Ladakh, Zanskar and Baltistan and the Karakoram range up to the borders of Afghanistan; to the south, beyond Mount Kailash (22,031 feet/6,715 metres) and the Trans-Himalaya ranges, it extends to the kingdom of Mustang and the southern face of the Himalayas, which includes the Tibetan-speaking kingdoms of Sikkim and Bhutan.

The great wall that is formed by the Himalayas protects Tibet from the full force of the monsoon rains. As a result, western Tibet is surprisingly dry and sunny, with the water for agriculture being supplied mostly by irrigation. Most of the fertile land is found in the basin of the Tsangpo – the 'clear river' as the Brahmaputra River is called where it flows from west to east to the north of the Himalayas.

Tibetans call their land Bod (pronounced Peu). The name 'Tibet' is perhaps derived from Teu Peu, meaning 'Upper Tibet', or from Peu-ba, meaning 'Tibetan' (*ba* or *pa* being the suffix of 'belonging'). The Chinese called it Tufan and refer to central Tibet as Xizang, a so-called autonomous region of China.

However, the Tibetan-speaking population is a significant element within four western Chinese provinces – areas that contain over half of Tibet's population. These places at one time constituted the Tibetan regions of Amdo and Kham – and recognized by the creation of autonomous prefectures and counties, into which most of the ethnically Tibetan people have been incorporated.

A quick glance at any atlas will reveal that, topographically, Tibet divides approximately down the centre into two sections. The east is mountainous and furrowed by mighty rivers – in fact, four of the greatest rivers in Asia have their headwaters here: the Yellow River, the Yangtze, the Mekong and the Salween. The western half is a flat, wind-scoured, high-altitude plateau covered with salty lakes, for there are no rivers to drain the small amounts of water that fall during the summer. It is the power of erosion that has modelled the damper eastern regions into a landscape of dramatic vertical peaks overlooking great forests – a world quite different from the northern plain called the Changtang. This bisection of Tibet is relieved by a single strip of relatively fertile agricultural land running east–west just behind the Himalayas and corresponding to the upper valleys of the Indus and Brahmaputra rivers.

The geographical expanse identified as the Tibetan plateau is the product of two natural phenomena: earthquakes and erosion. The first of these is the episodic manifestation of the clash and crush of the tectonic plates below Tibet, while the second is the manner in which the surface of the land has been fashioned by wind, rain, avalanches and rivers.

*The high-altitude, mountain-locked valley of Zanskar, with its irrigated and terraced fields, is but one perfect example of hundreds of isolated valleys in Greater Tibet. The people of these small kingdoms have their own dialects but are linked to one another through trade and the wanderings of monks on pilgrimage.*

## The crash of continents

Most of us are familiar with the effects of erosion, but perhaps less so with how earthquakes shape the Earth. The plateau that forms most of Greater Tibet constitutes the highest land mass on our planet. Here, covering an area approximately four times the size of Texas, the Earth's crust is 50 miles (80 km) deep, twice as thick as elsewhere. The Tibetan plateau has a mean altitude of 15,420 feet (4,700 m), which is almost the height of Mont Blanc in Europe; high, yet still more than two and a half miles (4 km) below the region's highest peaks – Everest (29,028 feet/8,848 m), K2 (Dahzang), Kanchenjunga and the eleven other Himalayan peaks that exceed 26,240 feet (8,000 m) in height.

Each summer for fifteen years, from 1982 onwards, an international team of geologists and seismologists under the direction of Frenchman Professor Paul Taponnier worked with Chinese scholars to try to record and understand the mechanism that had created the Tibetan highlands. During this time they walked, rode and used four-wheeled vehicles to travel across hundreds of miles of ranges and high desert plains before exploding depth-charges with which to record the propagation of sound waves in an attempt to increase their understanding of that mighty collision by which the India Plate, the tectonic feature that supports the Indian subcontinent, drifted north across the prehistoric Tethys Ocean 50 million years ago and crashed into the underside of the Eurasia Plate (now the continent of Asia). The collision formed a 'thrust fault', which forced the plate upwards to form the high plateau. Today scientists understand that our continents are actually immense 'rockbergs' floating upon the molten core of our planet.

The crash of two continents was certainly not an instant affair, but, rather, a slow coming together marked by a long-drawn series of earthquakes during which the Himalayas and the Tibetan plateau were slowly pushed ever up and sideways in a series of petrified waves. This process is still going on today, in parts reaching speeds of four inches (10 cm) a year. In bad years of severe earthquakes, the movement can, in places, result in a staggering 30 feet (9 m) of lateral displacement in just a few horrendous seconds. Such was the case in 1950 when eastern Tibet was rocked by an earthquake that ripped apart the land, opening a number of huge crevices down which people, cattle and even buildings all disappeared. Where scientists, such as Professor

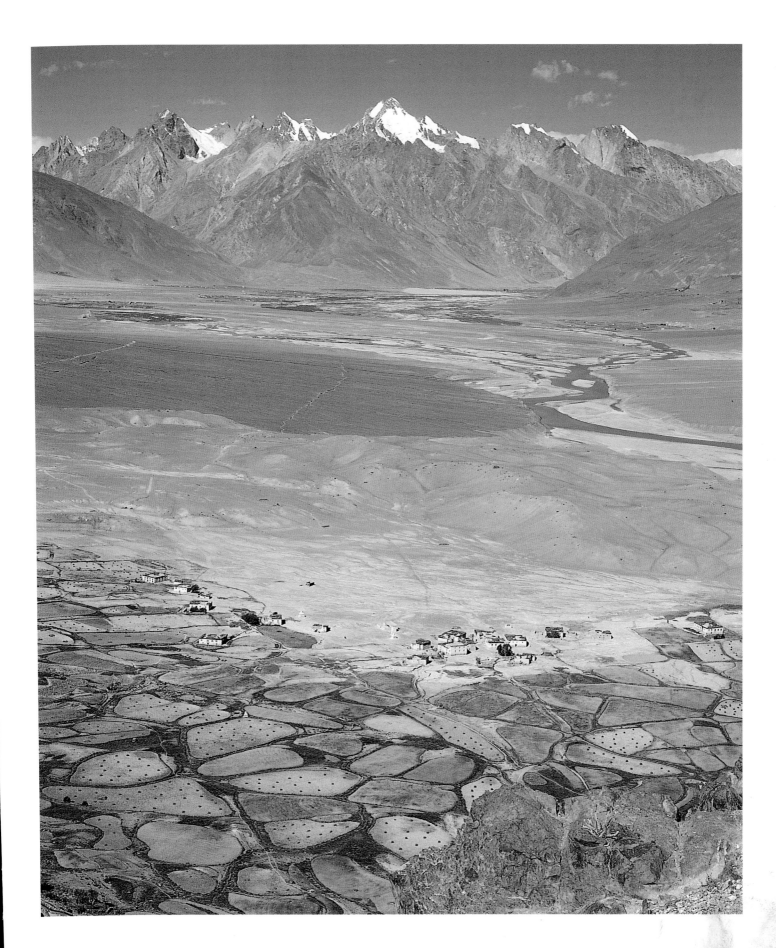

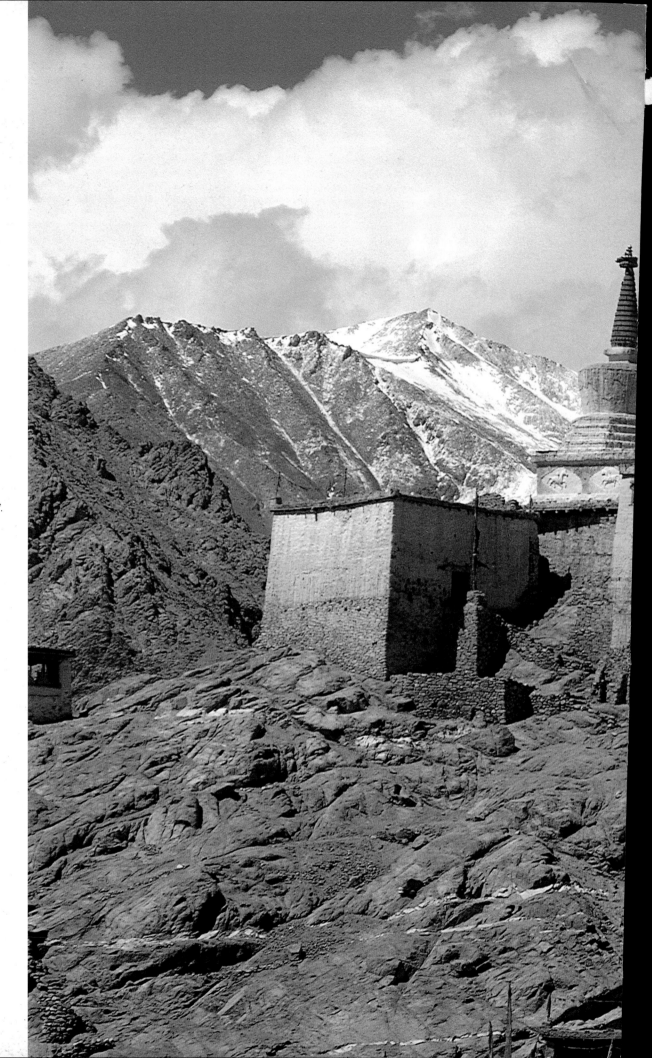

*The fortress palace of the kings of Ladakh overshadows the homes of traders and dominates Leh, the capital of 'Little Tibet'. Tibetan architecture has a distinctive allure and is, with language, the most obvious common bond between the far-flung regions of Greater Tibet.*

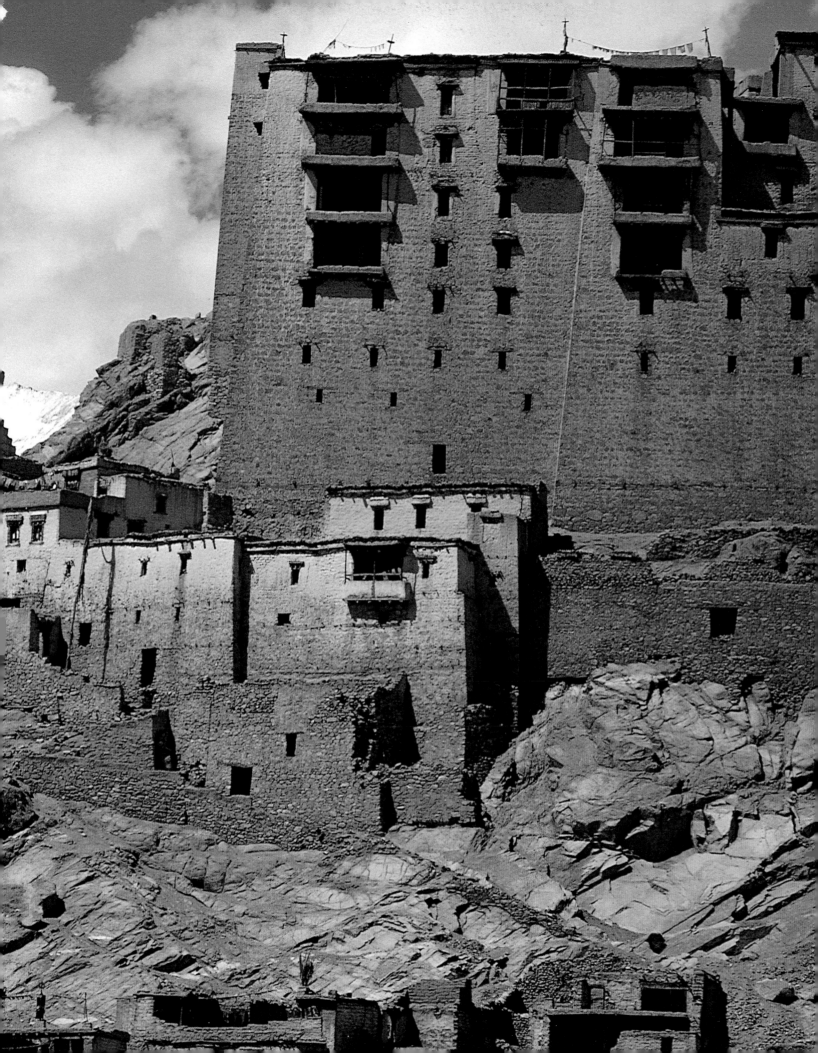

Paul Taponnier and his colleagues, saw an uplifting of the Tibetan mantle and a slow sliding of the landmass to the east, Tibet's religious leaders and their shamanic oracle decided that it was something more portentous and heralded the beginning of the takeover of Tibet by China. This was an event that had been predicted in a frightful prophecy contained in the testament of the thirteenth Dalai Lama, a document written in 1933: 'Monks and their monasteries will be destroyed … days and nights will drag on slowly in suffering'.

Both the oracle and Taponnier were right. Indeed, in terms understood clearly by Buddhist monks, both the long series of events that form the episodes of human history and the clashes of tectonic plates are related in as much as they can be interpreted as the results of cause and effect. The hundreds of thousands of students of Buddhist wisdom in Tibet – comprising monks, mantrins (a practitioner of *mantras*) and the laity – all know that the curse of humankind is that humans are inevitably subject to the natural law of cause and effect. Programmed, so to speak, by everything around them, human beings are just like everything else in nature – a product of what the Tibetans call 'the phenomenal world' – the physical world we all live in.

And so it is that the seismic rumblings of the earth are directly responsible not only for Tibet, its high plateau and its staggering peaks, but also for shaping that very special race of men and women whom we call Tibetans – a people fashioned by the unique ecosystem of 'the roof of the world', a land closer to the domain of the gods than any other place on Earth. For all the dramatic mountain scenery caused by the ancient tectonic clash, for all the beauty of the Himalayas and the cool, dry, crystal-clear air of the great plains of the Tibetan plateau, nothing is as important in the forging of Tibet as its elevation. Nowhere, not even in the Andes of South America, has altitude had such an impact on any land.

Today we are only just beginning to understand how atmospheric pressure has a radical and crucial influence on all living organisms – how the low pressure at such heights changes the parameters of living cells so that high-altitude plants, animals, insects and even human beings are truly different from their lowland cousins. Since pressure decreases with altitude there is no point in a comparison between the Tibetan plateau and the other, lower mountainous regions of the globe. In that sense, Tibet has truly bred a world apart.

The exact role that altitude plays on people's characters has yet to be determined, but there is no doubt, as all alpinists know, that the crisp, sharp, dry, cold climate, the light air and the intense sunlight are conducive to vigorous activity. Tibet is hardly a land of indolence as proclaims the Tibetan proverb that 'man is not made for comfort'.

Infant mortality is high in Tibet, especially during childbirth, due to a higher risk of oxygen starvation in difficult and lengthy labours. Studies have claimed that Tibetans are genetically adapted to high altitude, yet unlike the Indians of Peru they do not have enlarged lungs or major anatomical adaptations. Further research would be needed not only to study these adaptations but also to draw a precise map of the various ethnic groups that compose the varied population of Tibet. Many of the remote deep valleys of eastern Tibet (Kham) and isolated pastoral regions of Amdo contain isolated tribes whose genetic characteristics may prove revealing in solving the many mysteries that shroud the history of the early settlement of the Tibetan plateau.

What is certain is that the high altitude, combined with strong ultraviolet rays and a cold climate, has a very strong effect in reducing bacterial reproduction so that the Tibetans can dispense with much of the elementary washing habits and hygiene that would be essential for survival elsewhere. Tibetans have been described as dirty – dusty would be a more appropriate word – and although today the new urban population suffers from malnutrition and insalubrious lodgings, in general the Tibetan population can be considered as robust and healthy – the combined result of the characteristics of the land and a judicious management of limited resources.

*Dwarfed by barren peaks, the lone fortress of Zanskar dominates the smallest of all Tibetan kingdoms. Until a few years ago, when a road finally reached its lower fields, it was also one of the most isolated. The king of Zanskar is an erudite farmer and guardian of local traditions. His rule is the result of a tradition that extends back to the eighth century when the region was first brought under the control of central Tibet.*

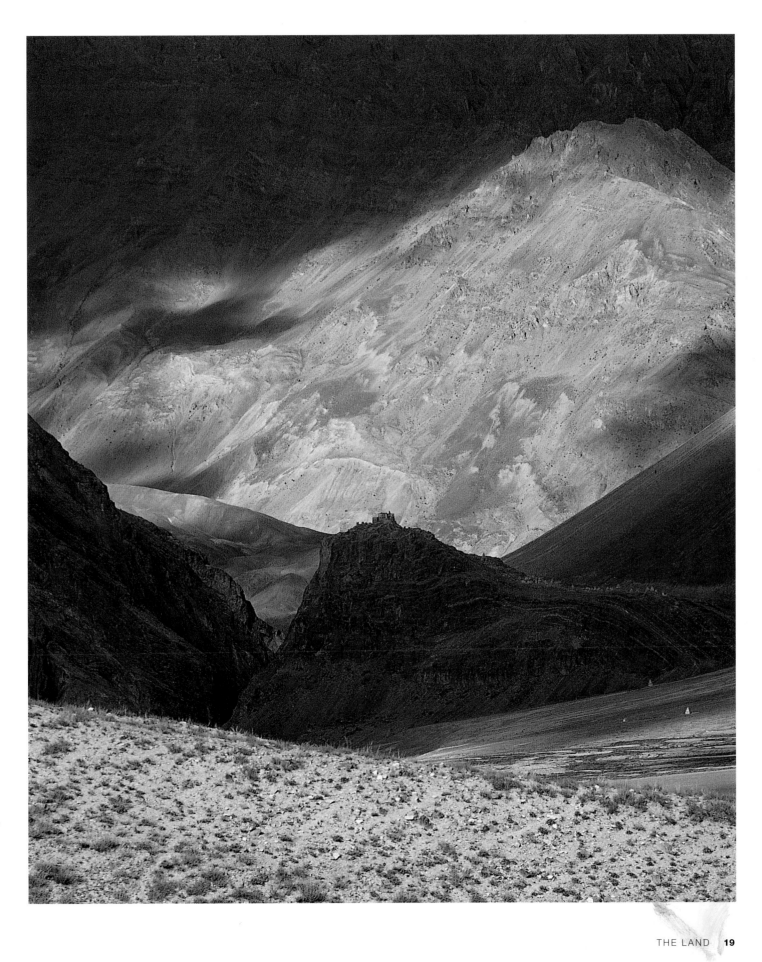

# Forged in earthly violence

**Everywhere upon the Tibetan plateau** one is confronted by the strength and beauty of nature. If Tibet is anything, it is a land of excess: it has the highest and the grandest peaks and valleys, which have helped to channel jet-force winds through the terrain, eroding cliffs into fairytale castles and crenellated dungeons. At every step, one is reminded of the frailty of humankind in the face of the immensely powerful elemental forces that nature can muster. I have found that the Tibetans are no less impressed than foreigners by the majestic beauty of their landscapes.

These steep rock-faces are believed to be the refuges of demons and saintly hermits. Each cliff, canyon and gorge has a name, and to that name is appended the legend of its creation as a result of the work of demons or goddesses. The demons belong to the ancient pre-Buddhist religions, which are dominated by the spirits of the earth, water and the winds. These spirits were later incorporated into Tibetan Buddhism by Guru Rinpoche, the magician from Urgyan (Swat), who, it is claimed, was the first person to introduce the religion of Buddhism to Tibet.

Most of Tibet's spectacular cliffs and mountains are believed today to be the petrified bodies or entrails of pagan demons destroyed by Guru Rinpoche, Padmasambhava and other early masters, as a result of which the 'land of the devils' became the 'land' (*sa*) 'of the Gods' (*Lha*), or Lha-sa in Tibetan, and the mountains and landscape now played host to holy gods and goddesses.

1. Southern Tibet, although it has the snow-covered Himalayan range as its backdrop, is a desert corridor. It suffers because it lies in the 'rain shadow' of the great peaks. Any humidity either drops upon the southern face of the great mountain chain or sails overhead and on to the plains of central Tibet. Humans can only survive here thanks to irrigation, which relies on water provided by the melting snow that runs down from the highest summits. The cliffs have been eroded by a combination of winds laden with abrasive sands and rare flash storms.

1

2, 3. A lunar-style desert landscape borders the riverbanks of a tributary of the Zanskar River beyond the Thonde Pass on the route to the high plateau of Rupshu in southeastern Ladakh. The dwarf willow trees lining the bank are considered a 'forest' by the local inhabitants of this desolate region, where ibex can still be seen roaming the rocky crags. That the rugged landscape of Tibet was once the bed of the Tethys Ocean is revealed by the ammonite fossils that abound. Hindu pilgrims to the holy lakes of Tibet call them holy stones, or *sale grami*, because for Hindus and Tibetans alike these fossils are believed to be miraculous reproductions of the Buddhist Wheel of Life.

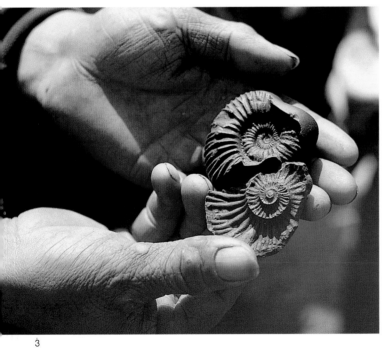

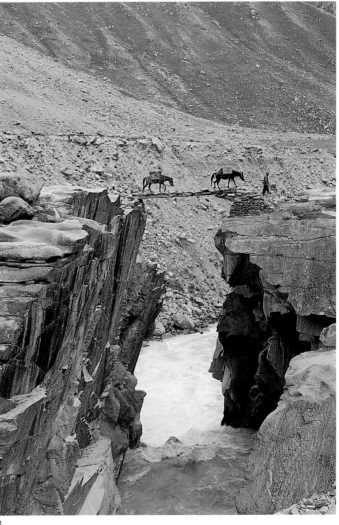

4. On the long road that connects Zanskar with Spiti, these two logs are bridging a fault line – a vivid reminder of the force of the shifting continental plates. Crossings of every type are the key links along the long trails that weave across the Tibetan world. Rivers rather than high mountains are the main obstacles to travel and this explains why winter, despite the cold, is a season when certain journeys are undertaken, because the rushing waters are frozen.

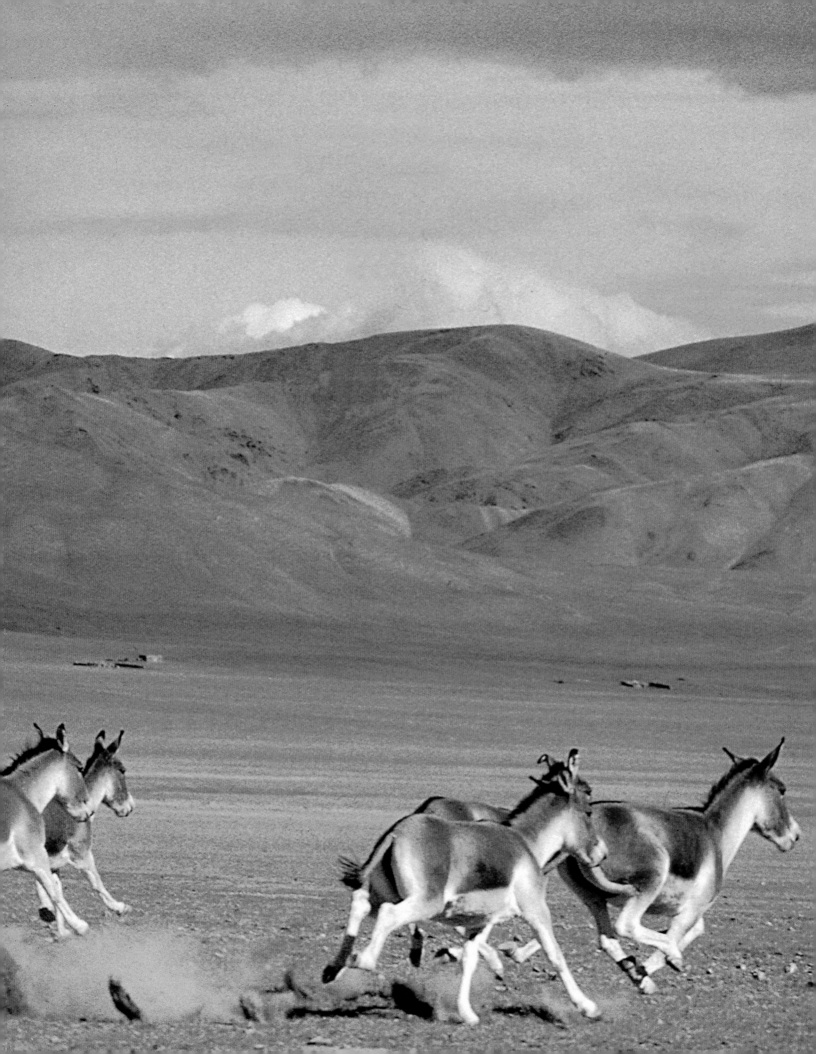

# 2 Flora and Fauna

Equus kyang *is the world's tallest wild horse. At fourteen hands (1.40 m), it is bigger than Przhevalsky's horse. Erroneously called a wild ass, the* kyang *is in fact a stand-alone breed. It is found in herds of more than 100 animals and it abounds to such an extent that it has become, with the Yak, an animal emblematic of Tibet.*

THE FIRST FOREIGNERS TO TAKE a serious interest in the Himalayas and the Tibetan highlands were botanists and naturalists. Prior to the Industrial Revolution, botanists were among the most respected scientists of their day – the quest to discover new plants around the world was as important then as the unearthing of new elements, particles or genes is today. If there are some old treatises describing the strange customs of the various peoples and cultures of our planet there are many more that have been written about the seemingly infinite variety of plants in the world – be they flowers, grasses, shrubs or trees.

First and foremost among the many European scholars to study the flora (and fauna) of Tibet at the beginning of the nineteenth century was Brian Hodgson, one of the most eminent of those scholarly civil servants of the British East India Company. Of the other botanists, mention ought to be made of George Pemberton, who explored Bhutan in 1835; William Moorcroft, a doctor turned veterinarian with a sound knowledge of plants who, in 1825, was the first Englishman to travel extensively in Ladakh; and also, in the twentieth century, the Scottish botanists George Sheriff and Frank Ludlow, and Frank Kingdon Ward, who discovered more than fifty varieties of rhododendron in southeastern Tibet. Recently, Adam Stainton has continued the tradition: in his book *Flowers of the Himalayas*, he calculates that there are more than 9,000 species in the region.

The specimens collected during these pioneering botanical studies, first preserved at London's Kew Gardens and now centralized in the Department of Botany at London's Natural History Museum, demonstrate that Tibet is the botanical crossroads of Eurasian flora. Often found side by side in Tibet are plants of the Mediterranean belt, the Indian subcontinent, Southeast Asia, China and Siberia – even plants akin to those of North America's Rocky Mountains are found in Tibet's northeastern ranges. As if this stunning variety were not enough, Tibet harbours countless mutations of such flora due to the effects of the Sun's intense ultraviolet radiation, which easily penetrates the thin air filter at high altitudes.

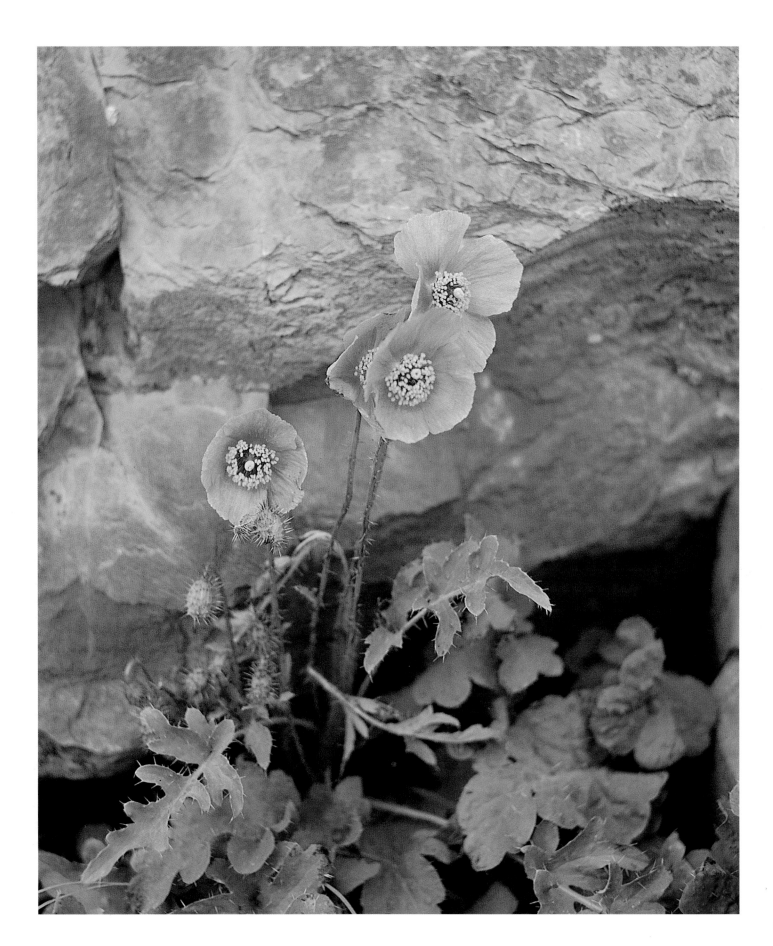

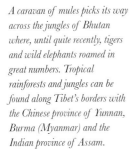

*Meconopsis aculeata is one of the blue poppies of Tibet. Large yellow poppies abound on the high grasslands, yet none of these poppies is used to produce opium. Tibetan doctors are accomplished botanists and more than 1,000 medicinal plants are recorded in Tibetan books, each linked to the cure of specific ailments when the herbal decoctions are appropriately prepared and administered.*

The flora of the Tibetan world can, roughly speaking, be divided into those of the high, dry cold plateau and those that grow on the damp steep slopes of the Himalayas and the eastern ranges of Tibet, with considerable variations by area. The plateau is generally semi-arid and treeless, while the foothills that dominate the Indian plains and those of China's Sichuan province are home to a range of exuberant flora.

The diversity of plants is very unevenly distributed because the southern face of the eastern Himalayas has some of the greatest volume of rainfall in the world, while the northern plateau is arid and possesses virtually no plants other than artemisia, wild nettles, dwarf willows and a small variety of grasses. Tibet's status as a land of botanical extremes is due primarily to the various micro-climates found in the numerous valleys – conditions brought about by their differing orientations and altitudes. In ascending zones of altitude can be found oak, chestnut and alder; deciduous sal trees; pine, cedar and birch; and above 10,000 feet (3,000 m) are found juniper, poplar and willow trees, and, thanks to irrigation, apricot trees. Among the best known of all Tibet's plants are rhododendrons, which were exported to Europe in massive numbers in the late nineteenth and early twentieth centuries.

In the wetter valleys there is an array of distinct herbal plant life, some flowering and others used in medicinal decoctions. The Tibetan Materia medica is particularly comprehensive, listing more than 1,000 plants, herbs and other ingredients. Many monasteries in Tibet have treatises on medicine, together with often ancient texts about the innumerable virtues of medicinal plants. In Tibet, practically every village has a doctor and a veterinarian, and both will be accomplished botanists. In 1959 Chinese mortars razed to the ground Lhasa's huge medical college, which stood on 'iron hill' facing the Potala Palace of the Dalai Lama. In it were stored priceless volumes on the various plants of Tibet, what diseases they cured and how they should be prepared and used as medicine. Fortunately, similar manuscripts and printed volumes were in safe-keeping elsewhere and have preserved much of the Tibetan knowledge about plants – invaluable material that had

*A caravan of mules picks its way across the jungles of Bhutan where, until quite recently, tigers and wild elephants roamed in great numbers. Tropical rainforests and jungles can be found along Tibet's borders with the Chinese province of Yunnan, Burma (Myanmar) and the Indian province of Assam.*

taken centuries to accumulate. Various species of *Meconopsis* are found in Tibet, the most common being the yellow poppy located on the high 16,600 feet (5,000 m) passes. The blue poppy, first discovered in the Pemako area of southeastern Tibet by Captain Bailey, is rare.

Mention, too, should be made of Bhutan and Sikkim, parts of Greater Tibet both famous for harbouring the greatest variety of orchids on Earth. Grapes can be found in Tibetan-speaking Ladakh, as well as in Kongpo where apricots and apples are to be found thriving alongside peaches. Cacti exist in some dry valleys, while in the tropical and subtropical regions, such as the southern portion of the Pemako district and the Tsari region, there are bananas. Eastern Tibet has extensive forests similar to those of the North American Rockies, with juniper and Douglas fir intermixed with many varieties of willow and plane tree. Another crop abounds in the mountain ranges fringing eastern Tibet that is thickets of bamboo, a food whose shoots are favoured by black Himalayan bears – found also in Bhutan, Nepal and parts of Kashmir – and, most famously of all, by the animal known to the world as the giant panda (*Ailuropoda melanoleuca*).

## Bears – the endangered and the dangerous

Tibetans call the panda *dom trata*, meaning the 'piebald bear'. Although it is a little narrow minded to give animals a nationality, it is quite distressing to observe that the Tibetan origins of one of the strangest and rarest animals in the world, certainly one of the 'most loved', are little known. The giant panda can be regarded as a 'Tibetan' animal in that nine established panda reserves are in what the Chinese call Tibetan 'autonomous prefectures'. Because regions that the panda inhabits were once part of Tibet and closed to foreigners, the animal's 'discovery' – in fact, confirmation of its existence, since furs had been seen in 1869 by Jesuit missionary Armand David – was not revealed to the outside world until Europeans on the Stötzner Expedition in 1913–1915 observed them in the wild. Thus, practically all the world's pandas are located in Tibetan-speaking regions that have been recently incorporated into the People's Republic of China. An endangered species, the animals remaining in the wild today are in the Gannan Tibetan autonomous prefectures, located in the southern extremities of China's Gansu province and in western Sichuan (the historic Tibetan provinces of Kham and Amdo).

The future of this distinctive creature is gravely threatened. It was once far more widespread and its numbers have been reduced through a long history of poaching and loss of forest habitat – something the creation of properly managed reserves should halt. The difficulties of this task are compounded by the panda's almost exclusive feeding habits. Because it has an opposable thumb, which is used for clenching the bamboo shoots prior to chewing them, the panda tends to eat almost nothing but these tasty shoots. Mismanagement of the reserves has kept the panda on the most endangered species list in spite of the money contributed by well-wishers across the globe.

All around the edges of Tibet in its forested mountains are to be found two other types of bear: the small Himalayan black bears, with their striking, perfectly delineated, football-sweater-like, white V-neck stripe and on the treeless high plateau the fierce Tibetan grizzly bears (*dremo*). In Kathmandu I made the mistake of purchasing two black bears who were barely three weeks old. They grew rapidly in size and were so sweet to look at that I forgot and forgave their terrible tantrums. Pumo, the female, would be eating her porridge quite happily when for no reason her brother, eating beside her, would straighten up and make a rush at her, his arms flailing like miniature windmills. The violence of these fits of bad temper was such that when the bears were two months old and no bigger than a good-sized stuffed toy I could hardly separate them. I was warned that once they were six months old these tantrums could have fatal consequences and that all bears had to be locked up. Because of their bad tempers and sudden changes of mood, bears are among the most difficult of all animals to train. Only the bravest

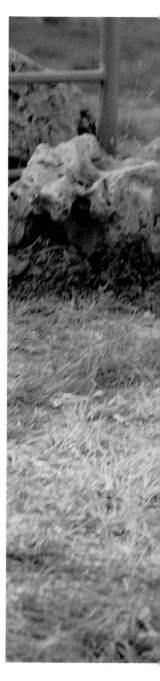

*The panda is very much an animal of Tibet, inhabiting the bamboo-covered foothills in the east of the country. The 'piebald bear' survives today in protected sanctuaries that are nearly all located in what the Chinese call 'autonomous prefectures', an administrative euphemism for territories inhabited by Tibetans and once an integral part of Tibet, but which are today incorporated into the Chinese provinces of Sichuan and Gansu.*

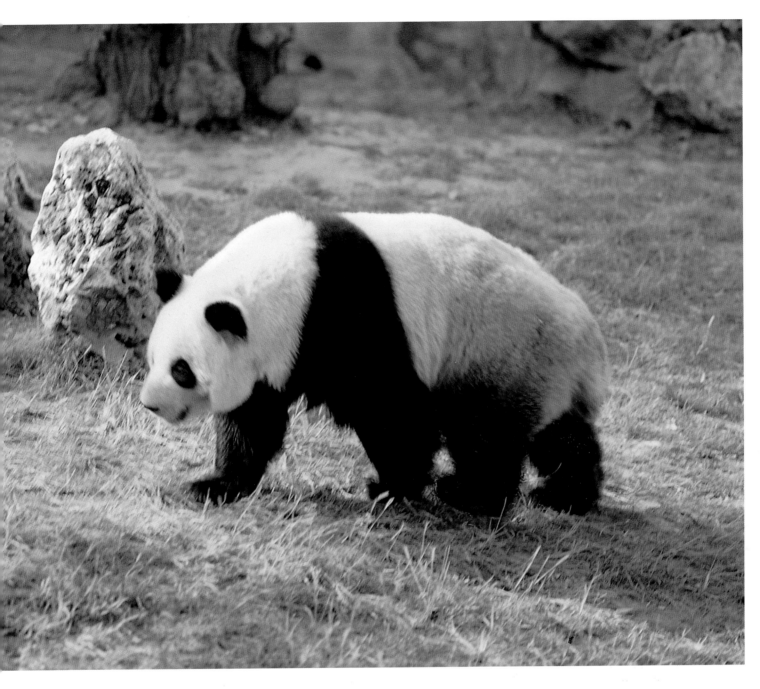

of Russian bear-tamers play around with them, for those on a leash – as used to be seen in Europe and still can be spotted in India and elsewhere – have, for the most part, been either lobotomized or drugged heavily to avoid the famous fits.

The *dremo* or Tibetan grizzly (*Ursus arctos*) is the fiercest bear of all, yet it is rarely seen and so little known about it that it does not even figure in most books, nor is it listed on the files of endangered species. Because encounters with it are so infrequent, it has no fear of humankind. Light brown in colour with long hair and a broad, fuzzy, pale yellow collar, this ferocious animal stands six foot tall (1.8 m). It has the unpleasant habit of entering nomads' tents, and while most adults can escape from this uninvited visitor, many children have been killed.

While tracking wild yaks (*drong*) at 18,000 feet (5,500 m) in a deep, rocky, snowed-in gorge close to Lake Aru in the Changtang in 1998, my guide Nakpo shouted '*dremo!*' … I scanned the

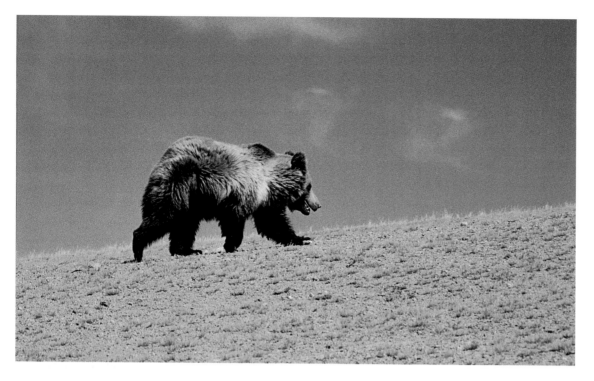

This is one of the very few close-up shots taken in the wild of a Tibetan grizzly. A fine specimen, it was surprised by us when we came over a grassy ridge and were able to photograph it before it could run out of sight. One can clearly see its particularly long and narrow snout. Our preceding sightings (below) had been from quite a distance away as we watched this bear scramble up and over a pass at an altitude of 19,000 feet (5,800 m).

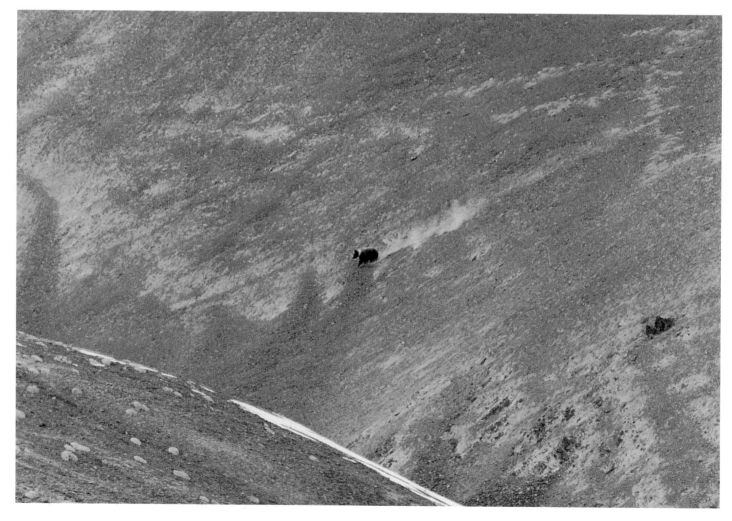

snowfields and the dark exposed patches of rock around me in vain, then suddenly there it was – fortunately quite far away, high on the mountainside. There was nothing to obstruct my view, no bushes, rocks or other obstacles, so for twenty minutes I observed and filmed, in awe as it progressed self-assuredly towards a mysterious destination, its gait breaking into a run when it scampered down a sloping ridge, creating a cloud of dust, before climbing up a shoulder to run down the other side. Finally, it reached snow and began walking away from me towards a pass, leaving behind it a well-marked trail of pawprints. Few animals resemble humans more in stature and gait than a bear when it stands and I could not help but feel a strange attraction to this long-snouted grizzly strong enough to survive in such a harsh and inhospitable land. What did it eat, or rather what could it eat on the barren Changtang? Surely not the burnt short grass? There were no bushes, so consequently no berries. I also thought of fish, but there are no rivers there, only salty lakes with little or no fish. When I asked Nakpo, he explained that they eat glacier rats (*picas*), marmots, possibly rabbits and hares, and maybe bigger game.

## A rich variety of animal life

Tibet has an amazing variety of wild animals, many of which have taken on specific, often unique, forms because of the altitude and the rugged terrain. Tibet has its very own member of the bovine family: in fact the largest, the wild yak; its specific equines; and its own felines, the *gsa*, or Pallas cat (*Felis manul*, a spotted cat smaller than a leopard) and the fabled snow leopard (*Panthera uncia*).

*The small musk deer has teeth that resemble those of a rodent. It is a shy and endearing creature but, sadly, it is one of the animals most sought after by hunters. The male musk deer has, near its navel, a glandular sac that produces musk of such unrivalled quality that it is more valuable than gold.*

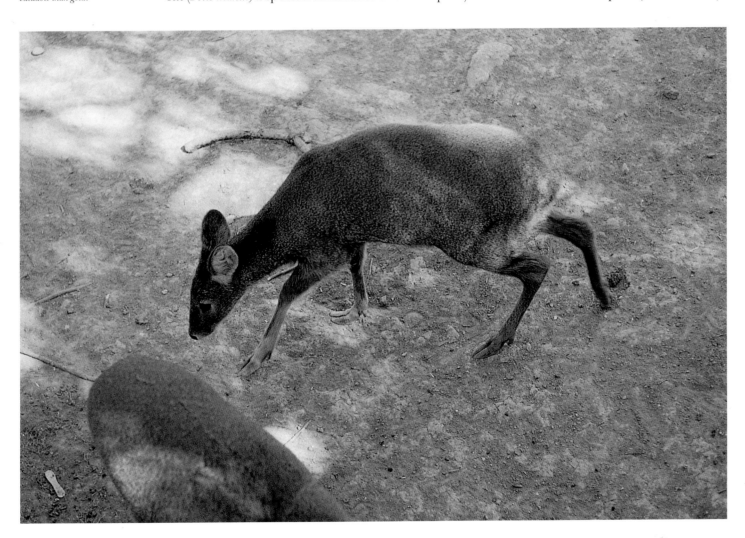

There are various types of deer, including the minute musk deer (*Moschus sifanicus*) with rodent-like fangs. This animal produces something as highly prized as gold – musk, which the world's greatest perfume houses must have to make their scents what they are, for no manner of artificial chemical substitutes can yet do the job of fixing scents as well as musk. Tibet is the home of two rare deer: the giant wapiti with immense antlers found along the borders of Bhutan and India, and the tall, graceful white-lipped deer (*Cervus albirostris*) to be found in the wooded regions of Riwoche and what was the kingdom of Nangchen (now in southeastern Qinghai province). I once caught sight of a herd beside the monastery of Gar in Nangchen. The monks had given hay to the deer in a time of heavy snow and consequently they now stick around for most of the year. There is also the famed Tibetan antelope (*Pantholops hodgsoni*), known as the *tseu* or *chiru*, whose golden fleece produces *shatoosh*, the 'king of wools', with strands only seven microns thick – half that of cashmere, which is derived from Tibet's keel goat. Tibet even has its own version of the Thompson gazelle (*Gazella picticaudata*).

Wild goats are plentiful, but they are physically dwarfed by the very strange 770-pound (350-kg) giant goat known as the *takin* (*Budorcas taxicolor*). This strange animal, the size of a cow, travels in herds and although I understand they abound in southeast Tibet and Bhutan I have never encountered them – mercifully so, because they have a tendency to push you off the tiny ledge-locked tracks that skirt the mountains of Pemako. Looking like a stub-nosed ox, the *takin* is very odd indeed. Some even have golden hair, a fact that spawned the legend that theirs might be the original golden fleece.

In a number of places within Greater Tibet, for example along the great bend of the Brahmaputra River and the upper Subansiri basin, a variety of primates abound – among them long-tailed langurs, macaques and other monkeys that the Tibetan peoples of Pemako eat. In these regions there are also occasionally crocodiles which, I discovered to my dismay, live happily on the banks of Himalayan rivers.

## Wild yaks

Foremost of Tibet's animals, however, is the yak (*Bos grunniens*) – as important to Tibetans as camels are to the Bedouins. The biggest wild yaks can stand six foot, six inches (2 m) high, which makes them the tallest and largest members of the bovine family. Wild yaks are bigger than both bison and the fearsome Cape buffalo. Nevertheless, yaks are not the size of elephants, as Marco Polo had claimed. As with so many subjects relating to Tibet, we know very little about the different types of yak. There seem to be several domesticated breeds, varying in size from nearly miniature to large, with an assortment of visual characteristics, ranging from square faces to elongated, round, globular muzzles.

As for wild yaks, nobody knows for certain if there are several different breeds or not, since too few scholars have ever seen them and none has studied them in detail – for reasons I can well understand. The wild yak is not only difficult to approach but also so ferocious that not even the Tibetans have got close enough to differentiate males from females, both of which are called *drong*. Given their long hair, you would have to be extremely brave to get close enough to discover which is which, although size is a clue (the male being much larger). Incidentally, *yak* is the Tibetan name for the tame, 'domesticated' males or bulls, while the females or cows are called *dri*, so that yak milk or butter is really a misnomer and does not exist any more than bull's milk or cock's eggs.

During the 1950s and 1960s, Bhutan still had many extraordinary animals, including tigers and wild elephants, even rhinos and a rare monkey, the golden langur, which had been discovered in the 1950s by E.P. Gee. Mr Gee, a legendary zoologist with many discoveries to his name, was primarily a tiger man. I met him in Kalimpong when I was twenty-two, and I was amazed that

*A yak loaded with wood paces slowly up the barren 15,750 feet high (4,800 m) pass leading to the mysterious Ralagong Valley – a remote high-altitude area of the Zanskar mountain range with no exit lower down. This secretive valley is known only to traditional doctors from Zanskar and nearby Ladakh because it is the source of many rare medicinal plants, which have been collected there for generations by one family. I believe I was one of the first foreigners to enter this secret harvesting ground when I investigated traditional medicinal practices in Zanskar in 1980.*

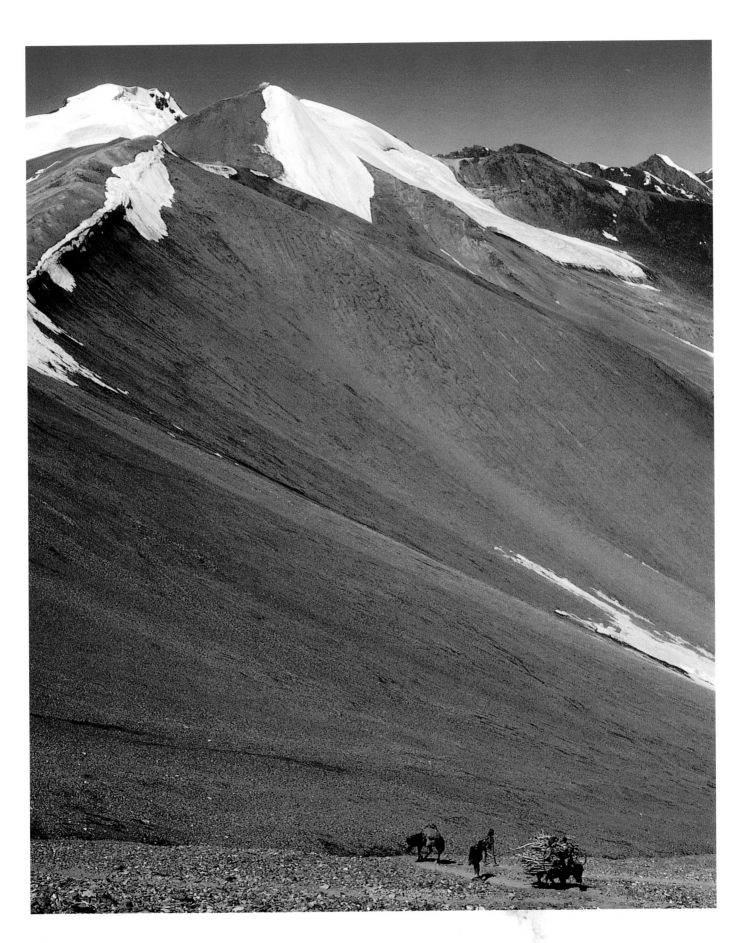

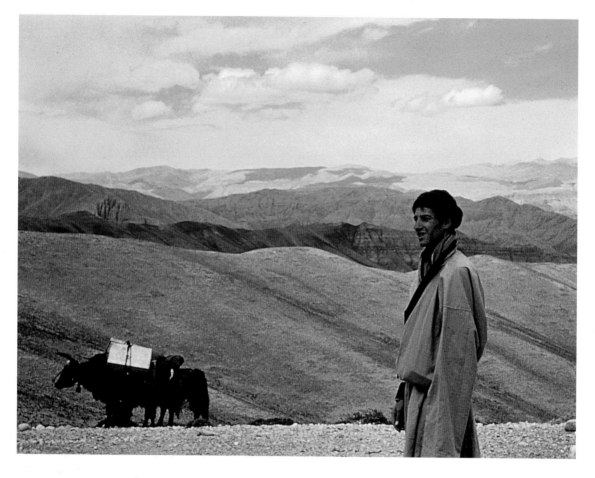

he looked not like the jungle adventurer I expected but a bank clerk with steel-rimmed glasses and a frail build. In a shy voice, the man who saved the Indian lion and the Assam rhino from extinction asked me if I could help him persuade the king of Bhutan to make a game reserve out of part of his kingdom. In fact at the time (1959), Bhutan, like Tibet itself, was a natural game reserve because of the religiously inspired reluctance to kill animals. If some Tibetans did hunt occasionally, the majority were loath to take life, and as a result many species were relatively tame.

Although wild yaks were once apparently found in their hundreds of thousands all over Greater Tibet, I encountered them only twice in my travels – the first time in 1968 in Bhutan when a herd of wild mountain yak erupted into a clearing in which I was camped at the foot of the 13,100-feet (4,000 m) Ruto Pass. I took them for tame yaks because my porters told me they belonged to the king. I was so impressed by their size that I asked Tsering, the young Tibetan who accompanied me on my long march across Bhutan, to take a photograph of me standing beside one of the yaks. I was wearing an orange puffer jacket and was quite unaware that the wild bull could, or should, have charged me as I grinned to camera. It was only the next day that I understood that these yaks 'belonged to the king' – as did the snow leopards and all the other wild animals of the kingdom.

## An expedition to the remote Changtang

Despite many extensive journeys to the remotest parts of Tibet, I failed to see any more wild yaks after my encounter with them in Bhutan. To remedy this, in 1998 I decided to set out from Lhasa in search of the 'legendary' *drong*. To do so I had to travel more than 1,000 miles (1,700 km) into the heart of the Changtang. I hoped to see, and film, wild yaks and maybe also the rarely observed Tibetan grizzly, but I found plenty more besides.

Changtang means 'northern plains' in the Tibetan language, but for every Tibetan the word is synonymous with hardship and desolation. There are no crops in the Changtang and very few people live there, with the exception of a few nomadic tribes who inhabit its rim. In actual fact, the Changtang covers much of Greater Tibet, stretching all the way from northern Ladakh in the west to the borders of China in the northeast. I had heard so many tales of horror about the region that when I approached its western extremity for the first time I expected some sort of high-altitude Death Valley. My first reaction was one of relief as I contemplated the endless sea of snow-capped mountain ranges that stretched before me, separated from one another by magnificent turquoise lakes. On sunny days the Changtang can look enchanting – and there lies the true danger, for few places on Earth have such a rugged and unpredictable climate. Here it freezes most days of the year, yet the ground is mostly clear of snow. Within a few minutes a clear sky can cloud over and a flash of lightning can mark the beginning of horrendous and potentially deadly hailstorms. These hailstorms are so feared that for millennia 'hail-makers', or men considered capable of stopping hail from falling, have been highly revered. Hail in Tibet can be fatal not just for crops but also for animals and humans. Every year large yaks, sometimes whole herds, are killed by hailstones bigger than chicken's eggs.

Personally, I'm not a fan of desert voids and desolate wastes. I prefer the comforts of home when watching the exploits of those who walk to the North or South Poles eating snow and filming ice and snow as they slide and sludge their way across a land that no living being in his or her right mind would dream of visiting. For years I believed the Changtang to be such a land, a combination of the South Pole and the Gobi Desert, with altitude thrown in. Statistically, the Changtang is a desert because it hardly rains there at all; yet the dry soil rests on permafrost. All this explains why I was most surprised to discover that, in spite of it all, the Changtang is, in its northwestern recesses, a true Garden of Eden, a sort of natural paradise alive with thousands upon thousands of antelopes, gazelles, *kyang* and wild yak. It is somewhat like the Kalahari Desert – an ecosystem that has produced specific forms of wildlife adapted to nature's extremes.

The wild yak, along with the Tibetan grizzly, is in many ways the king of the Changtang. Like its lesser cousins the tame yaks, wild yaks have evolved a substance that stops their legs and hooves from freezing during the howling gales of winter; they also possess stomachs – like those of reindeer – capable of feeding on moss and lichen so that they can survive the long winter months when most of the Changtang is barren, save for the short stubble of frozen burnt-out grass. Surprisingly, this stubble is what feeds the thousands of Tibetan antelopes, gazelles, wild sheep, *kyang*, hares, rabbits, marmots and glacier rats, which in turn feed the bears, wolves, foxes, lynx, stone martens, jackals and the occasional snow leopard.

## Poaching – a new enterprise

In the distant days of King Gesar of Ling, the semi-mythological hero of Tibet's great epic tale, only the boldest and noblest of men dared to hunt wild yaks. Today, alas, firearms make such killing an easier task. Our path across the trackless Changtang was littered with the impressive skulls and horns of wild yaks slaughtered by the modern-day poachers of Tibet. Yielding close to a tonne of meat, it pays to shoot a wild yak – provided that you own a truck to take your kill to the closest village or town hundreds of miles away. Unfortunately, the number of truck-owning Tibetan and Chinese poachers in certain parts of the Changtang is increasing rapidly.

While some poachers may cruise the great plains shooting wild yak, their favourite targets are the Tibetan antelope whose golden fleece fetches a fortune as the raw material of the illegal *shatoosh* trade (*shatoosh* being the name of both the antelope wool and the fabled shawls made of this wool spun in Kashmir). This wool, among the thinnest and warmest in the world, has incredibly fine

# Tibetan harvests

1. These two covered wagons belong to
Muslims from China's Gansu province.
Along with approximately 100,000 other
Chinese, the wagons' occupants have
flocked to what was Tibet's Amdo province
as part of an annual summer gold rush.
The prospectors come to pan for gold dust
in the headwaters of the Yangtze River.
There are no statistics to indicate the
amount of gold these adventurers collect
during their illegal activities, although it is
known that thousands of them die from the
cold and the effects of the high altitude.

**Despite being barren in appearance** and afflicted by a harsh climate, Greater Tibet has many more resources than might generally be imagined. Immense forests cover most of its eastern reaches, more than 40 million head of cattle graze the dry plateau, while the irrigated fields yield generous crops of the staple barley, which when fermented becomes the national drink, a beer known as *chang*. Even wine is not unknown, with grapes being grown and turned into alcohol in Tibetan-speaking Baltistan and Ladakh. Of all the peoples of Tibet, only the nomad herders do not have an intoxicating beverage. For the nomads, barley is considered too precious to brew alcohol from and they drink neither fermented mare's milk nor anything similar from their *dri*, or female yaks.

But Tibet has 'crops' other than barley to reap. For example, there are salt and allied minerals, as well as rare metals, including lithium and gold, which can be found in abundance in a number of rivers. Out of respect for the ancestral *lu*, or gods of the soil, the extraction of this mineral wealth was limited under the rule of the Dalai Lamas. Today, however, the Chinese, in addition to American and Australian mining concerns, have fewer scruples about plundering the wealth to be found within Tibet. Strip mines harvest gold and potash with little concern for the environment, while the use of chrome in the industrial tanning of hides pollutes rivers.

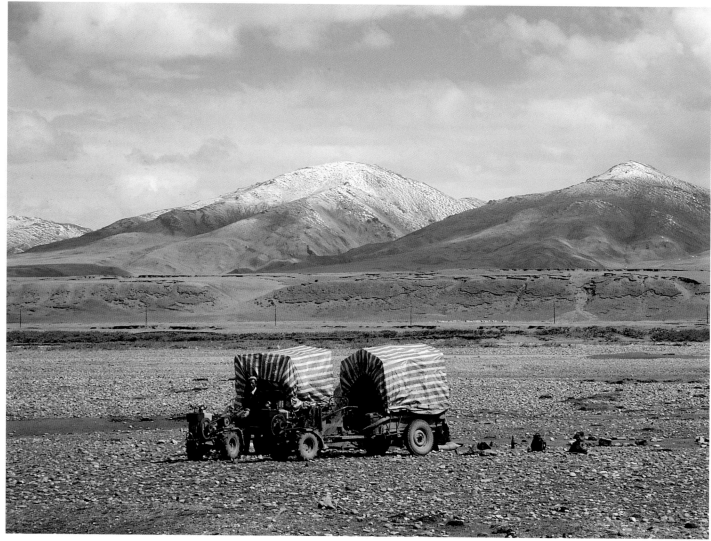

1

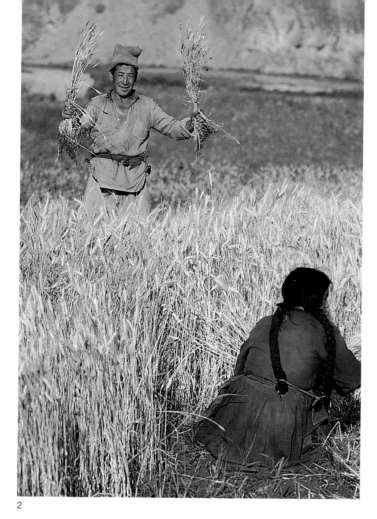

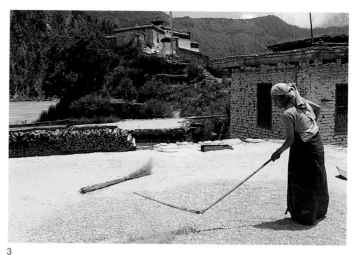

3

2, 3. In certain villages in lower Mustang the barley is not cut when it is ripe; instead each stem is pulled out with its roots so that nothing is lost (left). Nearly every valley has its own techniques for separating grain from the stems. The most frequently used method is the beating of grain with articulated flails of different shapes (above). In Ladakh, yaks and ponies are used to trample the barley, while in Bhutan the farmers themselves do this using their bare feet while holding on to a horizontal wooden railing. Elsewhere the grain is ripped off its stem by running it through steel combs or between two sticks.

6. A farmer in Ladakh enjoys a cup of wine. The grapevines cling to apricot trees and can be found growing as high up as 11,500 feet (3,500 m) above sea level.

2

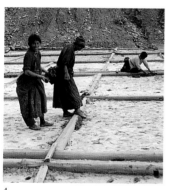

4. In the Nangchen region, which lies along the upper Mekong River, there are few salt lakes compared with elsewhere in Tibet. People therefore obtain salt by hauling up brackish water from the well and evaporating it in the sun. The water is put into lined rectangular pools from which the salt can be collected later once dried.

5. Tibetan barley beer is run through a sieve to produce mush-free *chang*.

4

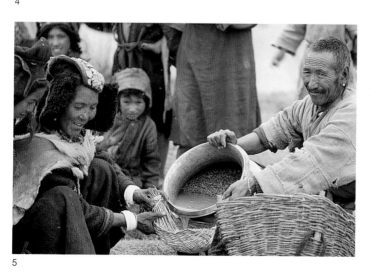

5

6

# A prehistoric breed of horse

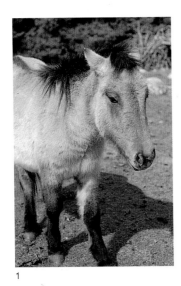

1

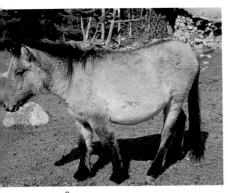

2

1, 2. Two views of the archaic Riwoche horse with its characteristic 'duck-bill' nostrils, its short black mane and weak hindquarters.

3. A fine example of the Nangchen thoroughbred. Note its fine neck, face and cannons (the bone between the horse's hock and fetlock).

**It was long believed that the only horses** to be found in Tibet were nondescript, rugged mountain ponies of uncertain Mongol origin. If this was true of most 'valley horses' that belong to farmers, a very different picture emerges among the nomadic herders who live on Tibet's northern plains. Documents prove that for more than twelve centuries, some of these nomad peoples have selectively raised thoroughbred horses. As in Arabia and Turkmenistan, it was the scarcity of suitable pasture and the extreme cold of the high plateau that obliged the Tibetans to carefully tether, feed and protect their mounts. Then, as a consequence of the close relationship with the animal, men selected the stallions and mares they wished to breed. This has led to the evolution of several distinct breeds – hotblood thoroughbreds with specific transmissible characteristics.

The finest of these breeds is, in my opinion, the Nangchen breed. A tall, swift and agile pony, it has enlarged lungs and fine features. It was while studying this breed in the company of Dr Ignasis Casas, an equine physiologist delegated by the Royal Animal Health Trust of Newmarket in England, that I stumbled upon a strange-looking pony in the highlands of the county of Riwoche. The pony proved to be a previously unknown archaic breed, one which is very similar to the mysterious horse 'No. 2' found depicted in prehistoric cave paintings alongside the wild Przhevalsky's horse that is found in Mongolia. Now known as the Riwoche horse, this 'living fossil' is domesticated and could be the missing link between wild and domestic horses. However, tests conducted so far have not revealed any genetic variance between the Riwoche and other horses, unlike the Przhevalsky's horse, which has a specific chromosome count.

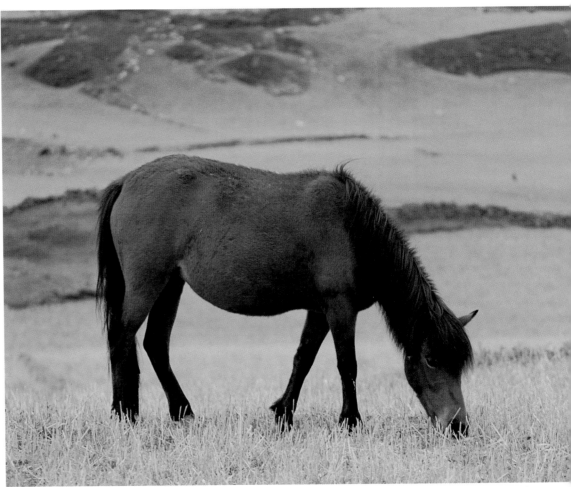

3

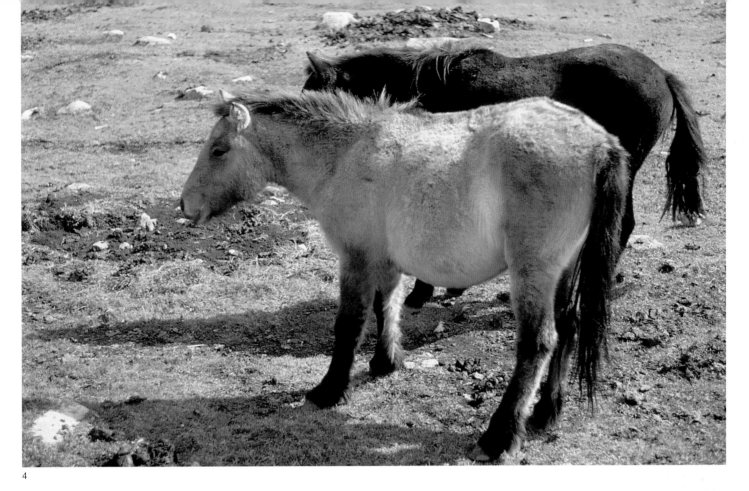

4

4. Two young Riwoche ponies. The Chinese are cross-breeding Tibetan horses with various other types in search of a new, heavier breed.

5. It was this rugged Himalayan pony that bore me during one of my expeditions across mountainous terrain into the walled city of Lo Mantang in 1992, the capital whose misspelled name provided the little kingdom of Lo with the name Mustang, by which it is known to Europeans today. The kingdom and its ponies have no relation with the wild horses of North America, the mustangs, whose name is derived from the Spanish *mostrenco*, meaning 'wild one'.

6. A Nangchen stallion, its enlarged lung visible. The Nangchen stands 13.5 hands tall (1.3 m), about one hand smaller than the rugged, heavy Hechu breed found in northeastern Tibet that was much appreciated by Chinese armies as many as 2,000 years ago.

5

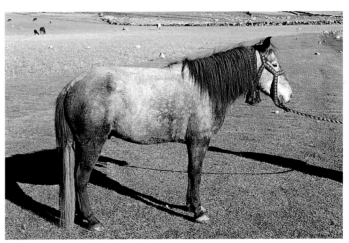

6

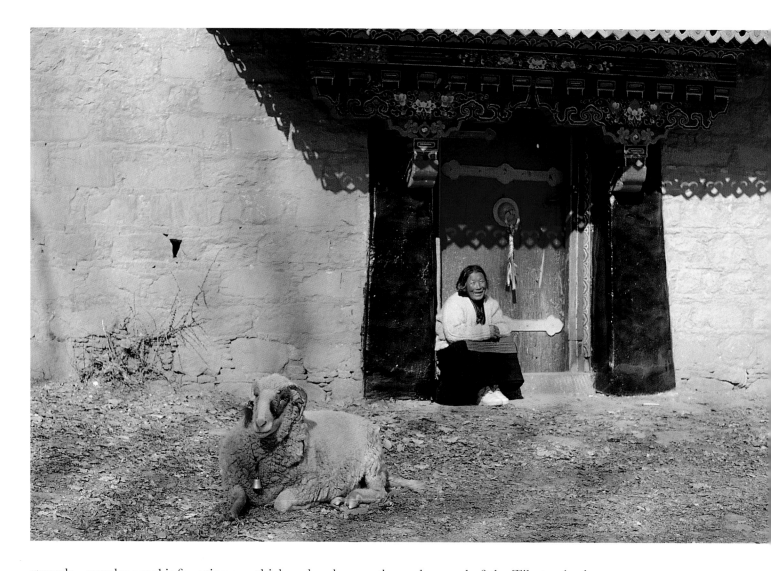

strands – regular wool is four times as thick and cashmere, the under-wool of the Tibetan keel goat, is twice as thick. So thin are the strands of antelope wool that it cannot be spun or woven mechanically; in fact, to date, the only people capable of spinning it are the agile artisans of Kashmir. Despite a ban against the purchase and sale of *shatoosh* shawls, the trade increased considerably with the opening up in 1982 of Tibet and China to private enterprise and speculators. Originally, the market for these shawls was restricted to the wives of Indian maharajas, but today the market has expanded worldwide to New York, Paris and London.

There are also a number of rackets operating in the trading of the wool. A true *shatoosh* shawl can sell for in excess of 6,000 US dollars, yet many so-called *shatoosh* shawls are fakes that sell for less than this, being simply fine cashmere shawls sold at a fabulous profit – for few people can differentiate between real and fake except for a handful of experts and scientists capable of performing DNA tests. Clients are told that only authentic *shatoosh* shawls are thin enough to be run through a ring, but so too can shawls made of the finest selected cashmere wool thinly spun and woven. Traders reassure purchasers that the antelopes are not shot and that instead their wool is collected on fences and on bushes – yet one look at a picture of the habitat of *Pantholops hodgsoni* reveals that there are no fences or bushes on the barren Changtang.

The Tibetan antelope has very long, thin serrated horns that appear quite graceful. Scholars are not at all certain, in fact, that it is an antelope. The paleontologist G.E. Pilgrim classified it in

1930 as a caprid or goat, a classification confirmed recently through a DNA analysis performed by George Amato of the Wildlife Conservation Society. Whatever the experts say, the *tseu* or *chiru* looks and acts exactly like an antelope.

Considerable mystery surrounds the breeding habits of the animal, a mystery perhaps no greater than the Changtang itself – a region so large and relatively unexplored that in spite of the inroads of poachers it can still be claimed as one of the largest unspoiled ecological zones on our planet, after Antarctica. How long it will remain that way is another question. Dr George Schaller, the world's foremost expert on the fauna of the Changtang, has obtained a promise from the Chinese to declare most of the Changtang a wildlife sanctuary, which would make it one of the largest in the world. However, it is naive to hope that the government will be able either to halt the poaching or to police such a vast area. Already, two senior Tibetan officials nominated to organize the protection of Tibet's wildlife have been assassinated, presumably by the gangs who run the illegal wool trade.

### The unique *equids* of Tibet

Less well known than Tibet's yaks and antelopes, yet just as fascinating and much more numerous, are the *kyang*, the tallest of wild equids. *Equus kyang* has rather too hastily been called a wild ass, when in fact it is a stand-alone breed, very different from the long-eared *Equus hemonius Pallas*, the wild asses of Asia. The *kyang* are more akin to a zebra without stripes than anything else. Although chased and shot by the Chinese for their meat, which most Tibetans do not eat, they are still found in their thousands. No detailed study has been carried out, but there are believed to be three types of *kyang*: the eastern variety abundant in Tibet, the western kind quite rare and found in the Rupchu region of Ladakh and in western Nepal, and the southern variety found in small numbers in Sikkim and southern Tibet.

*Kyang* have been described as shy, but other visitors to Tibet have said that they are curious and circle strangers to look them over. I have found them to be both shy and curious, keeping a respectful distance, yet often stopping to look. Like many travellers to Tibet, I have fallen under the spell of the sight of huge herds of *kyang* galloping across the great northern plains, their coats shining golden against the burnt grass or outlined against pale blue lakes, their thundering hooves raising small puffs of dust.

No less fascinating are the various breeds of Tibet's extraordinary horses. For many years it was believed that these domesticated horses were but rough, hardy ponies of Indian or Mongolian stock. Either no one had ever bothered or no one had been able to study Tibetan breeds, so in 1991 I resolved to do so and set out in search of 'horseflesh'. It took me four years to establish that Tibet has a variety of different native breeds, six in all by my latest count, among which the small Nangchen horse, standing 13.5 hands tall, is a true thoroughbred, having been raised with considerable care for at least twelve centuries.

This fine horse is to be found in the kingdom of Nangchen, a huge tract of land inhabited by nomadic Khampa herders who occupy the southern third of what is now Qinghai. The Nangchen is a unique breed, with enlarged lungs – an adaptation over the centuries to the oxygen-poor air of the high plateau. It is fine limbed and has a long, delicate neck, a flat back and fine face. The lungs would be the envy of many Western horse-breeders seeking to increase the 'wind' of their horses for endurance and speed, for they enable the Nangchen thoroughbred to gallop with ease at altitudes nearing 16,400 feet (5,000 m). The Nangchen is the product of careful selective breeding by the nomads.

In the treasure trove of ancient Tibetan manuscripts found by Sir Aurel Stein in a sealed cave at Dunhuang are accounts of how to breed such horses – evidence that Tibetan horses were the

*An old woman maintains a watch over her prized ram while she sits upon the doorstep of a side gate that enters into the garden of the Norbulingka, the summer palace of the Dalai Lama in Lhasa.*

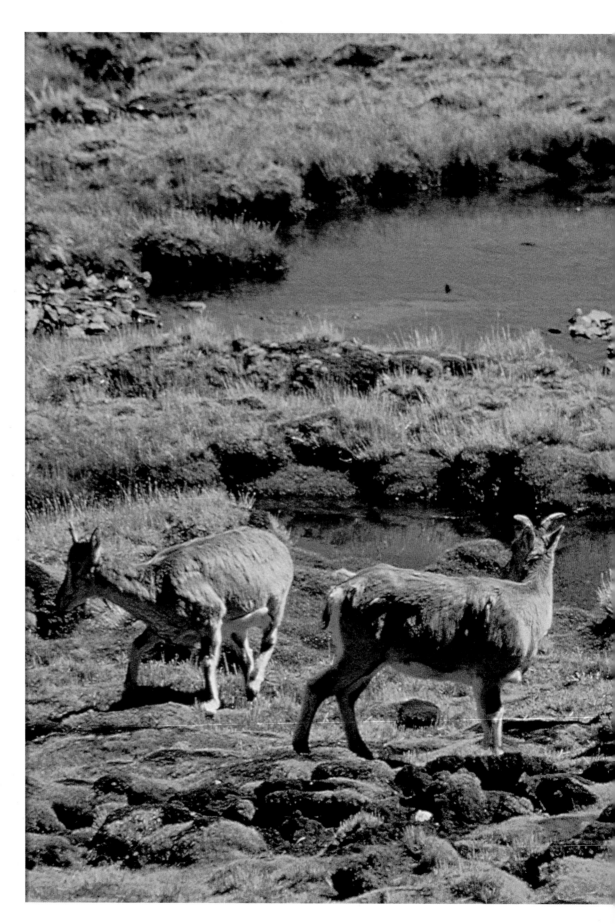

*A rare shot of a flock of Tibetan blue sheep (*Pseudois nayaur*), called* nar *in Tibetan and* bharal *in India. They are in fact mountain goats, Tibet's equivalent of chamois, which inhabit the rocky spurs of high mountains. A* nar *is not often seen on level ground (as here). These animals were surprised while drinking in a pool in the northwestern reaches of the Changtang near Ghertse.*

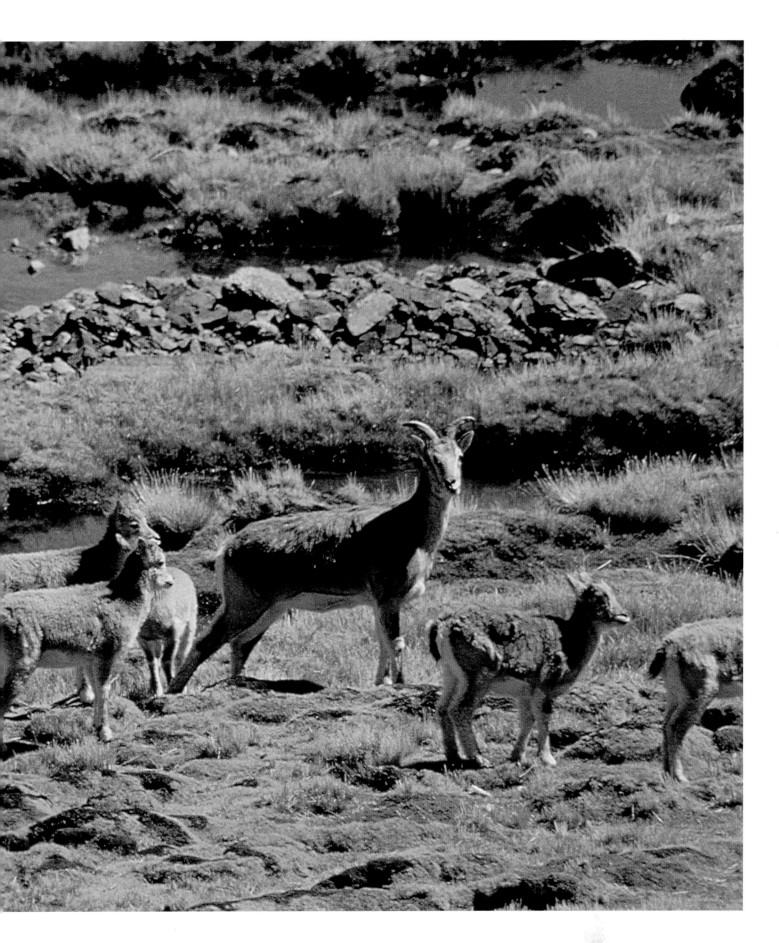

object of care and attention as far back as the ninth century. One of these manuscripts details the surprise of Tibetan horsemen upon seeing for the first time the horses of the Aza, an enemy tribe from the Silk Road region. This account demonstrates that Tibetan horses were, as they still are today, very different from both the Mongolian and the Turkoman horses of Central Asia.

It is interesting to note that across the world the finest breeds of horses were raised in those lands with little grass, such as Turkestan and Arabia. This is also true of the Nangchen horse, for Tibetan pastures are poor and sparse, and were it not for the capability of yaks to eat and digest lichen, wild cattle would also have trouble finding enough to eat. To survive in Tibet's harsh environment, horses need the constant attention of their owners – in winter foals must be given coats to resist the cold and when grass is scarce horses are often fed dried yak meat.

Horses are also corralled to protect them against wolves and snow leopards, which have been known to kill foals. This attentive relationship between humans and horses was in time probably extended to the selection of stallions for their mares. Through this selective breeding the Nangchen horse has been developed to serve the interests of the Khampas of Nangchen, a people who were once combative and competitive warriors as well as great travellers. The result is an exceptional horse with a deserved reputation for its stamina and speed, as demonstrated in races held annually in Nangchen and the surrounding areas. These races are part of the annual fairs to which the nomads flock to exchange wool, butter and yaks for grain, mostly barley grown in the low-lying agricultural regions.

## Legendary felines and majestic birds

Less strange than bears or wild yaks, but perhaps more frightening is the snow leopard. This legendary feline is nocturnal and rarely seen in the wild. As a rule it inhabits craggy areas, lives at altitudes that can reach 19,000 feet (5,790 m) and is seldom found on the open high plateau. It is a big animal as cats go – the only one I ever saw was dead, having just been shot by a farmer whose flocks it had attacked. This was in the kingdom of Mustang, and the farmer was bringing the body to the king. In general, such animals are crudely stuffed and hung up in monasteries, as much to ward off evil spirits as in contrition for the taking of life, a grievous sin for Buddhists. This snow leopard measured ten feet (3 m) from the tip of its nose tip to the end of its tail, very long indeed when one thinks that the longest Bengal tigers are only a foot (0.3 m) longer from tip to tail. Of course the snow leopard is a much lighter creature and its tail is extremely long, an exception to the general theory that the colder the climate the shorter the tail. This may be true for the short-tailed Siberian tiger, but it does not hold for the snow leopard.

No mention of wildlife would be complete without birds, for Tibet is home to more than 500 species. The birds are of three distinct kinds – land birds, aquatic birds and predatory birds. The first category is land birds, ranging from small snow finches and crested larks to large ravens, and also including Tibetan sand grouses and the still larger Tibetan snowcocks. The second category is that of the aquatic migratory birds found on or around many of the lakes: a large variety of ducks, the famed black-necked cranes and bar geese that nest in Tibet before flying at altitudes of up to 30,000 feet (9,150 m) over the Himalayas into India. Last, there are the predators – Himalayan eagles, griffins, hawks, falcons, and last but not least the vultures, the largest of which is the Lammergeyer (*Gypaetus barbatus*) with its ten-foot (3 m) wingspan. The eagle is the king of birds in many central Asian shamanic cultures, and Tibet is no exception; Bon believes it was from an eagle egg that the creator god Sangpo Bumtri emerged. Buddhism incorporates the eagle in the form of the Hindu protector deity Garuda. The graceful turns of such large hunters from the sky recall that the atmosphere is the realm of the sky gods (known in Bon as *tsan*).

*A flock of bar-headed geese (Anser indicus). Astronauts of nature, these birds have been seen flying at 30,000 feet (9,150 m), just below the troposphere, on their annual migration from Tibet and over the Himalayas to India. To survive at such altitudes, where the temperature is minus 80°C and it is difficult to absorb enough oxygen, the birds have evolved to cope with these conditions. It is estimated that in flight their hearts beat at 400 times per minute.*

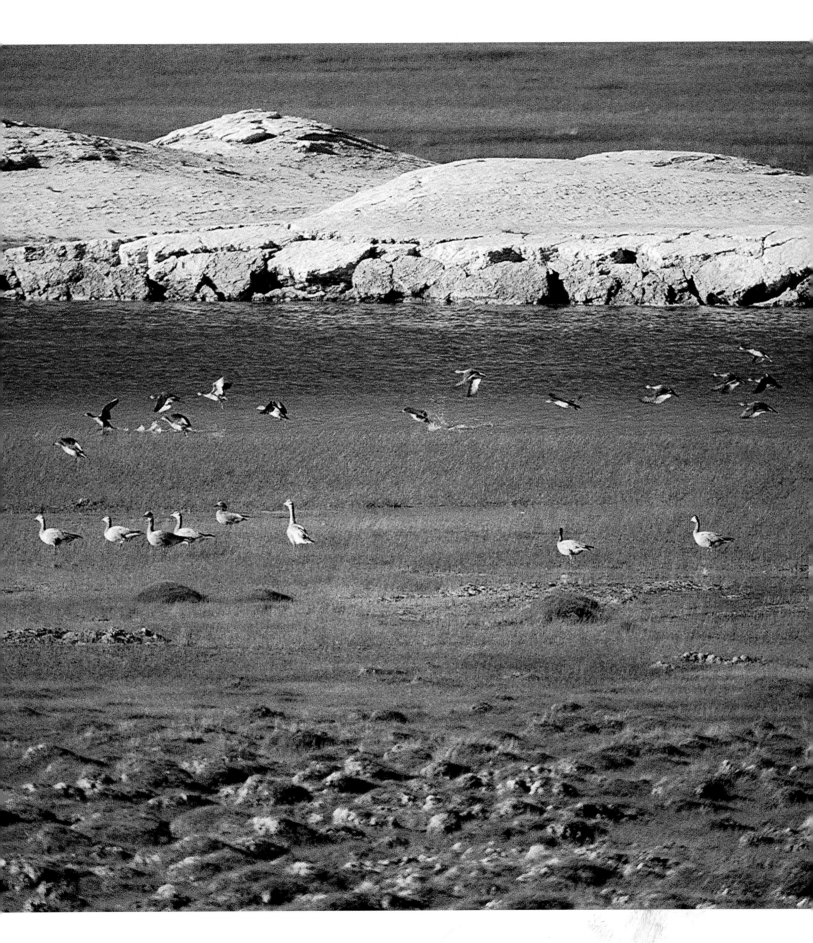

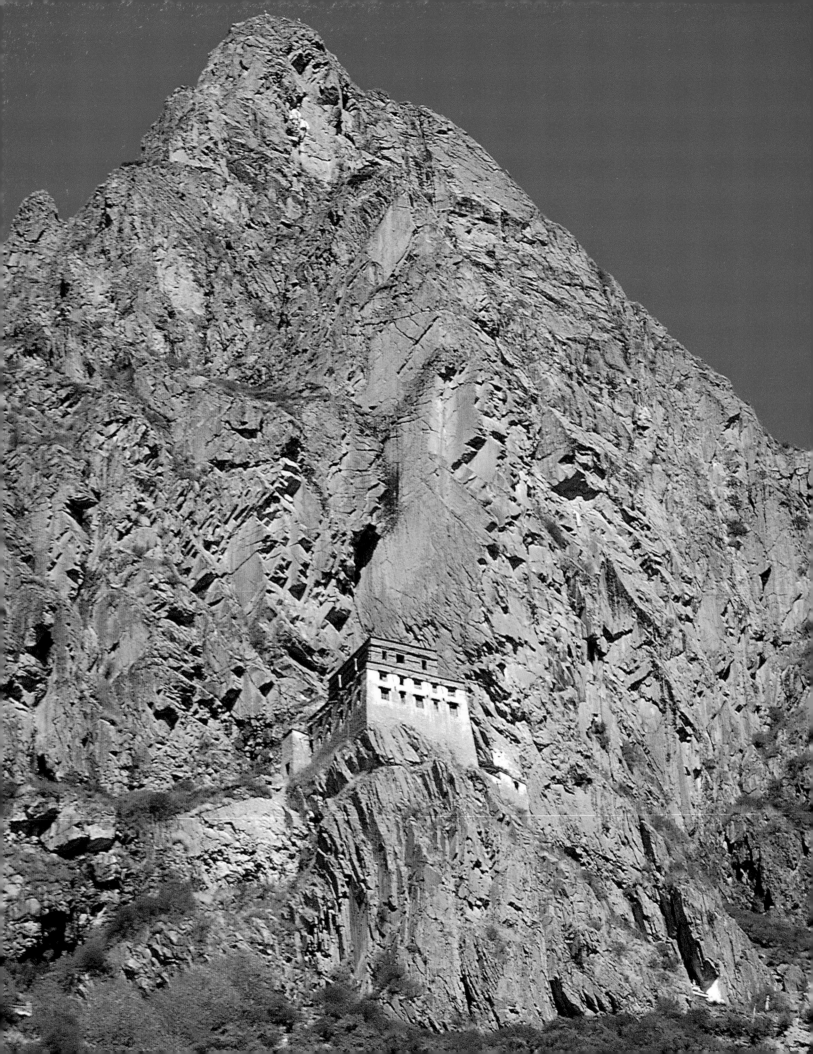

# 3  The People and Society

*Often set high upon the steepest crags, many Tibetan monasteries were built near or around the cave retreats of hermits. Ideally, such locations overlooked a waterfall, a cliff-face or a high peak.*

STONE AGE TOOLS ARE FOUND in relative abundance all over Tibet, even in the remotest corners of the Changtang region, where today so few dare to venture. This suggests that altitude did not deter the Tibetans' earliest forefathers. Hundreds of arrowheads, scrapers, axe-heads and other stone implements, some polished and others crudely flaked, testify to the occupation of Greater Tibet since time immemorial. Carved rocks, encountered all over the landscape, add further to evidence of an ancient past. Who were these people? How had they lived? These are questions that have fascinated me since my very first contact with Tibet in 1959.

More than forty years later I am still collecting stone axe-heads and clambering into holes and caves in search of more clues – for these are aplenty, and not just arrowheads, but mysterious, impressive cliff-side cave cities and archaic human beehive dwellings similar to those made in ancient Europe, which add further to the mystery. Perhaps more fascinating still is the fact that across the diverse regions of Tibet – from arid plains to tropical jungles – many people today still live according to customs whose origins stretch back to the Stone Age. The Tibetan highlands are a living museum of old traditions, beliefs and ways of doing things that are barely affected by the modern world, or, for that matter, even by Buddhism.

From the variety of racial characteristics visible among Tibetans, it is evident that the earliest inhabitants of Tibet were of diverse racial stock. There are tall, angular Tibetans with fair skin and long noses, while others are more squat in stature with pronounced Mongoloid features. Tibet, located as it is in the heart of Asia, borders various population groups, yet those peoples who inhabited Tibet have evidently been there for a long time – we can infer this from the fact that whatever their outward features may be, their bodies have become genetically adapted over thousands of years to high-altitude living. Thus, in spite of different and distant origins, the inhabitants of the high plateau share not only the same language and customs but also similar genetic characteristics.

My interest in Tibet's past began during my very first journey to the Himalayas in 1959. I had set out for India from Boston, accompanied by the Harvard anthropologist Alain Thiollier. Hoping to enter Bhutan, in India I made for Kalimpong, a small town that straddles the trade route that links India with Sikkim, Tibet and Bhutan. In Kalimpong I hoped to meet the prime minister of Bhutan, a land at that time closed to all foreigners. That year, what with the revolt in Lhasa and the flight of the Dalai Lama, Kalimpong was considered to be the centre of all intrigues concerning Tibet's struggle against China. People were too preoccupied blaming the Chinese to recall that Kalimpong and nearby Darjeeling were originally Tibetan settlements, both annexed by the British in the nineteenth century.

I had not been in Kalimpong a week when a missionary suggested I spend a few days in his isolated outpost among the Lepcha, the 'bamboo people' who were said to be the aboriginal inhabitants of the foothills of Sikkim. In the thatched hut of his mission, the priest presented me with a handful of carved stones of obvious prehistoric origin. Soon I was scrambling into a hole searching for more of these 'lightning stones', as they are called in both Tibet and parts of Europe.

Who then were the early inhabitants of Tibet? Were they Mongoloid or had they come from the west as some believed? It is very difficult on the evidence of a few artefacts and bones to establish the race and language of a people, but according to the earliest Chinese and Indian manuscripts, which relate the history of the past 2,500 years, while cultural influences certainly

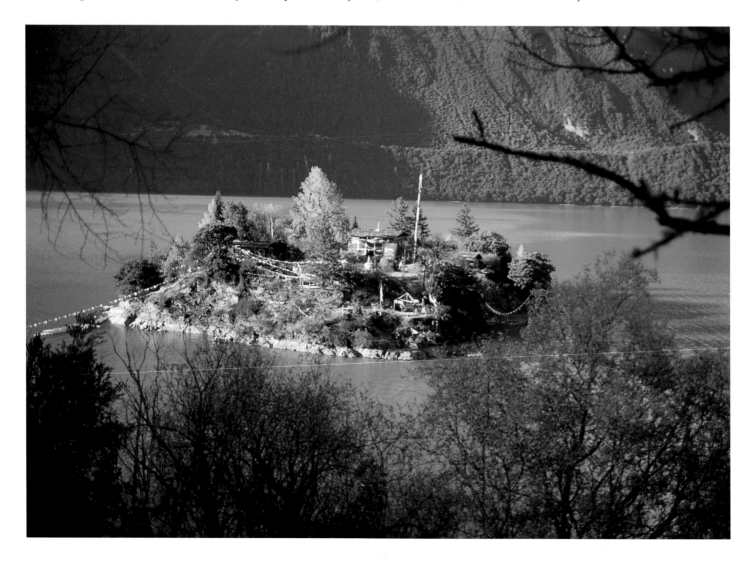

reached Tibet from as far away as Persia and Scythia, there was no major invasion of or settlement of foreigners in Tibet other than the dispersion within it in the first century BC of a branch of the Yueh-chi. The little Yueh-chi, a so-called 'white bearded people' ('dog faced' according to Chinese documents), had been displaced from their home along China's northwest borders by an early Mongolian people, the Hsiung-nu. The next recorded intrusion of foreigners into Tibet was the twelfth-century settlement of Mongolian soldiers in certain parts of Amdo, in particular around Blue Lake (Tibetan, Tso-ngon; Mongolian, Koko Nor), Tibet's largest.

The first written records on what might have been Tibet occur far earlier than this, however. They appear on Chinese oracle-bone inscriptions from the Shang dynasty (1500–1045BC) more than 3,000 years ago, which speak of a kingdom of tent-dwelling nomads, the Ch'iang, who are presumed to have been herders, since the ideogram of their name combines the signs for man and sheep. The Han Chinese feared the peoples living in this area and by the first century AD outposts had been established to protect the empire from being invaded by them.

The deterrent to other peoples settling in the area of the Tibetan plateau, then, may not just have been due to the uncomfortable nature of life at high altitude, for it would also seem that people sought to avoid inhabitants who had established a reputation as ferociously independent warriors. Men who were to become for a time the uncontested masters of Central Asia.

### Horse fairs and marriage markets

*Surrounded by stunningly blue water and shaded by trees in an alpine landscape, this tiny monastery set on an island in Pasung Lake in the Kongpo region east of Lhasa underlines the variety of landscapes that exist in Tibet. The monks are ferried across the lake on a simple raft made from four logs lashed together.*

The independent streak evident in the nomadic lifestyle remains strongest – in a society where many peoples are now sedentary – among the peoples of Kham, eastern Tibet. Until the Chinese invasion, the Khampa were organized into some twenty kingdoms and principalities independent of both the Dalai Lama's government and that of the Chinese. Of these kingdoms, Nangchen was the largest, covering a huge tract of land in the valleys of the upper Mekong and inhabited by twenty-five different clans of Khampa herders. The various tribes or clans still assemble today for their traditional annual horse fairs, where, in addition to the sale of wool, cattle and horses, the gatherings also serve as marriage markets that allow girls and boys of different, often antagonistic, groups to meet and get engaged. Because the local custom favours exogamy, by which a man must marry outside his own tribe, bride abduction was often the only way to acquire a wife outside the fairs, for the duration of which a truce was traditionally decreed between the tribes.

The seemingly barren high plateau is inhabited by nomadic herders (*drokpa*), while the lower valleys are occupied by the settled, grain-growing farmers (*rongpa*). The two communities lead completely distinct lives, although they meet occasionally when the farmers travel to the highlands to sell grain or work in the summer at skinning sheep and tanning hides. The nomads exchange salt, wool, meat and milk products for barley and sometimes wood and hay.

The staple diet of practically the entire expanse of Greater Tibet is roasted barley ground to form *tsampa*, a cooked flour. Yak meat (often sun-dried), mutton and hard sun-dried cheese complement the frugal diet. Wild animals are eaten from time to time, mostly blue sheep, in spite of the Buddhist ban on killing creatures. Tibetans, though, will not eat fowl or fish – monks claim that to take the life of a fish is doubly odious because they cannot even shriek in self-defence. Although the taboo on killing animals is not applied rigorously, in some places yaks are slaughtered only by Muslims or members of the *shenpa* or butcher class who are also employed to dismember corpses for 'sky-burials'. The main beverage is Tibetan tea, an excellent, bouillon-like soup made of tea churned with salt, butter and milk. Barley beer, or *chang*, is the national alcoholic drink, which is frequently distilled to produce a Tibetan 'whisky' known as *arak*.

The nomads of the Changtang region are some of the highest-living inhabitants in the world, camping for months on end at altitudes up to 16,400 feet (5,000 m) as they enter the wilds with

their flocks of sheep to seek the precious salt in the partially dried-up beds of the land-locked lakes. The entire Changtang is a closed basin with no external drainage except on its far eastern rim – where the Yellow River, the Yangtze, the Mekong and Salween have their sources – and on the far western rim, where the Indus has its source. The salt has always been a valuable commodity, and it remains so today for the various nomad groups that inhabit the Changtang – in particular the Sengo of the Ghertse-Oma region and the Sumpa.

## The mysterious Minaro people

In my quest to understand Tibet in prehistoric times I became one of the very few people to study the Minaro, who seem the most ancient of the inhabitants of far western Tibet. A people who inhabit the gorges of the upper Indus in Ladakh, between the Karakoram and Himalayan ranges, the Minaro speak Tibetan yet have preserved an archaic form of Shina, a proto-gangetic Indo-European language. The Minaro today inhabit what is possibly one of the most inaccessible places in the world – a set of seven valleys that can be reached only by clambering up snow-crested passes 15,750 feet (4,800 m) and 16,400 feet (5,000 m) high. Yet what makes the home of the Minaro unique is that, at their lower end, these valleys open on to sheer vertical drops as they fall into the great narrow gorges of the Indus River. This means they were and remain death-traps for any army foolish enough to enter them.

The unusual configuration of the valleys explains why the ceasefire line between India and Pakistan runs, in Ladakh, through Minaro territory. Without helicopters, these valleys are almost as inaccessible to modern soldiers as they once were to British colonial troops and, before them, to the central Tibetan armies and earlier still to the Chinese. As a result the Minaro were able to keep their ancient language and customs unchanged over the centuries; customs that preserve some of the oldest among all Tibetan beliefs. Interestingly enough, Minaro culture and beliefs appear linked in many ways to those of ancient Europe and Iran rather than to those of India or China. Not only do the Minaro still erect two types of standing stones – solitary monoliths to mark the point where the supreme goddess of fortune descends to Earth and Sun stones or *rdo nyima* to mark out the various points where the Sun rises during the solstices and equinoxes – but they also use great stone slabs as altars on which they offer up goats in sacrifice to the mother goddess of fortune. During this ritual a priest holds in his mouth twigs of life from the sacred juniper trees, in which resides their second great goddess, that of fertility.

It is to their beautiful mother goddess of fortune, a figure seen as being in total command of the world around her, that the Minaro appeal for help with their hunting of the ibex. When the Minaro set out to find their favourite game animal, they invoke the permission of the goddess, asking her to guide their arrows. In exchange, and to thank her after the chase, they carve images of ibex on to rocks. The lady of fortune relays the requests to the unicorn king of the ibex, who stands at her side. I often wonder whether this belief offers an explanation for the medieval European tale of the lady and the unicorn, illustrated in countless drawings and tapestries and yet whose origins are unknown, lost in time. In Europe, prior to the discovery of the Narwhal whale and its long, solitary straight tooth, unicorns, which have goatees and cleft feet like those of an ibex, were depicted as having a single curved horn such as the ibex has.

There are some traditions preserved by the Minaro that recall Iranian customs. For example, at New Year children run naked through the villages in a sacred race reminiscent of the rites of the earliest Sun worshippers of ancient Iran (Persia, a culture thought to have influenced the Bon religion). The Minaro have several rites that involve horses, the perspiration of whom is believed to be linked to rain. Strangely enough, the Minaro, despite their linguistic roots and their living in what is now India, abhor cows and bulls, and refuse to wear shoes made of cow hide.

There are still many parts of Tibet where the inhabitants have not succumbed to either Buddhism or Bon, and where earlier beliefs have been retained, and these it seems, according to the studies of Jacques Bacot, are related to Minaro beliefs.

Some people have suggested that Tibet was once entirely inhabited, like western Ladakh and Chinese Turkestan, by a 'white' Caucasian people, perhaps linked to the Scythians – I doubt it. In the past Tibet must have been, as it is today, a zone of transition and contact with a variety of human physical types preserved as a result of the relative isolation of valley communities, which now are united in language and culture. Interestingly, whether in east, west or central Tibet, local tradition names the earliest inhabitants Mon – the name still given to the Minaro today. Whether the Mon are another people or just proto-Tibetan remains a mystery.

The Himalayan people add further complexity to the racial make-up of Greater Tibet, for in addition to the Mongoloid and Caucasian peoples already identified, others too have joined this mix through the normal historical forces of conquest, commerce and admixture brought about by alliances. This was certainly the case until at least the seventh century AD, by when Tibet was a formidable, not to mention conquering and expanding, power in its own right.

## Neolithic standing stones and Scythian-style art

Over the years a considerable number of scholars have been attracted by the prehistory of Tibet, among them George and Nicholas Roerich. George, a Russian painter, and his scholarly son travelled Tibet looking for standing stones. In north-central Tibet, in a spot appropriately called Do-ring ('long' or 'tall' stone), George Roerich found an alignment of great stones similar in certain ways, so he claimed, to Carnac in Brittany. Only of late it seems, according to John Vincent Bellezza, have these standing stones been dismantled to form Buddhist *chorten*s. Standing stones (called *tho*) are encountered in many other areas of Tibet and are revered alongside cleft rocks as being sacred sites of the local gods of the land and the watery underworld, generally known as *sadag* and *lu*. Some of these stones may have belonged to the same mysterious ancient culture that erected standing stones all over Europe and the Middle East, others are more recent, while still others – such as some of the Minaro's – are actually modern.

It was George Roerich, too, who first reported the survival in Tibet of what is known as 'animal-style art' from the steppes. It consists of stylized images of deer, goats, stags, wolves and other animals, frequently in pairs, standing back to back with the heads turned to face one another, sometimes with spirals depicted at the shoulders and rumps. Objects in this style, made from gold and brass, were originally encountered in the Scythian mound-tombs of Ukraine (today they are in Russia's Hermitage Museum). Who exactly the Scythians were and how far east their domains extended has been a matter of conjecture for centuries.

Herodotus, who actually travelled to western Scythia from the Black Sea and up the Dnieper and Bug rivers, gives us precious information on their customs and beliefs. He tells us that they collected scalps from their victims in battle, that they had the customs of painting their faces red, drinking out of human skulls and using straight dagger-like swords – all similar practices to those of the early Tibetans, whose descendants still use human skulls as drinking bowls during some religious ceremonies.

For years, in the wake of George Roerich, I have been tracking down Scythian animal-style representations, on rock in the Karakorams and inside Tibet, and trying to elucidate what still remains a mystery – who exactly are the Tibetan blacksmiths who keep alive an artistic tradition, that everywhere else disappeared at least 2,000 years ago? I have yet to find the answer.

I am convinced that people closely related to the Scythians – maybe the Saka Sarmatians who were also familiar with 'animal-style art' – travelled far and wide over Tibet. This seems to be

demonstrated by the typically Scythian rock carvings found along the major trade routes leading into Tibet from the west. It may also be that the famous 'dog-faced' (meaning European-looking) Yueh-chi people mentioned by the Chinese, whose mummified bodies it seems have been found in Cherchen along the northern rim of Tibet, were those who introduced the style into Tibet. At this stage, with so little archeological ground work carried out in Tibet, we can only hypothesize.

Over the years I was able to interview several blacksmiths who made the 'animal-style' objects. Most of them came from the region of Draya in central Kham. I encountered one in a refugee camp at Pokhara in Nepal and he drew for me the various animals he had learned to reproduce – wolves, deer, foxes, horses and wild sheep – as well as explaining to me what kind of borders were compatible with each animal, giving me thus yet another lesson in prehistoric art. The blacksmith was unfamiliar with the use of pen and paper, yet he took my ballpen in one hand and then proceeded to hammer out the jerky lines of various animal shapes on to my notebook as he tapped lightly, hammer fashion, with his clenched fist upon the top of the pen.

Just like the Stone Age, the Bronze Age has left many of its traces in Tibet, in particular with the small bronze talismans worn on a string or leather thong around one's neck and known as *thokcha*. Many Tibetans have one, often thinned by centuries of wear. The variety of these and similar charms reflects the past history not only of Tibet but also of its neighbours. One can find Scythian animals with spiral designs as well as Garuda-like bat figures and even Nestorian crosses. These objects will some day help to unravel Tibet's past, but in the meantime it is not too late to ask the Tibetans themselves what they recall from their long stream of collective knowledge, which still in many parts links Tibet with the dawn of humanity.

*This bronze amulet – known as a thokcha or 'sky stone' – represents a kyung, a horned, griffin-like effigy that was revered by the followers of Bon (the pre-Buddhist religion of Tibet) and later associated by the Buddhists with the Indian divinity Garuda. In fact, its origins could be far more ancient than that and be derived from the Scythian worship of griffins.*

## The first Tibetans

Tibetan mythology is rich with stories of creation, the shaping of the universe and its features, the origins of the first Tibetan peoples and explanations for the various customs to be found in the land. To these archaic myths were added elements of Indian lore through the introduction of Buddhism, which originated south of the Himalayas. A Buddhist version of the Tibetan origin myth – there are many, both Buddhist and Bon – relates how the *bodhisattva* of compassion, Avalokiteshvara, sent a monkey into the mountains to meditate. A rock demoness desired him and transformed herself into a woman to seduce him. The monkey would not break his vows, but when he sought the *bodhisattva*'s advice he was instructed to accede, for this was regarded as an opportunity to create Buddhists to populate the land. Duly there were offspring, at first only six – one reborn from each realm of existence, with all the implied character traits this entailed – but as they grew in number they stripped bare all the trees and could no longer feed themselves. Avalokiteshvara then journeyed to the top of Mount Meru and brought back five grains for the monkey and his family to cultivate as crops. As time passed their tails withered and the hair on their bodies thinned, and gradually they learned to speak and build houses, but their short stature and dark hair always remained as a reminder of their origins.

Such a story encapsulates a great deal, providing not only an intimate and enduring link with Buddhism but also an ingenious rendition of what Westerners would regard as the theory of evolution, in which man is descended from the apes. Avalokiteshvara, the Lord of Compassion, is recognized as the father of the Tibetan race (in a related version he has transformed himself into a monkey) and it is the same deity who emanates the line of reincarnated Dalai Lamas stretching from the fourteenth century to the present day.

In Western literature the first mention of Tibet seems to be from Ptolemy who talks of the Bautai, a people whom Marcelinius later describes as 'living on the slopes of high mountains'. Later, Herodotus mentions the Darde (Dards) who live north of Kashmir. The word 'Darde' refers

# Human beehives and cave-dwellings

**In 1964 in Mustang I recorded** twenty amazing cliff-cities. They seemed to be of ancient origin, yet who had built them, when and why remained a mystery that has fascinated me ever since. More recent carbon-dating tests by scholars from Bonn University have revealed that the caves are more than 3,000 years old.

Still intrigued and keen to discover more Stone Age abodes, but denied access to the caves of Mustang, in 1997 I set out on an expedition with my companion Sebastian Guinness in search of more caves. We planned to cover some 2,200 miles (3,500 km) travelling from Mustang to Tibet's Changtang region. We discovered that the domestic caves are linked to the salt trade routes and that modern nomads still use caves to shelter from the bitter winter weather experienced at high altitude, where it freezes for about 280 days a year.

In the far northwestern portion of the Changtang, where there are no cliffs from which to dig out any cave shelters, we discovered that the local nomads of the Sengo and Sumpa tribes sought relief from the cold in beehive-like, dome-shaped dwellings built from hand-made, sun-dried mud bricks. At first we thought they were *chortens*, but when we looked closer we were surprised to see that these 'mud igloos' were in fact living quarters. The Sengo call them *mongo phuk* ('mongol caves') and the Sumpa refer to them as *bug-ri* ('hollow hills'), and they made it clear to us that they greatly appreciate their oven-like qualities when sheltering from the cold. These apparently primitive shelters were erected in large numbers in the 1960s, when the Chinese authorities attempted to 'settle' the nomads.

1. Caves in their hundreds line the cliffs of the forbidding Kali Gandaki gorges near Tsug, south of Mustang. These particular caves might have been inhabited by local farmers when they needed to seek a place of safety from the predations of warlords.

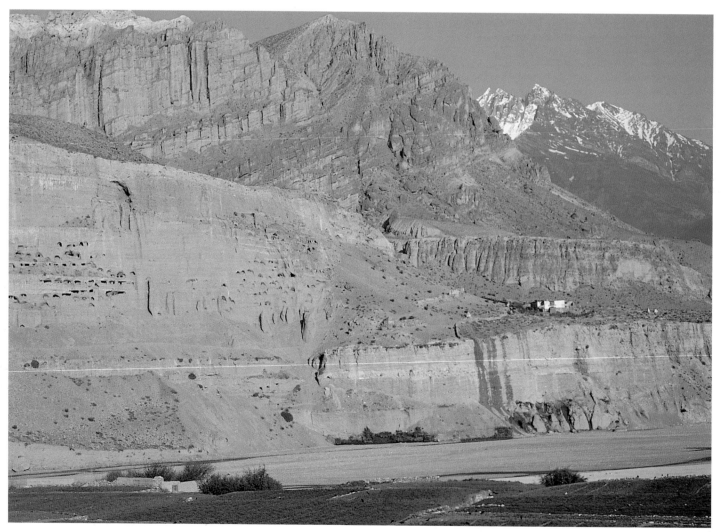

1

2

3

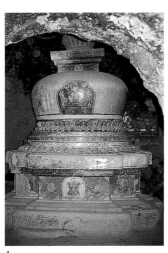

4

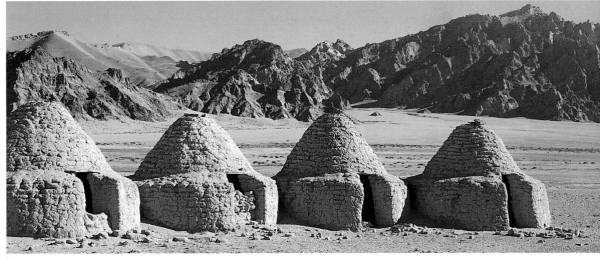

5

4. Many of the cave sites have in more recent times been converted into cliff-face Buddhist monasteries. This painted plaster *chorten* dates from the fifteenth century and lies hidden in the hermitage of the cliff-side monastery of Lori in Mustang.

2, 3, 5. Reminiscent of European neolithic dwellings, the *bug-ri* in northwestern Tibet are the only domed structures in the whole country. Unseen by outsiders until 1997, these wondrous 'mud igloos' were used as living quarters until the summer when the nomads set out with their cattle in search of pastures. On leaving, they bricked up their doorways to safeguard the few heavy possessions, such as millstones, that they left behind.

# The prehistoric art of the Minaro

**The Minaro who inhabit the upper Indus region** are an ancient people who can throw light on not only Tibet's ancient past but also on that of Europe. While explaining the significance of certain megaliths to me, they also gave me a lesson in prehistoric art by demonstrating how to depict ibex in what scholars refer to as the bi-triangular neolithic style, a form found in a great many caves throughout Europe and the Middle East.

These drawings, which have the dynamic signature of most prehistoric art, are executed according to a simple rule of thumb – a technique no one had yet understood. I stared in amazement as a local holy man struck a large boulder with a small stone, hammering first a simple flattened X. This was presumably the body; in quick succession the man then hammered two short lines joining and extending slightly the front and then the rear extremities of the X – these lines formed a single front and back leg. From then on everything was easy: the two other legs were drawn by bisecting the interior angle made by the first set of legs and the back of the animal. Finally, a shaman added a rough head, long horns and a tail. The end result was vividly realistic. Later, when I tried it myself, I discovered that as the X varied in shape, so did the leg positions vary from those extended right out to those drawn under the body. Yet whatever the stance turned out to be, the animals all looked amazingly real, elegant and anatomically correct – a hallmark of so much Stone Age art. It would seem that the ancients had, from long observation, broken down the complex anatomy of the locomotion of quadrupeds into a simple rule of thumb.

1. The favourite game of the early inhabitants of western Tibet was the ibex, which may well have been pursued from its winter to summer pastures by the neolithic hunters. Today, stories still circulate as to how, before the use of bows and arrows, herds of ibex were driven over cliffs.

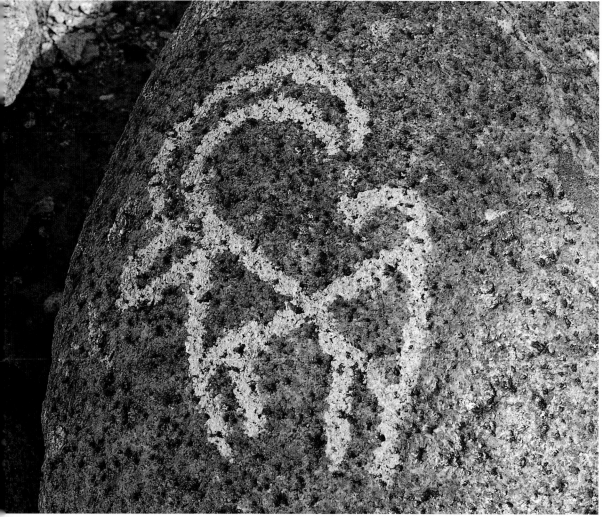

1

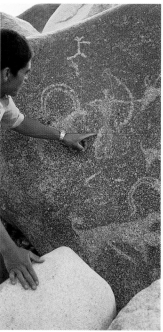

2

2, 3, 4. Hunters using bows and arrows and assisted by dogs are portrayed on many rock carvings. Who exactly these people were has remained a mystery, yet the genetic adaptation of Tibetans to life at high altitude points to their long occupation of the region. Consequently, the earliest inhabitants may have been the direct ancestors of those who today inhabit the Tibetan plateau.

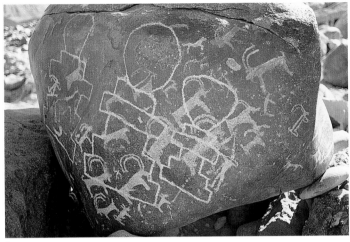

3

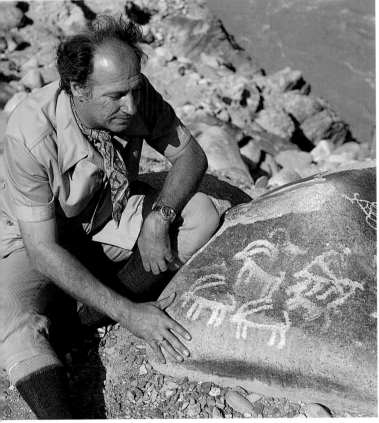

4

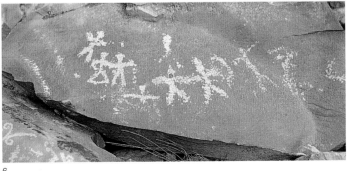

6

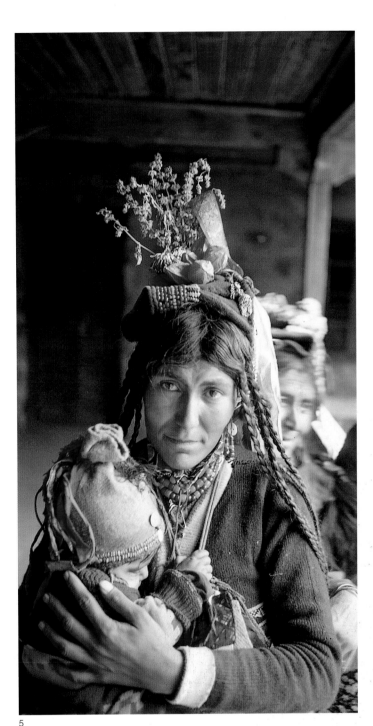

5

5. A Minaro woman and child. There is much debate as to whether the Indo-European-speaking Minaro people inhabited Ladakh and Baltistan prior to the Tibetan-speaking Mongoloid inhabitants of the region. It would appear that the matriarchal Minaro inhabited the 'Kingdom of Women', as Ladakh is called in ancient Indian chronicles, before the region was conquered by Tibetans coming from the east.

6. A rare scene of conflict between peoples, carved into a rock in the region of Ladakh, seems to depict some long-forgotten battle.

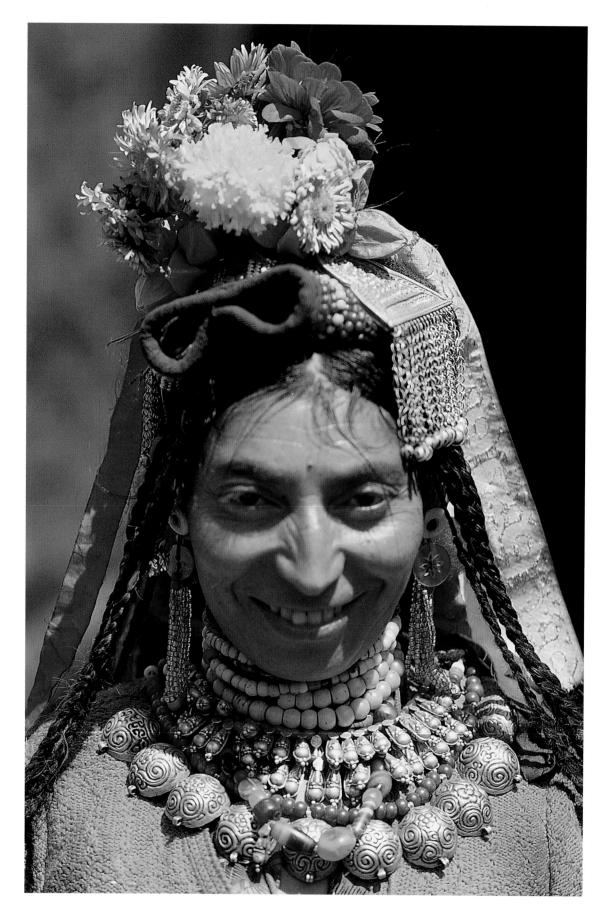

This Minaro woman is a force to be reckoned with. The Minaro are known as an 'acephalic' people, that is a people without rulers. However, it seems that women are in charge of the villages in what is the last matriarchal regime of the Tibetan highlands. The men also wear flowers in their hats. The Minaro's unusual features recall those of the Kalaish people of Pakistan and the inhabitants of Kafiristan in Afghanistan.

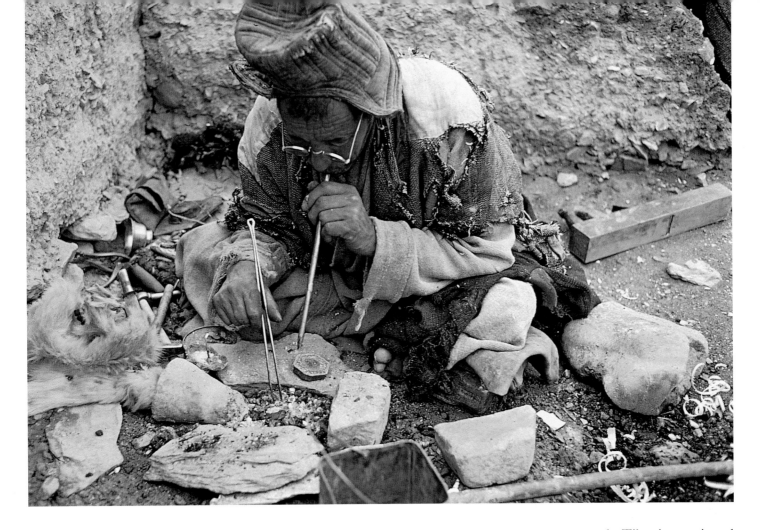

*This old man is both a blacksmith and a goldsmith. With the aid of a blowpipe, he can make sheep dung burn hot enough to melt metal. Here, the man is making a gold and silver reliquary box – a precious container in which to hold sacred prayers, pills and blessed objects.*

to the mountain people who wear wool. From the first century AD onwards, Tibet is mentioned in both early Chinese and early Indian writings. It is only recently that scholars have become cautious about using these sources, citing their lack of what we would regard as scientific rigour and the fact that they were often biased and written, or even rewritten, to suit the purpose of the authors or their patrons.

Thus it is that from Chinese texts (up to and beyond the tenth-century annals of the late Tang dynasty) there emerges an image of a so-called 'barbarian people', a word used pejoratively to label most non-Chinese people. Although China's emperors were impressed by the work of Tibetan artisans, they generally belittled and underestimated the true sophistication of their Tibetan neighbours. The tension and prejudice is further heightened by the fact that it was these nomadic, non-Chinese peoples of Central and northern Asia who were the constant threat to China's security, periodically invading and conquering Chinese-occupied territory.

While much has changed over the centuries, a continuity of lifestyle among the nomads is suggested by recent Chinese excavations on an 8,000-year-old campsite, which revealed that in many ways the herders of old lived very much as they still do on the great northern plains today.

Modern Chinese communists have continued the tradition of belittling and failing to understand their Tibetan neighbours, most obviously in the area of religion. Christopher Beckwith wrote a revised critical reassessment of Tibet's early history, cross-checking Chinese annals with Turkish documents from the Muslims of Central Asia, and from his study emerged an image not of a backward people but of what was, and remains still, one of the most sophisticated cultures in Asia. What is certain, however, is that the artistic skills have existed for some time in Tibet and the Buddhist period merely served to allow them to flourish in newer and greater ways. Lhasa's Jokhang Temple contains a long-necked jug from the pre-Buddhist era made out of silver and topped with a rendition of a horse's head. The same blacksmiths, yesterday as today, also worked

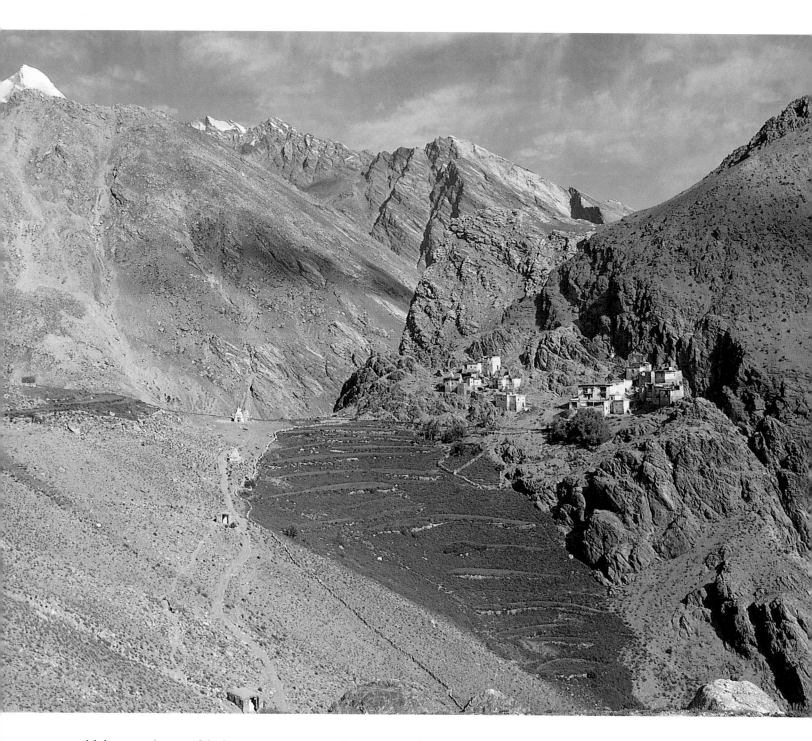

gold, hammering out fabulous vessels – one such was a wine jug seven feet tall (2 m-plus) made of pure gold, fashioned in the shape of a goose, that bedazzled the sophisticated court of the Chinese emperor in the seventh century AD. Similar comments about exquisite Tibetan craftsmanship often feature in the annals of visiting dignitaries from other cultures. It seems that Tibetan blacksmiths produced the best armour of the period, consisting of fishscale-like overlapping semi-cylindrical metal plates sewn on to leather and cotton underclothing.

Artists and artisans abound in Tibet; indeed, all forms of talent are much encouraged but although there are specialists in Tibet – particularly blacksmiths, the *gara*, who are considered a caste of their own – most skilled arts and crafts practitioners are ordinary farmers, herders or

monks. Such skills are not regarded as marketable attributes but as gifts; in fact many Tibetans would not dream of charging a fee for their services, on the contrary it is felt to be a duty, especially for the wise, to share knowledge. Thus it is that doctors, vets and other such specialists in Tibet work without a salary, other than the gifts and hospitality their clients offer them.

**Songtsen Gampo's enduring social system**

While racial and ethnic origins in the distant past may have differed, the unifying bonds of Tibetan culture were strong and came from a shared language (despite a variety of dialects), a rich literary and religious heritage, and, especially, a unique social system introduced by the great Tibetan king Songtsen Gampo – one that still influences the daily lives of most Tibetans. Perhaps this system is the greatest achievement and legacy of this revered ruler, because to a certain extent social laws have the most significant impact on any society – and if one were to pinpoint what makes Tibetans a very special people, different their neighbours, then one would have to refer to these customs.

The linchpin of this system is the *trompa* or 'household', by which is meant a farm and its fields. These constitute the basic family unit. Historic documents reveal that the early Tibetan kings equalized the landholdings so that every family had about the same amount of land, theirs to keep for ever – that is 'until the crows turn white' or 'the rocks grow beards'. These plots of equal size, and, more importantly, it was strictly forbidden to sell or buy these landholdings. Preserving small landholdings intact in this way sets Tibet apart from the other agricultural communities of Asia and it has spared most Tibetan communities many of the woes that have plagued other agricultural economies. Unlike other countries in Asia, or in the European feudal systems, Tibet's farmers were not subject to a landlord but held their land independently, somewhat like the *beneficiums* in ancient Rome.

If the farmstead belonged to the head of the household, whether he male or female, each owner was required to pay land tax to the king or local administrator. This tax was usually paid in kind, such as supplying one fully armed soldier, or having to transport for a minimal fee or even for free all holders of royal travel permits and their baggage. This was the famous and much hated 'Ulag tax', yet it was essential to guarantee fast communications over such a widespread empire.

The payment of these dues could be made by anyone the farm-owner chose, leaving him or her at liberty to do what he or she pleased. Short of selling the estate, the owner could and often did rent out the land to others who would till it and pay the taxes. This is a very important distinction, because in being able to rent out his land and the obligations that went with it, the Tibetan farmer was, in theory at least, a free man – the monarch, and later the local princes, had no say as to the way he lived or what he did. The peasants were therefore not the subjects of local lords because they had only to make certain that someone paid their land tax, which was attached not to a person but to the land.

This interesting system, in which holdings are small, still prevails in most of Greater Tibet but was breached in central Tibet during the seventeenth century when some members of the aristocracy, and the Dalai Lama and Panchen Lama, took over landholdings to run as private domains. This created vast estates in the vicinity of Lhasa and Shigatse, which in the process reduced the peasantry of central Tibet to agricultural serfdom – a sad condition that was at odds with the situation in the rest of the country.

The dwellings of the farmers were generally built out of stone or adobe brick topped with flat clay roofs or, in rainy regions, wooden shingles weighed down by stones. Nomadic herders lived in rectangular tents, called *ba*, which were made from woven yak wool. Nobles, distinguished by their administrative obligations to the king or the local princes, lived very much as ordinary peasants did but in somewhat larger houses or small fortresses. A small number were rich – those

*A typical village in western Tibet where water is scarce, the mountains are steep and the valleys isolated. A system of complex long aqueducts is used to irrigate terraced fields set at the foot of fortified villages. The architecture of houses, chapels monasteries and fortresses is very similar throughout Greater Tibet.*

who possessed the aforementioned vast estates – and they had large mansions in Lhasa where they held high office in the Dalai Lama's administration and government.

Administration of villages was, and remains in parts of the Tibetan world (Ladakh, Mustang and Bhutan), the job of the local village councils, which were generally composed of elected members. It was these councils that governed the community and provided justice on civilian affairs. There were also two other types of court – those of the monks for matters of morals and the faith, and a royal court of justice, known as 'the golden yoke' for matters of state. This system made for an equitable form of life, with checks and balances preventing any of the king, the religious authorities or the village council from becoming too dominant.

## Households, marriage and death

The social system described prevailed until the monks assumed power in central Tibet. The rules were then altered to enable land seizures and the formation of large estates at the expense of the peasantry. Nevertheless, the household remained the all-important institution, indivisible to the point that younger brothers who chose to stay at home rather than become monks could marry and share their elder brother's wife. As a rule, the second landless sons went to the local monastery and became celibate students who were maintained by produce from fields set aside for that purpose by their elder brother. The main farmhouse went to the eldest son upon his marriage, when the parents retired to a small house adjacent to the main one.

This custom of fraternal polyandry and the system of land tenure whereby you could neither buy nor sell land made Tibet a distinct place to live. So too did the custom whereby children inherited their father's position and land when they got married. This last aspect accounts for the exceptional dynamism of Tibetan society – one ruled by young people rather than ageing patriarchs, such as could be found in China and most of feudal Europe. Early Chinese chroniclers were shocked at the favouritism shown towards youth and the apparent lack of respect for older generations. Of all the social customs sanctioned by Songtsen Gampo, beyond doubt the most important was the one whereby a father stepped down and handed over his property, political rank and status the day his eldest son got married.

Three times the kings of early Tibet are said to have equalized rich and poor to keep the system equitable. This offers proof that, in spite of its remarkable nature, the system was not immune to abuse. The social system helped to support the erudite class of Buddhist monks and mantrins, who were financed by their elder brothers. All told, it was a relatively egalitarian society until Mongol and Chinese feudal structures were introduced by ambitious monastic hierarchs. The only true underdogs in Tibetan society were those without land – the tenant farmers on the larger estates (who received half the harvest as pay), the servant class, runaway children, vagabonds, orphans and prisoners of war. This underprivileged minority represented, according to the Chinese themselves, no more than 10 per cent of the total population. Since they had no land (which also meant they did not have to pay taxes to the ruler), the Chinese proclaimed that they were the only free people in Tibet – but this was to misunderstand Tibet's unusual land system under which the owners were in fact free men.

The status of women in Tibet was very much better than that prevailing elsewhere in the East. Women had the right to inherit and run a household and were therefore influential and esteemed in Tibetan society. This position was further reinforced by the polyandrous marriage system when one woman lorded it over several husbands, usually brothers. Women householders also took in a 'male wife' – a consort (a young man with no land) who acted during the marriage ceremony as if he were an abducted woman. Divorce was possible, even easy, but was rare – perhaps because the relations between the sexes were open and unencumbered by taboos.

*Seated in the lotus position and wrapped up in homespun wool clothing, the corpse of a dead woman is carried out of her village to the site where it will be cremated. To the left a man holds up a blanket so that the demons may not see and follow the corpse. Earth-burial, sky-burial, cremation and water-burial are the four ways Tibetans return their dead to four of the elements that humans are composed of – earth, air, fire and water.*

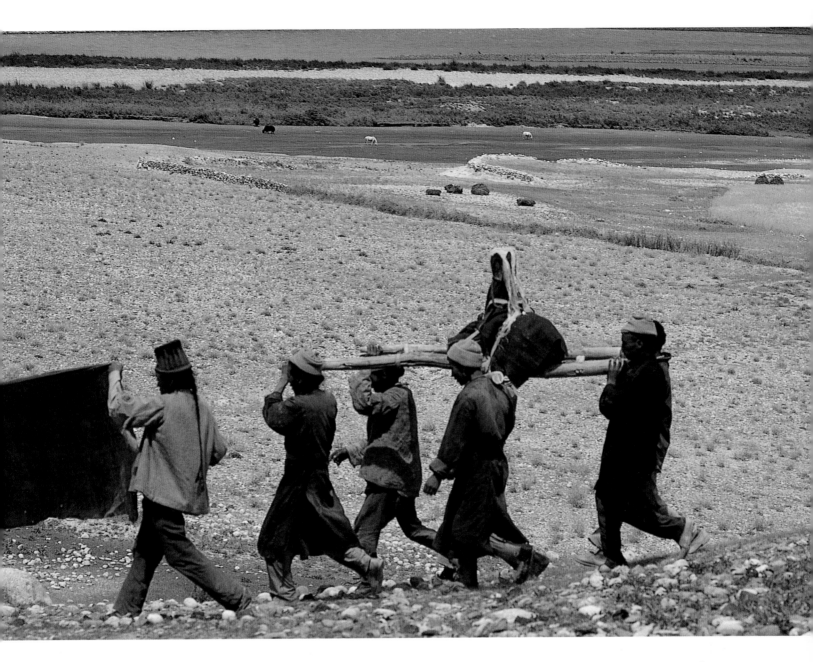

Burial practices in Tibet were prescribed by monks according to the cause of death. Corpses can be burnt, cast into rivers, buried in the ground or offered up to the vultures in the 'sky- burial'. In some places, a form of embalming still holds sway in which the deceased – normally an important *lama* – is packed in a box of salt and mummified. Undoubtedly the most famous rite is the 'sky-burial'. The corpse is cut into pieces and the bones are crushed, to be consumed mainly by birds of prey. By this means the body is returned to the spirit of air, one of the elements from which people are made, and the cycle of eternal transformation of death into life is completed.

### Literature and music

One overwhelmingly potent and binding cultural force among peoples throughout Greater Tibet is the rich and large oral, literary and musical tradition it embraces. Literature developed in Tibet as a result of Songtsen Gampo encouraging scholars to adapt the Indian Devanagari alphabet to Tibetan. Most early works were translations of Sanskrit texts, but Tibet rapidly developed a

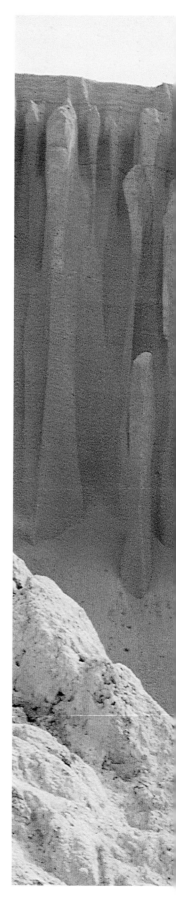

literature of its own: biographies of monks and important laymen, treatises on medicine and horse care, poems and love songs, and countless religious commentaries, guide books for pilgrims and practical manuals for monks. Books were produced using carved wooden blocks covered with an indelible ink derived from smoke-black from butter lamps and printed on to paper made from a bush that is abundant in the Himalayas. These books were distributed widely and could be found in most houses and tents. Monks could generally read or write and they taught their elder brothers, therefore the heads of most households were literate.

Tibet also has a strong oral tradition kept alive by storytellers and bards. The epic tale of the deeds, whether real or imaginary, of Gesar of Ling, a semi-legendary hero from eastern Tibet, is the subject of a seemingly endless work. Versions vary from region to region and are constantly embellished and augmented by new material. Gesar overcomes every form of demon and shape-shifting supernatural threat to bring order out of anarchy and restore life and wealth to a Tibet blighted by evil, corruption, oppression, death and violence. Gesar, identified with the forces of Buddhism, is the embodiment of the just, self-sacrificing ruler and any parallels to be drawn with subsequent dominant figures in Tibetan society are undoubtedly intentional. Another example of popular literature is that relating to the activities of the mystic sage and national hero Milarepa; it has a more overtly religious bent but still offers a gamut of heroic feats to spellbind any audience, with Milarepa being revered for his achievement of *buddha*hood within one lifetime.

Public acts of storytelling and dance dramas, not to mention the colourful religious spectacles, would be infinitely duller without music. Tibet developed a unique system of written notation, but much music is religious in intent rather than being for secular pleasure. Liturgical chant and the repetition of *mantra*s is infused with metaphysical meaning and the combination of instruments, chanting and drums can be heard echoing everywhere, from monasteries to private houses. This music acts as an aid to prayer, with the energetic bouts of percussion deterring demons.

From the seventh century onwards, music became an integral part of Tibetan Buddhism, and when it is performed in public today it is usually in the dramatic festivals (known as *cham*) with often grotesquely masked and costumed dancers who act out religious allegories and celebrate the triumph of Buddhism over Bon. As might, perhaps, be expected many instruments are Indian, with handbells, conch-shells, oboes and cymbals, although there are two instruments exclusive to Tibet – a long, telescopic metal guttural trumpet and a wind instrument fashioned from a human leg bone. Comparing the various types of sound and performance, Tibetan music appears a curious mixture of frantic shamanic activity and Buddhist monastic, meditative rite.

More pleasant to the Western ear are the traditional folk songs played using simple wooden recorders and a four-stringed, guitar-like instrument. Tibetans are poets at heart and lyrics are often improvised to match a situation – flirtatious songs exchanged between choruses of young men and girls; love songs, of which those of the libertine sixth Dalai Lama are famous; or satirical verses criticizing powerful people, whether aristocrats, high monks or, today, the Chinese.

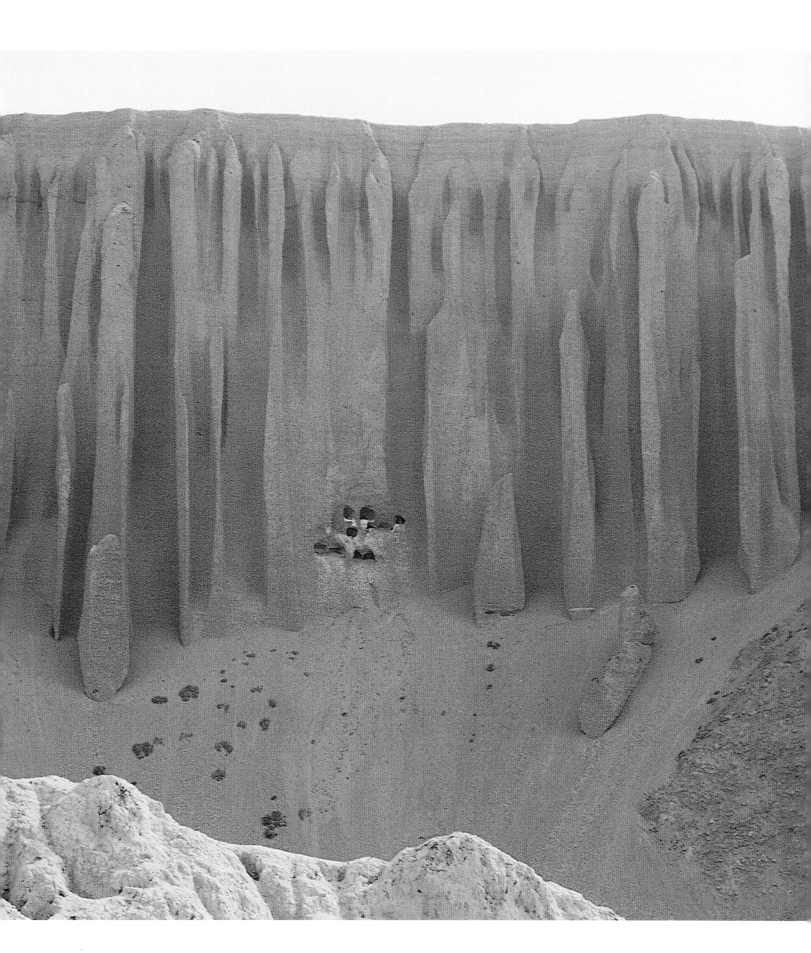

1. This man from Tsonkha in northern Amdo, photographed in 1994, wears the characteristic right-sided chignon sported by all the warriors of the terracotta army from the 2,000-year-old tomb of the first great emperor of China. The clay army's moustachioed warriors seem to hail from the Tibetan marshes, inhabited at the time by the Indo-European-looking and speaking Yueh-chi.

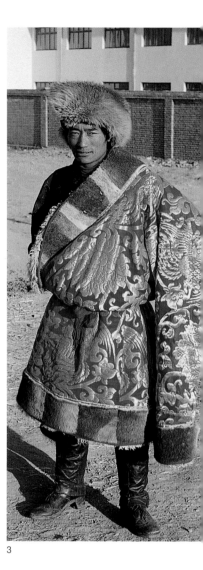

1                      2                  3

# The faces of Tibet

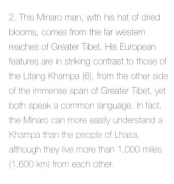

2. This Minaro man, with his hat of dried blooms, comes from the far western reaches of Greater Tibet. His European features are in striking contrast to those of the Litang Khampa (6), from the other side of the immense span of Greater Tibet, yet both speak a common language. In fact, the Minaro can more easily understand a Khampa than the people of Lhasa, although they live more than 1,000 miles (1,600 km) from each other.

**These faces recall that** Tibet is the true heart of Asia and the land where East and West meet. From Caucasian to Mongoloid features, and from Turkic to Indian, a great variety of racial types can be found in Tibet. Yet genetically Tibetans form one race characterized by its adaptation to life at high altitude. They are further united by a common language, a common diet and common customs and traditions, in addition to a well-defined ecosystem – that of the high, central Asian plateau.

Tibet has on occasion been referred to humorously as the 'land of hats', and indeed the variety and originality of Tibetan headgear has no rivals. Coiffure, too, is an indicator of region; for example, among Khampa men the use of black braids may indicate a man from Chamdo or Litang. Such distinctive touches serve as a reminder that maybe our prehistoric ancestors were more elegantly attired than museum dioramas would suggest. Dressed in a great variety of furs, otterskins, sheepskins, fox furs and even monkey fur (still much prized in southeastern Tibet), both men and women in Tibet are very conscious of their appearance. Although everyday clothes are often ragged and soiled, few cannot don elegant gowns when they attend the numerous fairs and ceremonies that enliven the calender. The most common materials are fur and homespun wool, but fine silk and gold-thread brocades (imported from both China and India) are also popular. Gold and silver are worn, and although turquoise, coral and amber are all popular precious stones in Tibetan culture, the most highly valued of all is known as *zi*, which is a type of etched agate or banded chalcedony.

3. A handsome Golok from the most aggressive tribe of Tibetan herders.

4. A boy from wooded Kongpo, where people still eat monkeys, whose furs are used to adorn their cloaks.

5. These girls from the remote region of Palbar had never seen Europeans before.

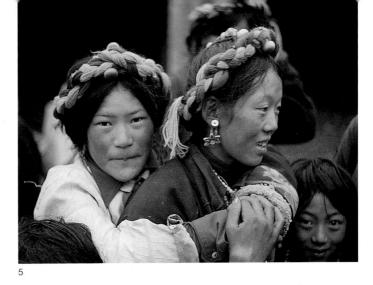

4

5

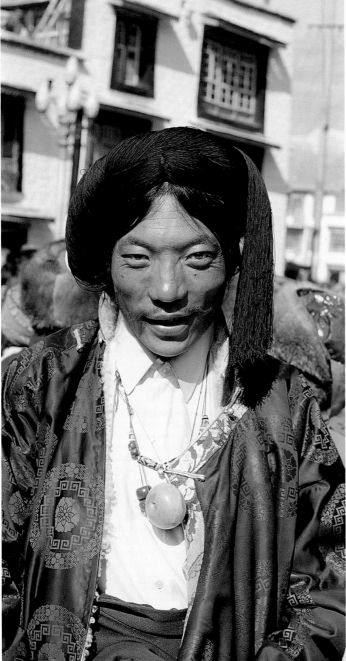

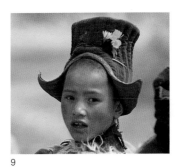

7

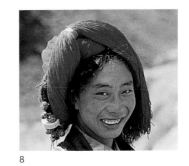

8

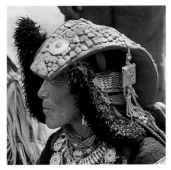

9

6, 7, 8. A Khampa from Litang (6) looks quite different from a Golok (7) or a young man from Derge (8).

9, 10. The characteristic head-dresses of Ladakh and Zanskar: the top hat worn by boys and men (above) and the *perak* (below) whose jewels constitute the entire dowry of a woman. A *perak* is worn every day, which keeps it safe, but its weight causes premature baldness.

6

10

# Tibetan literature

**The Tibetan alphabet** is a condensed derivative of India's ancient Devanagari one, having adopted just thirty of its letters. Sambohota, a Tibetan of the Thonmi clan who was sent with others to Kashmir by Songtsen Gampo in the early seventh century AD, was among those responsible for adapting it to fit Tibetan. The script the scholars brought back is easy to read and write, thus Tibet became a literate nation quite early in its history and as a result the literature of Tibet is vast. It consists not only of the translation of ancient Sanskrit texts from India (many of whose original versions have been lost) but also of thousands of volumes of lay and religious works.

The early use of woodblocks for printing books and the adoption of paper that is impervious to insect attack have helped to safeguard Tibetan texts during times of turmoil. Documents from the seventh century and modern pamphlets about the internet are both written using the same characters and with approximately the same 'literary' spelling. Surprisingly enough, the literary language (and spelling) is similar to the Tibetan dialect spoken today in Baltistan, the only Muslim region of Greater Tibet. This is probably because Baltistan was already home to Buddhist monasteries before the faith spread to central and eastern Tibet. More than likely, it was in Baltistan, just north of Kashmir, that the early central Tibetan scholars were originally sent by Songtsen Gampo to select a script for Tibet.

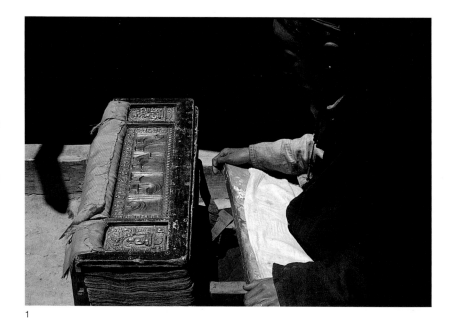

1

1. Solid gold tubular letters adorn the cover of the last remaining volume of a sixteenth-century gold-inked version of the 108-volume *Kangyur* (the Tibetan canon), found by the author in Mustang in 1964.

2. Young monks in Bhutan sizing and glueing strips of paper to give it gloss, thickness and tint for a special publication.

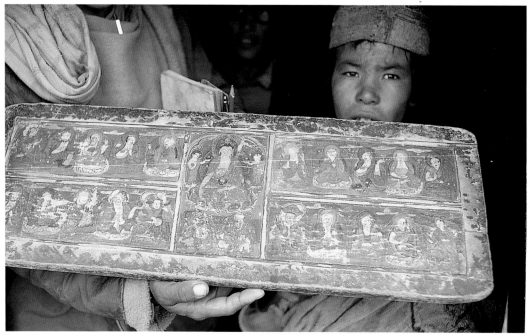

2

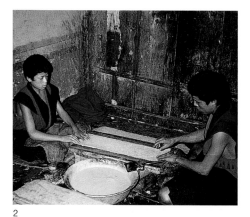

4

3. An old wooden book cover displayed by a monk in Zanskar. Such painted works are one of the great art forms of Tibet.

4. A magic square of words used in the practice of divination.

3

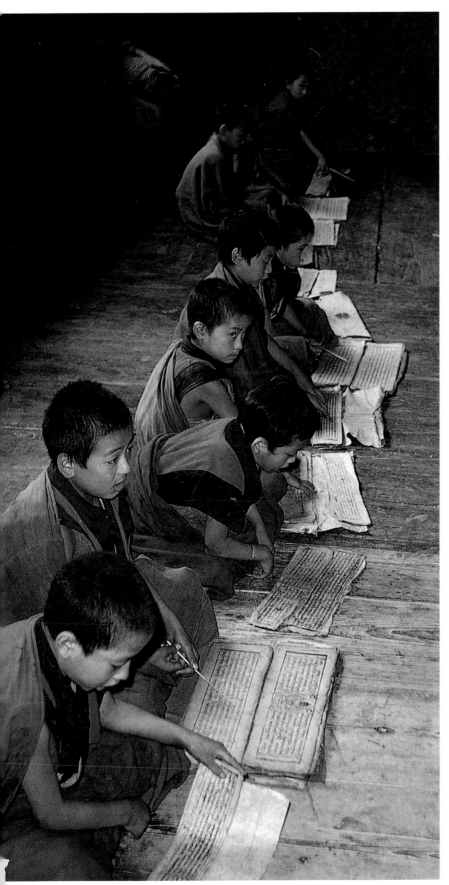

5

6

5, 6. On the rough floorboards of the main assembly hall of the monastic community of Trongsar in Bhutan young monks learn how to read. At the age of eight or nine the children become novices, but they have often already been taught the *ka, kha, ga. nga* (the Tibetan equivalent of the ABC in English) by their paternal uncle, who is generally a monk.

1, 2. A black demon hat on the head of a
Nyingmapa monk, the oldest Tibetan
Buddhist school. Dancers representing
demons twirl in all their morbid splendour
at Trongsar *dzong* in the heart of Bhutan.

1

# Festivals, dance and music

**Living in small isolated hamlets** or alone upon almost limitless
high pastures, farmers and nomads alike need little excuse to flock to
monasteries, private houses or *dzong*s to celebrate all kinds of festivals,
both lay and religious, with song, dancing and music. Weddings in
Tibet, like funerals, are elaborate and lively affairs that involve the
drinking of a lot of *chang* barley beer.

More sober, yet still incredibly colourful, are the Tibetan world's
religious festivals, which are marked inevitably with dancing and the
hoisting of great poles that sport prayer flags. The ritual dance
movements, or *cham*s, often enact historical pageants, such as the
wedding of Songtsen Gampo to the Chinese and Nepalese princesses
who converted him to Buddhism.

Also popular are the morbid skeleton dances enacted to portray
the journey of the soul of the dead as it wanders for forty days
in Bardo, the limbo-like netherworld that the deceased must visit
before he or she can be reborn into one of the six spheres of
phenomenal existence.

Elaborate masks and head-dresses adorn faces and heads, while
the gowns of the dancers twirl to the beat of drums and the wail of
oboes and human thighbone flutes. The men and women dress
elaborately for all these festivals, showing off their finest jewels, swords,
gowns and fur hats – not to mention the luxurious silver-inlaid saddles
and elaborate saddle blanket worn by their well-groomed ponies.

2

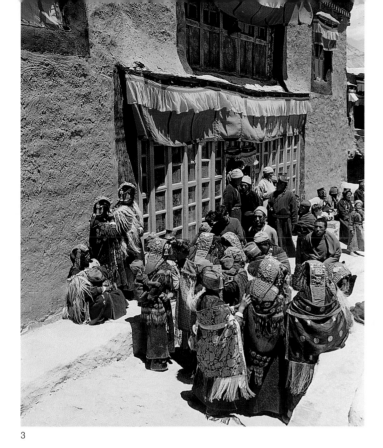

3

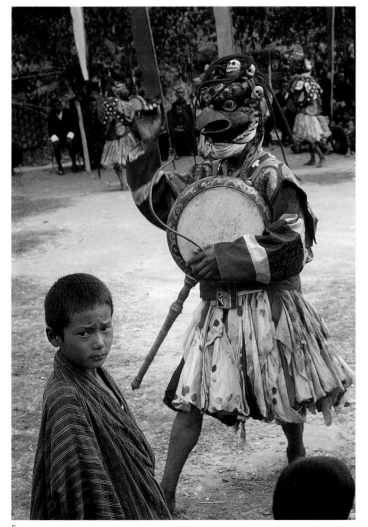

5

3. A cluster of turquoise-topped head-dresses indicates the presence of a crowd of matrons from Zanskar attending the annual festival of Tradum monastery.

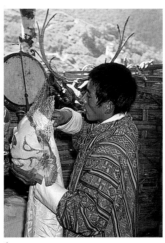

4

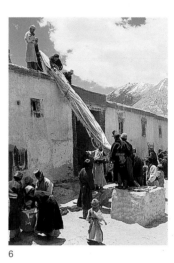

6

4, 5. Elaborate masks and gowns at a festival held at Trongsar *dzong*, said to be the ancestral home of Bhutan's royal family. Ponlop, governor of Trongsar, became the country's first hereditary king early in the twentieth century.

6. The raising of a prayer flag at the great annual festival of Sani, one of Zanskar's oldest shrines and monasteries.

7. Wearing gilt hats, three 'best men' at a traditional wedding in Zanskar relax after having symbolically abducted the bride. They are about to recite by heart the lengthy history of the kingdom and that of the families of the married couple.

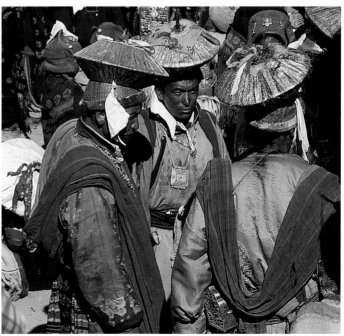

7

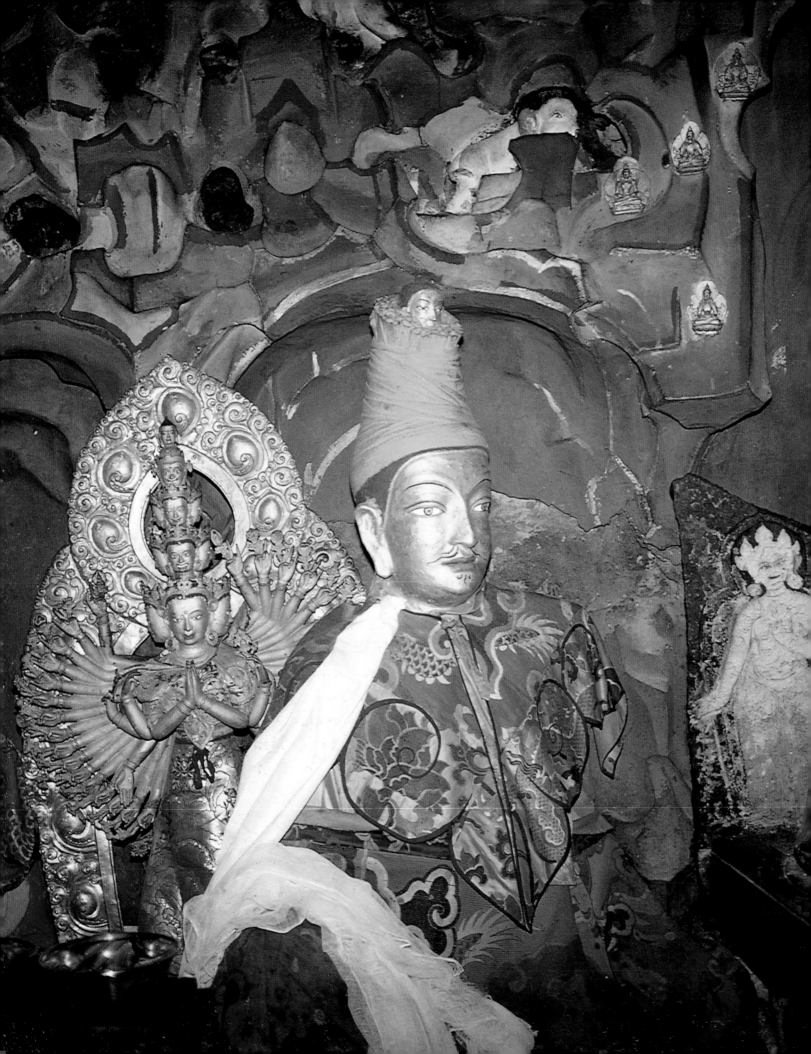

# 4    The Rise of the Tibetan Nation

*A statue in the Jokhang Temple, Lhasa, of the mighty King Songtsen Gampo, the unifier of Tibet who introduced the Buddhist faith and was a patron of the arts and of letters. Probably his foremost achievement, however, was the establishment in Tibet of unique social customs that gave power to the young — something that helps to explain the very special outlook and dynamism of most Tibetans.*

LITTLE IS KNOWN OF TIBET's earliest inhabitants but they seem to have been well established in agricultural communities in the lower valleys when, in the seventh century AD, Tibet began to emerge as a powerful, historical nation. The early Buddhist and Bon histories suggest that prior to the sixth century Tibet had six clans distributed within twelve ancient kingdoms (one of the clans giving rise to the lineage of Tibet's aristocrats). Traditional stories maintain that the first king of Tibet, Nyatri Tsenpo, descended from heaven by means of a sacred ladder or cord (*mu*) and he was followed by six successors who all arrived in the same way. Once their earthly tasks were complete, they returned to heaven by this route, until black magic affected the eighth king and the link with heaven was broken, binding the king to Earth and making him mortal. When the eighth king died he was the first to leave behind a corpse. According to Professor Rolf Stein, this story seems to establish that the early kings were indigenous to Tibet and not, as some have later argued, from a foreign land.

Whatever the early historical events may have been, the curtain of mystery that shrouds matters is raised at the dawn of the seventh century AD with the coming to power of what was to be known as the Yarlung dynasty of kings. It all began in the broad long valley of the Yar River, a southern tributary of the Tsangpo River (which becomes the Brahmaputra) located approximately 125 miles (200 km) southeast of modern-day Lhasa. Here there lived a prosperous agricultural community centred around the court of its local lord or king who inhabited a mountain-top castle, Yambu Lakhang. The castle has survived and is one of Tibet's oldest buildings, with its startling very tall, single rectangular tower. It was damaged by the Chinese but has since been restored.

The chief of Yarlung was one of many local potentates in Greater Tibet at the time. They ran vast agricultural estates established for the most part along other tributaries of the upper reaches of the Brahmaputra and Indus rivers. These communities seem to have flourished in Tibet since the third or fourth century AD, with the prosperous 'courts' of these local rulers providing the ideal

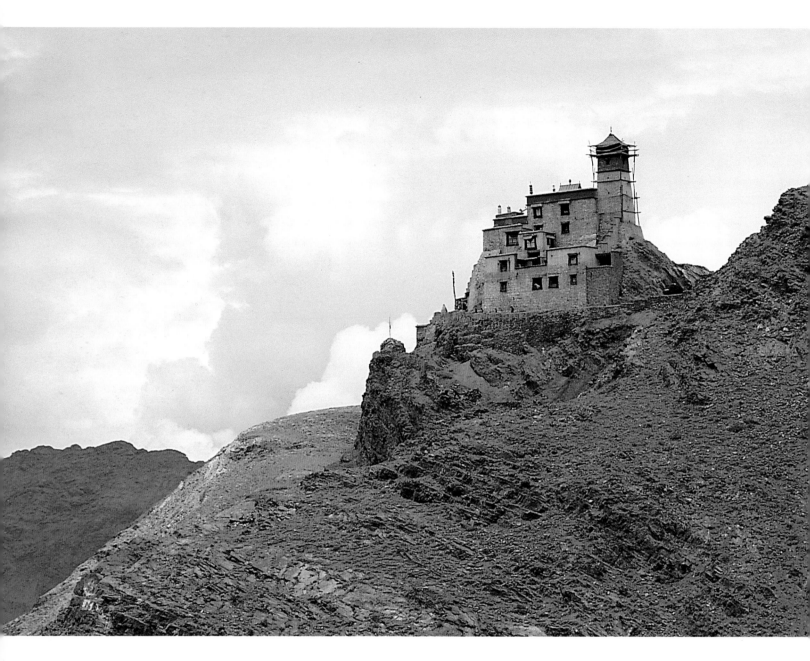

conditions in which small communities of scholars and artisans could thrive, particularly the blacksmiths and metalworkers who were famous for their craftsmanship in silver and gold, as well as for their fine coats of armour.

The founders of the Yarlung dynasty were neither nomads nor renowned cavalrymen. They were primarily sedentary farmers who grew barley and in combat they mostly dismounted to fight on foot. They owned sturdy houses and built fortified castles. They were, however, surrounded by herders who raised yaks and, more importantly, fine horses, and it was these men who would soon join forces with the kings of Yarlung to provide a fearsome cavalry.

At the beginning of the seventh century, the Tibetan plateau was divided into numerous independent principalities and a few large, loose federations, such as that of Shangshung ruled by King Ligkyamig. The capital of Shangshung is considered to be Khyunglung Ngulkhar located somewhere in far western Tibet (Ngari). Shangshung (perhaps initially an alliance of several nomadic tribes) had many allies, but also many enemies and it was these whom the

first great king or *rgyalpo* of Yarlung, Namri Songtsen, befriended so that he could overthrow Shangshung's powerful ally, Zingpor, the king of Ngaspo.

In doing this, Namri Songtsen made all those who took part in the conspiracy against Zingpor swear an oath of allegiance to himself and his descendants. This blood pact, by which the vassals swore loyalty to the king not only during his lifetime but also in death, meant they accepted they would die for the king or be killed when he died. After his victory the king of Yarlung started to conquer other districts and was proclaimed by his followers as *tsenpo* or emperor. These events mark the beginning of the meteoric rise of the Yarlung dynasty, the start of the process of Tibet's unification as one nation and the emergence of a new power in the Asian political landscape.

Those familiar with feudal or even modern Tibet would have been amazed by the court of the Yarlung dynasty, where the emperors of Tibet were attended by scholars and scribes from India, China and Iran. Well armed and well organized, the kings of Yarlung were soon to make the whole of Central Asia tremble.

## Tibet's empire

Tibet's transformation into a truly mighty entity began in earnest in 608 when Namri Songtsen, having subjugated several of Shangshung's allies, was in a position to face the T'u-yu-hun, or Aza, a Mongol group that controlled the Silk Road north of Tso-ngon (Blue Lake) in northern Amdo. Suddenly China found itself bordered by a highly organized state rather than a collection of aggressive herders. In a very short time the first emperor of Yarlung had succeeded in extending his influence over a large portion of central and western Tibet, but in 618 he was poisoned. Upon his death, his lieutenants, the oath-takers, were not in fact killed but were instead retired to spend the rest of their lives guarding the emperor's magnificent tomb, whereby they became known as 'the living dead'. These tombs were marked by gigantic tumuli some thirty feet (10 m) high and several acres in size, which can still be seen guarding the secrets of the gold-filled inner burial chambers where the earliest Tibetan kings were laid to rest. Today these royal tombs near the Yarlung Valley, not yet fully excavated, recall Egypt's Valley of the Kings and offer stunning reminders of Tibet's past greatness.

*The hilltop palace of Yumbu Lakhang stands on the site where Nyatri Tsenpo is said to have built a tower centuries ago. In the seventh century, Songtsen Gampo added some of the current buildings. Damaged by the Chinese, the structure has since been fully restored.*

The murdered king was succeeded by his son, Songtsen Gampo, a boy of thirteen; one, however, should perhaps write a man of thirteen, for at half the age of Alexander the Great, Songtsen, helped by his chief minister, Tongtsen Yulsung of Gar, immediately set out to unite the entire Tibetan highlands. He subsequently carved out an empire in Central Asia and today everyone in Tibet still recalls his name with reverence and admiration as the first great Tibetan king. For not only did he unify Tibet and lead it to military greatness, but he also contributed to the introduction of Buddhism (629–650) and gave the land its first alphabet, its early social code and laws. Songtsen Gampo was the first of the nine great religious kings who were to reign over Tibet until 836.

At the age of fourteen, Songtsen had defeated Shangshung, conquered the rebellious Sumpa nomadic tribes of eastern Tibet and then attacked the Aza, to complete the campaigns begun by his father. From that point on his conquests become so numerous and far flung as to seem unreal: his troops entered Nepal and India to the south, while attacking the Chinese border town of Sung Chou in 638 and threatening to invade China, were he not given a princess in marriage. Simultaneously, nearly 1,250 miles (2,000 km) to the west, Songtsen's troops had entered what is now Ladakh and Baltistan, to confront the Kashmiris and oppose the Muslim Turks. In less than twenty years Tibet had been established as a nation within the natural boundaries of the high plateau, a unified state under one ruler strong enough to confront China at the height of its powerful Tang dynasty. Thus it was that by the middle of the seventh century, Tibet had begun to establish its dominion over Central Asia, a domination that was to last fully three centuries.

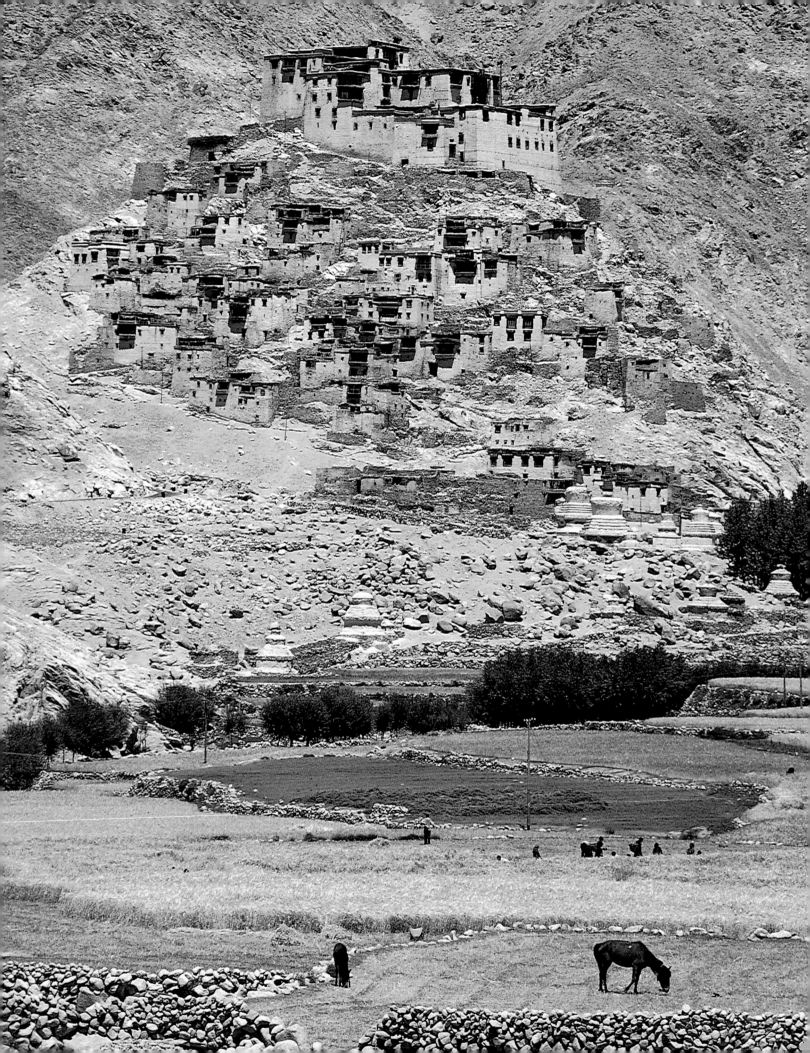

China's first Tang emperor, Gaozu (618–626), is supposed to have seen a presentation match of a game called *qiqiu* or 'horse ball', played by a team hailing from 'Turfan' in the far west. Whether the game came from there or from Iran cannot be determined for sure, but what is certain is that Turfan was at the time cut off from the rest of China by Tibetan troops. In 665 it was these same troops, by then known to have seized Turfan, who played a game they called *Ta polo* (*polo* meaning 'ball' and *ta* meaning 'horse') before the Chinese court in the Chinese capital of Chang'an (Xi'an). The emperor Gaozong (649–683) and his court were fascinated. The Tibetans spread the game far and wide to the limits of their conquests – all the way to Manipur in India, on the borders of Burma, and as far away as Gilgit 2,000 miles (3,220 km) to the west. Gilgit had been conquered by the Tibetans under King Tride Tsukten (712–755) in 737, when his army defeated the Chinese force sent to defend the town. Was it a mere coincidence that after this event the Chinese emperor (taking a cue, no doubt, from the Tibetans) made polo compulsory training for his cavalry? Interestingly, it was in Manipur and Gilgit eleven centuries later that, in 1860, British officers witnessed their first polo matches, a game they rapidly adopted from the Tibetan-speaking Baltis as being good training for their own cavalry, just as the Chinese had more than a millennium earlier. This game the British then exported worldwide as a sport under its Tibetan name of polo, using most of the Tibetan rules.

## Songtsen Gampo's enduring creation

Although the extent of territorial domination accomplished by Tibet was formidable, what is perhaps more amazing about the nation forged by Songtsen Gampo is that it has survived and thirteen centuries later still bears many of the hallmarks of his rule. Across the immense plateau, Tibetan remains the spoken language of the mass of the population, the writing introduced during his reign is still used today and the distinctive Tibetan form of Buddhism is still practised (except in Muslim Baltistan). Perhaps more important still is the fact that all over Greater Tibet the unique social customs introduced by Songtsen – the laws governing marriage, land ownership and justice – are still practised and respected widely, notwithstanding later modifications dating from the Sakya, Rinpunga and Tsangpa periods.

Thus it was Songtsen Gampo who created what constitutes the Tibetan nation and it is this same nation that has yet to be revived and to recover its territorial and political unity, long fractured by the avidity of those states that have forcibly appropriated elements of its territory. It is this large, forgotten kingdom, a once great state within Asia, that this book seeks to evoke.

In Lhasa's principal religious building, the Jokhang Temple (House of Buddha), there is a statue of Songtsen Gampo, during whose reign the building was begun. The statue is covered in shiny gold leaf and has been gaudily repainted to mask the fact that in 1959 it was scorched and the severed head served as a football for Chinese soldiers when the temple caught fire after its doors were battered open by tanks. Although replastered, gilded and repainted, the whimsical smile of the creator of the Tibetan nation is unmistakable.

In trying to destroy Songtsen's statue and his empire, one cannot help but feel that the Chinese were taking their revenge for centuries of fear of their western neighbours, the Mongols and Tibetans. The Tibetans invaded China several times from 650 to 768 and there were many incidents in later centuries as Tibet sought to regain territory occupied by China – notably the Sino-Tibetan wars in Kham, where Tibet's last successful attack against China was made in 1928. The very survival of Tibet as an independent land at China's 'western gates' was a constant reminder to the Chinese of their ancestral terror of those they called barbarians – the aggressive mounted hordes from Central Asia. This fear took solid and monumental form in the shape of the Great Wall, a testament to a national phobia felt throughout China's long history. It should

# Nomads

**Most of the Tibetan plateau is too high up** and too devoid of rainfall to grow crops, yet it manages to support a varying cover of grass, a terrain that is the domain of the nomads. The plateau lifestyle is permanent for some people, the nomads who move around and live out of traditional tents, but temporary for others, that is those settled farmers who undertake seasonal visits to the highlands with their cattle. In general, the 'full-time' nomadic herders consider themselves to be better off than the sedentary farmers, whom the nomads employ to do their chores, such as tanning the skins of their sheep or cutting and collecting grass.

The nomads live relatively independent lives and pay only small tributes in kind to Chinese administrators, just as they normally have done historically to either tribal headmen or local monasteries. Yaks and horses abound in the pampa-like, luxurious pastures of the Ma Chu region (which lies along the first great bend of the Yellow River), while in the colder, drier and higher-altitude western regions the yaks are outnumbered by sheep and the cashmere-producing keel goat.

The nomads have black–brown yak-hair tents, which vary in size, shape and general arrangement from one tribe to the next. Tents are pitched – using animal sinews as strong guy ropes – as far away from each other as required to ensure that the family herds do not overlap. Clusters of more than three tents are rarely seen, an exception being when annual market fairs are held, or in those districts where small satellite tents are used when the herds need to be taken to remote pastures, leaving the large tents to be formed into a 'base camp'.

1. On the rich plains just south of the monastery and town of Jeykundo, tents cluster in the late summer when the grass is at its best. Each July a great fair is held here during which the tribes compete in horse races.

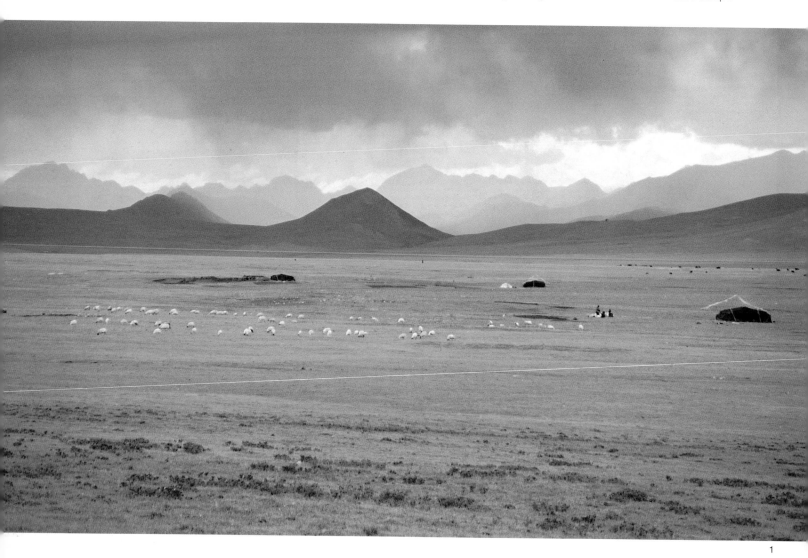

1

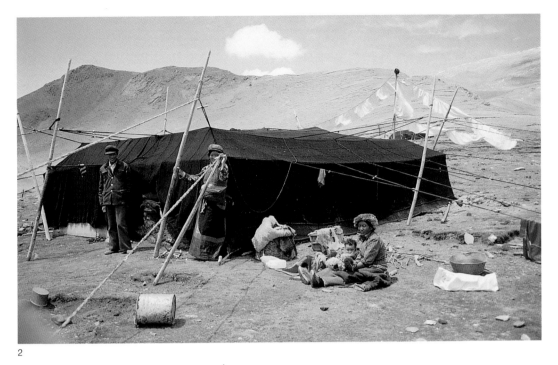

2

3

4

2, 3. A vast tent, typical of Amdo. Like most Tibetan tents, the two central poles are supplemented by exterior poles that lend spaciousness of the interior. Ablutions can be more difficult for those on the move, but a basin and washing can be seen here – for those men who can grow them, beards are not uncommon.

4. The elegant beauty of nomad women is said only to be rivalled by that of the aristocratic ladies of Lhasa.

5. The author's caravan crosses the stony bed – the residue of a high-altitude torrent – near Rangdum monastery on its way to Zanskar.

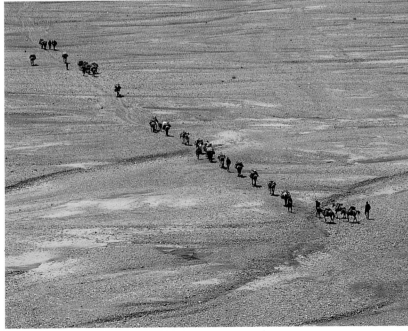

5

# Horses and festivals

1

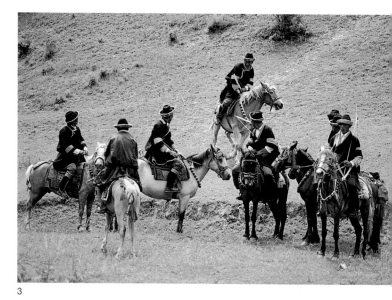

3

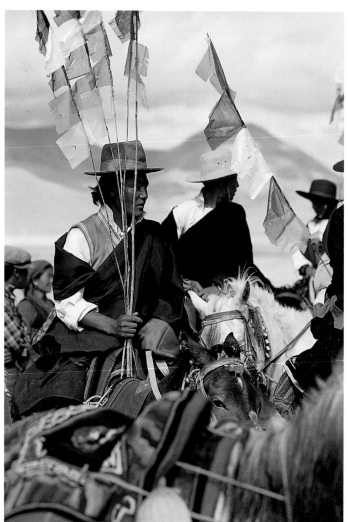

2

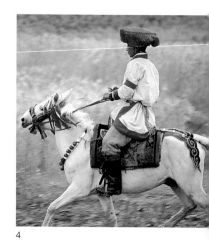

4

**In Tibet, as in many other parts of the world**, horses have maintained their links to social power and position. In a society in that requires both men and women to display themselves impressively on the right occasion, wearing their finest clothes and most splendid jewels, it seems only fair to extend the magnificence to their mounts. As a consequence, nomadic fairs offer the opportunity to marvel at the finest horse accoutrements, from silver-framed saddles, and even the occasional gold-inlaid bridle and bell, to elaborate horse blankets.

Festivals also provide a good excuse to show off one's prize mount in parades and, of course, races. That said, whether they are rugged village ponies or thoroughbreds of the grasslands, the horses in Tibet are above all else an essential means of transport in a vast land that would otherwise be difficult to traverse. The Tibetan kings covered several thousand miles every year simply travelling between their summer and winter royal headquarters.

Tibetan equestrian traditions are very different from those of the Mongols, with not only different horses but also distinctive saddles, bridles and schools of dressage. Grass is scarcer in Tibet compared to Mongolia, and this has obliged the Tibetans to pay more attention to horse raising and breeding. The foals must be nursed through the cold winters and the mares kept well fed, even with cheese or meat because of a lack of fodder. Fine stallions are, naturally, highly prized and rarely parted with.

1, 2. The nomads can surprise those with preconceived ideas by means of their elegant dress. The splendour of this nomad woman from Nangchen is matched by that of the men below, whose felt hats were probably imported from China.

3, 4. Men in Kongpo getting ready for an archery contest on horseback. The village headman has a red tasseled hat, while the others are sporting the bowler hat with a golden rim that is typical headwear in this part of Tibet.

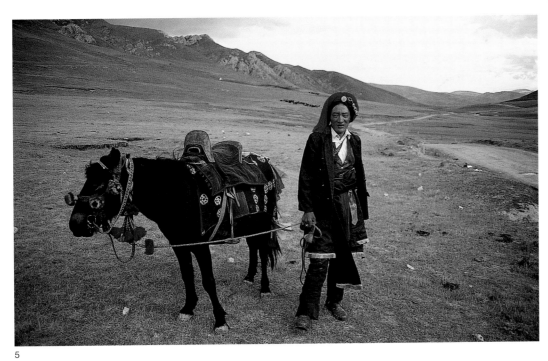

5. A herder from Nangchen. Although his mount is small, it is extremely robust and surprisingly fast.

6. A festival at Tingri, a trading township north of jomolangma (Everest), held annually to mark the planting of new prayer flags.

5

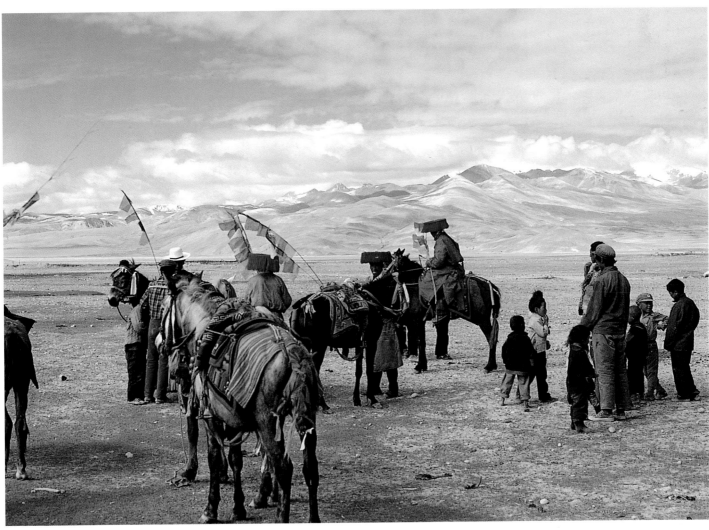

6

# Hunters

**Prior to being herders or farmers, Tibetans were hunters.** The land still abounds in game, and until recently the shooting of wild yak or goat for food was common practice among the nomads, who could not have survived in their environment without slaughtering animals. Hunting, both for food and skins, was tolerated by the monks, as was the killing of wolves and snow leopards in self defence.

Bows and arrows are still very much in use throughout Tibet, but only at festivals. The most common weapon of choice among modern hunters is a gun: the muzzle-loading musket. These are the only firearms authorized by the Chinese. Crudely made, most originate in Nepal, although some are produced in Tibet by local blacksmiths. Because the muskets are neither powerful nor accurate, traps remain a common method of hunting in certain areas and provide a reasonably reliable means of catching wolves, antelope and musk deer. In the wooded regions of Kongpo and the wild tropical jungle terrain of the southeastern province of Pemako, hunters seek monkeys, both for their skins, which are used to line the cloaks worn locally, and for their meat, which is enjoyed by many more than are willing to admit it.

In stark contrast, most Tibetans will refuse to eat fish, fowl, horse or dog meat, all of which are palatable to the Chinese, but considered uncivilized by Tibetans. For a Tibetan hunter, a dog is often one of his closest companions, because despite the existence of the Lhasa apso as a well-known pet lapdog, Tibetan mastiffs can be vicious and many have been trained to attack wolves, bears and snow leopards.

1

1. This snow leopard, fully ten feet long (3 m), has been shot by a farmer in Mustang. The stuffed animal is being taken to the local monastery as an offering.

2. This farmer is from Pemako, the forested part of eastern Tibet where many people enjoy eating monkey. Although the skins of the primates are used to line cloaks, this man's cape appears to be made from the fur of the cow-sized goat known as a *takin*, which is plentiful in Pemako.

2

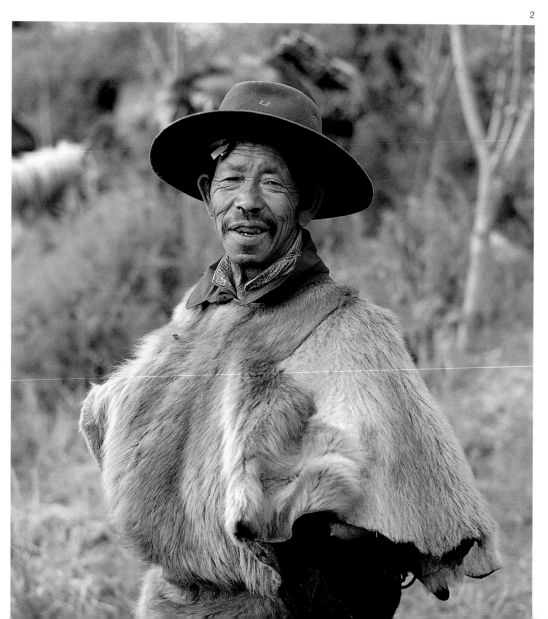

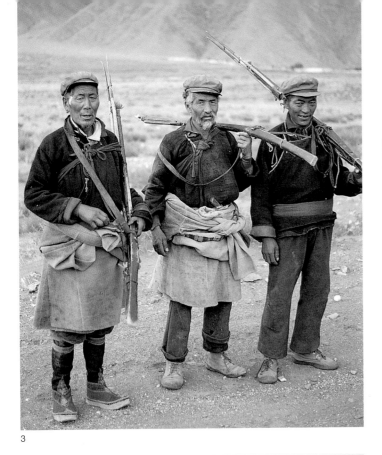

3

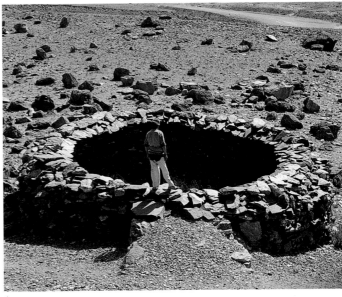

4

3. Three hunters set out in search of prey.

4, 5. A circular wolf trap in Zanskar. These are baited with a goat to attract a wolf, which once caught will be stoned to death. Here (right), a lone wolf prowls the plain in search of food.

6. Horns of the giant wild yak are used to serve as milk pails.

7. A trap made out of antelope horn and yak wool. The rope is staked to the ground with the antelope horn. Once stepped in, an animal will find it difficult to break away.

5

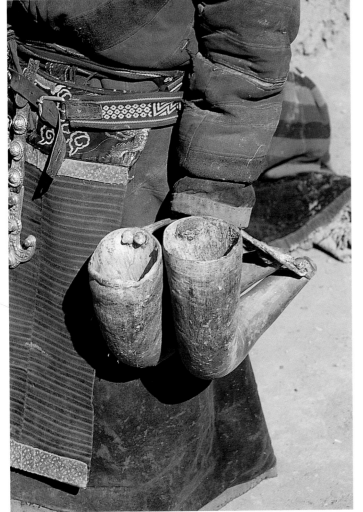

6

7

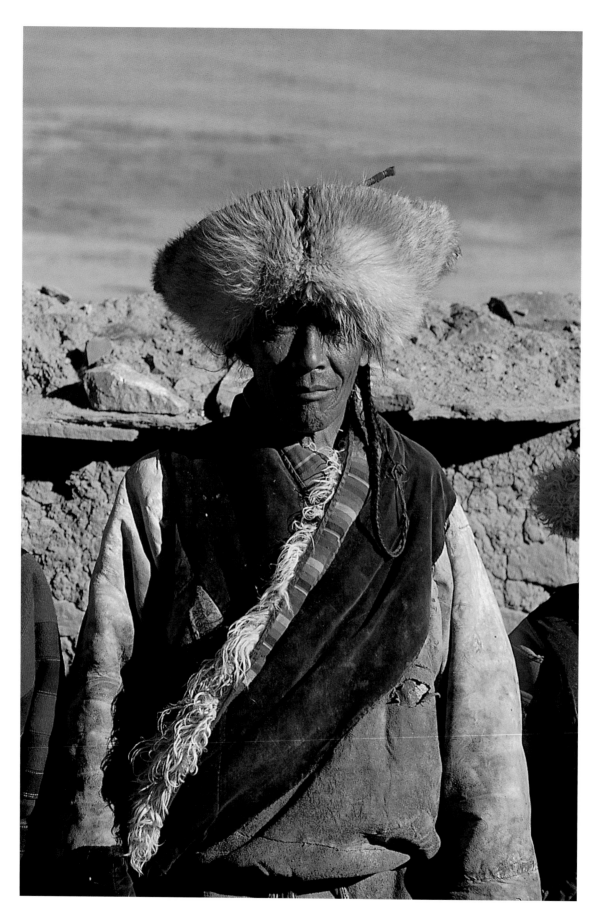

Wearing a fox-fur hat and sheepskin gown, this man, his skin burnt by the ultraviolet rays of the Sun, is a Tibetan nomad. To many foreign visitors, the nomads can appear frightening, but they are in fact a friendly and independent people. They are only to be feared when someone trespasses uninvited on to their grazing lands and are therefore assumed to be cattle robbers.

be recalled that many of China's rulers were themselves men of the steppes, be they Mongols or Manchus. It is true that these dynasties of foreign emperors of China adopted its customs and became 'soft and civilized', yet as soon as this happened there were more barbarians 'at the gate', ready to take their place – new warlords born on the nameless steppes of Central Asia. Although in the end the Mongols and the Manchus were finally overcome, right into the present the Tibetans continue to serve as a last reminder of that old threat, the terrible prospect of which lingers deep in the heart of every Chinese.

Having forged Greater Tibet, Songtsen Gampo had been quick to show his mettle to the mighty Tang emperor. When Tongtsen Yulsung of Gar was refused the princess the king had demanded in marriage and was slighted at the Chinese court, the Tibetan king reacted by assembling a force to threaten China's northwestern borders. Immediately there came an apology along with the gift of thousands of rolls of silk and the ambassador was at last entrusted with the beautiful Princess Weng Cheng to take back to Yarlung.

Tibetans know Weng Cheng as Munshang Konjo, and many tales are associated with her. The Chinese depict her as a weeping, unhappy, delicate beauty sold off to a barbarian. Others see her, along with the Nepalese wife of the Tibetan king (he also had three main Tibetan wives), as the holy woman who introduced Buddhism to Tibet. The truth was less glorious – it was said she had a child by the Tibetan minister who was escorting her to Lhasa where she was to marry Songtsen's son, who, by custom, would then ascend to the throne. Upon the premature death of his son, the elderly Songtsen Gampo finally made the princess his wife.

Upon getting to know the Tibetans, the Chinese were quick to revise their judgement about them; they were not just appreciative of their supremely gifted artisans, they were also amazed by the wit and intelligence of the people – a characteristic they still possess. Aware of these attributes, some scholars argued worriedly that if they allowed the Tibetans access to Chinese science and literature they might rapidly 'surpass the Chinese in learning'.

The Tibetans were certainly broad-minded, as is evidenced by the fact that Iranian wise men, Chinese scholars, Indian sages and even a Greek doctor were attracted to Yarlung to attend the rulers of Tibet. The young monarch, however, was rarely at home, spending his time on the road consolidating his huge empire and protecting it not only from China but also from the Pala Kingdom of Bengal, from Harsa who ruled the upper Ganges from Kanauj, from the Kashmiris of Ghandhara, the Iranians of what is now Tajikistan and, last but not least, the Muslim Turks and Uighurs of Central Asia. To support Songtsen Gampo's conquests, the hardy nomad-herders of Tibet were asked to join his armies and take the oath of allegiance, in exchange for which they received brass buttons and banners as they were incorporated into the royal legions. The nomads were then asked to supply the king and his men with the horses they would need to travel the great expanses of the kingdom.

From the Tibetan annals found in the caves at Dunhuang we learn that the king held court in splendid tent cities – ones not very different from the great camp that the Dalai Lama set up at the border with Sikkim in 1950 when fleeing the Chinese invasion. Songtsen Gampo held a summer court, or camp, and a winter one – the two often being located 1,000 miles (1,700 km) apart. Today we have lost all notion of what mobility was like during medieval times; we travel thousands of miles by air and barely a few miles on foot, and when we do travel, we have little or no contact with the terrain through which we move and the people who inhabit it. Our journeys are hasty return flights away from home. This was not the case in those far-off days; travel was a way of life for monarchs, the means by which a king could be seen by and could meet his subjects – a way also of gathering the taxes owed to him, and a means of recruiting men and horses, of informing and being informed. In fact, there would have been no far-flung kingdoms or empires

at all had not the rulers and their ministers spent their lives on the road as visible tokens of authority. One ruled not by decree but by one's physical presence, and an empire as large as that of the Tibetan king called for his having a rugged constitution, a good saddle and hardy horses.

In spite of the heavy schedules that involved him criss-crossing his domains, Songtsen Gampo somehow found time to send scholars to India, possibly to what is today Baltistan, to elaborate an alphabet for the Tibetan language. With the help of his two Buddhist wives, the emperor established the first Buddhist chapels in Tibet – those of the Jokhang and Ramoche at a place called Ra sa ('the goat's land'), which was soon renamed Lha sa ('the land of the gods'), and these remain today the main temples in Lhasa.

Songtsen Gampo's laws and social system helped to bind the nation and forge its identity, but Buddhism took longer to win over the mass of nobles and people who did not wish to abandon their adherence to Bon and other local beliefs. Politics, too, played a part in the initial hostile reaction to Buddhism, for powerful forces hostile to Songtsen used the public mood of anger to try to weaken his authority. His strictures, though, included instructions for the transition of power between the generations and upon his own son's coming of age in 641, the great leader, as mentioned previously, stepped down and handed over his throne, only to have to take up the reins of power once again six years later when his son died (his grandson being a mere child). When Songtsen himself passed away in 650 he was survived for seventeen years by his famous minister

*Villagers in the valley of Zanskar compete in a friendly archery contest. Such competitions of warrior prowess are a reminder that for a long time these isolated Tibetan communities had to defend themslves against marauding bands of brigands.*

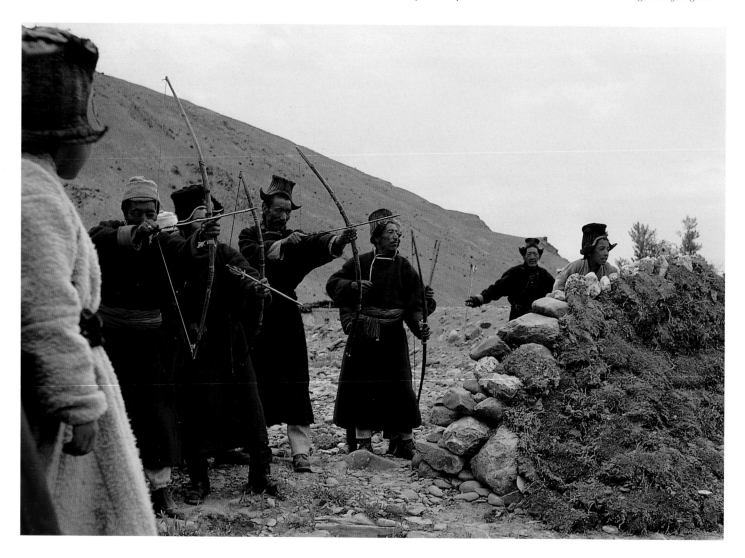

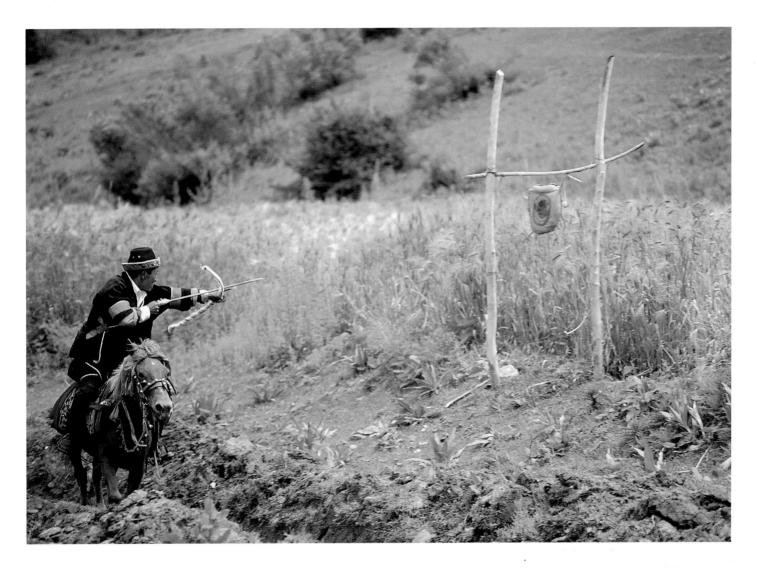

*In the Kongpo region, archery is still practised on horseback. It was the military power of mounted archers that enabled the Mongols to conquer most of Asia. What is, perhaps, less well known is that five centuries before Ghengiz Khan, Tibet's archers, on foot and horseback, enabled it to be the master of the region for three centuries.*

Tongtsen Yulsung of Gar who carried on the expansion of Tibetan power in Central Asia. In spite of some palace intrigues, it is notable that Tibet's powerful chief ministers never overthrew the kings, and if some, such as Tongtsen of Gar, did get a little too powerful, they generally remained loyal to the throne. Thus it was that, assisted by their ministers, the kings were able to continue to increase their already large domains and assert their power over the region for 300 years .

A short time before Tongtsen of Gar's death in 667, Tibet was able to wrestle control from China of the so-called 'four garrisons' – the chain of key trading cities composed of Turfan, Kucha, Kashgar and Khotan – along the Silk Road, and thereby command all trade between China and the rest of the world. This situation was to last until 692, whereupon it fluctuated for three centuries according to the agreements the Tibetans reached with the various Uighur, Turkic and Mongol tribes that rivalled for dominion over these places. Amazingly, to this day Tibetan-speaking peoples still straddle the Silk Road in Pari, north of Qinghai between Lanzhou, the capital of Gansu province, and the great Taklamakan Desert. This survival of Tibet's lost grandeur is even acknowledged by the Chinese communists themselves who have created the Pari Tibetan autonomous county along the Silk Road.

Under a succession of Yarlung kings lasting until the ninth century, Central Asia was to remain firmly within the Tibetan 'sphere of influence' through the repeated exercise of military prowess. The fifth of the nine kings, Tride Tsukten, had, like Songtsen Gampo, acquired a Chinese princess

as one of his (three) wives. During his reign, Tibetan armies travelled as far west as Farghana and Samarkand and this meant the Tibetans now became a threat and a matter of serious concern to Baghdad, the leading Muslim power centre. Thus it came to pass that Harun ar-Rashid, the famous caliph of the *Thousand and One Nights*, negotiated an alliance with the Chinese to counter the Tibetans. There are numerous references in Arab texts to the 'Qaghan of Tibet', and even mentions that the prince of Kabul, prior to converting to Islam, was a Tibetan, or more likely a vassal of Tibet.

As it turned out, Tibetan control of the Silk Road was soon ceded to the rising power in Central Asia, that of the Uighurs. This forced Tibet to turn its attentions elsewhere and so the Chinese were confronted yet again by a power marching east to China's heartland. The only solution was for the Chinese to sign repeated agreements of friendship and pay handsomely to maintain it – yet it did not stop the Tibetans who proceeded to invade much of Gansu, Sichuan and Yunnan. When the yearly tribute of 50,000 rolls of silk the Chinese emperor was supposed to give Tibet was not paid in time to Tride's successor, King Trisong Detsen, Tibet attacked, and in 763 the imperial city of Chang'an (Xi'an) was seized. The Tibetan king then installed on the throne a parent of his Chinese aunt. This puppet emperor reigned for only fifteen days, but it was more than long enough for the Chinese.

Such was Tibet's might in those days that Hugh Richardson, in his *History of Tibet*, rightly states: 'Tibet and China, it is clear, were then two powers on an equal footing'. This fact (that both countries were equals and independent) was recorded on stone in Chinese and Tibetan in the year 821, and one of three stele acknowledging this still exists in front of the Jokhang in Lhasa.

## Onset of a 'dark age'

It was Trisong Detsen who firmly established Buddhism in Tibet, systematizing the translation of its holy canons into Tibetan and, at his behest, the first great Tibetan monastery was founded at Samye in 775–779. The king welcomed sages from India and a debate was held at Samye to decide which form of Buddhism Tibet should adopt – Indian or Chinese. Indian Buddhism generally won out and Padmasambhava was invited to help to spread the fully developed Vajrayana Buddhism of eighth-century India. But this development was not without opposition from those who clung to the Bon religion. With Buddhism ascendant and adherents of Bon persecuted, dissatisfied noble families instigated attacks against the Buddhists, eventually finding a powerful ally in the anti-Buddhist, Bonpo Langdarma, who overthrew Tri Relpachen and reigned between 838 and 842. Buddhist monasteries now came under attack and only those in remote areas survived, until Langdarma was assassinated, shot by an arrow fired by a Buddhist master.

These feuds left Tibet divided and Buddhism weakened. It also brought to an end the amazing years of what is today referred to as the series of great religious kings who forged the Tibetan nation. Tibet has maintained its cultural identity ever since, if not its political unity, which from then on was to be weakened by the role of the clergy in political affairs.

The Tibetan empire was to disintegrate into feuding principalities under the divisive pacifist policies of rival Buddhist leaders who appealed to Tibet's rivals the Mongolians for support. After the tenth century, Tibet's influence was mainly to be exerted in a secondary manner, albeit an effective one, through the power of religion.

In the mid-ninth century, then, Tibet entered its 'dark ages', which have perhaps been a little exaggerated by later Buddhist writers who likened Langdarma to an archetypal demonic figure. It was not, in fact, a very long dark age, for already by 990 in western Tibet there had begun what was to be the great revival and subsequent 'golden age' of Tibetan Buddhism under the instigation of a monk called Rinchen Zangpo.

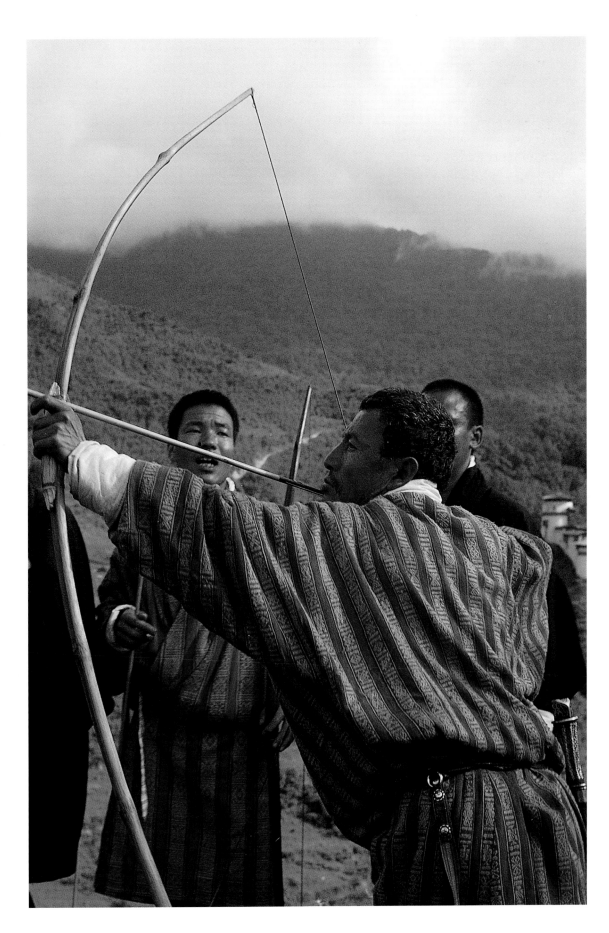

*Dressed in a fine silk gown, a Bhutanese official from the fortress of Bumthang, the seventeenth-century Jakar dzong, displays his skill in one of the many tournaments that made archery, until very recently, the country's national sport.*

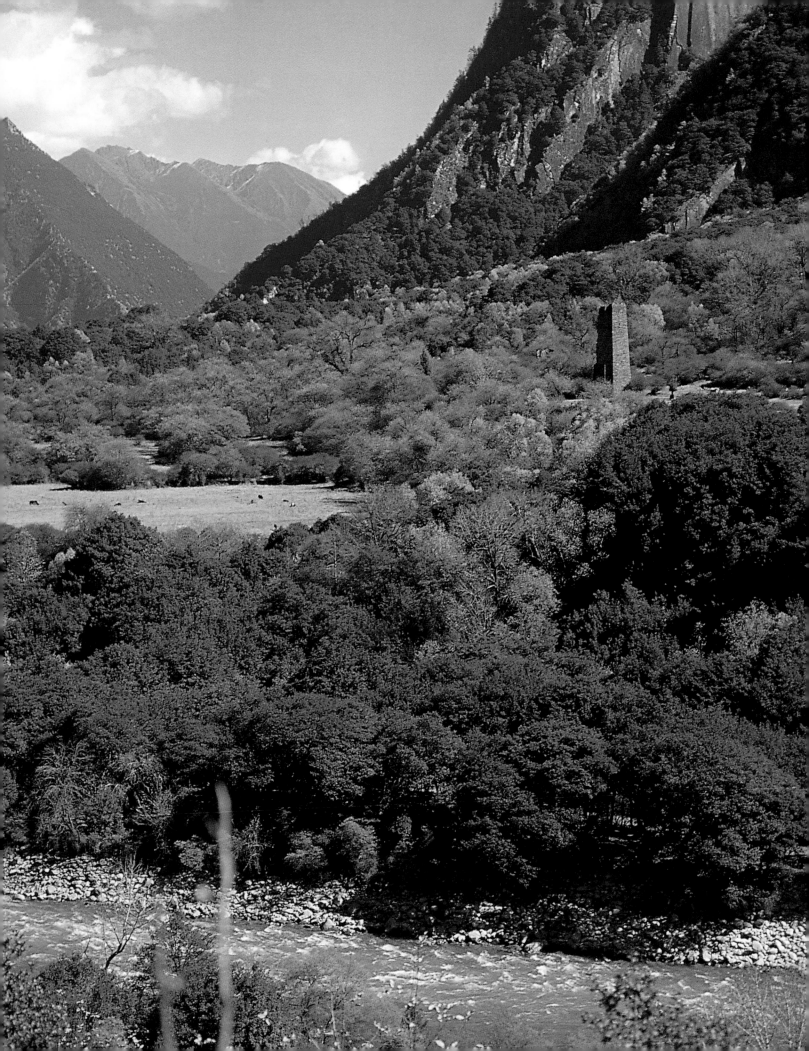

# 5   A Golden Age

*In the heart of the Kongpo region one of Tibet's many mysterious solitary towers rises above the fertile wooded valley that leads to Pasang Lake.*

HISTORY, ALMOST BY DEFINITION, is the product of the literate classes and in the case of Tibet this meant the monks. Given that Tibet's monks were pushed aside and mistreated during the reign of Langdarma, the apostate king, it would not be unreasonable to conclude that they later took their revenge by effectively deleting the period from the nation's history, to the point where little is known of those dark years. In fact, there are a few chronicles referring to this period, because monastic ordination was maintained in Amdo and non-monastic Buddhist activity continued in central Tibet.

Langdarma's two sons, Yumten and Ösung, disputed the succession and reigned over separate parts of Tibet, and as a result Tibet lost most of its advance outposts in Central Asia. Ösung's own son is said to have been a pious monk, but consequently he was murdered and it brought to an end the dynasty that had stretched back to the first king of Tibet, Nyatri Tsenpo. From 900 onwards, Tibet broke up into dozens of warring principalities and petty chieftainships, erecting fortresses on every hilltop in a manner reminiscent of medieval Europe. The religious persuasion of the warlords merely added to the vigour with which they pursued their rivalries, because Tibet was split between followers of the ancient Bon religion and various schools or orders of the ascendant Buddhism.

In less than a century, however, a Buddhism-led revival had begun in the southwest and far northeast of Tibet. By 990 monasticism was recovering and beginning to expand to unprecedented proportions. Slowly the monasteries began to benefit from the quarrels between local aristocrats, thereby gaining from their fractured power and influence – in fact, a golden age of Buddhism was set to commence. In the far northeast, around Xining in a part of Amdo known as Tsongkha, a monastic state of some importance had been set up by a certain king known as Gyelsé. This had become a refuge for monks fleeing from the persecution suffered elsewhere in Tibet. While Buddhism was strengthened there, some 1,300 miles (2,000 km) away in the far western kingdom of Guge, King Lha Lama Yeshe-o was sending young Tibetans to India to receive an

education in the great tantric Buddhist colleges there. Among these monks was one called Rinchen Zangpo (958–1055), who upon returning to Tibet built monasteries of renown in Guge, Purang, Spiti and, it is also believed, in Ladakh and possibly Zanskar. These were all places that had become minor, independent Tibetan principalities, ruled by men who all claimed some sort of affiliation, whether true or false, with the ancient royal dynasties. Alongside the efforts of Rinchen Zangpo (who was subsequently to translate many important canonical texts), the religious revival owed a great deal to an Indian sage known as Atisha (982–1054), who emphasized a more ethical, gradual path to enlightenment than the more overt practices of the tantric approach, which he felt were potentially corrupting. Atisha was the founder in Tibet of the Kadampa order, which was later to produce the indigenous Gelugpa order the Dalai Lamas belong to. The resurgence of Buddhism and the increased traffic with India led to a growing circulation in the numbers of Buddhist texts and ideas, creating a 'new wave' of religious thought within Tibet and the growth of schools such as the Kadampa, Sakyapa and Kagyupa.

## A land of small, vibrant communities

Having resided at length and explored in detail the small Tibetan kingdoms of Mustang, Bhutan and Zanskar, before tourism and progress had changed their feudal ways, I can well imagine what life must have been like in Guge, Purang, Spiti and Ladakh in those early days of the Buddhist revival. A life not very different from that of small medieval European towns and villages, a society ruled by nobles who were little more than rough, rich farmers, yet attentive to their duties as judges and keepers of order within their domains and sharing power and prestige with the abbots of the local monasteries.

This was a world dominated by agricultural considerations, yet open to the outside as a result of trading activity conducted during the winter. Each of the small kingdoms of southern and western Tibet controlled the trade of goods between Tibet and India, a trade that until quite recent times was essentially that of salt and wool being exchanged for grain – mostly barley and a little rice. This commerce was sufficient in scale to enrich the local nobles, providing wealth that they spent embellishing the chapels of the local monasteries as well as their own forts and palaces. It was, and remained until recently, a stable world of devout independent farmers and their erudite younger brothers who became monks. As a result of the social laws concerning polyandry and the tendency of younger siblings to receive monastic ordination, landholdings were not subdivided and population increases were kept in check. Monasteries proved a good outlet for the energy and intelligence of that segment of the population – namely the landless sons – that might otherwise have manifested itself in mischief. Children were turned over at the age of eight to the village monastery where they pursued careers of scholarship, often overseen by their paternal uncle. Those less academically gifted spent their time in prayer and self-improvement while carrying out chores for other monks. The students studied not only metaphysics and philosophy, but also medicine, science and art. They returned home frequently, with many students spending up to six months of the year helping their brothers on the farm or out on the high grazing lands. These monks would then teach their siblings and nephews how to read and write, thus playing an active and beneficial role in community life outside the walls of their monastery.

The vitality of these small, western Tibetan kingdoms in the eleventh and twelfth centuries is reminiscent of the city-states of Renaissance Italy where even small courts, such as that of Urbino, sheltered great artists and minds. As in Italy, artists throughout Tibet vied with one another to adorn chapels with superb frescoes. Some of these artists were laymen, others were monks, while many have remained anonymous – yet there were evidently some whose skills were in great demand, because their masterpieces can be found all over the land.

*With his hands in the position of turning the Wheel of Life, this portrait of calm assurance depicts one of the lamas of the Sakya order, which in the twelfth century ruled Tibet in the name of the khans who also became emperors of China.*

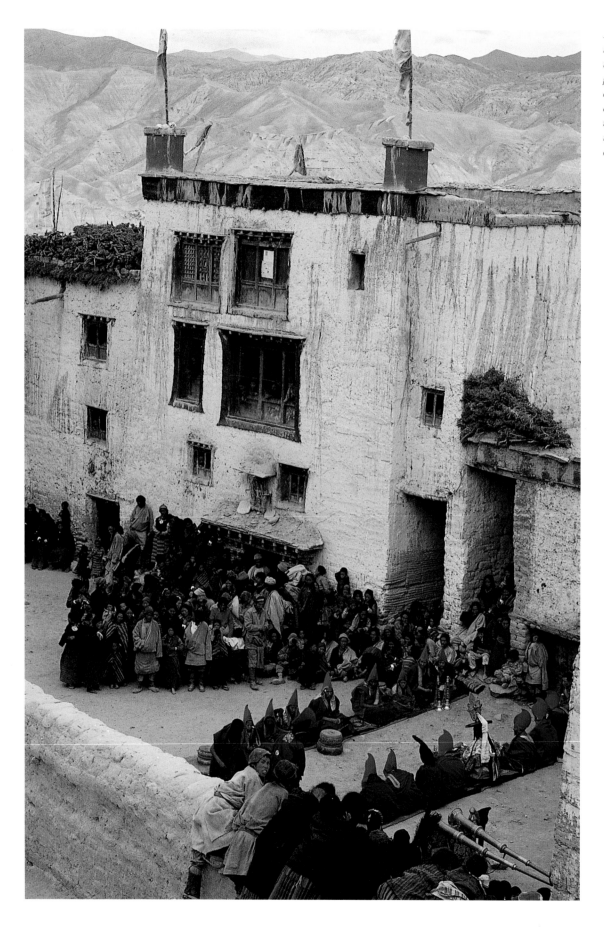

In a small sheltered square within the walled city of Lo Mantang, the capital of Mustang, monks perform an annual ceremony to chase away demons. Evil spirits are induced into a sacred trap made out of smouldering juniper twigs, which will then be carried out of the town and cast away.

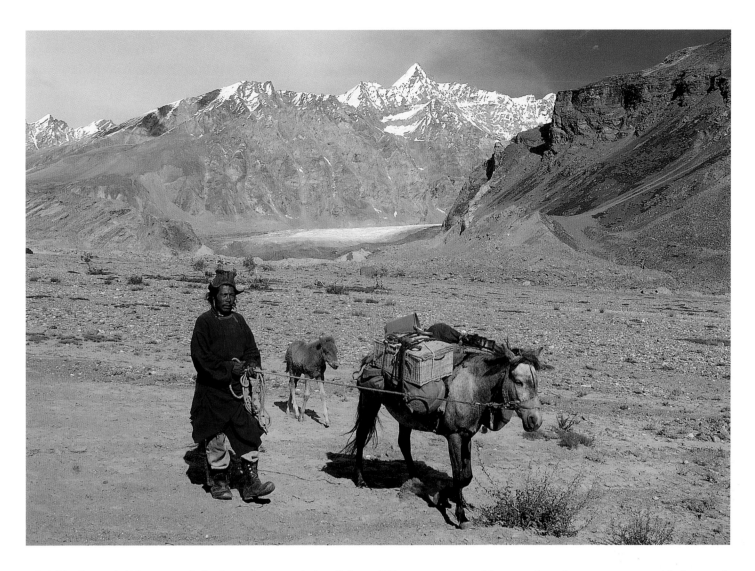

*A Ladakhi muleteer on the high road to the Zanskar valley. In winter, this route is cut off because of the snowfall, leaving a route along the frozen Zanskar River as the only means of entering Zanskar.*

A further characteristic of these Tibetan communities was that they were constantly in touch with one another – through trade and the peregrinations of the farmers in winter and a constant flow of monks between the various monasteries, irrespective of their distances apart. Although the central power of the great kings had waned, the notion of Tibet as one nation with a common language, social customs and religion (Buddhism) was well established. Today, around the humble yak dung fires, in Ladakh for example, one still hears talk about distant Bhutan or remote Amdo from one who has travelled on pilgrimage or on business. And while these regions may be far away, they are not considered foreign, as were and remain for most Tibetans places such as India, China and, to a lesser extent, Mongolia.

## Mongol influences

Being located in the heart of Asia, Tibet could not escape the principal terror of the times – the Mongol hordes. Yet at first Ghengiz Khan was too busy subjugating the Min-yag people along the Silk Road north of Tibet to bother Tibet; in addition, he was in contact with Tibetan monks and favoured their religion, so did not attack their country. It was only much later that Ghengiz's grandson, Godan, attacked Tibet in 1239, its first recorded invasion. The same hordes that were to subjugate China, and had made Europe tremble after they sacked Baghdad and conquered Russia, ravaged Tibet only briefly and never actually reached Lhasa, although a number of

monasteries were sacked. The destructive ardour of the Mongols was tempered by the zeal of Sakya Pandita, a Tibetan *lama* from the Sakya monastery founded in 1073, who had succeeded in converting the Mongol leader. In return, Pandita was appointed vice-regent of Ü and Tsang, the two main provinces in central Tibet, in which capacity he was to act as a representative of the Mongols. The Mongols thus began to use the influence of Tibetan monks to assist in the exercise of Mongol control over much of the territory Songtsen Gampo and his descendants had conquered in Central Asia. Starting with the heads of the sect at Sakya, there began a system of rule under monastic hierarchs backed by the Mongols.

If Tibet's military prominence had by this time subsided, it was now followed by a spiritual pre-eminence – backed by Mongol martial might – that enabled a Tibetan form of domination to be reasserted over Central Asia. It is one that, to a certain extent, still prevails today, not only in Mongolia but also in China, where the Tibetan form of Buddhism still has many adepts (the Chinese People's Buddhist Association is thought to have some 100 million members, which explains the true importance of the Dalai Lama beyond the narrow confines of modern-day Tibet).

What becomes clear from 1247 onwards is that the history of Tibet as a nation becomes inextricably linked with the Buddhist religion. With Sakya Pandita's appointment, and that of his successor Drogon Chogyel Phakpa, the Sakyapa order for a time became the dominant force in Tibet and marked the beginning of a process that was slowly but eventually to hand political power to the reincarnating *tulku*s (the word for a *lama* who has been reborn – a concept originated by the Karmapas of the Kagyupa school) and, ultimately, to the Dalai Lamas.

During this period, China had become weaker and had withdrawn from Central Asia just prior to being invaded and subsequently ruled by the fearsome Mongol leader Kubilai Khan (1215–1294). The *khan* had already appointed Phakpa as his private chaplain and after the conquest of China and the establishment of the Yuan dynasty in 1279, he nominated him as *tsiri* or imperial head of all of Greater Tibet, ruling from Dadu (now Beijing) through an appointed *ponchen* or administrator. Through their close ties to the Mongol leadership, the heads of the Sakyapa order had thus become the first rulers of Tibet to hail from a specific order. They exercised power in the name of the Mongol emperors and the *tsiri*'s relationship with them was likened to that of 'priest and protector'. This fortuitous turn of events left Tibet virtually autonomous as far as internal administration was concerned, although for a while the Tibetans paid a house tax to the Great Khan, who was then considered 'ruler of the world' – up to the doors of Vienna at least.

Once settled in China, the Mongol leaders seemed gradually to lose their aggressive spirit and the power and prestige of the Yuan dynasty began to wane. Hated, of course, by the Chinese, the Mongols were duly overthrown in 1368, barely a century after they had conquered the 'celestial throne', and were replaced by the Chinese Ming dynasty.

**Tibetan independence reasserted**

Few things are simple – and certainly not Tibetan politics. Not unexpectedly, other orders became jealous of the influence of the Sakyapas and sought to obtain similar power and influence. Before the demise of the Yuan dynasty there were Tibetan clans that had begun to challenge the power of the Mongol-backed *tsiri*s. Noble families led by a certain Changchub Gyaltsen, from Nedong in the south, ganged together to rival the Sakyapas and in 1350 Gyaltsen seized control of Tibet, appointing himself its new king. The last enfeebled Mongol emperor, Toghon Temur, even officially recognized Gyaltsen as the new *tsiri* and accepted the ousting of the Sakyapa order.

After the fall of the Yuan dynasty, Tibet regained its former independence under the leadership of Tibetan kings, beginning with Changchub Gyaltsen's new dynasty of Phakmodru. Gyaltsen

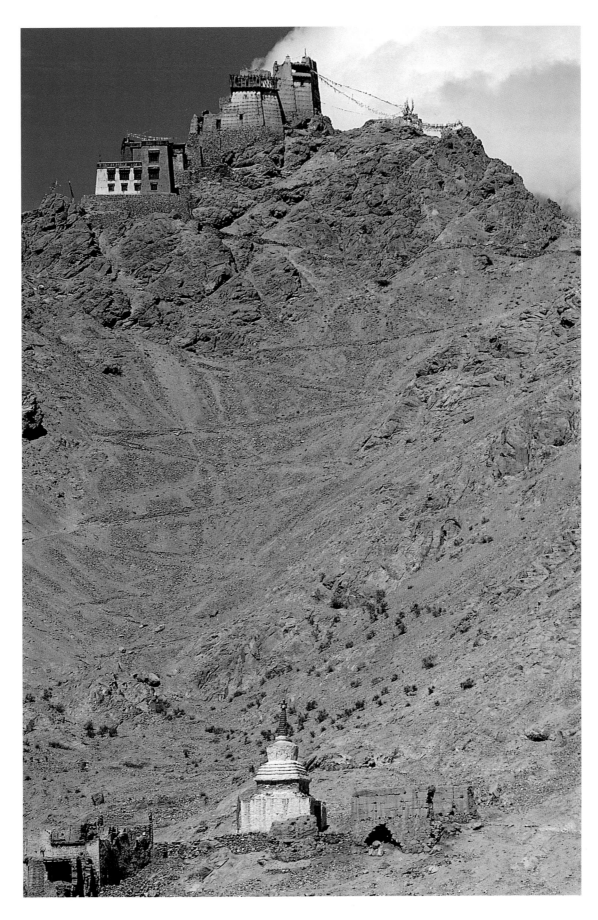

*The royal fort of Leh, the capital of Ladakh, which is the largest Tibetan kingdom not under the administration of the Dalai Lamas. Ladakh broke away from Tibet in the tenth century, but came under British rule in the middle of the nineteenth century.*

reorganized Tibet into a system of county fortresses known as *dzong*, which enabled a system of autonomous power to develop. Although certain monks still appeared at the court of the Ming emperor in search of honours and patronage, they were not acknowledged upon their return to Tibet as having been invested with any imperial power. This fact was later overlooked and even contested by the communist Chinese as they tried keenly to prove that China's 'ancient right to rule' Tibet was part of its Mongol legacy. This claim was backed up by documents that purported to prove that the numerous traders who travelled to the imperial capital were recorded in the Ming annals as having been 'tribute missions from vassal states'. This same custom, however, later had the Chinese record the United Kingdom as their vassal on receiving an envoy bearing presents from King George III. Rather than ruling over Tibet, China was in fact its eager client, for the Ming had lost control of the Silk Road to the powerful western Mongols.

As a result of this loss, the imperial armies of China became dependent on the importation of Tibetan horses (the Chinese knew the Silk Road as the Horse Trail), and for this purpose the Chinese established a 'tea exchange' on its border alongside eastern Tibet. The name derived from the fact that tea was traded for the much-needed Tibetan steeds. In some years, up to 10,000 horses were bought by China. In the meantime, Tibet was growing wealthier and the income fortified the throne of the Phakmodru kings. The Phakmodrupas supported the Kagyupa school led by the Karmapas, but the rising power at the time was the Gelugpa order founded by Tsongkhapa in the distant northwest. This was the first indigenous tradition (that is, not Indian-derived); it merged the Sakyapa and Kadampa traditions, and slowly it gained in power and prestige. This was initially around Lhasa, where Tsongkhapa and his followers established the monasteries of Ganden, Drepung and Sera; by 1447 this influence had extended to Shigatse, where the first Dalai (see below) founded Tashilhunpo, later to become the seat of the powerful Panchen Lamas.

**Rise of the Gelugpa order and the Dalai Lamas**

The Phakmodrupas were succeeded in the late fifteenth century by the Rinpung family, who were in turn replaced by the princes of Tsang in 1565. The Tsang rulers relied heavily during their rule upon the influence of the Karmapas. However, at that time the third reincarnation of Gendun Drupa of the Gelugpa order, a certain Sonam Gyatso, managed to obtain the conversion of the influential Mongol prince, Altan Khan. The prince gave Sonam Gyatso the Mongolian name Talé, meaning 'ocean' – the direct translation of the Tibetan name Gyatso. Thus Sonam Gyatso became the first Talé (Dalai) *lama*, although the title was later extended retrospectively to Gendun Drupa and his successors, so Sonam Gyatso is recognized as the third Talé (Dalai Lama). For the time being, the title had no political significance, but as Altan Khan grew in power and prestige, uniting the long-divided Mongol tribes into a fearful force once again, so did the influence of Sonam Gyatso and his successors. The fourth Dalai Lama, Yonten Gyatso, was born as the nephew of Altan Khan.

The end of the Tsang rulers came in 1642, during the stay of the first Capuchin missionaries in Lhasa, after several years of civil war when the Mongol Gushi Khan invaded Tibet with the backing of the dynasty's rivals, the Gelugpa order. The Mongols killed the Tibetan king and handed over religious power, as well as a degree of temporal power, to the new head of the Gelugpa, the fifth Dalai Lama – Ngawang Lobzang Gyatso. Thus 1642 marks the beginning of the process, quite late on in the long history of Tibet, when the Dalai Lamas began to acquire supreme political power over part of the 'land of the snows'.

At first, Gushi Khan named himself king of Tibet, but after his death his successors seldom lived in Tibet or bothered much about its administration, handing over their temporal power to

the exceedingly clever and long-lived fifth Dalai Lama, whose office thus became that of the combined spiritual and temporal ruler of Tibet. It was under his rule that Tibet experienced a flourishing of literary, artistic and religious activity – the commencement of a second golden age.

In 1644, China's Ming dynasty, which had done so much to keep the Mongols at bay by rebuilding the Great Wall, succumbed to a variety of socio-economic forces and collapsed. The new emperor, Shunzhi, hailed from Manchuria in the north, a territory beyond the Great Wall and to the east of Mongolia. Welcomed in order to restore order, the new Manchu or Qing dynasty was culturally close to the Mongols, most of whom they had subjugated, and felt it quite natural to assume the past role of the Qosot tribe of Mongols as prince-protectors of the Dalai Lamas.

The Qosot Mongols, however, had not been conquered by the Manchus and the astute fifth Dalai Lama was able to take advantage of this to go to Beijing (Dadu) and play the role of mediator between various such Mongol tribes and the Chinese Manchu emperor. What the Manchus feared was a reunited Mongol world with the strength to menace China. This did, partly, come to pass with the emergence of the Dzungar Mongols of Turkestan, under the leadership of a certain Galdan, to the west of the Qosot Mongols. Ironically, the Qosot leader Lhazang Khan sought an alliance with Manchu China, which had been fighting the Dzungars. The Dalai Lama then allied himself with Gandan in order to serve as the peacekeeper between the rival Mongol forces – such deft diplomatic skill was not to survive his death.

The Chinese claim that the fifth Dalai Lama was a vassal of China, but the records show that such was the respect in which he was held that when he travelled to Beijing he was received with the pomp and ceremony normally accorded to a powerful independent ruler. The prestige and

*Elegant-looking* chortens *straddle the trade route that links Mustang with Tibet where it passes at the foot of Nyphu monastery. Rectangular* chortens *are rare in western Tibet but common in Bhutan.*

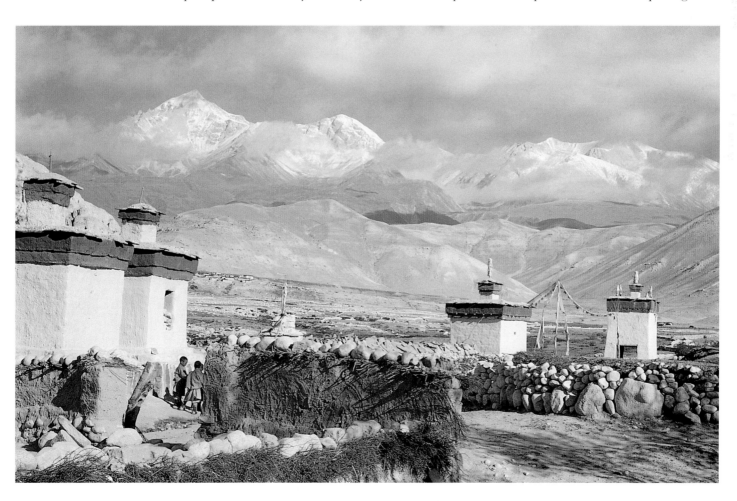

# Ladakh

**Straddling two major trade routes**, Ladakh was for a long time one of the most prosperous of the Tibetan kingdoms. The trade route that linked India and Kashmir with Central Asia, and beyond that with China, passed through the domains of the kings of Ladakh. Along it there travelled caravans of camels carrying all manner of goods. Another trade route, this time using yaks and ponies, ran from Ladakh to Lhasa, and from there to central China.

The region was Buddhist long before the armies of Tibet conquered the region early in the eighth century, as is testified by numerous representations of Buddha carved into the rock and which date to a preceding period. The quantity and splendour of the large monasteries built in Ladakh can be traced back to the days of Rinchen Zangpo, who was responsible for the renaissance of Tibetan Buddhism in the twelfth century.

In the nineteenth century, Ladakh came under British rule when the small Hindu state of Jammu, which had deposed the king of Ladakh four years previously, was annexed. The British then proceeded to set up the Hindu ruler of Jammu as the maharaja of the much larger Muslim state of Kashmir. The end result of this unfortunate history is that Buddhist Ladakh forms part of Kashmir, which is administered by India, a state that has a Hindu majority, with Kashmir itself claimed by the Muslim state of Pakistan. The struggle for Kashmir appears to be one of the world's insoluble imbroglios.

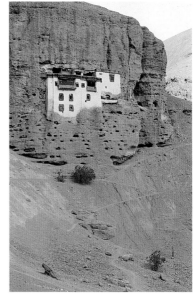

2

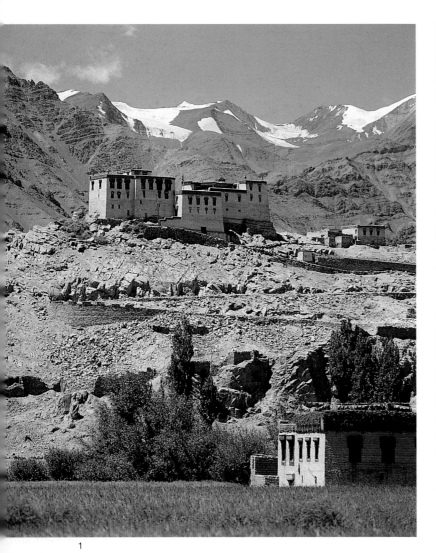

1

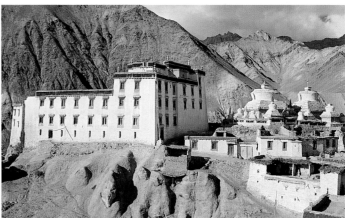

3

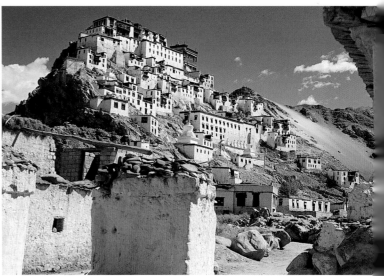

4

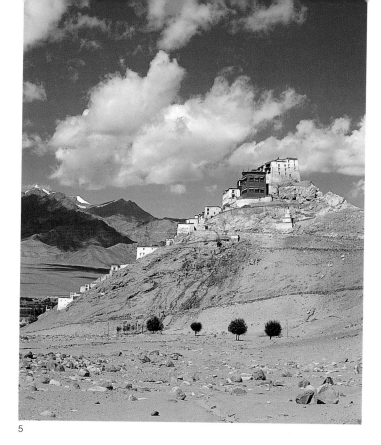

5

6

1. The Chendey monastery in central Ladakh belongs to the Kagyupa order.

2. The cave monastery of Shergol.

3, 7. The facade and a more distant view of the spectacular monastery of Lamayuru, which is built, like so many others, above what were the cave shelters of hermits. Lamayuru, situated between Kargil and Leh, is the oldest monastery in the region.

4, 5. A frontal view and profile of the monastery of Tikse, reminiscent of Lhasa's Potala Palace.

6. The courtyard of Hemis monastery, famous for the sacred dances performed there at festival time.

8. Phugtal is a cave monastery (*phug* means cave). It is the most incredibly located group of buildings, perched several hundred feet up a cliff-face. There are several more buildings inside the cavern itself.

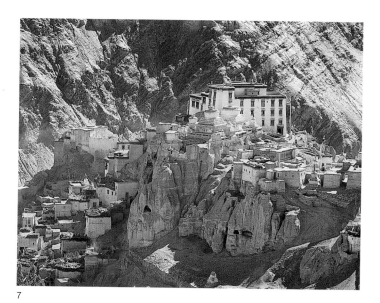

7

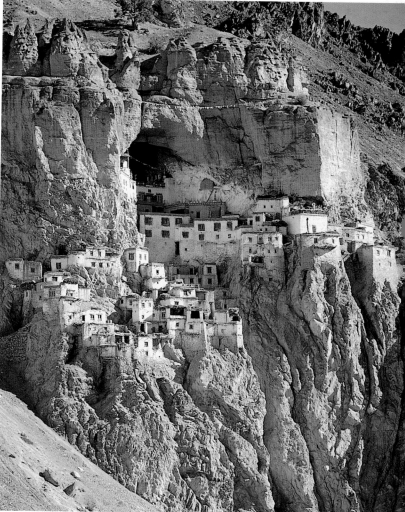

8

# The mystery of Tibet's skyscrapers

**In a vast arc stretching from** the central, southern Tibetan region of Kongpo up to the traditional borders of China can be found numerous isolated towers, several of which rise an amazing 160 feet (50 m) into the air. Who built these amazing edifices, when and why remains a mystery. Recent research, including carbon-14 dating analysis carried out by Fréderique Darragon, has revealed that the towers are between 600 and 700 years old.

The towers appear to conform to one of four different structural configurations, one of them an unusual octagonal shape, The eight-pointed star configuration would seem to be a twelfth-century scientific breakthrough – a design that enabled the buildings to withstand the earthquakes so frequently experienced in this part of Tibet. Judging by the fact that the towers are still standing after six or seven centuries, the system seems to work remarkably well.

There are several hundred of these *garong* in total and it would appear that they had a dual purpose, serving as a mark of rank on behalf of their builders and offering a practical defensive structure. That said, the towers lack the apertures found in the walls of regular forts and they are generally located on their own, away from houses or other buildings. In some villages there are more than a dozen of them, all with the same tall, thin shape that gives them a modern industrial appearance when viewed at a distance. Their distribution does not yield clues as to their origins either.

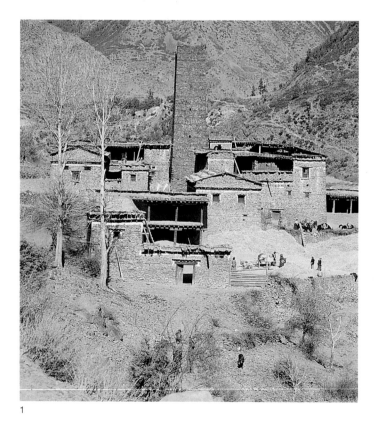

1

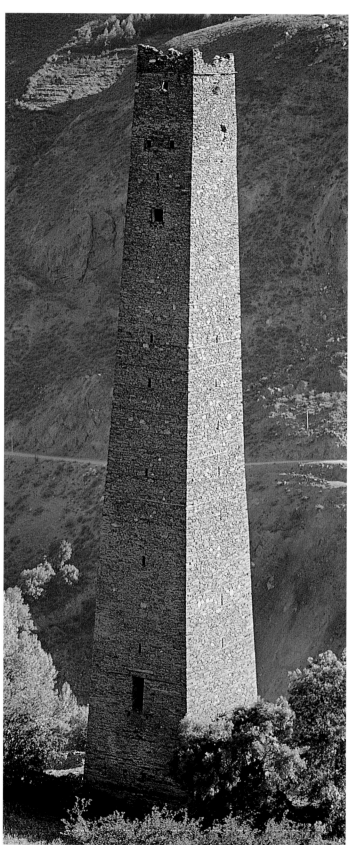

2

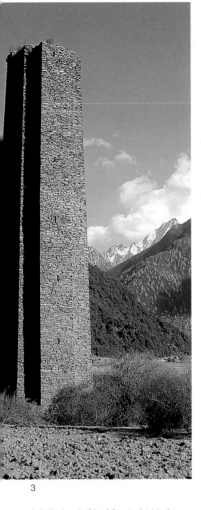

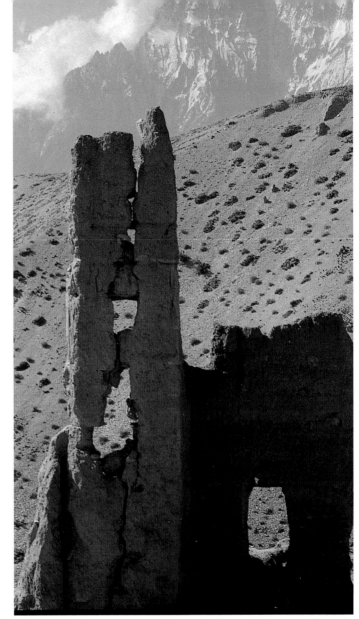

3, 6. This tall, solitary tower is a very similar structure to the partially collapsed tower below (6), both of which exist in isolation in the Kongpo region of Tibet.

4. This six-pointed tower is located 375 miles (600 km) east of the Kongpo pair.

5. This ruined tower, some 375 miles (600 km) west of the Kongpo towers, was once part of a fortress that guarded the southern approaches to Mustang.

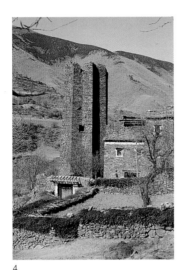

3

4

5

1. In the heart of the Minyak district of Kham, along the border with China, this partly ruined tower is surrounded by a large manor house built more recently.

2. This slim tower has withstood centuries of earthquakes despite the fact that it was erected without the star-type buttresses that endow a structure with great sturdiness.

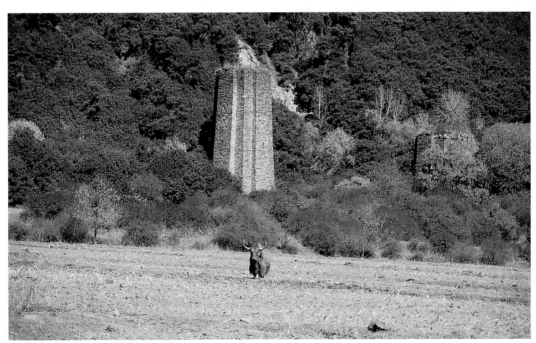

6

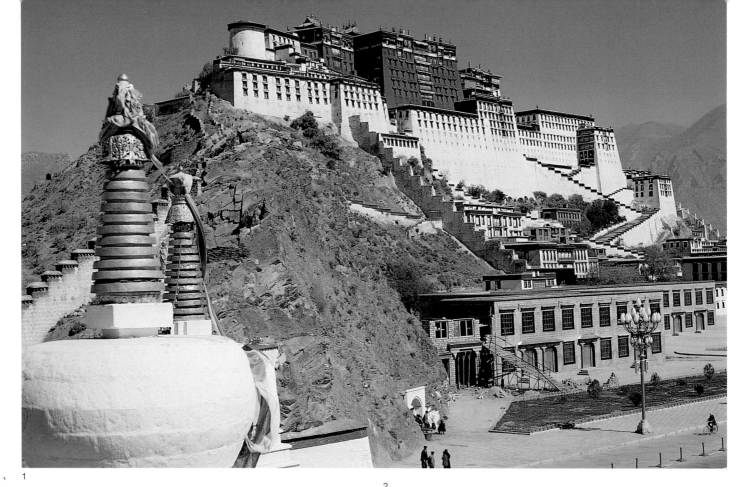

1

2

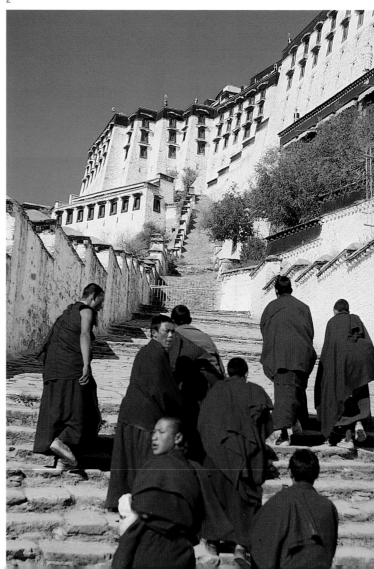

# Potala Palace

**Considered one of the grandest structures in Asia**, the Potala Palace stands as a monument to the might of the Dalai Lamas. It was built in stages on the slopes of a hill (Mount Marpori) that overlooks the old city of Lhasa. The palace takes its name from Mount Potalaka, the sacred abode of the *bodhisattva* of compassion, Avalokiteshvara, of whom the Dalai Lama is considered to be an emanation.

Work on the palace began in 1645 with the construction of the multi-storey outer section known as the White Palace, which was erected upon the ruins of an earlier building that was said to have been built by Songtsen Gampo. The great fifth Dalai Lama, the first one to actually rule Tibet, established his residence there, before the new structure was completed in 1653. It served as the administrative centre of Tibet. The Red Palace has a more spiritual function and was completed by the regent Sangye Gyatso in 1694. Later additions include the buildings that house the gold-covered tombs of the fifth, eighth and ninth Dalai Lamas and, more recently, the thirteenth Dalai Lama, who died in 1933. The gilded, pagoda-shaped rooftop pavilions shelter the lattice-windowed apartments of the Dalai Lama.

Inside the building are thousands of priceless books and chapels containing remarkable, jewel-encrusted golden statues, varying from representations of the Buddha to early Buddhist masters and reformers such as Padmasambhava and Tsongkhapa. Perhaps most spectacular are the tombs of the Dalai Lamas, particularly that of the fifth.

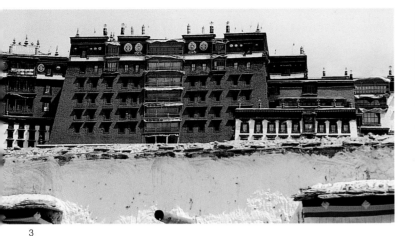

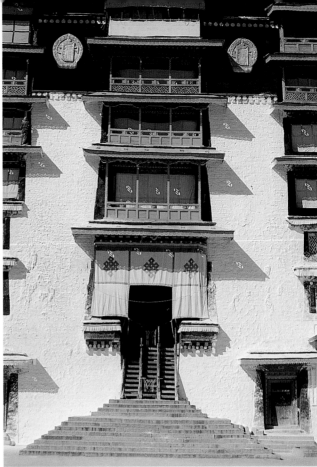

3

1, 2. A frontal view of the Potala showing Zhol Square and the Central Gatehouse in the foreground. The palace has four approaches, the main one being that used to reach the Eastern Courtyard.

3. The Red Palace. Visible at the left is the reliquary chamber (Serdung Gelek Dojo) of the thirteenth Dalai Lama.

4. The triple wooden ladder leads from the Eastern Courtyard to the entrance of the White Palace.

5. This view shows the bifurcating Central and Western staircases. The lower floors contain granaries and treasure vaults.

4

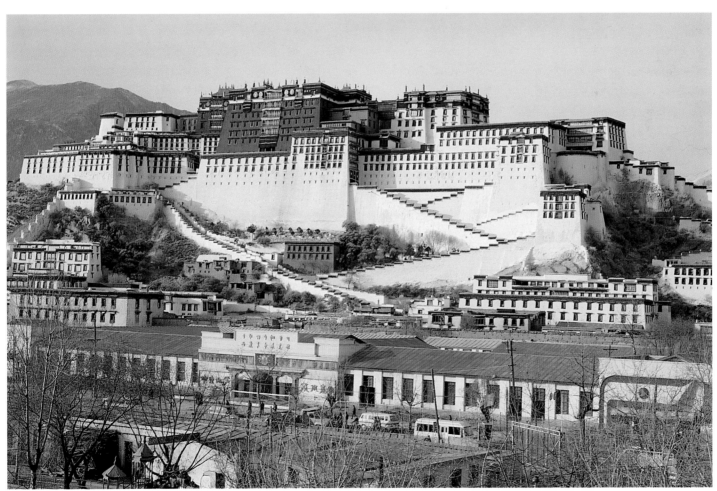

5

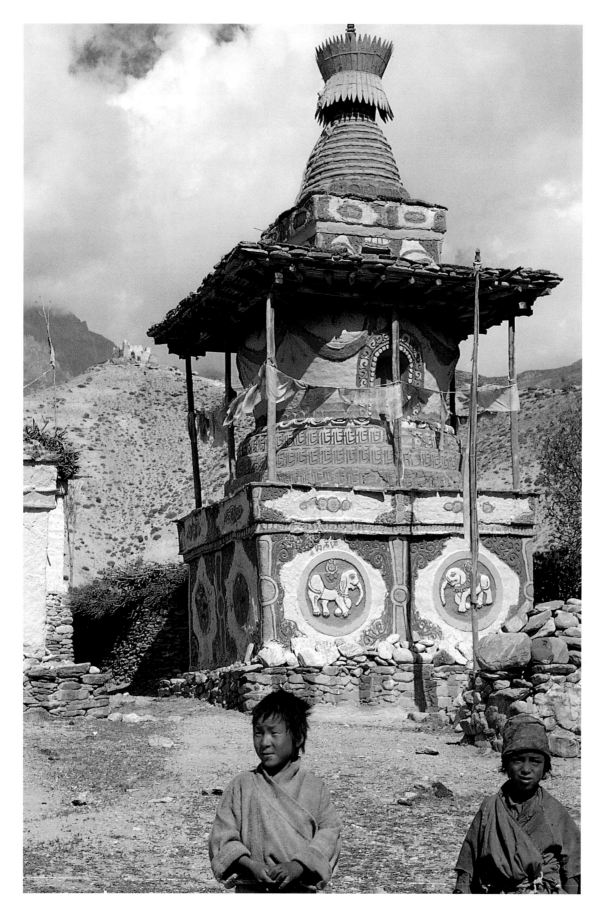

*A chorten typical of those to be found in the kingdom of Mustang. It is highly decorated with low relief designs sculpted in adobe and painted with the mineral colours redolent of the land's eroded gorges.*

importance of the Dalai Lama was such that it is recorded that the Chinese emperor took an unprecedented twenty-eight paces away from his imperial throne to greet him, and that a huge ramp nearly 3,300 feet (1,000 m) long was erected over the city wall so that the Dalai Lama would not have to suffer the indignity of having to walk through the gates on his way to see the emperor.

The power and prestige of the fifth Dalai Lama was so great that he backed the struggle of ethnic Tibetan tribes in Yunnan for independence from the Chinese and helped on several occasions to pacify the Mongol tribes. Not least of his achievements was the rebuilding in Lhasa of Songtsen Gampo's mighty Potala Palace into what it is today – one of the most impressive and elegant buildings in the world. A palace, a fortress and a mausoleum; if its lower dungeons are somewhat gloomy, the rooftop apartments are quite magnificent, while hundreds of chapels and dozens of assembly halls lie in between, linked by a maze of corridors that leads to the huge golden mausolea of the Dalai Lamas. Here, embalmed and plastered with gold leaf, nearly all the Dalai Lamas sit erect inside huge jewel-studded *chorten*s covered in thick gold plate. With 1,000 rooms and all those embalmed remains, the Potala is not really a cosy place, but it is a worthy symbol of the power and wealth of the Tibetan state.

### Times of renewed trouble

When the fifth Dalai Lama died in 1682 he was succeeded by Sangye Gyatso, whom he had appointed to be his third regent until the sixth Dalai Lama was found. It was the beginning of a troubled time for Tibet. Over the years, the dynamic facet of the Tibetan character, which had proved such an asset during times of war and territorial expansion, had been diverted into religious activity. This manifested itself in the design and erection of monasteries, the establishment of religious schools and universities, and the sending of monks to the furthest corners of Central Asia. In short, Tibet had become a land of sages and was considered to be far more cultured than its neighbours, whether Nepalese, Mongols or Burmese. All this was very well, but given Buddhism's aversion to violence it meant that Tibet lacked a strong army. Princes and local kings situated on the borders of distant Ladakh or Kham were left to use their own initiative and resources when it came to defending Tibetan territory from those who were interested in acquiring the rich grazing grounds or in plundering the ever-increasing wealth of Tibet's monasteries.

If Gushi Khan had once gained prestige from ruling Tibet, now other Mongol leaders dreamt of doing the same and among their number was the leader of the Dzungars. The *khan* had observed how Mirza Haidar, a Muslim general from Kashgar, had invaded Baltistan in far western Tibet and converted its population to Islam without any great trouble. This was the same Baltistan that had in the seventh century witnessed the flourishing of the first Buddhist monasteries in Tibetan-speaking territory.

Regent Sangye Gyatso had enthroned a certain Tshangyang Gyatso as the sixth Dalai Lama (born in 1683). Very soon this young man began to cause a scandal by composing love songs about his involvement with various young ladies of Lhasa, which he recited around the city. Many monks frowned at this behaviour, yet he was immensely popular; as he declared in one of his poems, he could be pious by day and satisfy his mistress by night. The Qosot Mongol ruler Lhazang, ally of the Manchu emperor, used this scandal as a pretext to invade Tibet. Lhazang Khan killed the regent, abducted the Dalai Lama and tried to impose a young man of his choice as the seventh Dalai Lama.

Infuriated by these actions, the Tibetans appealed, ironically, to the Dzungars who invaded Tibet from the far west. They confronted the Qosot Mongols and, in 1717, Lhazang Khan was killed. Tibet descended into chaos and China's Emperor Kangxi sent in a strong military force, which in 1720 expelled the Dzungars from Lhasa. This was China's first major military

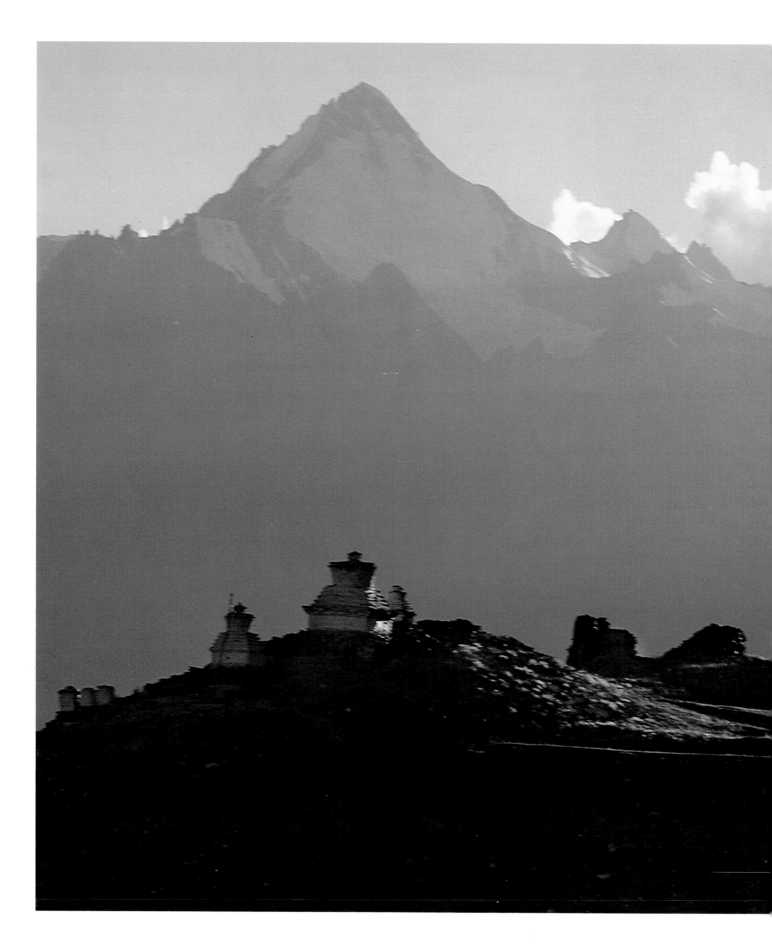

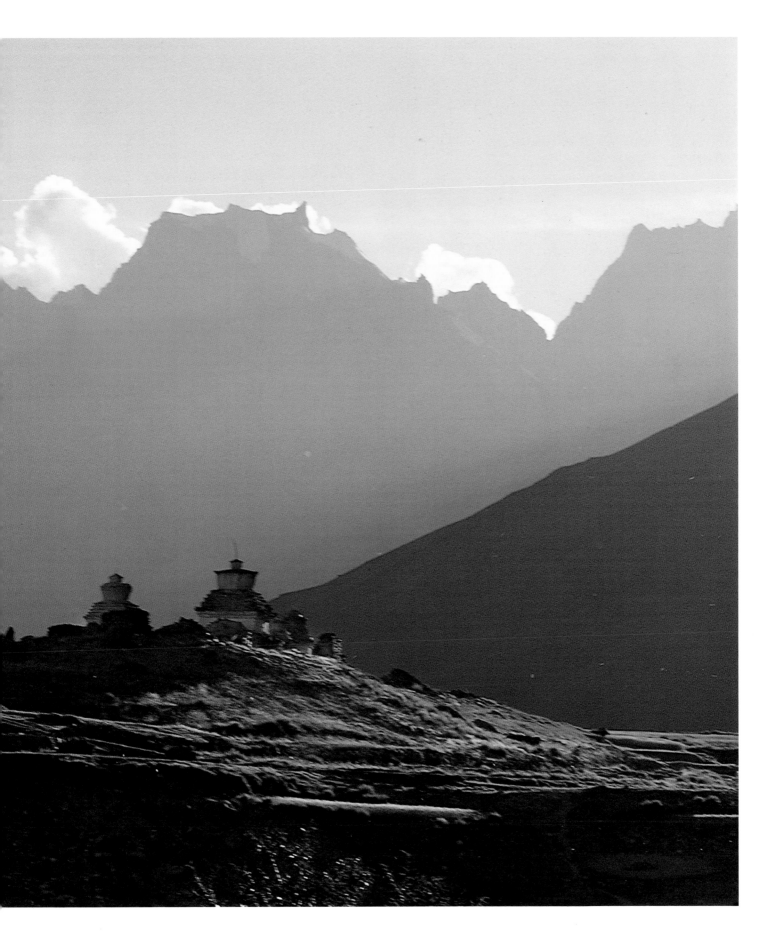

intervention in central Tibet. The Chinese installed the true seventh Dalai Lama, a young man from Litang in Kham, and they then pulled down Lhasa's defensive walls and established a loose Chinese protectorate over Tibet – one which was to last until 1912.

Due to the distances involved, Chinese influence in central Tibet was relatively mild, but the eastern and northeastern regions of Amdo and Kham were subject to increasingly larger degrees of Chinese authority. In 1724 there was a unilateral declaration that Amdo along with Nangchen and Jyekundo would be the Chinese province of Qinghai, which provoked an angry response from both the Golok tribesmen and the kings of Nangchen whose domains represented a substantial part of the new province. Both refused to acknowledge the self-appointed Chinese overlords and the Golok pillaged all the caravans that crossed their territory. The same situation prevailed in much of Kham, where the mixture of isolated valleys and plateau nomads meant most peoples remained virtually independent right up until 1953, three years after the communist invasion. All told, Tibet was too vast and too rugged to be managed by outsiders who could not cope well with the altitude and who found the terrain presented serious obstacles to the enforcement of their will by military means.

Eighteenth-century Tibet bore no resemblance to a modern, national political unit. If the Dalai Lamas were influential nationwide because of their religious prestige, as far as the average farmer was concerned his only true acknowledged ruler was the local king, prince or head of the local monastery to whom he paid taxes in kind. Many of these rulers, such as those of Nangchen, Guge or Kham, were for all intents and purposes independent. Farmers in these regions continued to abide by the now ancient social customs of the great early Tibetan kings: holding on to their land, which they could not sell; transmitting their land to the eldest son; and practising polyandry as a necessity when the younger son preferred to stay at home rather than become a monk.

## Central Tibet's monastic estates

Matters were a little different in central Tibet, because there much of the land was now divided among three huge monastic estates (more like principalities or states). To the west of Lhasa were the vast estates of the Sakyapa monks, the order that had converted Ghenghiz and Kubilai Khan in the thirteenth century. It ruled a huge province in which the monks levied taxes and owned all the land. The farmers there were little better than serfs who worked the monastery's land for a share of the crop (usually split equally). The same arrangements applied to a large proportion of the farmers on the huge holdings of the Panchen Lama in the lands around Tashilhunpo along the fertile banks of the Tsangpo River, near Shigatse. Thirdly, there was Lhasa where the large monasteries of Drepung and Sera and a few, very powerful, noble families (many of them relatives of previous Dalai Lamas) owned most of the land. Thus here again most of the peasants were somewhat like serfs in contrast with the free land-owning peasantry that existed elsewhere. Each of these three monastic territories were practically independent of one another, even if they did acknowledge a certain national authority to the Dalai Lamas.

Surrounding these agricultural communities there stretched the domains of the nomads in which the high pastures were divided among various independent-minded tribes. These groups had local chiefs and were made up of family units – generally a tent composed of one couple and their children, to which the chief allotted a specific summer and winter territory where the family could graze their animals. Over this territory a family would roam, grazing the herds it owned – of yaks, horned sheep and keel (cashmere-producing) goats – and turning over a percentage (usually 10 per cent) of their herds to the tribal chief when he came calling.

It mattered little either to these independent and relatively rich nomads or to those near-serfs working on the monastic estates whether the high priests, the Dalai Lama or the Panchen Lama

*Previous pages: The Tibetans are masters in the art of harmonizing their monuments and buildings within their natural surroundings. This row of chortens in Zanskar replicates the jagged crests of the Himalayas behind.*

enjoyed friendly relations or not with the distant Chinese emperors, or, frankly, whether these same superiors acknowledged China as their suzerain (overlord) or not. However, people throughout Tibet, regardless of their order or territorial allegiances, retained a pious admiration for the Dalai Lama, who was believed to be an incarnation of Avalokiteshvara and therefore the very embodiment of compassion. Such respect sometimes contrasted starkly with the lack of it they bore to the political administration, which some openly criticized and despised as the 'sweet mouths' or 'black hearts' of Lhasa.

Although he was technically now under the patronage of the Chinese Manchu emperor, the Dalai Lama was still the virtual king of most of Tibet – extending from Ngari in the far west to the Yangtze in the east – and free to rule as he pleased. The two Chinese *ambam*s ('residents') and their small military force were neither willing to nor capable of administering the land in his stead. To quote Professor Rolf Stein, 'The Dalai Lamas were tacitly recognized as sovereign of Tibet'; this meant head of what might be identified as a 'Tibetan Buddhist state'. In reality, after the seventh Dalai Lama it was in fact the regents who ruled Tibet, because four successive young Dalai Lamas died mysteriously on their coming of age. Politics in Lhasa was a muddled, dirty affair conducted by the top noble families and the upper hierarchies of the great monasteries, each vying for the control of huge estates.

Over the years, both Lhasa and the Tibetan government came to be dominated by the three giant monasteries of Sera, Ganden and Drepung. The institutions had fluctuating populations of several thousand monks, including their own police-monks and soldier-monks. Each great monastery took it in turn to be in charge of order in Lhasa during the month-long New Year festival held every February, when thousands of people flocked to the holy city on pilgrimage from all over Tibet. Among the monasteries' roles was taxing the pilgrims and merchants, along with being in charge of administering justice.

### Tibet dismembered

In many ways Tibet during this period can be compared to fifteenth-century Europe, where there was almost constant quarrelling between monarchs, princes, independent bishoprics and the papal states. A Tibet so internally divided among independent princes and rival religious land-owning monasteries offered an inviting target and an easy prey for envious neighbours. However numerous the warrior-monks (the police-monks and *dobdob* warrior-monks), they failed to constitute anything like an efficient army that might be strong enough to guarantee Tibet's frontiers. At the dawn of the nineteenth century, there were various parties with different reasons to attack Tibet, which had become rich from centuries of well-administered agricultural resources and where the economic surplus had been converted into the gold and jewels that adorned the altars of the country's thousands of monasteries.

In 1798 Nepal had become unified under the aggressive leadership of its militaristic early Gurkha kings, and as a consequence of this expansion Nepal was the first to invade Tibet. Meanwhile, in the west, the Moghul Muslims of Kashmir and the Dogras of Jammu were poised to invade Ladakh. The dismemberment of the Tibetan empire was about to begin, along with the slow process that was to lead to the demise of the theocratic state run by the Dalai Lamas. To some it seemed the inevitable outcome of a process whereby powerful rival monasteries and a ruling elite jostled to maintain their revenues and privileges at the expense of the mass of the people. As a result of the diffuse fragmented nature of religio-political power, the process of Tibet's disintegration was only to be stalled temporarily by the arrival of the astute thirteenth Dalai Lama. Meanwhile, the future for Tibet looked grim. Defenceless except for the charms of the oracles, Tibet lay surrounded by aggressive kingdoms.

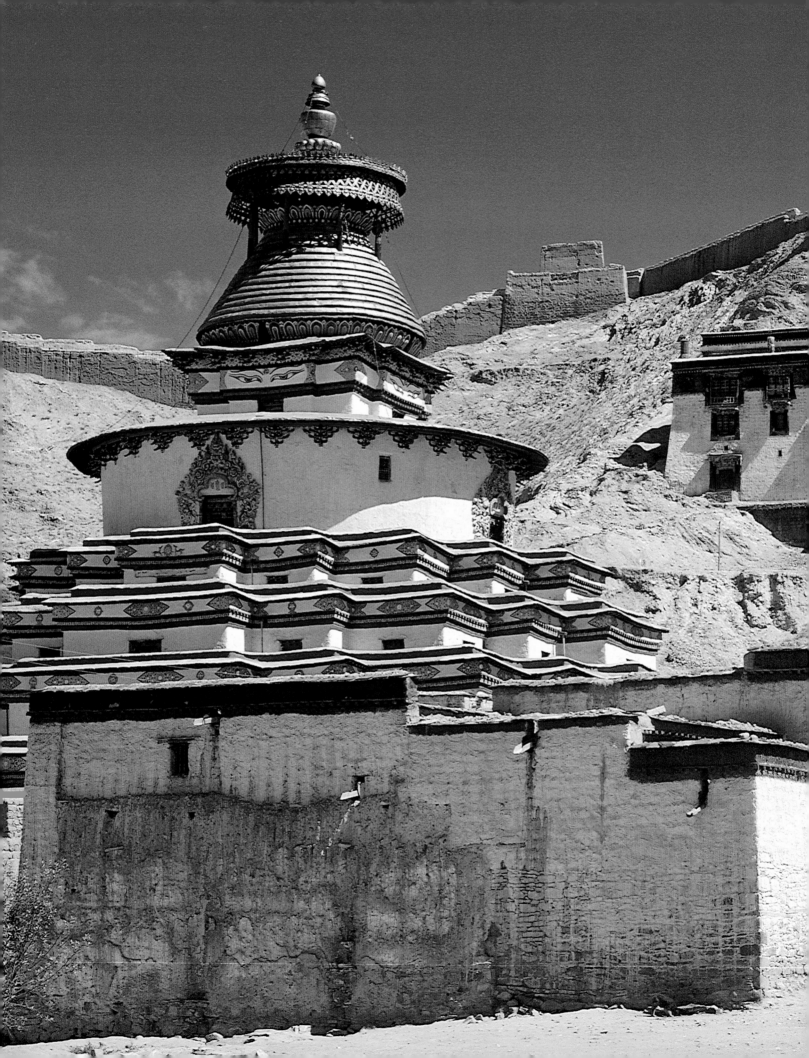

# 6    Realm of the Faithful

*The Kumbum* chorten *is in the town of Gyantse, which lies along the trade route to Sikkim, Bhutan, Nepal and eastern India. The Kumbum is a three-dimensional* mandala, *or model of the Buddhist cosmos. Consecrated in 1427, the nine-storey Kumbum is the largest, finest and most remarkable* chorten *temple in Tibet. Its name means 'one hundred thousand holy statues'. Octagonal in shape, it contains seventy-five chapels with countless sacred images and statues.*

IT IS DIFFICULT TO THINK of Tibet without associating it with the Buddhist religion, or rather the specific assimilation of Buddhism that is identified with that country and its various distinct orders and leaders. Modern Tibet is probably better known for its religion than for its agriculture, art, literature and its long history under the rule of lay kings and princes. Buddhism has been Tibet's dominant faith since about the seventh century, despite an age-old struggle for supremacy over the older Bon religion – a contest which, over the years, was to change both Bon and Buddhism in Tibet.

The Bonpo explained Tibet's monarchy in terms of a dynasty of divine kings who had originated as gods in the sky and were now rooted on Earth (as recited in the kingship myths). Buddhism absorbed this and in part reflected it by means of the *tulku*, the reincarnation of a *lama*. Bon, in common with most early religions, ascribed great significance to elemental gods and a multi-tiered division of the universe, each the domain of specific good and evil powerful deities – Tibetan Buddhism reflects many of these figures as lesser deities in its pantheon. Bon involved the practice of magic, seeking to propitiate demonic forces for the benefit of humankind and maintaining a shamanic priesthood steeped in the arts of trance-inducing oracular activity – all of which are aspects that can be discerned in Tibetan Buddhism to differing degrees.

Bon, in common with and in addition to even earlier animistic creeds, encouraged the worship of local divinities, often feminine and including a goddess of fortune and fertility, and spirits associated with mountains, cliffs, rocks, trees and rivers. What Bon did over time was provide these animistic beliefs with the trappings and organization of a more formalized religion, including a specific pantheon and prescribed rituals. Many of these aspects were then incorporated in some related form into Buddhism as it became practised in its Tibetan form, contributing in part to the latter's distinctiveness.

Although Bon, with its shamanism, magic rites and deeply held beliefs in demons and spirits, remains an active religion in many parts of Tibet (in some

places it is still the major faith), such was the triumph of Buddhism that up until the middle of the twentieth century Tibet's social and political institutions were based solely on it. The monasteries offered practically the only means of education and approximately one-quarter of the entire population belonged to a religious order. With a great deal of land owned by the major monasteries and worked by the peasantry, Tibetan society within the domains ruled by the Dalai Lamas (wherein resided about half the population) can readily be defined as feudal. The relations between peasant and landowner were similar to those in medieval Europe. The theocratic nature of Tibetan society was most readily apparent in the person of the Dalai Lama himself, who for 300 years was both the political leader of the nation and its spiritual figurehead.

Buddhism probably first reached western Tibet from India via Kashmir – the oldest Buddhist statues with Tibetan script stand in Baltistan – and then later from Central Asia, perhaps as early as the third century AD. It was, however, not until the eighth century that Buddhism gained any real foothold – and then it was the Indian schools that proved more influential. According to tradition, Buddhism was introduced to Tibet by King Songtsen Gampo through his Nepalese and Chinese wives in the seventh century. At the time, the majority of Indian Buddhism was affiliated to what is called the Vajrayana tradition of the Mahayana or 'Greater Vehicle' school, as was Chinese Buddhism. Nevertheless, Chinese and Indian Buddhism still varied to such an extent that both prevailed for a while in Tibet during the reign of Trisong Detsen. A debate was held at the monastery of Samye to decide which one should be adopted, and, as revealed earlier, the Indian form emerged as the victor.

Buddhism's ascendancy in Tibet during the eighth and ninth centuries then provoked a series of violent struggles between the ruling house, whose members sided with Buddhism, and the powerful noble families, which sided with Bon. The latter eventually lost out and persecution ensured Bon never regained sufficient strength to threaten Buddhism's dominance, although it was not eradicated and survives as a living faith. Ironically, it was Buddhism's promotion of writing and literature that enabled Bonpo to record all their ancient rituals and to develop a more systematic form of the religion with its own sacred texts – although in the process Bon also absorbed many influences from Buddhism.

**The Dharma**

A full explanation of the intricacies of Tibetan Buddhism is beyond the scope of this book, because that is a field reserved for dedicated scholars. As Professor R.A. Stein, an expert on Tibetan religion and culture, has observed: 'There can be no question of giving even the most incomplete overall account. . . It is a whole world, immensely complex, embracing many aspects: a rich and subtle philosophy, with its own dialectics and metaphysics; a very advanced depth-psychology linked to techniques of meditation and the control of psycho-physiological functions (yoga); an enormous pantheon; countless rituals; popular practices; cosmological speculations; systems of divination. The Tibetans have devoted thousands of volumes to all these sides of their religion, which is perhaps best considered as having preserved the very highest developments of the original Indian Buddhism (for in India, Hinduism and Islam largely extinguished Buddhism).'

The average layman in Tibet has a simple understanding of Buddhist beliefs. Ordinary people are usually familiar with the life of the historical Buddha, Siddhartha Gautama or Shakyamuni, an Indian prince born some 2,550 years ago. After indulging all manner of sensual pleasures afforded by courtly life, he renounced it and reached the conclusion framed as the Four Noble Truths – that life is characterized by pain or misery. This misery he declared was caused by 'wrong' or 'excessive' mental states, including delusion, hatred and desire. He concluded that the elimination of misery comes with the uprooting of such dissonant states by following the

*Held in the grip of Yama, the Lord of Death, the Wheel of Rebirth depicts the six impermanent spheres, three higher and three lower, of existence into which one can be reborn while awaiting liberation through the attainment of nirvana. At the centre are symbols of the three mental states that underlie the cycle: the pig, snake and cock representing delusion, hatred and desire.*

Eightfold Path, which consists of right views, right intentions, right speech, right actions, right livelihood, right effort, right mindfulness and right concentration. The first and the last of these – right views or wisdom and right concentration – are complex topics that provoke much discussion and differences of opinion between the various Buddhist orders. The remainder are considered to belong to the realm of good morals, which are achieved by observing the equivalent of Christianity's Ten Commandments. The Buddha's teaching or doctrine is known as the Dharma.

On having discovered that life was pain, Siddhartha had sought spiritual guidance from priests to attain liberation, but in vain. He also tried penance, suffering hardship in the hope of purification, but again his effort was wasted. It was then that he remembered having attained in childhood a condition of 'mindful happiness'. Thus it was that he sought to find and perfect this happiness, and through this method – a middle way between extreme pleasure and asceticism – he eventually achieved a freedom from self known as *nirvana* – an absolute peace and the status of the unborn, detached from the cyclical nature of life itself in all its forms.

The Buddha proffered the theory of causality, which suggests everything comes into being on account of something else and then passes. The root causes of man's failings and wrong desires are believed to be delusion, hatred and desire. This trinity is represented by a pig (delusion or ignorance), a snake (hatred or anger) and a bird (desire or passion), which form the hub of the Wheel of Rebirth into which we are all born. Held in the clutches of the god, or lord, of death,

it is this Wheel of Rebirth that can be found painted in the portico of many of the chapels in Tibet. It is divided into six segments that represent six spheres of existence into which one can be born – or rather reborn, for Buddhists believe in the notion that life is a series of successive rebirths.

Three of these spheres are relatively happy ones, while three are unhappy ones. One of the former is to be reborn on Earth as a human being; the two other reasonably good options are to be reincarnated as a god (a mortal god), who will be spared physical discomfort and live a good life but will be tortured by the fear of having one day to die yet again, or to be recycled into the Wheel of Rebirth. Or, instead of a god, one might become a Titan, one of the quarrelsome anti-gods (*asura*) who battle incessantly with the gods, suffering wounds and great pain in the process until at last they too are recycled into the Wheel and perhaps a fate that has been worse than their experience as a Titan. Rebirth as a human means one has to suffer all the same anguishes as other beings, the fear of death being high among them, yet a human has the great privilege of being able to practise the Dharma and therefore can hope to gain merit, which will earn a better reincarnation and perhaps one day it will even permit the attainment of *nirvana*, or liberation from the Wheel of Rebirth.

One can, of course, also be reborn into one of the three unhappy spheres of existence. The least fearful is to be reborn as an animal, for although they may be hunted and endure hard lives as beasts of burden, their life is relatively tolerable. The second unhappy sphere is to become an anguished spirit, rankled by thirst and hunger yet unable to quench it because one's mouth is as small as a pinprick and water turns into fire when it is about to be drunk. Worst of all, however, is to be reborn in the hells where one is tortured by both fire and extreme cold.

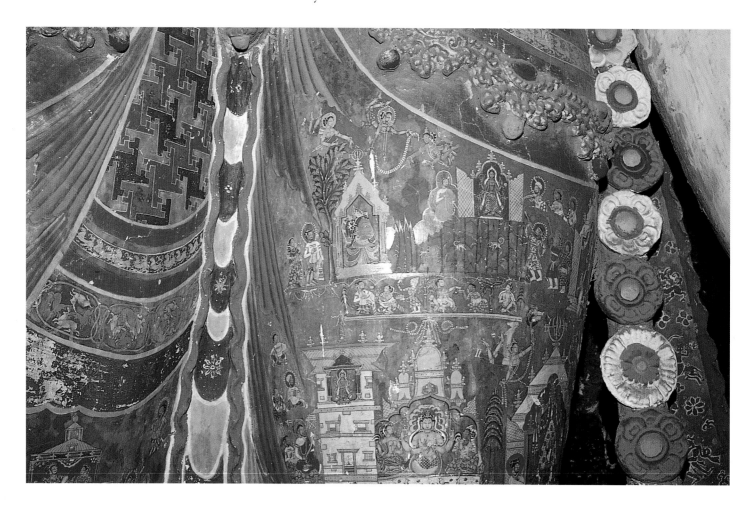

These rebirths are functions of what is called *karma*, a sort of sum total of one's good or bad actions in previous lives. One's *karma* can be improved through good deeds, yet it is a burden that may take centuries of rebirths to eliminate. Thus, the only escape from the Wheel of Rebirth is through the accumulation of merit during the course of successive lives (reincarnations). The acquiring of enough positive *karma* to achieve *nirvana* – the absolute transcendence of all forms of cyclic existence – is the ultimate goal of every follower of Tibetan Buddhism. Some revered Buddhists, such as the Tibetan hermit sage Milarepa, are distinguished in part by their having achieved this status in just one lifetime.

Buddhism centres on the so-called Three Precious Jewels: the Buddha, the Dharma (the Buddha's teachings) and the Sangha (the monastic community). The older Theravada branch (often referred to dismissively as the Hinayana, or 'Lesser Vehicle') had become somewhat stratified between monks *(trapa*s) and lay people, as well as having the philosophical drawback of a selfless doctrine being used for self-benefit. These issues were addressed by the Mahayana branch, for it taught that certain holy men, on having attained *nirvana*, remained in the world in order to teach and guide humans towards achieving liberation. Their doing so is proof of their selflessness. These saintly *guru*s (teachers) are called *bodhisattva*s and constitute what we might call living *buddha*s. Tibetan Buddhism accords a prominent status to *bodhisattva*s, for their actions are considered essential in guiding mortals towards liberation; they are the supreme, enlightened teachers, all important in communicating to their pupils the practice of Dharma, of 'the faith'. (There is an important distinction to be made between *nirvana* and *parinirvana*, with the former being the achievement of enlightenment or *buddha*hood and the latter being the final *nirvana* attained at the death of a *buddha*.)

### Bodhisattvas and schools

In Tibet there are hundreds of *bodhisattva*s and the Dalai Lama is but one of them. These emanations are considered either to embody one particular attribute of *buddha*hood or to be reincarnations of holy personages. Some, such as the Dalai Lama, are both. The Dalai Lama is specifically considered to embody the aspect of *buddha*hood representing compassion, an attribute given the name of Avalokiteshvara; yet at the same time he is also the reincarnation of his immediate predecessor as Dalai Lama. It is no coincidence that King Songtsen Gampo was also considered to be a reincarnation of Avalokiteshvara. Each different aspect of *buddha*hood is given a name and specific physical attributes, and it is this rich variety that provides Tibetan Buddhism with its immense and complex pantheon. It is these divinities whose faces, serene or tortured, decorate the walls of Tibet's chapels and assembly halls.

In the temples, ordinary humans who, on having attained *buddha*hood, have chosen to remain in the world as a *bodhisattva* are represented as portraits of the person in question, draped in the robes of a monk or mantrin. The most famous *bodhisattva* in Tibet is Guru Rinpoche (Precious Teacher), also known as Orgyan Rinpoche (for he hailed from Orgyan, the old name for the valley of Swat, now in Pakistan). This saintly, eighth-century master is considered to be the patron of Tibetan Buddhism and he is revered in Tibet. In his lifetime, Guru Rinpoche travelled extensively all over Tibet preaching the doctrine and combating and converting the evil spirits and negative forces that were said to haunt Tibet at the time (probably a reference to the prevalence of Bon). There is hardly a valley without its special shrine or cave or mountain where Guru Rinpoche slept or preached or, more often, bound some demonic force under an oath of allegiance to Buddhism. Swat was famous for its magicians and Guru Rinpoche himself was adept in the ritual practices of the *tantra*s that lent a special, esoteric flavour to Tibetan Buddhism. In the eleventh century, the Indian monk Atisha initiated a movement of reformation that sought to emphasize monastic

*A detail of the delicate imaginative paintings that adorn the chapels and buddhas of the modest twelfth-century monastery of Alchi in Ladakh, which is considered by most to house the grandest masterpieces of Tibetan religious art – many of them rendered in a recognizable Kashmiri-influenced style.*

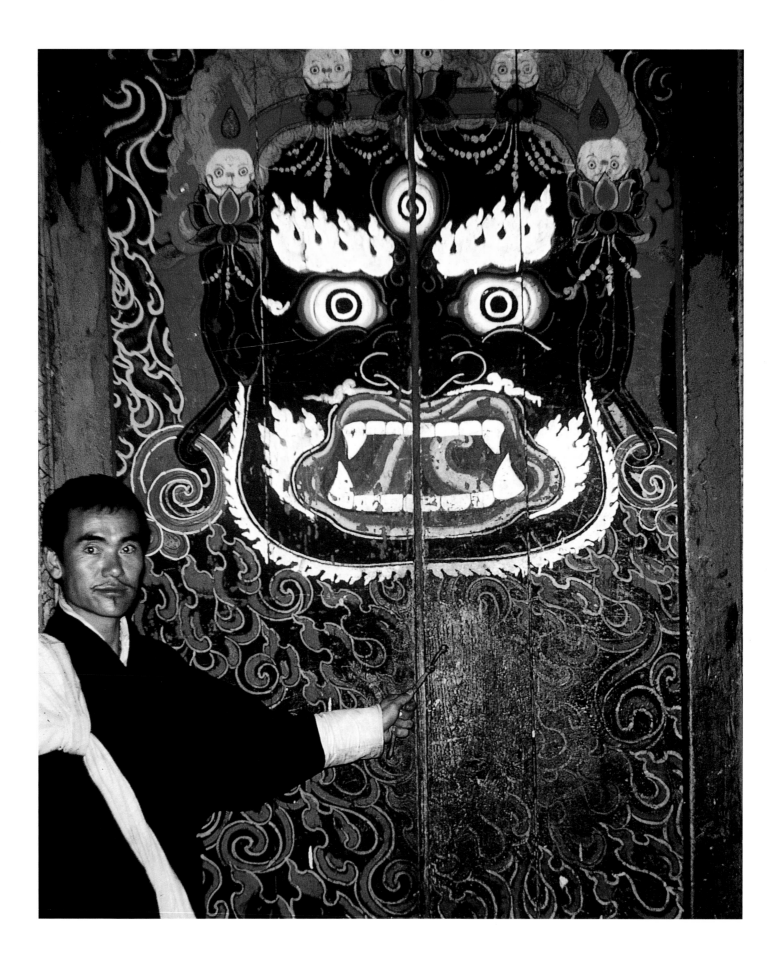

discipline and ethics rather than these magic practices. It was for this reason that Atisha founded the Kadampa order, which led in the fourteenth century to the founding of the Gelugpa order, that of both the Dalai Lama and the Panchen Lama.

Among the other orders, the most ancient is the Nyingmapa (literally 'the old ones'), while the 'new' schools – introduced from India from the eleventh century onwards – included the Sakyapa, whose leaders converted the Mongol leaders, notably Ghengiz and later Kubilai Khan, and through them extended the influence of Tibetan Buddhism to Mongolia and much of China. Towards the end of the eleventh century Marpa introduced the Kagyu order, which a century later had split into four major branches and eight minor ones. These included the Karma Kagyu and the Drukpa Kagyu, both of which remain highly influential down to the present day. Each order possesses its own specific books and stresses particular practices, yet all concur on the ultimate goal: the search for perfection and the attainment of *buddha*hood, achieved through meditation, yogic practices and refinement of philosophical views. To achieve these states, some practitioners spend much of their time in meditation, while others engage in yoga; some study the scriptures or the commentaries on the doctrine, while others go into lengthy retreat (for three years, three months and three days). The schools divide principally over their historical transmission and philosophical matters, each one favouring a slightly different answer as to the true nature of relative and ultimate truth. Needless to say, the Tibetan Buddhist orders and their innumerable practices have led to a vast collection of beliefs, hence Professor Rolf Stein's statement that Buddhism in Tibet escapes simple description.

All the schools of Tibetan Buddhism espouse the two aspects of the Mahayana: the way of the *sutra*s, which expound a graduated path to enlightenment; and the way of the *tantra*s (known as the vehicle of indestructible reality or Vajrayana), which advocates a continuous evolution from ignorance to enlightenment. Nonetheless, the various orders do have their distinctive teachings: Dzogcha (Great Perfection), as followed by the Nyingmapa; Mahamudra (Great Seal) as followed by the Kagyupa; Lamdre (Path and Fruit), as espoused by the Sakyapa; and Lamrim (Graduated Path), as expounded by the Kadampa.

Philosophical distinctions are also found as far as the dichotomy between relative and absolute truth is concerned. In general, relative truth refers to the veracity of phenomenal existence in which mind interacts with external phenomena; ultimate truth refers to the emptiness or interdependent nature of all phenomena. Some schools place less emphasis on the scope of relative truth, in which the processes of cause and effect apply, and more emphasis on the nature of emptiness and the subtleties of its realization, achieved through meditation and higher insight.

## A simple faith

Outside of these circles, lay persons are largely content to practise a simple faith. They do so through the repetition of holy formulas or *mantra*s, such as the famous 'Om Mani Padme Hum', each syllable of which is visualized as purifying the sufferings of living beings born in one of the six aforementioned realms of cyclic existence. This and other formulas are repeated many thousands of times. They are also carved into rocks and stones or printed on to prayer flags.

Everywhere in Tibet, one encounters prayer flags and prayer wheels (rotating cylinders stuffed with printed prayers). Another familiar sight are *chorten*s, which symbolize the faith. The word *chorten* literally means 'receptacle of offerings' and their shape recalls the mound tombs of ancient India (where they are known as *stupa*s), the original of which was said to have contained the ashes and relics of the Buddha himself. Prayer flags fly all over Tibet: at mountain passes, at the entrances to villages and at the four corners of buildings (where demons are believed to lurk) – these are the ever-present testimonials of a faith that still pervades the daily life of most Tibetans.

# Protector shrines

*Tantric* **Buddhism relies heavily on magical practices,** through which it is believed possible to achieve enlightenment in one's lifetime. The techniques used include magical spells and the invocation of fierce divinities and *yogin*s along with their mysterious female partners, the *dakinis*. The demonic *yogin*s and *dakinis* were introduced to Tibet from the valley of Swat by Guru Rinpoche. According to the scholar David Snellgrove, 'their presence was essential to the performance of the psycho-sexual rites'. In India, the activities of these people had earned them the name of witches, being 'gruesome and obscene'. In Tibet, they seem to have become less offensive – even, in fact, charming symbols of wisdom considered to be the 'bearers of divine offerings'. Nevertheless the *tantric* chapels of Tibet still represent the *yogin*s and their female partners as fierce demons and witches, each having a specific colour and gory attributes that add a sinister flavour to all Tibetan monasteries. This complex pantheon of spirits makes for fantastic artistic displays, an iconography that never fails to impress foreigners and Tibetan layfolk, both of whom see little beyond the outward ferocious appearance of an ostensibly horrific skull-garlanded effigy.

Adjacent to the assembly hall in most monasteries are found 'protector chapels' (*gon khang*s), within which can be found representations of these fierce protector divinities. In this setting, liturgies are practised and offerings are made. Stored on the walls are sacred masks, old armour, bows and arrows, coats of mail, shields and other tools of war, some of which may actually have been used by warrior-monks called *dobdob*s.

1. A soaring *yogin*, a figure that represents the victory of Buddhist doctrine over evil, prances beneath the various symbols of mortal victims: flaying skins, lungs, heart and an eye.

1

2. A fierce, red-faced divinity cloaked in the flamboyant robes of a dead potentate guards a 'death' chapel in Bhutan. Above him there hangs the skin of a victim to symbolize the wrath of the gods.

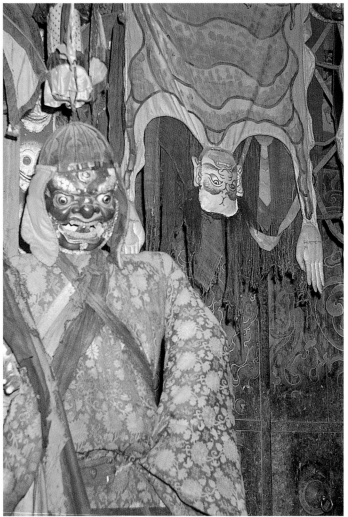

2

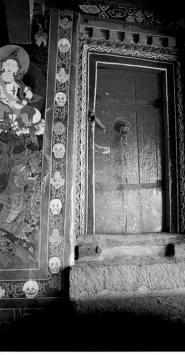

3

3. This doorway leading into a side chapel of Nechung monastery, is garlanded in skulls. Nechung, southeast of Drepung, is the seat of the state oracle and the abode of the protector deity Pehar, who is said to possess the oracle. The monastery is home to awesome frescoes depicting the fierce divinities of *tantric* Buddhism.

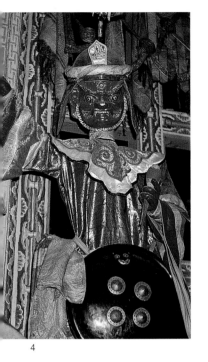

4, 5. Fierce divinities, shields and swords, all seized in battle are stored in the protector shrine of the Bhutanese fort of Trongsar.

6. A bear killed by villagers in the Zanskar valley and hung in the Karsha monastery. It is common practice to offer dead animals to local monasteries, probably to atone for the taking of life.

7. *Dakinis* are women with supernatural powers, and these goddesses can be fierce. This ancient example frames an effigy of a *buddha* in a chapel in Ladakh. One of the powers of a *dakini* is an ability to fly through the air.

4

5

6

7

# Mantras as prayers

**Mantras are holy spells** to which have been attached sacred powers. Some are secrets whispered into the ear of a pupil by his master, others – such as the ubiquitous *Om* – are in near-constant use because of their perceived magical power. *Om* was described in the Indian texts the Upanishads as the 'seed sound' of all other sounds, and in this way the Sanskrit syllable has acquired a variety of sacred meanings. The ancient Sanskrit meaning of many *mantras* has been lost, yet they remain in use just for the magic that is attached to the sound.

The most famous of all Tibetan *mantras* is 'Om Mani Padme Hum', which is the *mantra* of Avalokiteshvara, the *buddha* of compassion. The first great Tibetan king was considered to be a manifestation of Avalokiteshvara, as was the fifth Dalai Lama eight centuries later. This *mantra* is the one that Tibetans repeat incessantly. Old people often become 'mani-pa' – people devoted to doing nothing else but the repetition of 'Om Mani Padme Hum'. A practitioner of the *mantras* is a mantrin, and this devotional act accrues merit and can improve one's prospects of rebirth by reducing or eliminating bad *karma*. The incantations can be recited verbally or printed on paper or cloth and 'repeated' by being twirled inside a prayer wheel, which can be hand driven, water driven or wind driven and can contain thousands of prayers.

Fluttering prayer flags also transmit sacred spells and gain merit for those who set them up. Similarly, stones carved with *mantras* (*mani* stones) gain merit for those who inscribe them and for those who walk or circumambulate around them clockwise, or pass them on their right. Rosaries with 108 beads or stones thrown upon a pile are used to keep a count of either muttered prayers (*mantras* that are quietly whispered or silently repeated in the mind are considered to be more powerful) or circuits of a shrine.

1 A woman from Mustang spins a prayer wheel while keeping count of the number of times she has recited the *mantra* of Avalokiteshvara.

2

2. Two *sherpas* carving the *mantras* 'A Sha Sa Ma Ha' and 'Om Mani Padme Hum' on a huge boulder in the Solu Khumbu district of Nepal.

3

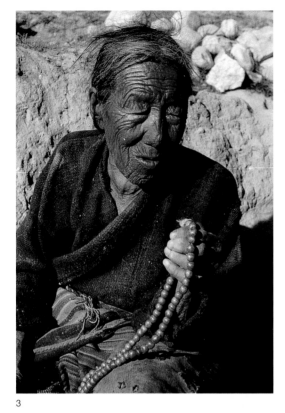

3

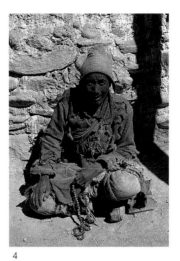

4

3, 4, 5. Both beggars and young monks recite the *mantra* 'Om Mani Padme Hum', whose meaning is generally accepted as 'Hail thou jewel of the Lotus flower' – referring to Avalokiteshvara, the embodiment of compassion.

6. Prayer wheels for sale in Lhasa.

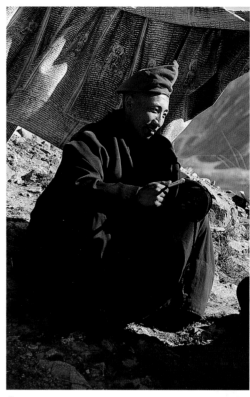

5

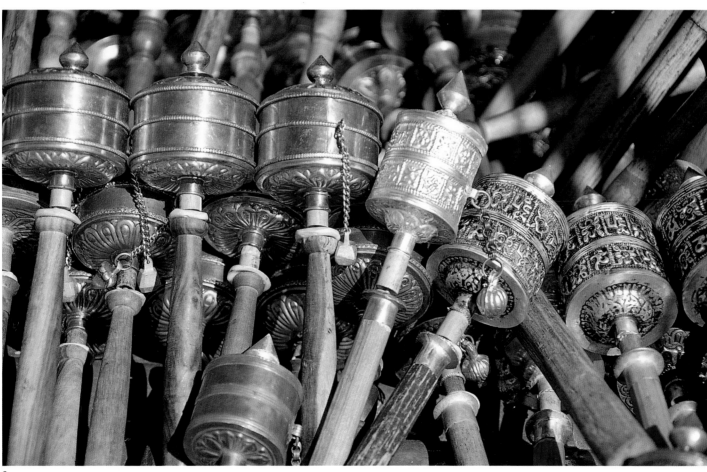

6

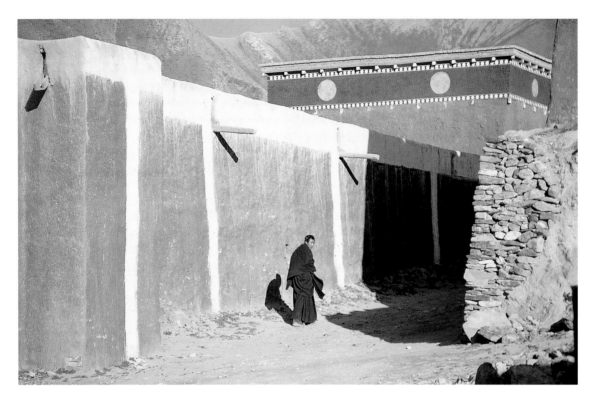

The flags are ornamented with auspicious prayers and they distribute these blessings across the landscape as they flutter in the breeze. The different colours of the flags reflect the elements and one of the basic philosophical ideas of Buddhism, that all material phenomena are composed of fire, water, earth, wood and metal. Reciting a prayer, spinning a prayer wheel, building a *chorten* or erecting a prayer flag are all good acts performed to gain religious merit.

Whatever the theological and philosophical arguments of Buddhism, through its benevolent influence, the Tibetans have become a pious, kind and tolerant people. Alas, the kindness of the Tibetans and their aversion to violence has proved to be a handicap in terms of defending national sovereignty. It is almost a miracle that Tibet was able to survive so long without a proper army. That it was able to maintain its independence was mostly due to the alliances established by various religious leaders (Sakyapa, Kagyupa and Gelugpa) with the all-powerful Mongol chiefs or assorted Chinese emperors. Such alliances were sometimes, arguably, at the expense of the Tibetan aristocracy or the people themselves.

### Monasteries and personal development

As has been outlined, Tibet's traditional social system had the effect of enabling the monasteries to flourish through the influx of landless second sons of farmers and the younger sons of nomads. The monks dedicate themselves to a life of religion at an early age – often when they are just eight or nine years old. Typically, the parents present the child to the abbot who heads the local monastery of the order to which their family adheres. The child's uncle may already be a monk at that same monastery and it is often he who the abbot will appoint to be the child's tutor.

The parents of the child are responsible for his upkeep – thus it is a family's burden to support a monk, not society's – and generally a field or two are set aside to provide for him. Very often a family owns a whole house or, at worst, a cell within the monastery, a property that is passed on from uncle to nephew. The landless monk will have to work for the other monks or for the monastery's steward's office to earn a little money. This work might be physical, such as carrying

water from a distant stream, or intellectual, perhaps the copying of manuscripts; it might be carving woodblocks for the printing of books or carrying out far-flung business journeys on behalf of the monastery. Monasticism, with its attendant celibacy, stalled population growth, which would have stretched the very limited resources of the arable land available in Tibet.

Upon entering the monastery the young apprentice has his head shaven and although he wears a monk's gown, sleeveless waistcoat and shawl, he is yet to be fully admitted, for he must spend a year studying how to read and write, learning the basic Buddhist prayers by rote and the ritual positions of the hands that are used in accompaniment of the prayers. The same hand positions can be seen in the paintings or sculptures of the various aspects of the Buddha or the *bodhisattvas*.

Ordination is a three-stage process: *genyen*, with five vows; *getsul*, with thirty-seven vows; and, finally, *gelong*, with 256 vows. After a year. the young monk becomes an official student and from this point on he can have a dual career – a scholarly one, rising in the academic hierarchy and sitting for various exams that may lead to the title of *geshe* (the exalted degree of doctor in theology), and an administrative one, rising in the hierarchy of the monastery itself to become a head steward (*nyer-chen*) and perhaps the elected abbot or monastic preceptor. Academic and administrative hierarchies are separate, although generally an abbot will have the appropriate academic degrees.

The student is not required to live in the monastery except during *yarne*, the one-month summer rainy retreat in which the assembled monks read the entire *Kangyur*, all 108 volumes of the holy scriptures. Otherwise monks are quite at liberty and many undertake long journeys, which may involve business but are also made to serve as pilgrimages by incorporating various holy sites en route. Many monks, of course, spend a lot of time helping with the harvest or tending the family cattle. Monks are also frequently asked to perform religious ceremonies, blessings for a long life, prayers to exorcize evil spirits or funeral rites. In many ways, the life of a monk is an enviable one, free from many normal family obligations and chores but also of worries and work, while they pursue the gaining of merit.

For those who wish to study the most sophisticated aspects of the doctrine, there is a near-endless succession of texts and exercises. Teachers are an all-important feature in the practice of Tibetan

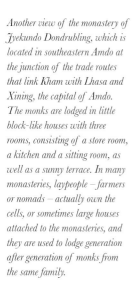

*Another view of the monastery of Jyekundo Dondrubling, which is located in southeastern Amdo at the junction of the trade routes that link Kham with Lhasa and Xining, the capital of Amdo. The monks are lodged in little block-like houses with three rooms, consisting of a store room, a kitchen and a sitting room, as well as a sunny terrace. In many monasteries, laypeople – farmers or nomads – actually own the cells, or sometimes large houses attached to the monasteries, and they are used to lodge generation after generation of monks from the same family.*

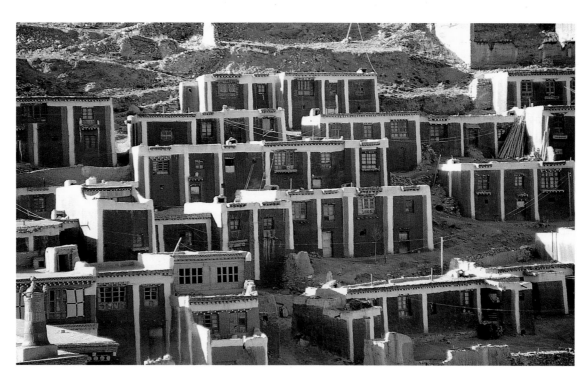

Buddhism, with each monk under the supervision of a personal tutor who guides him towards achieving the particular spiritual path he has chosen. Through meditation and yoga, the practitioner believes he can rid himself of all unharmonious mental states and experientially cultivate the diverse attributes of *buddha*-nature.

Monks, just like laymen, can be simple people with little knowledge of or concern with the more esoteric teachings being followed by their more erudite or studious brethren. Such a monk will content himself with accumulating merit in the hope one day of achieving *nirvana*, but he will also have grasped the simple rules governing good and evil and the need to warn off evil spirits or malign psychological forces through the use of rituals, demon traps or scapegoats – all themes that frequently underlie many of the festivals and religious ceremonies held in the courtyards of the monasteries.

The average Tibetan frequently amazes outsiders by the intensity of his faith, the way in which he practises those cardinal virtues of his religion and the insistence on respect for and admiration of learning. Tibetans admire intelligence for intelligence's sake; for them it is a supreme virtue, praised in both traditional tales and holy writings. Parents do not, for example, praise 'the obedient child or the reliable child or the hard worker', as in European culture, but instead laud the 'quick, intelligent child'. Two popular sayings are 'With intelligence the world is yours' and 'A good mind is like having 1,000 eyes'. Intelligence is what monks seek out first in the children they believe might be the reincarnation of their dead *lama*. This admiration for a lively mind explains much of the charm of Tibetans, so many of whom are bright because they have been encouraged to develop their wits. There is little to thwart the gift of intelligence, because in Tibet the ancient cultural traditions that favoured the young were there to encourage bright young men and women to develop their capabilities. At the monastery, the bright child is not limited to the study of philosophy and theology, but can study medicine, divination or animal husbandry. The greatest engineer and bridge-builder in Tibet was a Buddhist master, Thangtong Gyelpo (1385–1464), who built steel chain-link bridges all over the country in the fifteenth century.

## Ritual life

Tibetan Buddhism is filled with rites and rituals. If these are secondary to the philosophical beliefs, they nevertheless play an important role in the lives of most ordinary people. These rites are frequently directed at keeping in check the negative demonic forces that, whether environmental or psychological, operate in our relative, mundane world (aspects of belief that were carried over from Tibet's earlier religions and incorporated into Tibetan Buddhism), a world not considered ultimately to be real. Although the demons are also regarded as not ultimately real, being essentially 'empty' and having no inherent existence in themselves, within the terms of relative existence, the rituals of subjugation are taken seriously and must be properly performed. Thus the malevolent beings must be placated by prayers and offerings, either actual physical gifts or spiritually imagined solutions derived through meditation or verbal *mantra*s, which invoke sacred magic formulas that can bring to life good spirits to chase away evil ones. In addition, through this manner of viewing the world, illnesses – mental and physical – also become attributable to malign spiritual influences, although an important place exists for other types of medical treatment.

Altars, whether in a chapel or a household shrine, are presented with outer, inner and secret offerings. Outer offerings, symbolized by the seven water-offering bowls and the butter lamp, represent water for consecration and water for washing, flowers, incense, light, perfume, food and sound. Inner offerings are those of blood and nectar, substances symbolically represented by the two skull caps placed on the altar. Secret offerings are represented by the *torma* offering cake of barley dough, which is placed between the skull cups, considered emblematic of *buddha*-mind.

*This young monk from Zanskar is called Sonam and was photographed in 1980. He is holding a* kata, *or scarf of greeting, and is standing in anticipation next to the route along which the Dalai Lama is expected to pass on his visit to the region that year. Sent to the monastery at the age of eight by his parents, Sonam was not a particularly gifted student of Buddhist theology, and as a result he could only look forward to a life of routine chores at the service of the more erudite monks. A few years later, Sonam left his monastery to join the Indian Army and serve as a guard along the frontier with China.*

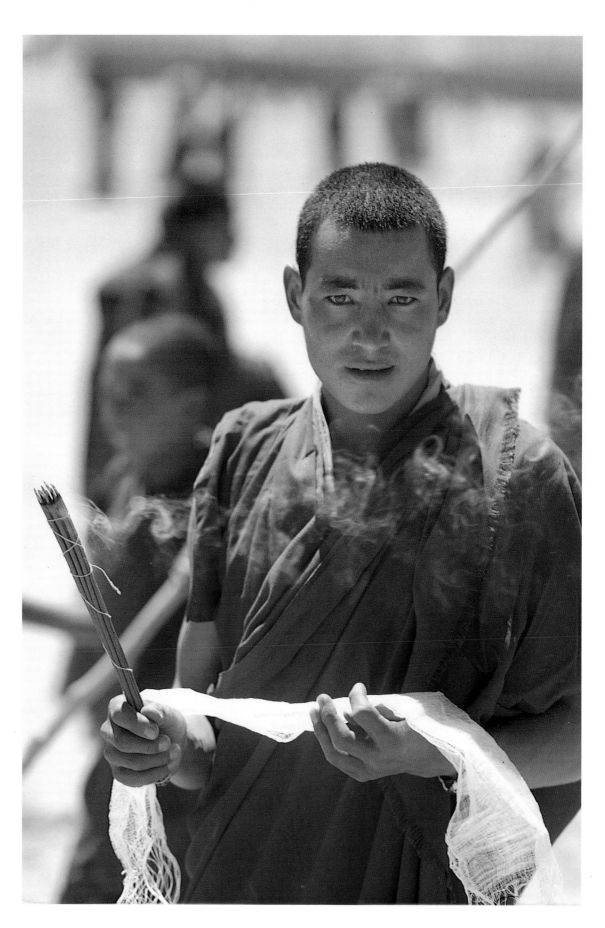

These offerings set out at the foot of an altar in a monastery in Bhutan represent fine examples of the art of sculpting butter. Dyed using various natural colourants, butter is carved to represent religious subjects – here, it is a chorten. Gold leaf has been used, while the red bases have been fashioned from tsampa, or roasted barley flour. At the large monastery of Kumbum Jampaling, large butter sculptures are traditionally displayed during a winter festival. Afterwards, examples are retained to display to pilgrims and visitors alike.

Most houses and tents have a bench-like altar or a corner set aside for a statue or two. Above the images may be hung a painted banner or *thangka*. The water in the seven bowls is replaced each morning to the accompaniment of prayers. Similarly, grains of barley or rice are offered in a bowl, from which they are scattered towards the altar while sacred *mantra*s are recited. Brass and silver lamps shaped like tulip cups and fuelled by small knobs of butter are carried as an act of merit by pilgrims on their holy rounds.

Purification of an altar is achieved through the burning of incense, or more commonly the burning of juniper leaves or twigs whose fresh resinous odour is believed to honour the divinities. Juniper trees were the traditional abode of the pre-Buddhist Tibetan goddess of fertility. These trees once abounded in Tibet but the forests have been receding with the desertification of parts of the plateau. Juniper twigs are considered symbolic of life and to snap one is the equivalent of death in certain rituals.

Divination, the art of consulting the future by supernatural means, is much practised at all levels of Tibetan society. Its varied methods include a complicated ritual involving the *torma* offerings, the daily examination of water droplets laid out upon bronze or steel mirrors, or the examination of shoulder-blade bones from sheep. More systematic are the methods of Indian astrology and Chinese elemental divination, which are integrated in the annual almanacs produced by institutes in Lhasa, Dharamsala and elsewhere. The outcomes of such ceremonies dictate daily life: natal horoscope, marriage, obstacle years, ill-health and death. There are auspicious days and unfavourable days and it is the task of the diviner to steer his client through this complex minefield.

The Tibetan belief in the power and importance of divination means that people commonly seek the advice of diviners and oracles. The latter are those who enter into a trance when 'possessed' by the spirit of a specific demon or god, and as such they are the modern face of ancient shamanic practice. There was once an oracle attached to many large monasteries in Tibet – the most important one in the country was the state oracle who lived at the Nechung monastery near Lhasa and was consulted by the Dalai Lamas themselves. It was this oracle who told the Dalai Lama not to flee to India in 1950; later, the state oracle followed the Dalai Lama into exile, but many oracles remain and are consulted frequently. The utterances of oracles are often incomprehensible and so have to be interpreted by gifted monks. While some might find this world of magic, spirits and wonder to be one of superstitious dread, which might perhaps fool the naive, it should be noted that the constant presence of jesters, who fool around the altars and the priests during the course of the most serious ceremonies and make the crowds laugh through their acting, seems to offer a constant reminder to any onlooker that such demons and divinities are merely relative appearances and are not to be taken all that seriously.

## Sacred imagery and structures

Tibetans have an extraordinary ability to turn the most commonplace of items into objects of religious devotion. At various festivals across the Tibetan world I have seen sculpted offerings made out of butter, one of the key commodities of Tibetan commerce, and dyed the appropriate colours. In Nangchen I even saw a great wall of dried yak dung that had been moulded on the outside with deep-relief religious designs, thus transforming this otherwise rather unholy fuel into a symbol of prayer. Artistic representations of sacred images offer a particularly potent means of interacting with the divine, for it is believed that they constitute not just representations of particular meditational deities, but they also confer liberation through their sight. At certain festivals, gigantic painted banners, nearly 100 feet (33 m) in length, are unfurled from monastery rooftops, steep mountain faces or, as in one of the most famous events held at Shigatse, from huge, purpose-built screen-like stone walls.

Perhaps the greatest visual representation of all is that of the *mandala*, a geometrical design that serves as an aid to meditation and symbolically represents the array of a specific meditational deity as it is perceived by Buddhists. A *mandala* consists of one or more protective circles surrounding a central square palace filled with depictions of its appropriate meditational deities. Its walls, gates, thrones and symbolic features represent the divine attributes of the Buddha. A *mandala* is a very powerful tool because the divinities actually enter it. A *mandala* can be constructed in a permanent and three-dimensional form within a building, or it may be temporary, created as an intricately patterned artwork by pouring coloured sands from copper funnels in order to depict the appropriate array. When this artistic, yet scholarly, work is undertaken, it is accompanied by the appropriate prayers, for the slightest mistake can incur the wrath of the divinities and therefore bring about terrible calamities. After a few days, the two-dimensional representation is literally swept away: the coloured sands are all mixed together to signify the ephemeral quality of all phenomena – a key philosophical point in Buddhist belief.

A number of *chorten*s have been built on a grand scale as three-dimensional *mandalas*, notably Gyantse's Kumbum. There has never been an official count of the number of monasteries and monuments constructed in Tibet, but the figure must run to many thousands. In addition, there are traditional Tibetan monasteries in India, all over Mongolia and China, and even in Russia from the Altai to St Petersburg. The most famous religious building of all is the Jokhang Temple in Lhasa, founded in the mid-seventh century, but there are also tens of hundreds of magnificent monasteries across Ladakh, Zanskar, Bhutan, Mustang, Amdo and Kham, not to mention all those inside Ü and Tsang. The huge structure that stands at Sakya is a fitting reminder that this was once the spiritual centre of the vast Mongol empire.

It would be impossible to recite a list here, but there are a few that cannot escape mention. The monastery of the Panchen Lama at Tashilhunpo is a long alignment of magnificent assembly

*Tied between wooden boards that serve as covers, these silk-bound volumes of the Tibetan canon are housed in typical fashion in a pigeonhole bookcase that lines the walls of a chapel. Most Tibetan books have no spine and are held together by a thread through the centre of the page, much as the original, ancient palm-leaf documents were. The covers are usually decorated with paintings and carved figures. Tibetan paper is made from the bark of a bush found only in the mountainous districts along the distant borders with India and China.*

halls, libraries and shrines. That at Labrang on the northwestern frontier with China is vast and not too far from the huge monastery of Kumbum Jampaling in Amdo. Closer to Lhasa is Samye, the oldest in Tibet, dating back to 775–779, with its encircling walls and its interior buildings laid out to reflect Indian Buddhist cosmology, including a central, multi-storeyed temple representing Mount Meru and four surrounding temples to represent the four continents.

Then, in addition, there are the spectacular cave monasteries whose assembly halls and cells are carved out of cliffs and rock-faces. Whether in distant Baltistan to the west or Gansu to the east, all are rendered in that characteristically elegant Tibetan style, with slanting walls, black roof friezes and windows whose surface and size increase as the level rises up from the ground floor stables to the rooftop latticed window apartments of the abbots. The assembly halls are generally painted ochre red, with the exception of the Sakyapa monasteries (painted with vertical stripes in blue, red and white ochre) and Taklung Kagyu (tawny red and white vertical stripes). I feel that the greatest of all Tibetan art is found in its architecture, which is sober, elegant, spectacular and unique – needless to say, the creation of religious works of art is an act of particularly great merit.

## Monasteries

In English, the word monastery is used liberally to describe everything from a hermit's small cave, inhabited perhaps by a solitary monk, to the great monastic cities such as Sera, Ganden, Drepung and Labrang, each of which had between 5,000 and 8,000 monks. The Tibetan term for monastery is *gonpa*, which literally means 'wilderness' or 'isolated place', and refers to the fact that monasteries were ideally constructed in such places where they would be remote from social diversions. The terms *ritro* and *lha-khang* refer to hermitage and temple respectively, and there is never any confusion with a *gonpa*.

In theory, it takes only a teacher and his pupil to form a monastery, but in practice monasteries were proportionate to the size of the community from which they recruited their pupils. In Zanskar, for example, there is approximately one monastery for every village of more than twenty households. In nomadic areas, monasteries can be very large, such as the monastery of Lung shi in Nangchen, with some 1,500 monks – one of modern Tibet's largest monastic communities.

Monastic buildings consist of the monks' personal residences – often the private property of the monks and their families – and then the communal buildings that form the actual monastery, some of which might be colleges that belong to a particular province and may exist independently of the rest of the monastery. The colleges can thus form 'monasteries' within a monastery, and the heads of colleges can be just as important as the head of the monastery itself.

Foremost among the buildings that actually form the monastery proper is the assembly hall, of which there may be several. This large, pillared room has a central skylight and facing the entrance door is an elaborate, long altar dominated by gigantic statues placed before and beneath the niches that contain either the 108-volume *Kangyur* or the 204-volume *Tengyur* (the two-part Tibetan Buddhist canon). In this hall, the monks congregate to pray, facing each other several times a day on special feast days while seated on cushions. In the course of their prayers and ceremonies they are served tea by scullion monks, tea that they mix with butter and parched barley flour (*tsampa*), the Tibetan staple. This food and drink is given to the monks by the monastery, paid for from the monastery's land revenue, from money collected by monks for a special celebration or from money donated by a layman. Such handouts are not commonplace occurrences (except in rich, well-endowed institutions), for normally the monks have to feed themselves in their own quarters.

Adjacent to the assembly hall in most monasteries can be found 'protector chapels' (*gon khang*s) containing representations of the fierce protector divinities in the Tibetan pantheon. In this setting, liturgies are practised and offerings are made. On the walls, sacred masks, old armour, bows and

arrows, coats of mail, shields and other tools of war are stored, some of which on occasion may actually have been used by warrior-monks called *dobdobs*.

Most monasteries have a *nyer khang*, a building that serves as the steward's store house and offices, containing ledgers. Here the steward looks after the reserve of grain, dried meat and butter, and keeps track of the monastery's landholdings or far-flung business operations. Then there is at least one large smoke-blackened communal kitchen with huge brass pots set on baked clay hearths fuelled with burning yak dung bricks or, in some places, by faggots of willow twigs. These kitchens are used only on feast days, because on other days the monks cook in their own premises. A monastery may also have stables for the horses of its abbots and stewards, and almost certainly there will be a holy shrine – perhaps a rock-carved statue, a holy spring, a cave or sacred rock that is the object of special veneration by the monks and lay pilgrims.

The monks go out and collect funds from the villagers. This might be used to pay for the butter to be used as food and fuel (in lamps) for special festivals. Distant trading missions are also undertaken to secure all those products the monastery needs but that are otherwise difficult to obtain locally: dyes and paints for the artists to adorn or restore chapels, cotton cloth for prayer flags and paper for the printing of books.

## Masters and pupils

Most of the more profound spiritual life of a monastery takes place in private between a pupil and his master, and it comes into public view only in the spectacular annual or biannual open-air public examinations. These are usually held in a tree-shaded courtyard before an assembly of all the monks. The examinees take their turns to sit cross-legged on a raised platform ('the chair') in front of the gathering, where they are then cross-examined by various erudite monks. The examiners rush up to the student and throw the questions at him, literally accompanying their query with a thrusting gesture as they bring both hands forwards to clap them in his face. To pass an exam a student has to be able to show that he can 'hold the chair' for a certain length of time. An unsatisfactory answer or no answer at all and the pupil is 'sent down'. Those who succeed in 'resisting' the examiners obtain their appropriate title of bachelor or doctor.

Outside of exam time and the annual prayer months, the monks are free to roam Tibet on various pilgrimages. These lengthy journeys, a favourite occupation of many monks, can take them to China and Nepal – or even India when they flock to the Tibetan monasteries at Bodhgaya, the centre of the Buddhist world and the so-called 'diamond seat' (*vajrasana*) where the Buddha was enlightened. En route to Bodhgaya monks will probably visit such other holy shrines as the site where the Buddha was born at Lumbini in Nepal or the deer park near Benares in which the Buddha preached.

Had the leaderships of the monasteries concerned themselves with just religious matters, then perhaps Tibet might have achieved a degree of balance between 'church and state'. From the Sakyapa hegemony onwards, however, the religious authorities were too quick to grasp the advantages to be gained by using the appeal of the faith to secure the powerful military backing of foreign princes. In so doing, monastic institutions unintentionally contributed to the loss of Tibet's political independence from the thirteenth century onwards. Ironically, this occurred at a time when many other Buddhist nations, such as China and Japan, were forging an identity around their cultural rather than religious heritage.

Thus, it is unfortunate that the ardour of the faithful and the ambitions of the religious establishment paved the way to the loss of independence of the Tibetan nation. Yet at the same time, this faith and the highly specific social and cultural values of the Tibetan-speaking people make it likely that this demise is only temporary.

*Ngodrub was a companion of mine on many a Tibetan journey. Born in Zanskar, the son of a poor landless couple who made a living by working as labourers, Ngodrub rose through the ranks of the local monastery, from water boy to steward's assistant. As such he undertook long journeys over the Himalayas to trade on behalf of his monastery. The purchases he made – of dyes or cotton cloth for making prayer flags – were paid for with sapphires. In fact, the stones were the finest of their kind in the world and came from the mine at Paldar in Kashmir, which the Karsha monastery had once owned. In 1899 the mine was seized by the maharaja, but the Buddhist miners still managed to find ways of compensating the monastery for its loss.*

# Chortens

1. The door *chorten* is encountered during the approach into Tsarang, the second largest town in Mustang. It is common to erect *chortens* at the entrance to a village to ward away demons.

2. Monks from Karsha monastery building a *chorten* in Zanskar at the request of a local farmer, who is paying for it.

**The *chorten* – meaning 'receptacle of offerings'** – is undoubtedly the most characteristic of all the forms of monument in Tibet. Some call it a 'support of the faith', and it is, literally, a support in the structural sense. Its origins lie in the Indian funeral monument known as a *stupa*, the most famous of which stands at the deer park in Sarnath and was erected by Emperor Ashoka to commemorate the site where the Buddha preached. Not all *chorten*s are tombs, although some do contain the ashes or corpses of holy men, and such is the case with the gold reliquary *chorten*s at the Potala Palace in which the Dalai Lamas are enshrined. A complex symbolism is associated with the *chorten*: its base represents earth, its bulb water and its steeple fire; some are then crowned with finials of the Sun and the Moon to represent air. Additional meaning is inherent in the structure: the tiered, triangular spire is said to be composed of thirteen parasols for the number of echelons towards enlightenment; the four steps below the bulb represent the stages of learning. In the rectangular base may be set four pairs of eyes – the all-seeing eyes of the Buddha of wisdom or compassion.

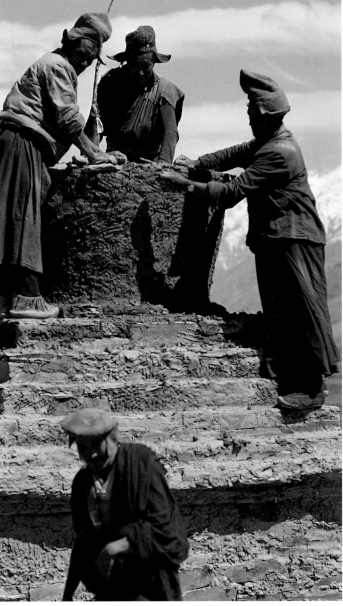

1

2

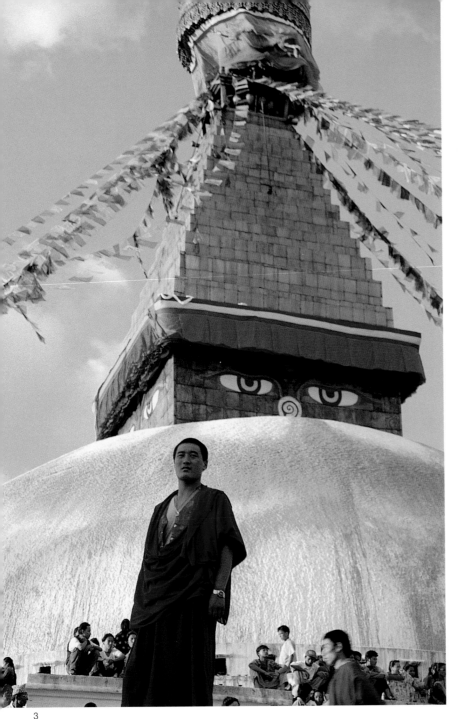

4

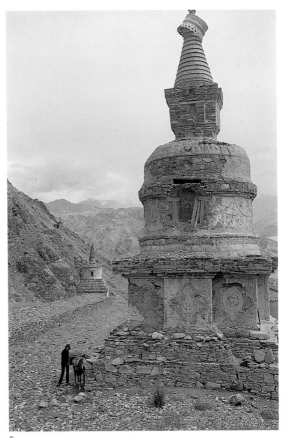

5

3

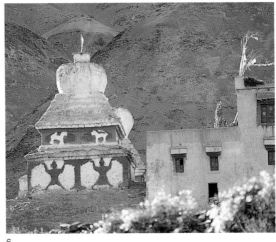

6

3. The massive *chorten* at Bodhnath, a few miles outside Kathmandu, is one of the major holy sites outside Tibet to be visited by Tibetans. To them it is known as Jarung Khashor. Pilgrims come from far and wide to visit Nepal's largest *chorten*, which is believed by Tibetans to contain the relics of the *buddha* Kashyapa. A poor widow called Jadzimo is said to have built it and her reward is believed to have been *buddha*hood and her sons' rebirth as Trisong Detsen and Padmasambhava. The Newar people have a different story, and for them the monument is an atonement for patricide by a king called Manadeva.

4. A series of eight *chorten*s upon the high plateau of Amdo announces a nomad camping ground. In Tibet, *chorten*s have eight recognizable forms, each of which represents a different principal deed of Gautama Buddha.

5. A fine *chorten* outside Hemis monastery in Ladakh, executed in the ancient Indian style.

6. This attractive, decorated *chorten* stands outside Alchi monastery, which overlooks the Indus River in Ladakh.

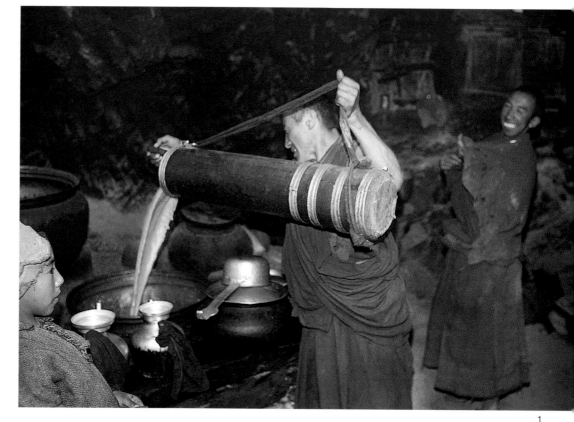

1, 2, 3, 4 and 5. Tibetan tea has featured as part of the average Tibetan's diet for more than a millennium. It is in fact a hearty soup made of yak butter, milk, salt and sometimes an egg, flavoured with a compressed brick of black tea from China. The ingredients are mixed together and heated in tall, cylindrical wooden churns. Although often drunk on its own, this rich bouillon is more usually mixed with roasted barley, which, when mildly buttered and salted, produces a delicious dough.

1

# Economics of monasticism

2

**As was the case in medieval Europe, the flourishing of monasteries** and monks in Tibet has as much to do with economics as with religion. The scarcity of arable land and the fact that it was impossible for herders to obtain additional grazing rights meant that second sons lacked the opportunities that would otherwise have enabled them to establish households of their own. Prior to the introduction of Buddhism, only war and fraternal polyandry provided forms of relief for this male overpopulation problem. With the advent of *tantric* Buddhism, monasticism provided a perfect solution to the perennial issue of how to channel the energies of second sons. In a fairly short space of time, nearly every agricultural community in Greater Tibet had established a local monastery – as can still be seen in Ladakh and Zanskar, where landless second sons are sent to live a celibate life.

The sexual abstension of the monks results, in effect, in a culturally or religiously inspired form of population control. Rather than becoming burdens on the larger society, the monks are supported and fed by their own families, with produce or income from fields set aside specifically for that purpose. This solution produces a system that is more viable economically and more acceptable socially. In comparison, for Tibetans to have divided family landholdings would have resulted in greater impoverishment and overpopulation.

Each monk with a family normally has his own food supplied by them, while those without relatives will carry out simple chores to earn their way – this might be intellectual work, such as writing, copying or printing books; or tasks such as painting sacred banners or trading on account of the monastery.

Only on special occasions will a monastery feed its monks. *Tsampa* and tea will normally be served during general assemblies, with the food concerned being either drawn from the monastery's fields or provided as gifts donated by laymen.

3

4

5

6, 7. Young monks, some of whom will have been in the monastery since early childhood (7), learn important ritual dances that can be performed during various festivals.

8. Many monasteries require that all the monks be present for one month of the year. This is to enable a collective reading of the entire *Kangyur*. The young monk seen on the first level here is carrying a large unbound text into the monastery. Outside of this one-month period, the monks are allowed to travel and they go on pilgrimages or range far and wide on trading missions.

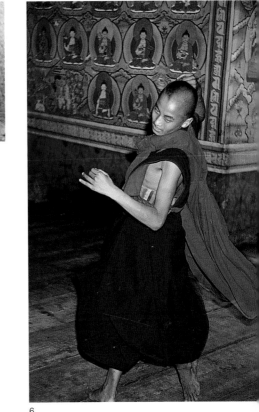

6

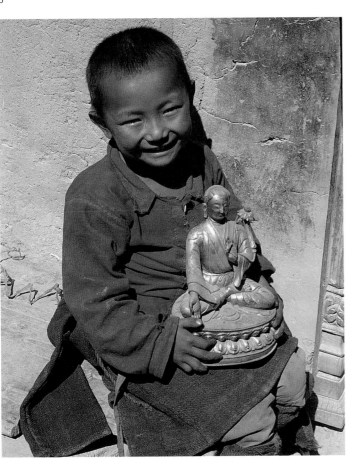

7

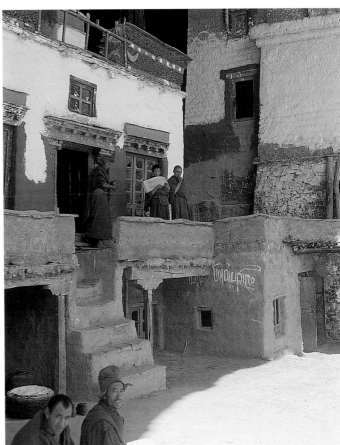

8

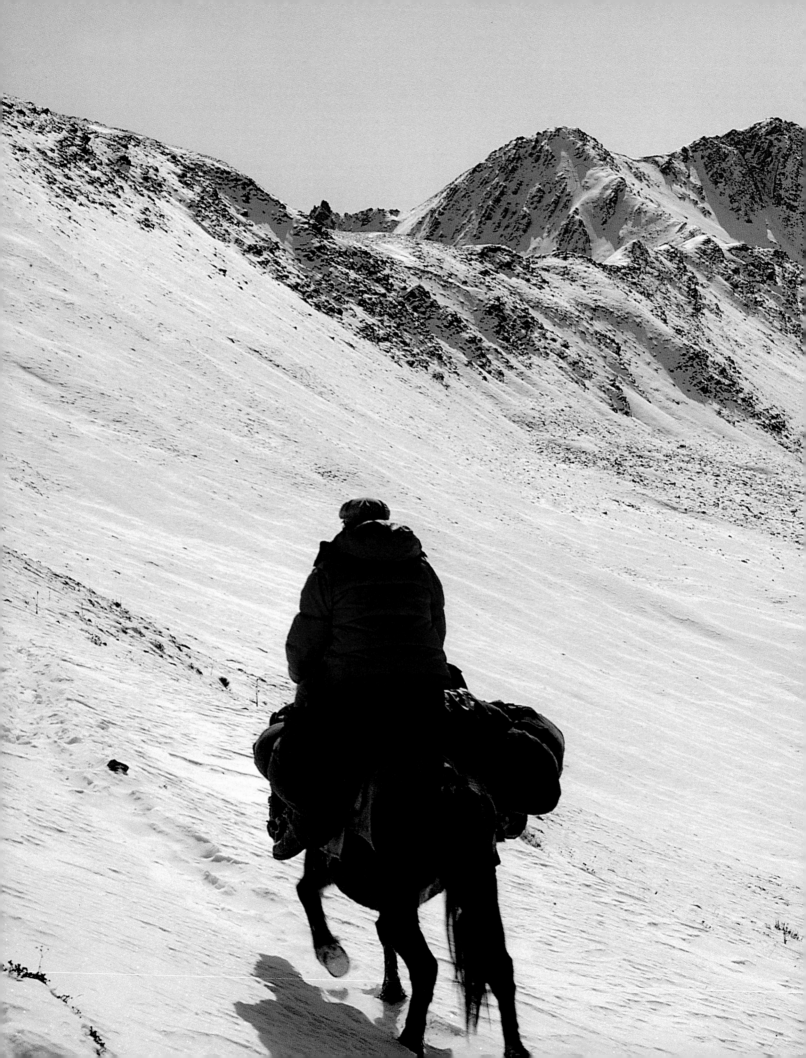

# 7 The Exploration of Tibet

ALTHOUGH DIFFICULT TO REACH because of the mountains, Tibet was far from being an isolated nation. Its location in the heart of Asia meant that its people were in constant contact with all the varied nations around them. Tibet's image as a mysterious, forbidden country is relatively new in origin and stems from its rulers' fear of colonization by the West.

The history of the exploration of Tibet is a long, drawn-out adventure. Whether coming from India, China or Russia, the journey to reach Tibet was difficult – a true adventure in itself and one that attracted a colourful breed of unusual characters. Herodotus was the first person in the West to mention the Himalayas, which two centuries later the armies of Alexander were to skirt on their way to the northern plains of India. Herodotus reported tales that north of Kasapatyros, later identified as the ancient capital of Kashmir, there were high mountains where there lived an Indo-European people later named by Pliny the Elder as the Dardicae, or Dards. Herodotus revealed that the area was famed for its wealth in gold, some of which was collected as gold dust from the burrows of 'ant-like creatures bigger than foxes yet not so big as a dog, which bring up great quantities of gold-bearing sand as they dig their burrows'.

This account initiated what was to prove the longest treasure hunt in history – the quest for the ants' gold. The stories circulated worldwide, cropping up in both Chinese and Indian folklore, while in Europe Sophocles, Strabo, Arrian, Pliny the Elde, and many others commented on the subject. Some were believers in the Greek 'Eldorado', while others, such as Strabo and Arrian, were sceptical. In his monumental work *Geography*, Strabo accused Herodotus of being a 'marvel monger'. Strabo argued that the story was 'a magnification to make things appear more marvellous'. Arrian went further still, and in his biography of Alexander he warned, 'I have not thought it convenient to stuff this history with … a long detail of the ants which are here said to dig up gold'. Regardless, the legend survived down the centuries. Thus, it was gold that first attracted Europeans to mountainous Central Asia. Alexander the Great and his treasure-

*Herodotus wrote of the presence in the mountainous north of strange animals that brought up, from below the earth, gold-bearing sand. This prompted the legend of the gold-digging 'ants', but despite many men searching for them they were never found. In fact, the animal in question was the marmot, a ground-dwelling rodent that belongs to the squirrel family.*

hungry troops first among them, confident they would discover the famed giant ants and their riches. The Greeks also hoped to encounter the seductive Amazons. However, although they saw specimens of the gold-digging ants in the menagerie maintained by the Persian kings, the Greek soldiers found neither the gold nor the beautiful warrior-women. Upon reaching the foothills of the Himalayas, the disappointed and exhausted troops forced their young leader to turn back. Thus Alexander and Geodrus, his mining expert, never reached Tibet or the uppermost reaches of the Indus where the 'kingdom of the women', the 'ants' and the gold were all said to be found.

As the centuries went by, ever more people searched for the gold, yet all did so in vain. In his capacity as ambassador for Seleucus I, the Greek historian and diplomat Megasthenes visited the Indian court of Emperor Chandragupta in the third century BC. He confirmed the story of the ants' gold and saw a skin of one of the giant 'ants', which he reported as having fur. Centuries later, medieval Europe was rife with mysterious tales of a certain Prester John, a European who had converted the Asians and was said to rule over a kingdom in either Ethiopia or Central Asia. In the twelfth century a letter said to be from the famous priest asserted that he had an empire encompassing the 'three Indies' – a reference to lands west of the Indus, between the Indus and the Ganges and east of the Ganges. The basis for such stories is unknown but may refer to the heretic Nestorian Christians who had fled east in the fifth century and established thriving communities in India and China and also, it seems, along the Silk Road.

Despite some enticing pieces of evidence, the Herodotus tale seemed to be a historical tall story. However, in 1996, I was most fortunate in being able at last to vindicate Herodotus and locate the famous goldfields. In 1982 I had heard tales about the gold from the Minaro people but had been unable to enter the ceasefire zone on the plain of Dansar, a plateau between India and Pakistan at an altitude of 11,500 feet (3,500 m), where the Minaro claimed they collected gold from marmot burrows. I had to wait fourteen years to be led under military escort to the area that overlooks the Indus, just half a mile from the Kashmir ceasefire line. The Minaro had long collected the earth

*After extensive research, I discovered that the Minaro people who live on the Dansar plain, which lies in Kashmir along the ceasefire line with India, still occasionally collect sand from the proximity of local marmot burrows because it can be laden with gold dust. The revelation vindicates Herodotus – and the explanation for the confusion lies in the fact that in the ancient Iranian spoken by those who had informed Herodotus, marmots were called 'mountain ants'.*

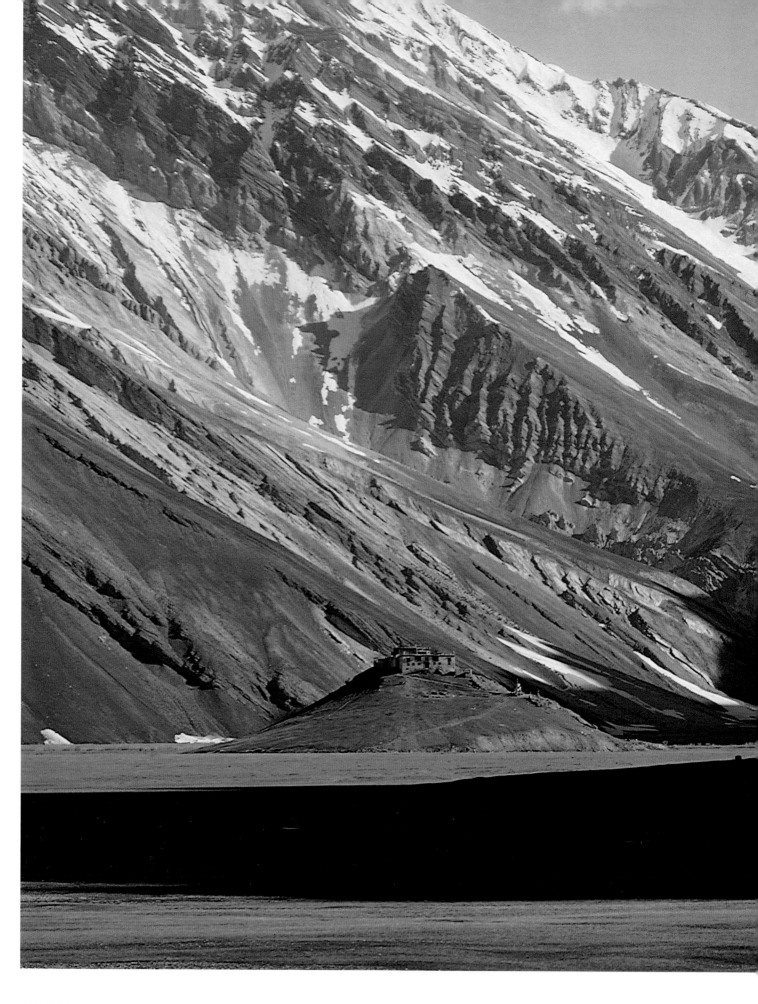

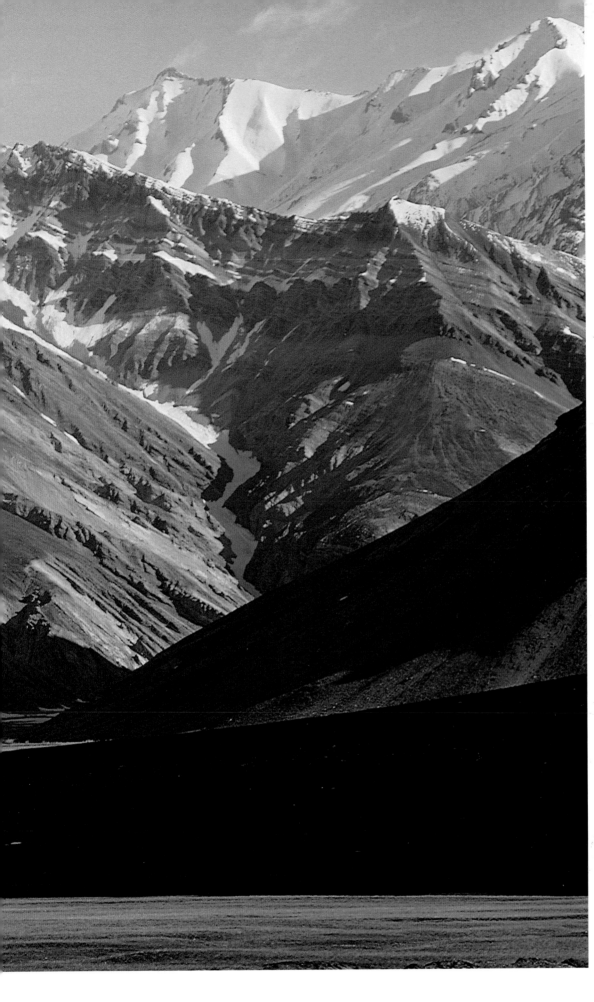

*Guarding the far western extremity of Greater Tibet, where the Himalayas and the Zanskar range meet, stands the lone monastery of Rangdum at the head of Suru Valley.*

thrown up from local marmot burrows. This dirt contained quantities of gold dust because the gold-bearing layer lies just several feet below the Earth's surface. The marmots still bring up this golden sand today. It would seem likely that the confusion and the consequent legend arose because in ancient Iranian, the word for marmot is equivalent to 'mountain ant'.

## European explorers

Despite the Prester John stories, there was little in the Middle Ages to encourage exploratory travel to the Far East. On the contrary, mountains were considered at that time to be terrifying places – the home of the devil. An indication of what people thought of mountainous terrain can be gleaned from the names that were used to describe geographical features – gorges were generally called 'devil's gates' and tall cliffs were often named 'demon's leap'. Thus, to reach the region where Tibet was located called for braving such demonic sites and, of course, both enduring the rugged exertions required to scale such mountains and suffering the physical effects of high altitude, where the pain caused by a lack of oxygen, which might result in unconsciousness and death, was attributed to evil, mysterious poisonous gases found in the high passes. Over the years, I have entered Tibet from the north, the south, the east and the west, and I must admit there is no easy route – each involves climbing over passes in excess of 16,600 feet (5,000 m). The lowest passes are found in the northeast, along the route that links Xining to Lhasa, and to the south through Mustang, yet both these routes are the longest ones with hundreds of miles of arduous travel over barren regions before one can reach any place of consequence in Tibet.

Matters changed at the beginning of the thirteenth century when the Christian world was suddenly threatened by the Tartars (the Turkic and Mongol peoples). Europeans began looking eastwards with justified apprehension. Pope Alexander IV warned of the menace of 'the inhuman Tartars, erupting as it were from the confines of Hell'. No one was keen to travel to hell, yet Pope Innocent IV sent Giovanni di Piano Carpini to Asia in 1245 on a mission to ask the Great Khan to repent and convert to Christianity; needless to say he failed, as did Guillaume de Robrouck in 1253 who went at the request of King Louis IX of France. Both these pious travellers reached the camp court of the *khan*s after riding three months across the steppes of Central Asia. It was there that they heard mention of Tibet for the first time. Carpini stated that the Tibetans were a nation of cannibals, while Robrouck wrote a naive description of Tibetan Buddhism, to which the Great Khan had been converted. It is surprising that neither man bothered to investigate in more detail where the *lama*s who attended the court of the Great Khan had come from.

When one knows that Tibet at the time was the scene of a dynamic spiritual revival and was home to hundreds of monasteries adorned with exquisite frescoes, whose intense beauty we can still admire at Alchi in Ladakh or on the walls of the assembly halls of Tsaparang in western Tibet, it is strange to hear the Tibetans described as wild cannibals. Yet this was an entrenched reputation based on a misunderstanding of *tantric* ritual implements, which included ritual cups made of human skulls, flutes made from human femurs and aprons composed of carved human bones. Carpini's remarks were to be expected given the account presented to him, but it still reflects poorly on his desire to enquire further, as might be expected of a more enlightened individual today.

Ironically, rather than an erudite priest, it was a Venetian businessman, Marco Polo, who was to provide the first reasoned account of Tibet. Although Polo never went to central Tibet, he travelled within its frontiers on two occasions. His first specific mention concerns the Tibetan town of Sinju (modern Xining), the capital of the Amdo region. This was the northern gateway to Tibet for travellers coming along what the Chinese called the Horse Trail, better known as the Silk Road.

Xining today has close to one million residents, most of them Chinese, and is the bustling entry point to the mineral-rich northern reaches of the Tibetan plateau. Yet for fifteen centuries it was

an ethnically mixed trading town (Chinese, Hui Muslims, Mongols and Tibetans) situated not far north of Kumbum Jampaling, one of the largest monasteries in Amdo and the seat of Tsongkhapa, the founder of the Gelugpa order. On mentioning Sinju, Marco Polo gives us the first report and description of wild yaks and musk deer, both animals then unknown in the West. Of the wild yaks, Marco Polo wrote, 'There are many wild cattle here as big as elephants, and very handsome … The length of their hair is fully three palms'. Wild yaks are gigantic, the tallest being fully six feet eight inches (2 m) at the withers – taller than Clydesdale dray horses but not exactly elephants. Today, wild yaks are difficult to find. When I finally saw some large ones during my twenty-eighth journey to the Tibetan highlands in 1998, they did match Marco Polo's description – certainly impressive and by far the finest cattle I have seen, although definitely smaller than elephants.

In one version of Marco Polo's travels it is said that he brought back a yak tail, which was admired by the Venetian gentry for having strands as fine as silk. Marco Polo goes on to explain that Tibet is the home of the musk deer and gives a description of this amazing animal with 'four slender (rodent's) teeth, two above and two below, about the length of three fingers'. Here again, as with the elephants, there is a slight exaggeration because the musk deer has only two long, rodent-like incisors on the upper jaw.

Marco Polo then mentioned two very different aspects of Tibet. Perhaps not a stranger to this custom, he related that Tibetan girls were liberal with their charms (and since there was no social taboo concerning illegitimate children it is possible that the custom prevailed) – 'When it occurs that travellers from a foreign land are passing through. . . the matrons from neighbouring villages and hamlets bring their daughters to these camps … and beg travellers to take them and lie with them. So these choose the girls that please them best, and the others return home disconsolate. So long as they remain, the visitors are free to take their pleasure … but are not allowed to carry them off anywhere else'. The girls then ask for a trinket as a token of the affair and are later rated by the number of lovers they have had, although, says Polo, they are faithful to their husbands.

In spite of this advice, Marco Polo also warns that the Tibetans are 'out and out bad'. 'The natives of Tibet are idolaters and notorious brigands' – no doubt a reference to the Khampa or Golok border tribes, men who have until today retained their reputation as brigands, or as some have called them 'gentlemen robbers'. Nevertheless, Marco Polo also records: 'Here are found the most skilful enchanters and the best astrologers … They perform the most potent enchantments and the greatest marvels to hear and to behold by diabolical arts, which it is better not to relate in our book, or men might marvel overmuch'. (This was a tellingly cautious remark from a European fully aware of the powers of the Church in his home state.) Later, Polo insisted that he saw Tibetan 'hail men' at work, an old Tibetan tradition and specialty that pre-dates Buddhism and involved shamans whose duty it was to stop hailstones from damaging crops and cattle.

Never blind to business opportunities, Marco Polo remarked that a good profit could be made by selling coral to the natives, 'for it is hung round the necks of women and of idols with great joy' – a fact that remains true today. In spite of its gold, magic and liberated girls, Tibet was not to be visited by another European for about 350 years. This was because the collapse of the unified Mongol empire meant the Silk Road was no longer safe or open to European travellers. By then, it had become known as 'secret Tibet'.

This European was a Portuguese trader – Lourenco d'Almeida – who entered Ladakh in 1600. Not a scholar, d'Almeida was impressed by the monks and monasteries, which he believed must have had Christian origins because the robes and the communal life were so similar to that of monks in Europe. On returning to Goa, d'Almeida spread the rumour that Tibet was perhaps a long-forgotten Christian state – a story that aroused considerable interest in the Portuguese colony. Then Goa was home to several religious communities, the most notable being the Jesuit order.

# Bhutan – land of the dragon

**The example of Bhutan illustrates both the dynamism** and the weakness of the Tibetan monastic system of government. Evidence of the dynamic side is revealed by the rapid speed with which Buddhism spread among the primitive animist hill tribes of Bhutan from the fourteenth century onwards. The fortress monasteries (*dzong*) brought Tibetan culture to Bhutan and a common language in the form of a Tibetan dialect that became known as *dzong ka*, or 'the language of the forts'. Being composed of a loose federation of rival fortified monasteries, this state was also weak and until 1908 it remained a theocracy under the holy but powerless leadership of a *lama* known as the Dharma Raja.

Each fort had its own lay administrators and when internal strife developed it led to wars between the forts and feudal chaos. Keen to establish order along their frontiers, the British encouraged the head of Trongsar *dzong* to establish himself as the hereditary monarch of the whole of Bhutan. In this way Bhutan finally established a system better able to adapt to modern times than a conservative theocracy. Today, Bhutan is the only remaining Tibetan-speaking, independent state.

I first explored this mysterious mountain kingdom in 1969, after a decade of trying. Travelling through the heart of this high-altitude domain, I felt that in addition to having ascended, I had simultaneously been transported back in time. I encountered scenes, people and customs that felt medieval: fairy-tale fortresses, men on horseback, wooden bridges and archery tournaments.

1. The fortress of Bumthang, in central Bhutan, is the Jakar *dzong*. It shelters hundred of monks, soldiers and civil servants. No women are allowed to spend the night within its walls.

2. The head of Trongsar fortress gets ready to set out and tour his district. As the all-powerful local administrator he acts as both councillor and judge.

3. A Bhutanese village overlooking irrigated rice fields. Much of the rice is exported to Tibet.

1

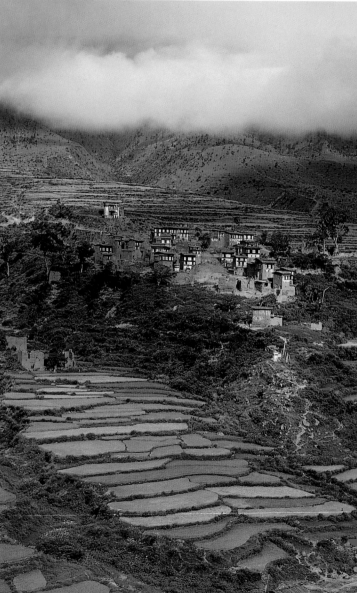

3

2

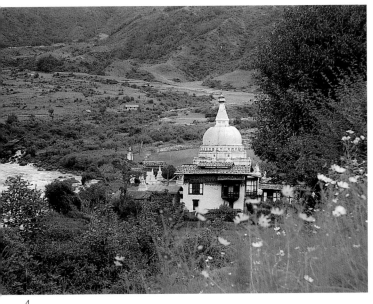

4

4. Durong *chorten* is a holy shrine in the far northeast of Bhutan, built to ward away the poisonous evil after which the valley is named.

5. The author pictured before Trongsar, a fortress in the heart of Bhutan. The country is known to its people as Druk, which translates as 'land of the dragon'.

6. Archers in a contest held below Lhuntse *dzong* in eastern Bhutan. The white vertical board is the target. I can recall these contests clearly: the men with their split-bamboo bows, stinging nettle fibre strings and stout reed arrows with copper arrowheads. A shot on target led to whoops, cheers, bow-twirling and animated dances to chase away bad luck – all by the opposing team.

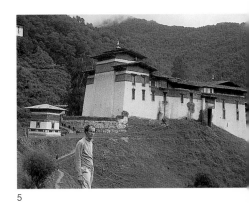

5

7. A lateral view of the Trongsar *dzong* illustrates how traditional Tibetan architecture has been only minimally modified to accept the pitched roofs required by Bhutan's rainy climate.

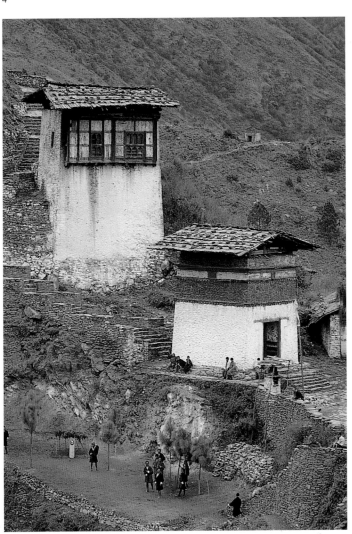

6

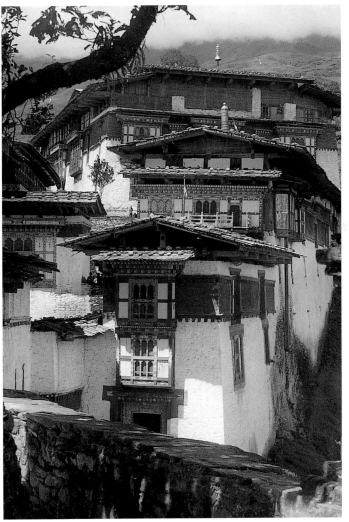

7

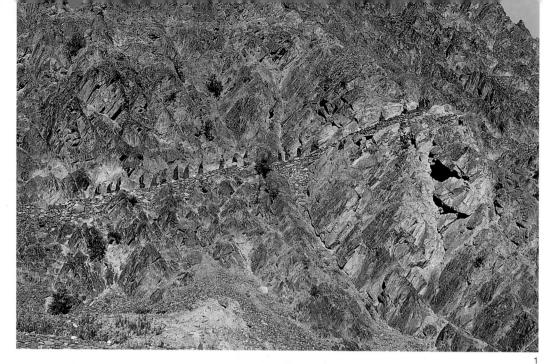

1, 3. A long parade of red-robed monks makes its way up the steep cliff that leads to Karsha monastery's main assembly hall (visible, right). Karsha, a Gelugpa monastery, is the largest of the seven monasteries that exist in Zanskar. Located atop a mountain, all the local evidence seems to point to this site and area having long been a sacred place.

2. A view of the valley from beneath the steward's office. The snow-capped heights can be seen clearly, emphasizing the perilous nature of travel in the area during the harsh winter. Moving along the frozen river was often the only means of entering or leaving Zanskar, a journey that can prove fatal if there is a sudden thaw. A few decades ago, thirty people fell through the ice to their deaths.

# The valley with two kings

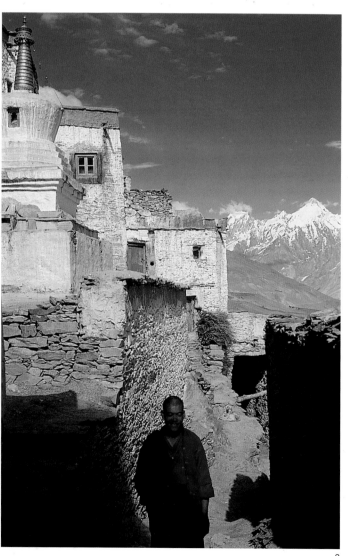

**Situated between the Great Himalayan range** and the Zanskar range south of Ladakh, the Zanskar Valley is sealed off from the outside world by snow for most of the long Himalayan winter. A road was finally driven into the valley in 1980, but hitherto it was its isolation that had enabled the Tibetan-speaking community to thrive. There are actually two kingdoms in the valley: one is ruled by the *gyelpo* (king) of Padum, the other by the *gyelpo* of Zangla. Zangla is composed of a lone fortress and three villages located where the Zanskar River leaves the main valley to flow north through a deep gorge leading to the Indus.

Zanskar came under Tibetan rule in the eighth century, having previously been part of the ancient Dardic federation of matriarchal villages, which had led to both Ladakh and Zanskar being given the name 'Kingdom of Women' in ancient Sanskrit texts. It is so cold in Zanskar and the summers are so short that the farmers are obliged to spread earth over their snow-covered fields in spring to hasten the thaw and give their crops time to grow before winter returns in September.

The people of Zanskar retain a close affinity with Amdo, although it is thousands of miles away to the east. They tell a legend about a young man from Zanskar who went to Amdo and discovered a huge lake out of which emerged a beautiful princess. The two fell in love and had many children. Thus it is that the two peoples feel they share the same 'bones', or blood as we would say. Indeed, in the people one can see that there are fewer traces of Dardic ancestry than is evident in neighbouring Ladakh and historical evidence seems to suggest a recolonization of the area from the Dards and Kashmiris in the eighth century. The links between the two places are still maintained by the monks, many of whom went to study in Amdo. Zanskar's largest monastery is the Gelugpa community at Karsha, which serves as the central monastery for eight villages of northern and central Zanskar.

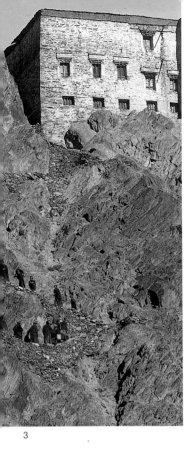

4. A prancing *dakini* exemplifies the Indian influences often found in Buddhist Himalayan art.

5. The elegance of this white divinity, painted by a forgotten grand master at Karsha, illustrates the talent of the now obscure fifteenth-century artists who visited such remote valley kingdoms.

6. A young novice clutches a brass teapot while he waits to enter Karsha's assembly hall and serve the monks.

3

4

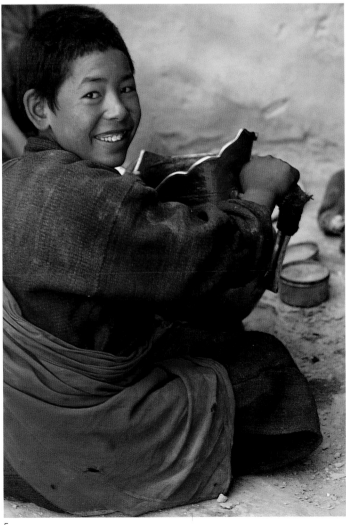

5

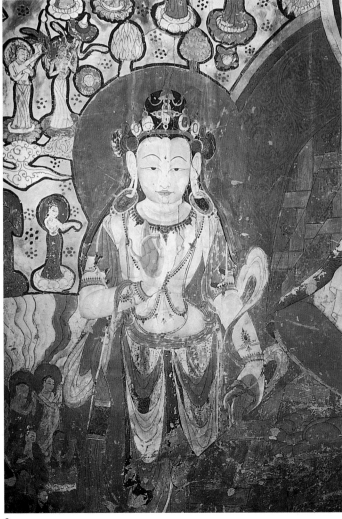

6

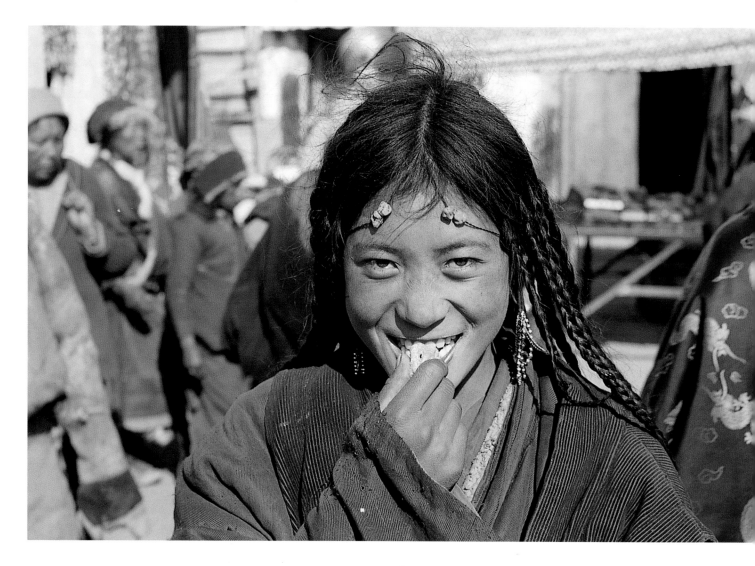

## Jesuit missions

The Jesuits had sent priests under the leadership of Francis Xavier to convert the Japanese residents of Hiroshima. The same order had also sent Xavier's nephew overland through the Pamirs and along the Silk Road to the borders of China, to prove that China and Marco Polo's Cathay were one and the same land. At the same time, a Father Benedict of Goa had travelled all the way to Kashmir and returned with the news that in Tibet there was a religious leader who wore a mitre and a chasuble (sleeveless vestment) similar to the attire of European bishops. Despite these reports, it was only twenty years later (in 1620) that the head of Goa's Jesuit Mission, Father Antonio de Andrade, who had been named superior or overseer of 'Mongol territories', decided to set off to try to enter Tibet.

From Andrade's portrait in the Academy of Sciences in Lisbon we can see that he was a handsome, slightly austere man. He was forty years old when he left Goa for Tibet in the company of Brother Manuel Marques. Dressed like Hindu pilgrims, the two travelled up the Ganges to the holy shrine of Badrinath. There the pair left the other pilgrims in order to make their way to the village of Mana at the foot of the 16,400 feet (5,000 m) Tang-ri Pass.

As they left Mana for Tibet they were stopped from travelling by the village headman. Leaving Brother Marques behind him, Father Andrade, with two servants and a local guide, made a rush for the pass, but he was caught by villagers and ordered to turn back. Andrade and his two

servants then broke away and pushed on regardless. Encountering deep snow the three men were obliged, in Adrade's own words, to 'drag ourselves laid out on all our length as if swimming in water'. As a result Andrade lost part of one finger to frostbite after a night spent in a hole in the snow; the next day, struck by snow blindness, the three hardy travellers were obliged to turn back to save their lives.

### Entering Guge

Meeting up again with Marques, Andrade stayed several months in Mana to restore his health. During this time, the missionaries managed to persuade the villagers to help them enter Tibet. When they set out in late August the snow had melted and with little trouble, the two missionaries made it into the amazing gorges of the upper Sutlej River, which waters the Tibetan region of Guge. This region is high up and arid, yet here and there were oasis-like golden fields of barley set on ledges overlooking the river. Passing little hamlets of whitewashed houses the two missionaries were taken to Tsaparang, the capital of Guge, which was set precariously upon the craggy, vertical sides of a huge, yellow, cliff-faced rocky outcrop pockmarked with hundreds of caves. Clambering between the red walls of chapels and assembly halls the pair were ultimately led up a steep flight of steps that passed through tunnels in the cliff until they reached the carved wooden doors of the royal palace. Here they were presented to the local king (*gyelpo*) of Guge.

Guge, along with Mustang and Purang, was at the time one of the independent principalities of Ngari, as western Tibet was called. In the twelfth century, Guge, Spiti and Ladakh had been the scene of the dynamic spiritual revival promoted by Rinchen Zangpo. The monasteries of Guge still exhibit some of the most remarkable religious paintings in the entire Tibetan world, seen in the chapels of the now abandoned town of Tsaparang and in the halls of the nearby monastery of Toling. But in 1623, Guge was in a state of economic decay due to the ever-increasing aridity of the region, which lies in the so-called 'rain shadow' of the Himalayas. As in all the other places found immediately behind the great ranges, the few monsoon clouds that make it over the peaks in summer do not precipitate just behind the ranges, but farther north. Thus the only water available for agriculture is that produced by melting snow running down from the nearby summits.

When Father Andrade and the king met, Guge was already impoverished as a result of repeated droughts. From Father Andrade's writings we know that he found Tibet, and Tsaparang in particular, wretched. This was due to the fleas in the smoky little room, set above stables, that the missionaries were given on arrival. Evidently the religious art made no impression on the two men, neither of whom knew anything about Tibetan Buddhism and could not speak Tibetan. Somehow, they were able to converse with the king through interpreters (perhaps in Farsi).

As holy men, the king treated them with great reverence and then explained, somewhat to the priests' surprise, that he wished to learn the tenets of their faith. This was as welcome as it was unexpected. The king then issued an edict proclaiming the pair to be his personal guests and inviting them to stay and teach his subjects their beliefs. Leaving Marques behind in Tsaparang, Andrade hurried off back over the pass to seek, as it were, reinforcements. While in India he wrote a report of his journey entitled 'The new discovery of Great Cathay or the kingdom of Tibet'. This was published as a little book and soon became a best-seller in Europe, where it was translated into seven languages including Latin. This was the first account of a whole new world existing in the heart of Asia – one which, amazingly, had escaped notice for too long. From that point onwards, Tibet has exerted a special fascination for many Europeans.

*The mischievous smile of this young nomad girl is characteristic of Tibetans in general – a people who are quick to laugh and who delight in teasing. The friendly informality of most Tibetans and their humorous disposition is often commented on by visitors.*

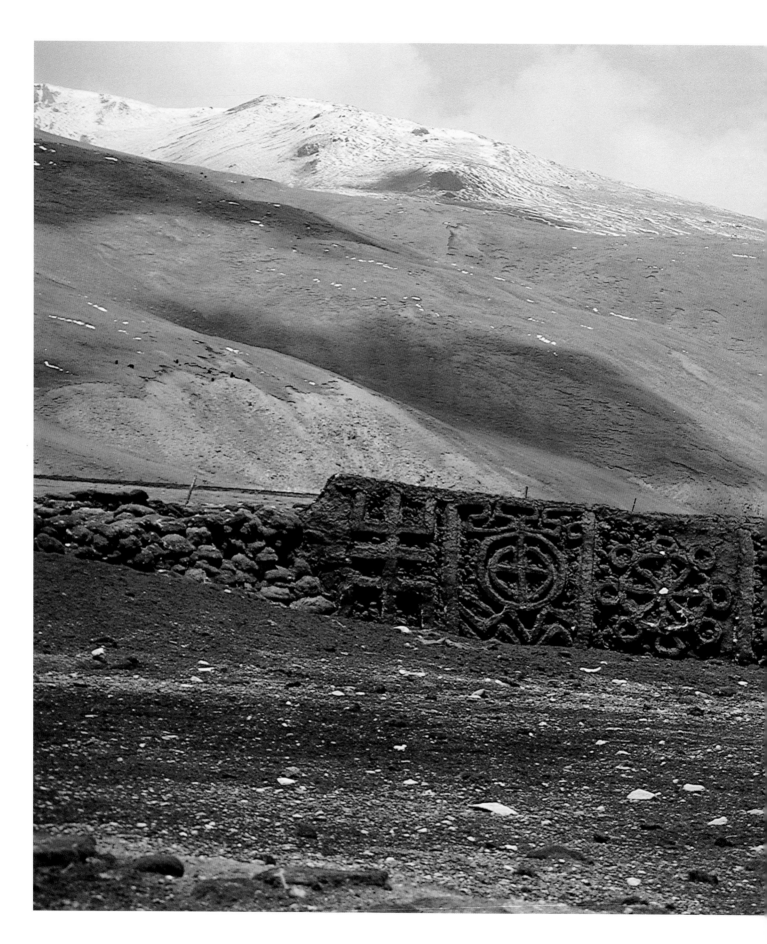

*This large wall of dried yak dung represents a life-saving stock of fuel with which its owners – nomad herders from Nangchen – intend to heat their tents. The fresh dung has been moulded into shapes representing, among other Buddhist symbols, the Wheel of Life.*

## In search of converts

It seems that Andrade was a little too optimistic. Returning with two more missionaries, he began by building a chapel in Tsaparang that he decorated with European pictures. Persuaded that the king was a sincere convert, the Christian missionaries were oblivious to the growing discontent among the local population. They had similarly failed to appreciate the rising antagonism of the local monks – particularly those of the large nearby monastery of Toling, which was headed by the king's brother. This unrest increased in proportion to the favours the king extended to the Europeans and it became irreparable when the king ordered the knocking down of village houses to make room for the mission. The king himself was now unpopular, while the missionaries were accused of making fun of Tibetan Buddhism and its beliefs, having failed to understand the sophisticated religious and philosophical thought underlying it.

Before matters reached a crisis in Tsaparang, Father Andrade hastily established a second mission in Guge. Then, in 1626, he dispatched two missionaries to central Tibet – Father Juan Cabral and Father Stephen Cacella. The two priests entered Tibet via Bhutan in 1627 and, incredibly, were allowed by the king of Tsang (south central Tibet) to set up a mission in Shigatse, the holy city of the Panchen Lamas. (This mission was to last nine years. It closed after the death of Father Cacella – and because the priests had made so few converts.)

The tolerant, polite and courteous attitude of Tibetan Buddhists misled many missionaries into believing that they were truly welcome and about to acquire converts. However, unlike the Jesuits in China, who learnt Mandarin, and later the erudite Jesuit Father Ipolito Desideri, who learned in Lhasa to speak, read and write Tibetan, in Guge Father Andrade failed to win any hearts, let alone any souls. Relations between the king and his pious brother erupted into war and Ladakhi troops were called in by the local monks to topple the king. The two missions in Guge were subsequently sacked and two of the missionaries were made prisoner and taken to Ladakh. This was a severe blow to Andrade who had left for Goa just before the hostilities. Undeterred as usual, Andrade was determined to set out for Tibet yet again, this time with a new group of six missionaries. This journey was a disaster: Andrade was poisoned on the way and died, two more priests in the party later expired, while two more fell ill and abandoned the venture before reaching Tibet – and the two who did reach Tsaparang were promptly expelled. However, the misadventures of Andrade did not spell the end of the Catholic missions to Tibet.

It was by chance that the first Europeans to be recorded – in 1661 – as entering Lhasa were two Jesuits: Father John Grueber, a mathematician-counsellor to the Chinese emperor, and Father Albert d'Orville. They had been stationed in Beijing and, unable to return to Goa or Europe by sea because of the British blockade of Macao, they decided to travel overland to India via Tibet and Nepal. This is one of the most arduous overland exploratory journeys ever undertaken anywhere: it involved travelling more than 2,000 miles (3,200 km) across the entire Tibetan plateau, not to mention the crossing of a swathe of China and India, a route at the time entirely unexplored by Europeans – at least as far as the crossing of Tibet and Nepal were concerned.

The Jesuits spent two months in Lhasa, where Grueber calculated the latitude and longitude of the holy city (precise to within half a degree) and executed sketches of the Potala Palace and of the Dalai Lama himself. Disappointingly, neither of the travellers left a transcript of their amazing expedition, although they were aware that they were breaking new ground. After arriving safely in Europe, Grueber imparted some of his experience to Athanasius Kircher who incorporated the story into his book *China Illustrata*, published in 1667 in Latin. Yet, once again, the portrayal of Tibet failed to do justice to its sophistication and civilization. Grueber's account lingers on butter tea and sky-burials, and it reiterates the myth that Tibet was the degenerated ancient realm of Prester John. Europeans had still to appreciate Tibetan culture

and acknowledge the scholarship that had resulted in the thousands of volumes found in the monasteries on subjects ranging from medicine to poetry. The missionaries also failed to notice that many of the monasteries that offered them shelter on their long march had been founded eight centuries earlier.

The Jesuits had hoped to open a new mission in Lhasa but this privilege was granted in 1707 to the Capuchin order instead. Tibetan tolerance was extended further in 1720 when a historic edict – far ahead of its time – in Lhasa permitted the free practice of all religions. That same year Lhasa's first mosque opened. The Capuchin mission was to endure several eventful decades, until it was closed down in 1745 due to pressure put upon the seventh Dalai Lama by Buddhist monks.

If the Capuchins had made few converts, they had at least supplied the West with information about Tibet and had begun to respect the nature of Tibetan culture and its civilization. No one appreciated this more than Ipolito Desideri who reached Lhasa in 1716 hoping to get permission to set up a Jesuit mission. He stayed there for five years, until he was declined in favour of the new Capuchin mission. During that time, Desideri learnt more about Tibet than all his predecessors had, becoming so fluent that he was able to write a treatise in the language in which he refuted Tibetan Buddhism. He befriended Tibetans and was awed by their faith, even regretting that he personally had neither the faith nor the tolerance and kindness of many Tibetans. Desideri left a complete account of his stay and a priceless description of Tibet, its customs and the troubled politics of the day, which were a consequence of the Dzungar Mongol invasion from the northwest and the subsequent Chinese invasion from the east.

Today, with flights instantly available to any place on Earth, including Tibet, it is difficult to imagine just how remote the place was in those times. This is illustrated by the journey undertaken by Desideri to get home to Rome. First he had to walk all the way from Lhasa to Goa, enduring not only the cold and oxygen-thin high altitudes of the Himalayas but also the sweltering heat of the Indian plains. It is hard for us to imagine the dingy resting places, the meals eaten around yak and cow dung fires, the threat from highway robbers and running the gauntlet of the arrogant soldiers who served local maharajas – yet even after he had reached the safety of Goa, there still remained a terrible sea voyage around the Cape of Good Hope and months of sleeping on hard berths being rocked by rough seas.

In the Atlantic Ocean, Desideri's ship was blown off course and forced to Brazil, from where slowly he made it back through North Atlantic storms to the Mediterranean. Then, as he sailed towards Rome along the coast of Spain and France, his ship was attacked by pirates just off St Tropez. Able to disembark with his meagre possessions and precious notes, the missionary continued on foot, finally reaching the eternal city after a 600-mile (1,000 km) walk. Perhaps unsurprisingly, Desideri died the year after his arrival, but the most tragic aspect of his story was that his remarkable account of Tibet and its customs and culture was not published for more than a century, and only became available to the wider public and an international audience, in translation, during the twentieth century.

When the Capuchins were obliged to leave Lhasa in 1745, they returned to India via the Kathmandu Valley, where they had a prospect of establishing a mission. In their desire to regain a foothold in Tibet, one of their fathers, Guiseppe Maria da Gargnano, wrote to his superior suggesting that the order might try to open a mission in 'Mustan, a Kingdom of Great Tibet, independent of the King of Lhasa, dependant only of China, in the same manner in which Lhasa is itself dependant of China'. This is the first mention of Mustang in Western literature and attests to the independence of Mustang as a small state within the Greater Tibetan world. Mustang was to wait 320 years before Tony Hagen became, in 1962, the first European known to have entered its territory – a realm that I had the privilege of exploring and studying in 1964.

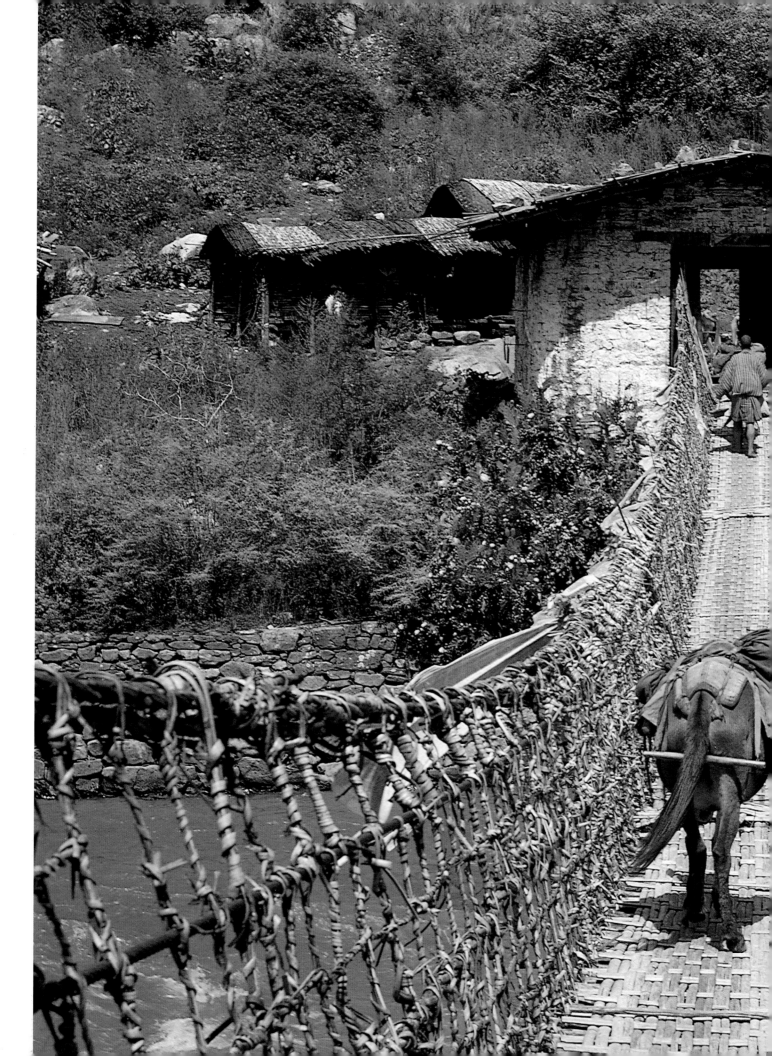

In the end, the Capuchins were never to enter Mustang or return to Tibet, nor were any other missionaries able to settle in Tibet until the middle of the nineteenth century when both Catholic and Protestant (Moravian) missionaries entered Kham in eastern Tibet and Ladakh in the west, respectively. The missions in eastern Tibet were established among the Khampas, traditionally a warrior people, and, unlike Lhasa two centuries previously, the missionaries were not made welcome – on the contrary, tolerance rarely prevailed and attacks and killings were commonplace. From reading the correspondence of several of these missionaries it seems they aspired to martyrdom and in so doing they frequently provoked the local *lama*s. These missionaries appeared to prefer to adopt Chinese customs rather than accept the Tibetan way of life, a trait that did little to endear them to the Khampas, whose traditional enemies were the Chinese. The last killing of a Christian missionary occurred as late as 1928.

## Not an isolated land

From the sixteenth to the eighteenth century, Tibet was not the secluded, practically closed country it later became. Missionaries were far from being the only foreigners to enter Tibet. Among the early visitors was a mysterious and rather eccentric wealthy Dutch merchant and traveller called Samuel Van der Putte. Between 1725 and 1735, he travelled from India to China and back across Tibet, repeating in part the incredible journey of Grueber. An erudite man, Van der Putte is said to have stayed a long time in Lhasa and written considerably about the capital and his journeys. Alas, after his death all his papers were burnt, as he had requested.

This sad loss of priceless information is a reminder that exploration and discovery involve not just getting there first or writing about one's experiences but leaving a record of them for posterity. It is highly likely that other merchants also made journeys to Tibet, for wealthier Tibetan women constituted a lucrative market for traders in amber and coral, while felt hats and Italian gabardines were also sought-after items, all of which were being supplied by people whose identities are not known.

Tibet was not an isolated land. Tibetans were in constant contact with all the varied lands around them, and they constituted a vast market for goods from India and other places to the south. The kingdom of Nepal, home of the industrious Newar artisans, was a particularly popular source. Since the seventh century, the Newar had supplied Tibetan chapels and monasteries with bronze statues smelted in the Kathmandu Valley. Nepal was the source of paper, gold, ink, gilt-copper roofing and roof ornaments, as well as the carvers who adorned the wooden door lintels and beams of chapels. So great was the volume of commerce between Nepal and Tibet that Nepalese traders and artisans formed a large community in Lhasa, marrying Tibetan girls and creating mixed-blood families. Even in Kathmandu, the second tongue of the Newars was Tibetan, as was that of many traders from Kashmir who also settled in the Tibetan capital.

Although there was no written agreement among the European colonial powers, it was more or less understood that Asia was the exclusive hunting ground of the British, the Russians and the French. As far as Tibet was concerned, matters remained peaceful and uneventful until the rise in 1769 of the Nepalese Gurkha dynasty, which unified Nepal. As Hindus, the Gurkhas had little sympathy for Tibetan Buddhism. The aggressiveness of the Gurkhas disturbed the traditional trade between the subcontinent and Tibet, and the British found the belligerence unsettling.

As a result, in 1774 Warren Hastings, the governor of Bengal, sent an envoy to the Panchen Lama to discuss matters of commerce. For this mission, Hastings chose a young Scot named George Bogle, who became the first Briton to visit Tibet. Bogle proved to be a very good choice, because he befriended the Panchen Lama and seems to have learnt to speak some Tibetan. He appears to have appreciated Tibet and the sophistication of its culture. He also recognized

something that has drawn others, including myself, to Tibet and that is the amazing broad-minded, open, friendly, intelligent and amusing character of so many Tibetans. It is something so refreshingly different from the more formal and aloof public behaviour of Indian Brahmins or Chinese Mandarins.

Bogle gives us an enchanting account of Tibet, so much so in fact that the historian and Tibet expert Hugh Richardson believed what many others had insinuated – that Bogle might have married a Tibetan. This remained unproved, though he might well have had more than a formal relationship with his Tibetan caretaker, who was mentioned in his will. What is beyond doubt, however, is Bogle's affection for Tibetans and his ability to forge intimate friendships with them – as mentioned, he maintained good relations with Lobzang Palden Yeshe, the sixth Panchen Lama (1738–1780) and one of the most influential of that line.

In 1788, some years after Bogle's visit, the Gurkhas sent troops into Tibet. It was the first of several incursions over the years and it eventually took Chinese intervention in 1793 to force the Nepalese out and back to Nagarkot, close to Kathmandu. As a result of this episode, the Nepalese were forced to pay tribute to China and the Chinese obtained a firmer grip on Tibetan affairs. It also led to the sealing of Tibet's borders to foreigners, because the Tibetans were gravely disappointed that the British had done nothing to help them against Nepal in spite of assurances of friendship received by the Panchen Lama from Bogle.

In 1814 and later in 1836, the British eventually ventured into the Himalayan foothills to fight both the Nepalese and the Bhutanese. The expeditions, though, were disastrous and the British suffered enough setbacks to cause them to acknowledge that combat in mountainous terrain was best avoided. Unable to defeat the Gurkhas, the British promptly hired them as mercenaries. (Today, the British Army's Gurkha brigades are mostly composed not of Hindus but peoples from Nepal's Buddhist Gurung, Tamang and Magar communities – all of Tibetan origin.)

As the nineteenth century progressed, Britain, Russia and France divided Asia among themselves, with the coastal areas of China under international control through the establishment of zones of influence based on 'treaty ports'. Tibet found itself sandwiched between Russian-controlled Central Asia and British-run India, with China a humbled and uncomfortable giant to the east. After having discovered the difficulties of fighting in Himalayan terrain, the British were not keen on pushing any further north towards Tibet. Bhutan, Sikkim, Nepal and Kashmir were left alone and classified as 'buffer states'. But buffers against whom? Did they stand between British India and the Russians or British India and the Chinese – or perhaps even the Tibetans? In fact, because of the fluctuating political scene, they were considered all three. As a result, these Himalayan kingdoms enjoyed independence from colonial internal interference – as, of course, did Tibet. A British 'hands-off' policy further isolated Tibet because the buffer states, regarded as a British zone of influence, were deemed out of bounds to non-Britons.

## Closed Tibet

The Tibetans were quick to understand that elsewhere in Asia merchants and missionaries from abroad had inevitably been followed by troops. Consequently, the Tibetan government closed its frontiers to Europeans – a ban that made Tibet all the more mysterious and alluring. With relentless zeal and efficiency, Tibetan frontier guards were to succeed in turning back expedition after expedition of hopeful Europeans and Americans who were seeking to enter Tibet and visit Lhasa uninvited.

In spite of the ban, in 1811 the eccentric scholar Thomas Manning became the first Englishman to enter Lhasa and he was well received by the Tibetans. He found little to his liking, for he was a scholar of China and shared the Chinese scorn for Tibet. Although he has left us an amusing,

# The kingdom of Mustang

**Known in Tibet as the Kingdom of Lo**, Mustang was founded in 1380 by a warlord called Ame Pal. I learned this in 1964 in the course of my first interview with King Angun Tensing Trandul, and a few weeks later, in a monastery, I was able to consult a *molla* or historical document that outlined the 580-year history of the tiny kingdom. In so doing, I became the first foreigner to learn of Mustang's identity as an independent realm, a fact that had escaped the attention of everyone, including Guissepe Tucci, the foremost scholar of the day on matters Tibetan, who had actually visited the region before me, albeit briefly. During my three-month stay I explored all the kingdom's villages, monasteries and forts to gather material for my doctoral thesis. After my visit, Mustang was closed to all foreign visitors for twenty-eight years, having been drawn into the Sino-Tibetan conflict by playing host to Tibet's freedom-fighters.

My experience there offered me the unique opportunity to study a small Tibetan community that still lived very much as the rest of Tibet had in the days of its early kings. Mustang had not been affected by the modifications of Songtsen's laws as a result of Mongol interference in Tibetan affairs. By studying Mustang I could understand not only why the social and political organization of ancient Tibet had been so successful but also why it still prevails today in so many other regions of Greater Tibet. I felt as if I were living a legend – of a lost city hidden in a fold of the Himalayas.

1. Set in a barren and eroded landscape, the walled capital of Lo Mantang, the capital of Mustang, is a sheltered haven from the winds and dust of the trade route that links it with Tibet – seen here on the distant horizon. The wall was built in the fifteenth century with only one door, which was still closed every night to keep out brigands when I first visited Mustang in 1964.

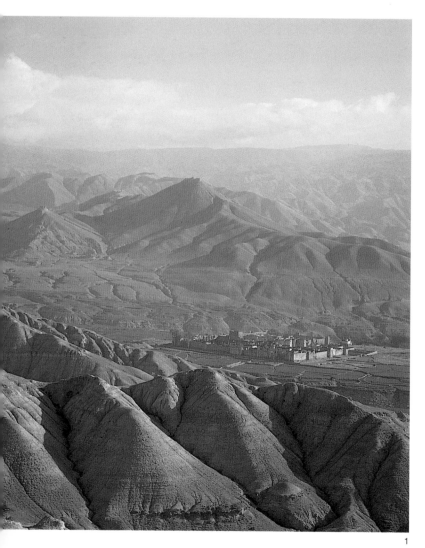

2

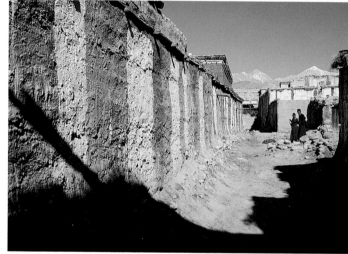

2. These stripes are typical of religious buildings belonging to the Sakyapa order – the school to which the kings of Mustang belonged.

3. A Lo-ba peasant wearing a homespun gown, probably made from goat's wool. Note the amulet hanging from his waist.

1

3

4 The high wall of the impressive assembly hall of the monastery of Tsarang, the second largest town in the kingdom.

5. Still intact after five centuries, the great wall of Lo Mantang stands as a proud testimonial to long years of service guarding the inhabitants of Lo.

6. A nomad follows his flock of sheep and goats through a door *chorten* on their way back from having made a delivery of salt to Lo Mantang. The salt trade between Tibet and India was responsible for Mustang's prosperity, until the invasion of Tibet disrupted normality.

4

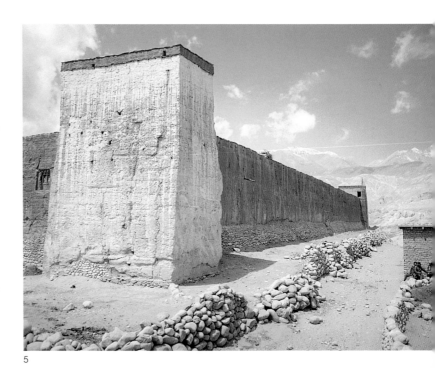

5

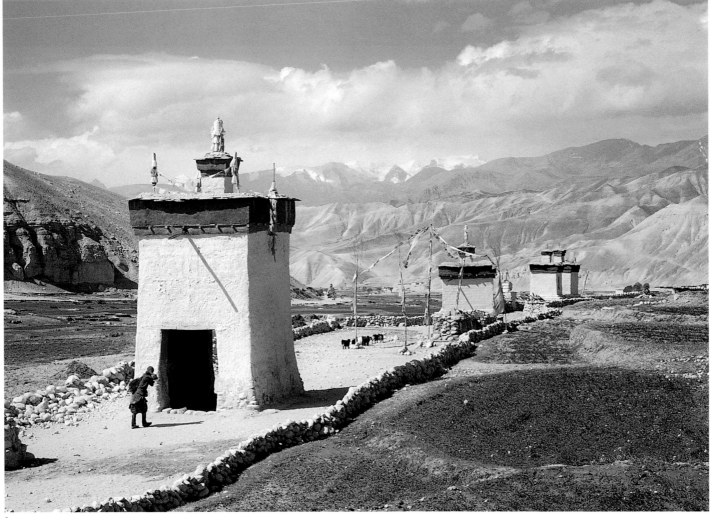

6

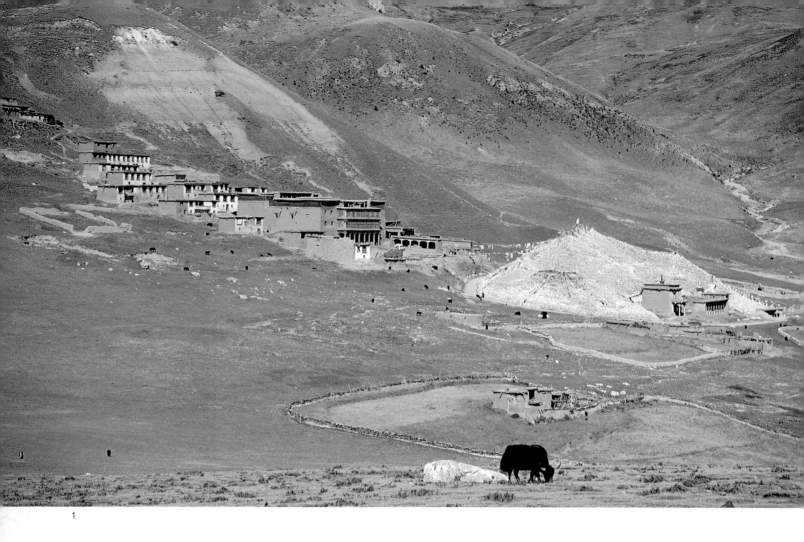

1

## The source of the mighty Mekong

1. Nangchen Gar the 'camp capital' of the twenty-five nomadic Khampa clans who inhabit the kingdom of Nangchen. Here, around the huge votive mound of prayer stones, the representatives of the clans would camp once a year. It was also the summer capital of the region's kings. It is in Nangchen that the Mekong River Valley lies.

**For 160 years explorers have sought to find** the source of the mighty Mekong River – despite their efforts, in 1994 its exact location was still unclear. The reason for this was that it lay somewhere in the heart of the kingdom of Nangchen, a federation of Khampa nomad tribes, who had a reputation for ferociously opposing any intrusion on to their grazing lands. The closest a European had come was in April 1894, when the Frenchman Dutreuil de Rhins and his companion Francis Grenard had made their way east across Tibet, crossing a pass they called the Dzana-Loung-Mouk and following a small river called the Lung Mouk (Lungmo). They speculated that it might be the main source of the great river itself. However, less than a month after their crossing, Dutreuil de Rhins had been killed by Khampas and the issue of the river's source was considered best forgotten.

Foreigners kept out of the troublespot until 1994 when I was fortunate to secure permission to seek horses in the region. With my companions Sebastian Guinness and Dr Jacques Falck, we decided to verify Grenard's assumptions and chart the Mekong's principal source. In pursuit of this place, we experienced storms of ice-cold hail, lightning storms on the open plains and prowling wolves. Finally, in a marshy field below the head of Rupsa Pass at 16,300 feet (4,900 m), we found the first trickles of water of the Mekong. They were somewhat modest, but it was undoubtedly the river's easternmost point – the farthest from the South China Sea into which the Mekong eventually flowed. We found the point lay at Latitude 33° 1616' 534 N Longitude 93° 52' 926 E, west of the source of the Lungmo River. Along the way, our journey had become one of inner discovery and reflection: we met people who were free and natural in a manner that it is difficult for anyone used to the comforts, organization and material expectation of Western society to begin to be able to understand. At one point an expensively adorned tribesman rode up on a beautiful white steed, fixed us a stare and then rode away. The encounter, momentarily unnerving, made us remember Dutreuil de Rhins.

2. Sebastian Guinness, Michel Peissel and Jacques Falck stand before the nascent Mekong at the foot of the Rupsa Pass.

3. The rolling hills of Ghegi where the excellent grass in summer provides an ideal place for the nomads to breed and raise the best of the Nangchen horses.

2

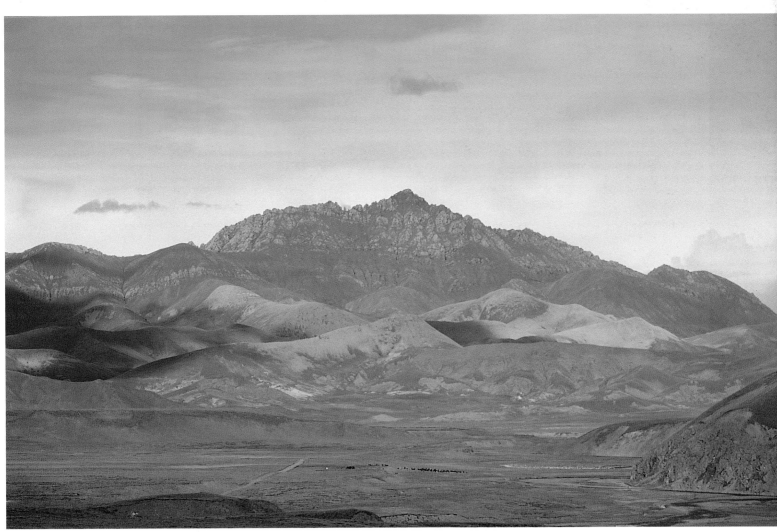

3

detached account of his journey, it is not the most enlightening as to the character of Tibetans themselves. Manning was but the first in a long list of eccentrics attracted by Tibet. After him came Moorcroft, a womanizing doctor-turned-vet, and then the Hungarian Csomo de Koros, the father of Tibetan literary studies who compiled one of the very first dictionaries of the Tibetan language. Then there came the botanists mentioned earlier, and in 1846 the French missionaries Regis Evariste Huc and Joseph Gabet who have provided one of the most straightforward and enlightening accounts of the journey from Beijing to Lhasa – together with detailed accounts of the comparative calorific values of yak chips, camel dung and sheep's droppings (in fact, goats' droppings are deemed the best and the only one capable of melting steel when assisted with bellows). The duo's journey was considered to be so incredible that it was declared a hoax by the Russian explorer Nikolai Przhevalsky. Famous because of a horse he did not in fact discover – it was first reported by the Scottish doctor John Bell who had travelled across Mongolia in 1719 in the service of Peter the Great – Przhevalsky deserves credit for bringing back specimens to Europe. This was no small task, given the animal's aggressive spirit. Przhevalsky tried repeatedly but unsuccessfully to enter Lhasa and thus became the first in a long line of frustrated explorers who tried and failed to reach the holy city.

### *Pundit* explorer-spies

In 1865, the British in India began training Tibetan-speaking Indians as spies to infiltrate Tibet and map the terrain. These men were the legendary '*pundit* explorer-spies' and their adventures and discoveries fill many books. Masters in the art of duplicity, they often dressed as monks and it was in just such a disguise that the *pundit* Nain Singh, the most famous of all, crossed Tibet from west to east and reached Lhasa in 1874. The achievements of such men led to their being awarded gold medals and watches by the Royal Geographical Society and the Société Geographique.

One of their number, Sahrat Chandra Das, who undertook missions in 1879 and 1881, was a scholar who later compiled a dictionary of Tibetan that is still in use today. He featured in Rudyard Kipling's *Kim* as Mookerjee. Other *pundit* explorers were murdered or disappeared, never to be heard of again. As these men travelled on their daring missions, they counted out their paces on 100-bead rosaries, instead of the normal 108-bead Tibetan rosaries, and they hid their notes inside prayer-wheels while computing altitudes by secretly placing thermometers at night into the boiling tea kettles of their Tibetan fellow travellers.

Among the Europeans who never made it to Lhasa mention must be made of the brilliant American scholar and diplomat William Woodville Rockhill. He spoke both Chinese and Tibetan and explored eastern Tibet in 1889. The result was one of the most enlightened travelogues ever written on Tibet and an accurate record of its customs and traditions. Travelling clandestinely into northeastern Tibet in the winter of 1888 through bandit-ravaged western China, Rockhill dressed in the manner of a Chinese and took the risk that ordinary Tibetans would assume he was Chinese, since hardly any Tibetans knew what a Westerner looked like. Although he got closer than Przhevalsky, Rockhill was eventually forced to give up before he could reach Lhasa.

After Rockhill came the Frenchmen Gabriel Bonvalot and his young photographer friend Prince Henri d'Orleans, who in 1890 were the first Europeans to cross the most inhospitable central section of the Changtang. For two months, the pair struggled at altitudes of more than 16,000 feet (5,000 m) without seeing another human being. Turned back from Lhasa, they then explored southeastern Tibet, crossing Kham and eventually reaching French Indo-China via Yunnan. This journey was all the more incredible because in the process they had become the first Europeans to traverse the feared Lop Nor desert flats in Chinese Turkestan.

Bonvalot was succeeded across the Changtang in 1893 by Dutreuil de Rhins and his companion

*Less than forty years ago, justice was harsh in the Tibetan world, as is demonstrated by this offender under guard in Bhutan. Robbery was punishable by the amputation of a hand, while those guilty of black magic had their eyes torn out. William Woodville Rockhill's travelogue records the many criminals, chained and wearing iron collars, he saw being transported for execution. The scene pictured here would therefore have been familiar to him.*

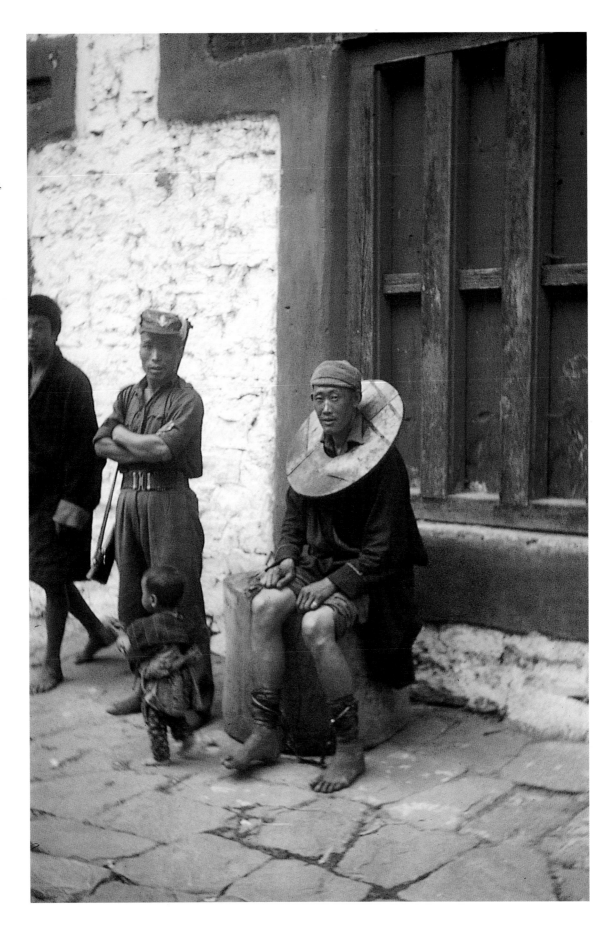

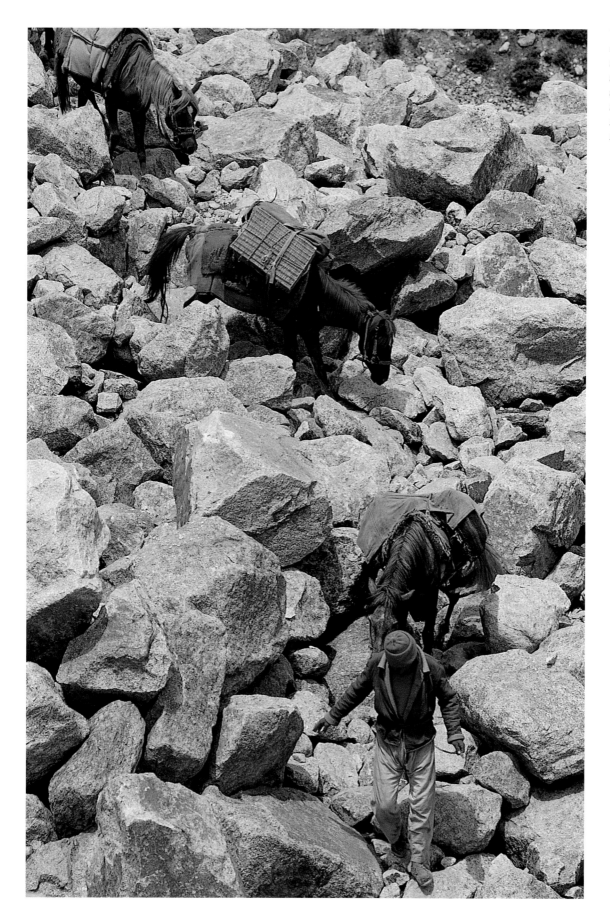

*There are few easy trails into the recesses of Greater Tibet. Here the pack animals are having to negotiate a tricky passage on the way down from the Shingo La on the road that links Zanskar with Lahaul across the Great Himalayan range.*

Granard, who continued eastwards after being refused access to Lhasa. They sought the source of the Mekong, which they nearly found, but in April 1894 Rhins was shot and killed by Khampas during a row over stolen horses. A century later, it was my good fortune to map the historical source of the Mekong to a place some 60 miles (100 km) further west.

Also in 1893, the British sent out the first of a series of young officers to collect information for what was to be the eventual invasion of Tibet in 1904. Captains Deasy, Bower, Welby and Rawlings, to mention only the most daring, all entered Tibet from Ladakh, which Britain had annexed in 1846. Last but not least of these intrepid Europeans was Sven Hedin, the great Swedish geographer who spent thirty years roaming Tibet. His work as a cartographer is prodigious, because he mapped thousands of miles of uncharted territory in Central Asia, including much of far western and northern Tibet. He too had to turn back when less than a week's travel from Lhasa. The formidable English couple Mr and Mrs St George Littledale and their nephew William Fletcher also deserve mention for enduring the worst of hardships for months on end only to be turned back a few miles from their elusive goal, Lhasa.

The Tibetan administration was incredibly efficient in stopping travellers and intruders. Officials posted in every key location (particularly the essential mountain passes) made it next to impossible for foreigners to hire animals or buy food without official knowledge or approval. The Tibetan ban on travel by foreigners to Lhasa was one of the many irksome points that led Britain's Lord Curzon, Viceroy of India, to embark on his infamous Tibetan adventure. Infuriated that his official letters were returned unopened by the thirteenth Dalai Lama and frustrated by the fact that Lhasa was closed to British subjects, not to mention suspicious that the Russian *tsar* entertained good relations with the Dalai Lama through the Buriat Mongolian Lama Dorje (the fabled Dorjieff considered by Curzon to be a Russian spy), Curzon and the British launched a military expedition in 1903. The force concerned eventually entered the holy city only to find it empty. The Dalai Lama had fled to Mongolia. This unfortunate expedition ended as a fiasco and scandal. Tibetans armed only with muzzle-loading muskets were mown down in their hundreds by troops using Maxim machine guns. The worst consequences for Tibet were only to be felt in the future, because in order to save face and to avert Russian interference, the British hastily declared that China was the only nation entitled to oversee Tibetan affairs.

In a separate development, the much-publicized British march into Lhasa merely enlarged the myth of secret Tibet rather than putting an end to it. Soldiers returned with fantastic and contradictory tales; for while some talked about Lhasa's squalor, others mentioned its splendour. The attractions of Tibet grew, because from that point onwards the only outsiders allowed into Tibet were, with very few exceptions, a limited number of British subjects. All foreigners were turned back by both the Tibetans and the British. Among the few excepted were the Greek Marco Palis and the Italian Guiseppe Tucci, probably the greatest scholar of Tibet in modern times. Later, the communists maintained the seal on Tibet's frontiers, until 1982 when the Chinese authorities allowed the first tourists into the forbidden city of Lhasa.

Now, with modern hotels to stay at, the holy city, devoid of the Dalai Lama, has lost some but not all of its ancient mystery and charm. Tibet has still relatively unexplored regions, with regions sufficiently unknown to quicken the pulse of an inveterate explorer such as myself, who was born in the lowlands of our unromantic modern world. Indeed, with very few exceptions, all those missionaries, spies, soldiers and early adventurers did not speak Tibetan and, if anything, they avoided all contact with the natives in case they were turned back. As a result, culturally and even geographically, there still remain unexplored areas of Tibet whose peoples and archaeological ruins are waiting to be studied. Thus it is that the Tibetan world, in spite of its being flooded with tourists, trekkers, Chinese officials and businessmen, still remains in places a land of mystery.

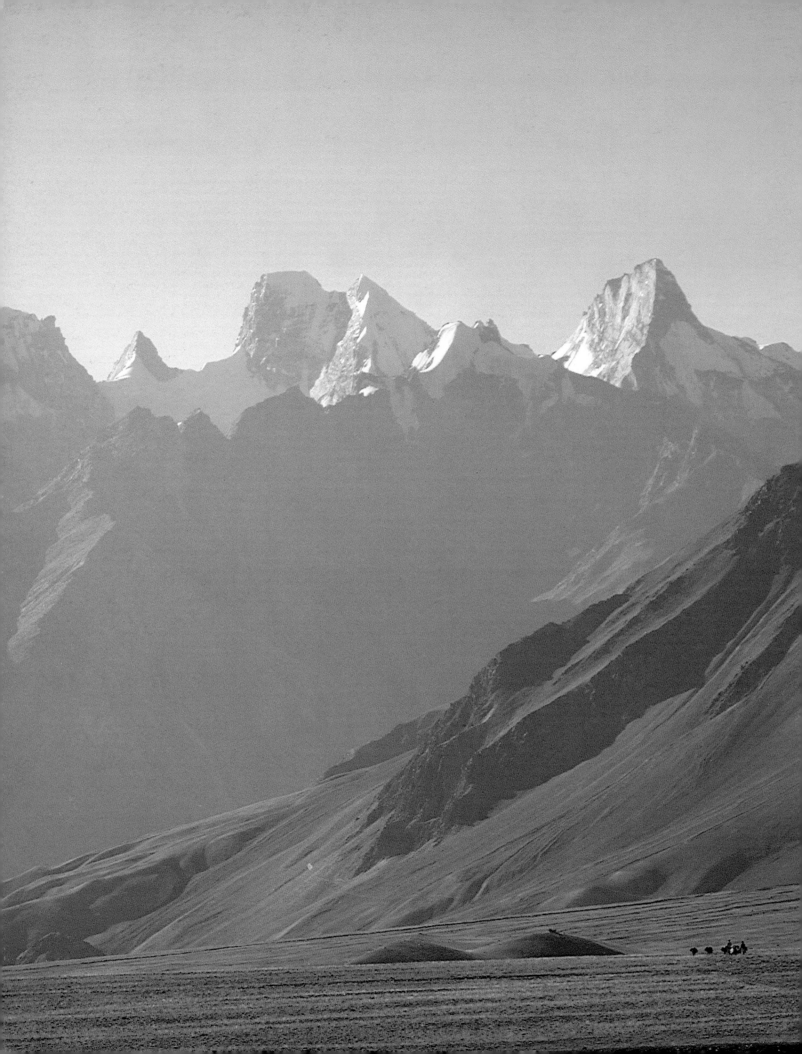

# 8 Plunder and Destruction

AT THE DAWN OF THE EIGHTEENTH CENTURY, Tibet was beset by aggressive Mongol-ruled territories. To the east, China was governed by the Manchu dynasty; to the northeast, the Qosot tribe of Mongols, allied to the Manchus, were established at Tibet's doorstep around Tso-ngon (Blue Lake), although they claimed to be the patrons of the Dalai Lama; to the northwest, the Dzungar Mongols were poised; to the west, the Muslims of Kashmir chafed under Moghul domination; while to the southeast, in India, the Moghul empire was well established in Delhi and Agra. Mongols notwithstanding, there was a further aggressive threat in the form of the newly expansionist Hindu Gurkha rulers of Nepal, warriors of Rajput descent who had fled into the Himalayas when the Moghuls conquered Rajastan. Starting in 1769, Prithvi Narayan Shah launched a war of conquest along the Himalayas, during which he unified Nepal and attacked Bhutan and Sikkim.

Within Tibet itself, the Panchen Lamas had grown in wealth and importance over the years. Against general expectations, the two principal religious leaders generally got on well and shared, so to speak, spiritual authority over Tibet – a Panchen Lama standing in for a Dalai Lama when he was young and vice versa. Thus in 1774, with the eighth Dalai Lama aged just sixteen, it was the Panchen Lama who received George Bogle, Britain's first envoy to Tibet, on a mission to encourage trade between the country and the British East India Company.

The Hindu Gurkhas took offence at this threat to their control of the centuries-old trade between India and Tibet, which added further to an existing tension deriving from a Nepalese–Tibetan dispute over the mintage of coins. Thus in 1788, the Nepalese invaded Tibet, egged on in their actions by the eighth Karmapa (1742–1792), still embittered at his school's defeat in the Tibetan civil war of 1641. The Nepalese advance was halted only by the promise of tribute, but when a year later the Dalai Lama refused to pay the second instalment of the tribute, the Gurkhas invaded again and plundered Tashilhunpo, stealing the jewels and gold that adorned the Panchen Lama's monastery.

This sacrilege infuriated not only the Tibetans but also the devout Manchu emperor of China who sent a retaliatory expedition to eject the Gurkhas. In 1793, the Chinese force pursued the Gurkhas across the Himalayas and down to Nagarkot, a small township close to Kathmandu. The Gurkhas were obliged to restore what they had looted and pay a tribute to the emperors of China. After this latest Chinese military intervention in Tibet's favour, the emperor decided to reinforce the control of his representative, the *amban*, over Tibetan affairs – but to little effect.

With the outbreak of the Anglo-Chinese War in 1840, China became seriously weakened and the Tibetans took advantage of the situation to reassert their independence. Tibetan affairs, however, continued to be the preserve of the nobles acting in conjunction with the powerful regents who exercised power in the place of the Dalai Lamas, a series of whom failed to reach their coming of age. In the process the *amban* was reduced to the rank of powerless ambassador, who could only, at best, spy on Tibetan affairs.

When in 1841 the Dogras of Kashmir invaded Guge in western Tibet, the Tibetans defeated them without any Chinese assistance and killed their chief Zorawara Singh, an adventurer at the service of the Hindu maharaja of the state of Jammu, south of Kashmir. Singh's force had rampaged across the ill-defended, Tibetan-speaking kingdoms of Zanskar and Ladakh, and also attacked Muslims in Baltistan (once a land of Tibetan Buddhists). After his death these territories would have reverted back to their local Tibetan-speaking rulers had Britain not been so quick to

*This modern wall-painting depicts Samye, the oldest Buddhist monastery in Tibet. It was at Samye in the mid-eighth century that a great debate was held on the question of whether Tibetans should follow the teachings of the Chinese or Indian schools of Buddhism. The latter prevailed and more than a millennium later Samye is still an active monastery, although officially the Chinese refer to it as a 'cultural institute'.*

grasp the opportunity presented by the situation. It approached the insignificant Hindu maharaja of Jammu – the now defenceless patron of the ill-fated Zorawara Singh – and offered to place him on the then vacant throne of wealthy, Muslim-dominated Kashmir. A hybrid Indian state called Jammu and Kashmir was then created – one which also included Ladakh, Zanskar and Baltistan. Thus, a Hindu puppet ruler found himself head of a Muslim and partially Buddhist state, and Britain thereby extended its dominion over many of the outlying areas of Greater Tibet. Today, more than 150 years later, Jammu and Kashmir remains part of India, but because it is mainly populated by Muslims yet ruled by Hindus from New Delhi, it has long been prone to outbursts of sectarian violence. As for the Tibetan-speaking Buddhists of Ladakh and Zanskar, it is the policy of the Indian government to try to wean them from their Tibetan roots.

## Tibet dismantled

By the mid-nineteenth century, one-time parts of Songtsen Gampo's empire were in the hands of China, Nepal, Bhutan and British India. Ladakh was not the only part of Greater Tibet now controlled by Britain, for the Treaty of Segauli signed with Nepal had given Britain control of the Tibetan-speaking regions of Karsha or Lahaul (from La yul or 'country of the gods'), Kumaon and the Machel district of the Gharwhal Himalayas, all located on the southern face of the Himalayas between Nepal and the new state of Jammu and Kashmir. Meanwhile, some 800 miles (1,300 km) from Kashmir in the eastern part of the Himalayas, the British were still embroiled in a war with the Bhutanese. After experiencing some difficulties, the British managed to secure the Sikkimese hill town of Darjeeling ('the valley of the thunderbolt') and the Bhutanese region of Kalimpong. Sikkim, a Tibetan Buddhist state founded in the sixteenth century, was then declared a British protectorate.

The slow process of the dismantling of the Tibetan world was well underway. Deprived of its western regions of Ladakh, Zanskar, Spiti, Lahaul and Baltistan, Tibet's eastern areas of Amdo and Kham were subject to periods of rule at the hands of Chinese warlords. On British and Chinese maps, Tibet was reduced to the central provinces of Ü and Tsang, Ngari in the west, Lhokha in the south, a small part of Kham around Chamdo, along with a vast, seemingly useless tract of the uninhabited Changtang. Then, in 1855, Nepal invaded Tibet once again and forced it to cede Kyirong and Khuti, while it also made claims to Mustang. Although Nepal did not forcibly take over these regions, which remained virtually independent, they were lost to central Tibetan government control.

A great many of these changes existed only on paper, because few Nepalese, British or Chinese administrators dared to brave the mountain climate in order to make their presence felt on the ground. There were no British or Indian representatives residing in Zanskar or Spiti and envoys made only infrequent trips to Ladakh, where the king appeared to rule much as he had before. Similarly, in most of Amdo and Kham, Chinese officials were hard to come by and any that were encountered were rarely respected. The local Tibetan princes continued to live their feudal lives unmolested, remaining independent Tibetan entities within the shelter of their almost inaccessible valleys.

This state of affairs was to last until relatively recently. During my early journeys to Mustang, Zanskar and Ladakh during the 1960s and early 1970s, there still existed medieval Tibetan societies that were being ruled by their traditional kings. As an old woman in Mustang asked me in 1964, 'Please tell me under whom are we?' – a good question, as it happened, because at the time the country was a base for Tibetan guerrillas fighting the Chinese who, along with Nepal, were claiming Mustang as theirs, while at the same time in the capital of Lo Mantang there resided the traditional king of Mustang.

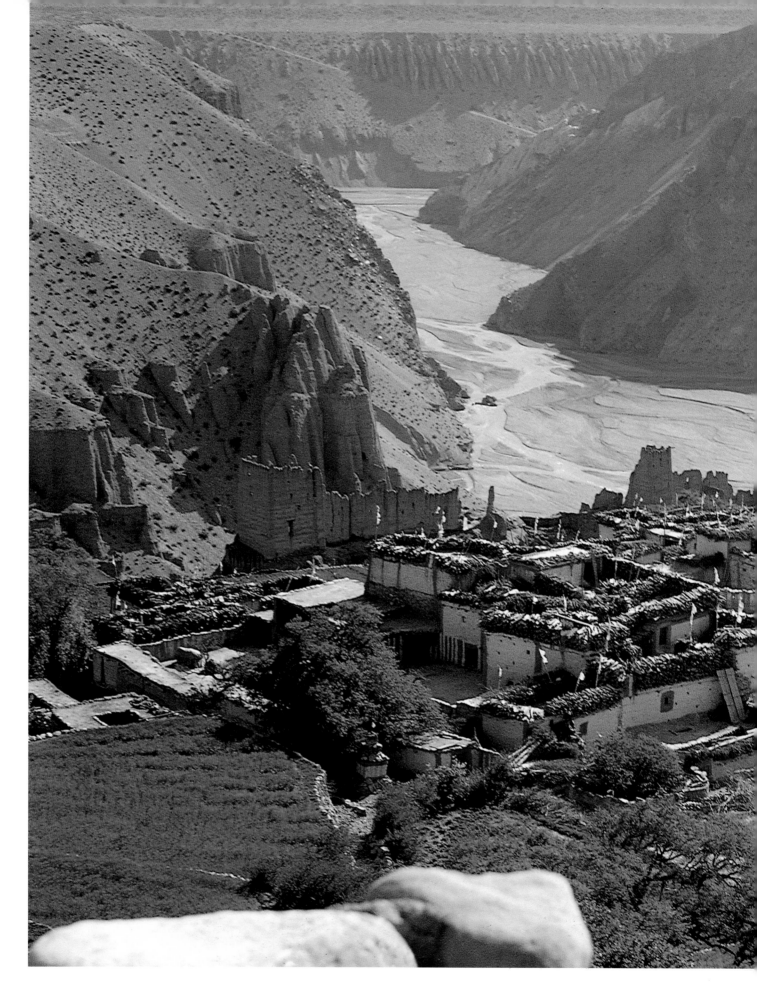

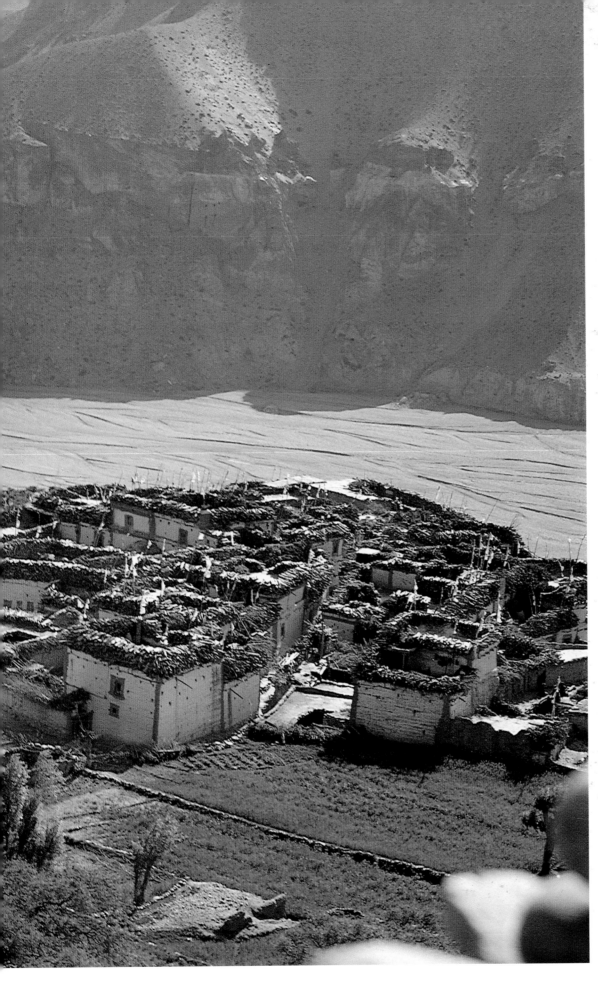

*The ruined great fortress of Tayen stands as a silent sentinel overlooking the trade route that links the plains of India with Mustang and central Tibet.*

The loss of more peripheral areas of Tibet did not, however, prevent central Tibet from continuing to reassert its independence from Chinese interference. That this was achieved owed much to the skilled management of affairs by the thirteenth Dalai Lama, one of the most important and astute leaders Tibet has ever had. Born in southeast Tibet in 1876, Tubten Gyatso was discovered when he was three years old. As with all Dalai Lamas, this was the result of a quest participated in by the state oracle and dozens of monks. Finding the reincarnation of a *lama*, particularly the Dalai Lama, is a complex process, exacerbated further by the need for tacit approval from the Chinese emperor, who remained the patron of Tibetan Buddhism – this 'need', however, was often disregarded. The young child also had to be acceptable to the regent and the richest lay nobles of Tibet, with the latter playing a leading role in the daily administration of the country by means of the Dalai Lama's cabinet or *kashag*.

Tubten Gyatso was enthroned as Dalai Lama in 1895 and was to become known as 'the great thirteenth', the man who rid the land of the cumbersome presence of the Chinese – who had been loosely established in Tibet since 1720. The thirteenth Dalai Lama also had to face up to the threat posed by the European colonial powers, which by the second half of the nineteenth century were encroaching ever more on Tibetan territory. To the north, Russia was expanding across Siberia after having conquered and seized Khiva, Bokhara, Khokand, Khazakstan and Tashkent before reaching the borders of Manchuria and entering Alaska. The Russian advance was common knowledge in Lhasa, where many of the new Buddhist subjects of the *tsar* came to study. Likewise, the actions of the British were well known through the traders who came up to Lhasa from Kalimpong and Darjeeling, bringing wares as well as tales from Calcutta, the capital of the British Raj.

Concerned by these developments, the Tibetans regarded the so-called scientific expeditions mounted by Western cartographers and suchlike as vanguards of colonialism and objected to what they felt were unwelcome intrusions. The world's 'great powers' had overcome many greater obstacles in pursuit of their objectives and it proved to be irritating to them that so many scholars, diplomats, priests and adventurers were being thwarted by what many people dismissed as a powerless religious state. Britain's Lord Curzon, Viceroy of India, feared what the Russians might be intending to do, but he was also aware of the difficulties presented by the terrain in the Himalayas. The Gurkhas had demonstrated the valour and skilled fighting abilities of the local men in Nepal, and a similar scenario prevailed in the mountainous territories of Afghanistan. Tibet remained one of the few lands in Asia where Westerners were neither gods nor masters.

**Britain invades**

Despite such topographical ill omens, Curzon used every resource at his command to persuade the British government to launch an invasion of Tibet. Although there was a great deal of opposition to the plan, Lord Curzon prevailed after having demonstrated that if the British did not assert some degree of control over Tibet then the Russians would – perhaps as a result of a secret deal with the Chinese. Curzon argued that it was essential for Tibet, like Nepal, Bhutan, Sikkim and Kashmir, to be turned into a 'buffer state', a sort of no man's land between the British and the Russian empires.

Thus, in 1903, the British embarked on what was to prove a shameful adventure, the outcome of which was eventually to prove detrimental to both Tibet and British India. The Tibetans had become understandably aggrieved at this point by what they suspected were dealings between China and Britain about Tibet's future. The pretext for Britain's entry into Tibet was a minor incident over grazing grounds along the Tibet–Sikkim border when Tibetan herders were accused of removing little stone cairns that marked the border.

A small detachment of Indian soldiers under Francis Younghusband, Curzon's man and a veteran of the European struggle in Asia that was known as the Great Game, was sent up to the border to mount a show of force and open negotiations with the Tibetans. Nothing resulted from this and a frustrated Curzon felt that the Tibetans' obstructiveness merited a full-scale military mission (he referred to Tibet as 'a petty power which only mistakes forbearance for weakness'). He did so despite the prospect of Russian intervention receding during the same period, a trend further confirmed with the outbreak of the Russo-Japanese War in February 1904.

In December 1903, a British expeditionary force (which included Gurkhas and Sikhs) duly entered Tibet by crossing over the Dzaleb La (Jelap) Pass. The British brigadier-general in command, James MacDonald, was a cautious officer and from the start there were disagreements as to what exactly the British hoped to achieve and who was in overall charge of the operation – the senior, and popular, diplomat Younghusband or the military man MacDonald. It was to be unfortunate for the Tibetans that a whole new generation of weaponry had just been developed – among them the Maxim guns that equipped two whole detachments of British soldiers.

The British marched slowly onto the high and frigid Tibetan plateau, wintering up above 15,000 feet (4,600 m). It was hoped contact could be made with the Tibetan authorities and bloodshed avoided. Younghusband took considerable risks in going practically unarmed to meet with the Tibetan commanders to discuss matters, which included the conditions under which trade could commence – but all to no avail. In the meantime, although it was unknown to the British, the Dalai Lama had fled to Urga (modern Ulan Bator) the capital of independent Mongolia, which was controlled by a Tibetan, the Grand Lama of Urga.

**Bloody massacre**

The British advanced cautiously, aware that the Tibetans had previously lured invaders deep into their land before attacking them. The force proceeded into the Amo-chu, or Chumbi, Valley and beyond Sharsingma (Yadong), the capital of Dromo county. Word reached MacDonald that a Tibetan army awaited them at the town of Phari Dzong, but the fortress there surrendered without any resistance. The weather now deteriorated and the mood began to change following the arrival of hostile monks from Lhasa. The aristocracy in Lhasa had assembled an ill-trained band of peasants whom they equipped with archaic matchlock muskets, swords and some rifles. The British force negotiated the Tang La Pass en route to Duna, which it reached in January 1904 after experiencing bitter below-zero temperatures and icy winds. To preserve supplies, the British group now split – with MacDonald retiring across the pass – despite the news that a Tibetan army was assembling ahead at Guru.

By late March, orders and the supply situation had led to the British force reuniting, ready to advance. Obeying their commander's orders to block the invaders, the 1,500-strong peasant army at Guru had erected a stone wall in the valley. When the British armed force reached the wall, it found itself confronted with Tibetans shouting that it should come no further. For some time, a stalemate ensued and a non-hostile atmosphere prevailed. Neither side wished to initiate hostilities, but when the much smaller British force started trying to disarm the Tibetans, a shot rang out from the Tibetan commander. Within seconds the Maxim guns had opened up on the poorly equipped Tibetans and a massacre had begun. Before the eyes of the British officers, soldiers and accompanying reporters, the compact Tibetan army was literally mown down at point-blank range. The Tibetans retreated slowly, even while under fire, leaving hundreds dead and wounded. There was not one fatal British casualty.

The British established a field hospital to treat the Tibetan wounded, but the campaign continued. The British advanced cautiously to the fortress town of Gyantse, then the third largest

settlement in Tibet. Here and elsewhere in the vicinity, the Tibetans made further stands and incurred more heavy losses. As the invading force neared Lhasa, the determination of the courageous but ill-armed Tibetans increased while the British became bogged down. This was partly a consequence of MacDonald's caution and partly through the laudable desire of Younghusband to limit the carnage and negotiate. Eventually, superior firepower and feats of arms broke the morale of the Tibetans and in August 1904 the British proceeded unopposed into the mysterious city of Lhasa. Apart from the magnificence of the Potala Palace and the grandeur of the monastery's gilded halls, the British were sorely disappointed with Lhasa, which most men considered to be dirty and squalid. Others were impressed by the dignity of the cultured religious and lay elites and the refined, soft-spoken manner of the Tibetans – an attitude felt to be in contrast with their scruffy appearance. Yet rather than such deflating reports serving to destroy the myth of Lhasa, the forbidden city, the widely reported British mission actually helped to popularize Tibet as a land of mystery.

Younghusband secured an 'agreement' with the Tibetan authorities by which the British were to occupy the Amo-chu Valley in Dromo until a huge indemnity was paid. Meanwhile, in Britain there had been a change of both government and policy and Younghusband was reprimanded for having exceeded his brief (to proceed to Gyantse). The government did not wish to upset the balance of power in Central Asia by antagonizing the Russians, so the indemnity was lowered and the British troops withdrawn. These events did not, however, signify any gains for the Tibetans. Instead, matters got considerably worse because Britain recognized China as Tibet's suzerain. This opinion was then given status with the Anglo-Chinese Convention of 1906 and the Anglo-Russian Convention signed a year later – both undertaken without Tibet's consent and effectively offering Tibet as a vassal state to China.

## China exercises its claims to Tibet

Of the 1906 convention, Hugh Richardson has observed, 'Chinese rights in Tibet were thus recognized to an extent to which the Chinese had recently been wholly unable to exercise them'. In short, by acknowledging Chinese suzerainty over Tibet the British hoped to save face and dissuade the Russians from entering Tibet. This selling-off of Tibet was quite unjustified and it angered the Tibetans. Led by the thirteenth Dalai Lama, they immediately attempted to redress the situation. Even so, after 1950 it was to be these British conventions that gave partial justification to claims made by the Chinese that Tibet had long been theirs.

The British invasion having weakened Tibet, the Chinese began to prepare to assert their 'suzerainty'. First, a proclamation was issued that deposed the Dalai Lama (who was then still in Mongolia). In Amdo, while en route back to Lhasa, the Dalai Lama was 'invited' to meet the emperor in Beijing. Once there, the Chinese humiliated him by refusing to treat him as a head of state, and they reprimanded him when he visited the heads of various foreign legations. As the Dalai Lama was making his way home to Tibet, a well-armed Chinese army led by General Chao Erh-feng swept into Kham, while another detachment beat the Dalai Lama to Lhasa by entering from the north.

General Erh-feng's force made its way through eastern Tibet, killing anyone who resisted. The Dalai Lama appealed to the British for help and sought sanctuary in Sikkim, prior to going into exile in Darjeeling, the Sikkimese district incorporated into British India. At the same time, thousands of ordinary Tibetans fled ahead of the Chinese invasion force and went south to tropical Pemako, a place cited in the Tibetan scriptures as a refuge, a holy paradise on Earth. Alas, many of the refugees were to die of starvation and dysentery in an unfamiliar realm inhabited by fierce, monkey-eating Abor tribesmen.

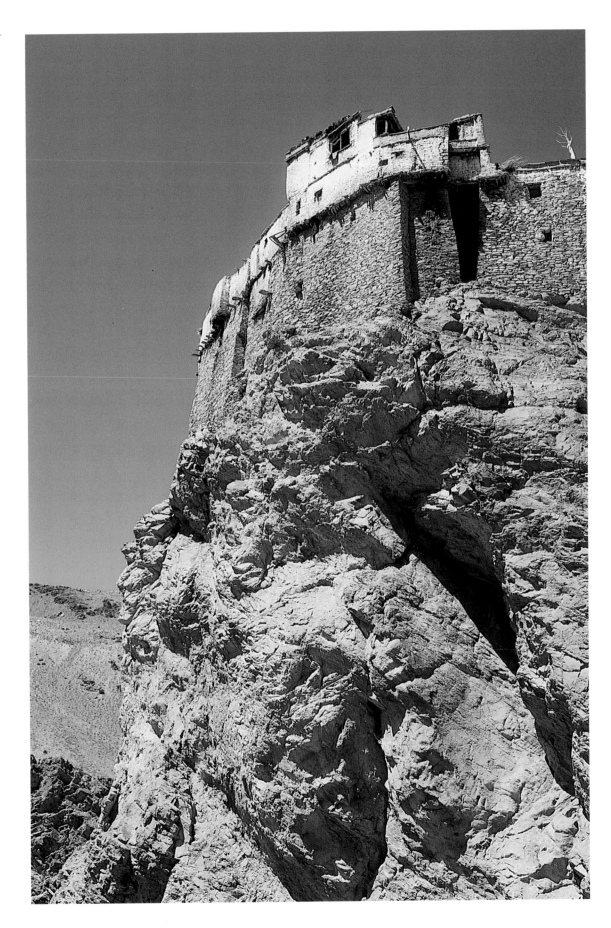

*The small, fortified monastery of Bhardan in Zanskar sits atop a craggy outcrop, where it guards the access route to the kingdom from the south. The isolation of most valleys in Greater Tibet made them vulnerable to marauding armies and bandits, which explains why so many villages, monasteries and palaces were fortified and built high on hilltops.*

# Murals and *thangkas*

**Tibetan Buddhism has a vast pantheon** of gods, spirits and demons, which presents artists with a wide choice of subject matter when they adorn the walls of chapels and monasteries. Although these gods and demons originated in India, Tibet quickly developed its own identifiable artistic style, with distinct regional variations that reveal the underlying influence of Tibet's three major neighbours. For example, one can distinguish a Kashmiri influence at Alchi in Ladakh, where the surviving wall-paintings of the Mahayana pantheon form the most important early Buddhist monuments in the western Himalayas. At Sakya in central Tibet a Nepalese style can be discerned, while in the far northeast one detects the influence of China.

Even so, a strong common bond unites the various styles of Tibetan paintings, whether they be murals or illustrations upon linen scrolls, known as *thangkas*. For example, all are religious in purpose rather than decorative. The deities and saints depicted are brought to life by prayers, and the images are hung according to ritual practices. In fact, some images can be viewed only by initiates.

Until recently, the colours used in Tibet were derived only from the minerals that were available in the area of the monastery, or acquired by trading. These were employed by the artist along with gold leaf and, more rarely, silver paint. Although most artists were monks and the themes were traditional, this did not prevent some masterful practitioners from acquiring considerable fame and stamping their distinctive works with the mark of their individual genius.

1, 2. Two details of a fine nineteenth-century Tibetan painted scroll on which are depicted the major monasteries of the Sakyapa order. Note the dozens of tiny characters, armies, monks, *yogins* and divinities. Such scrolls were often hung up in village squares by itinerant monks or bards who used them to relate stories for their audiences.

 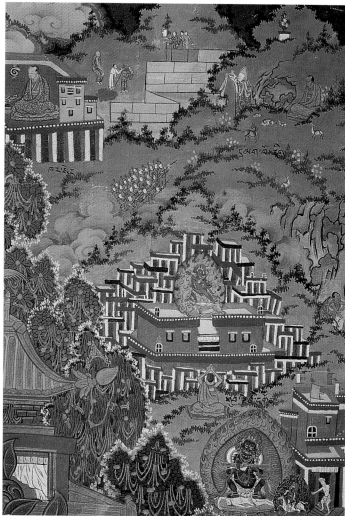

1    2

3

4

3. The incomparable colours and refinement of one of the thirteenth-century murals from the main chapel of Alchi monastery in Ladakh.

4. A fine gilt image of Ngawang Namgyel of the Bhutanese Drukpa Kagyu order who established the theocratic state there in the seventeenth century.

5. A fine, rare seventeenth-century *thangka* depicting the great Sakyapa *lama* Ngorchen Kunga Zangpo, who founded the independent-thinking monastic retreat of Ngor Evam Chokden.

6. The painting of wood or stone sculptures is a complex task. The sculptures themselves are very holy objects, because they are a living presence of what they represent. This sculpture is the figure of a god achieving perfect union with a goddess, thereby potently combining opposites.

7. Wooden blocks are used not only for printing books, but also to make illustrated posters and to impress images and prayers onto cotton cloth, which can later be hung up as 'prayer flags'.

5

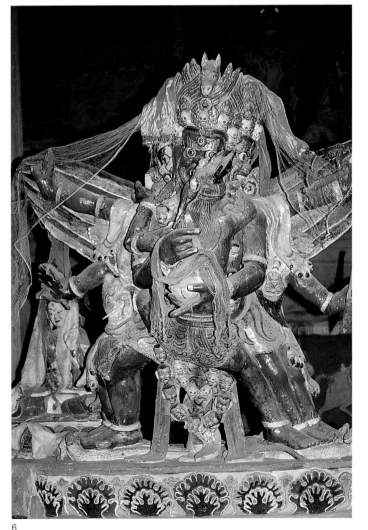

6

7

# The rich symbolism of the Jokhang

**The first temple erected in Tibet** was the House of Jowo, that is 'of the Buddha', the holiest shrine in the country. Building began here in the early seventh century and, despite recent aggressions, it still stands today at the very heart of Lhasa. The Jokhang is said to have been erected deliberately on what is believed to be the main geomantic site in Tibet.

For nearly fourteen centuries pilgrims have flocked here from all over the Tibetan world. The Jokhang is the focal point of their faith, not the more recent Potala Palace nor the other important sanctuaries to be found in the town. The temple, which has been enlarged over the centuries, contains hundreds of chapels that shelter priceless, ancient jewel-studded images of the Buddha and saintly *lama*s. Some chapels were part of the original seventh-century temple and still bear wooden beams carved in Nepalese style. The elaborate gilt-copper roofs were expensive gifts from a Mongol prince, a Chinese emperor, the king of Guge and other dignitaries. On the first floor stands the statue of Songtsen Gampo, restored after having been abused by Chinese soldiers, when in 1959 they battered down its doors using armoured cars and set the building alight.

1. The Jokhang seen from the Chinese-built plaza that was cut out of the old town. In 1987 and 1989 it was here that there was a massacre of hundreds of monks and civilians by the People's Armed Police.

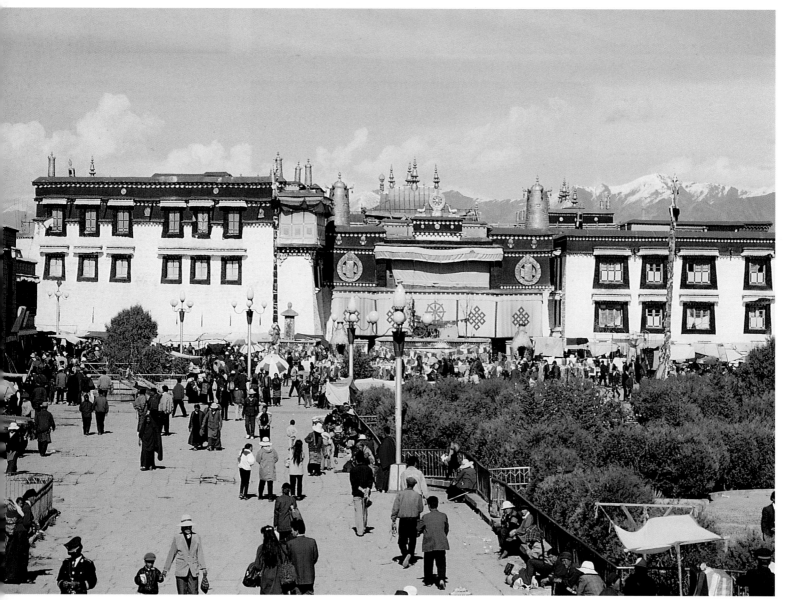

1

2

3

4

5

2. Two gilded deer ready to be placed upon a temple roof.

3. Very ancient Nepalese-style carvings, (possibly seventh century) inside a minor chapel in the Jokhang.

4. Pilgrims sit before an ancient stele from 823 that recalls the days, now long gone, of Sino-Tibetan friendship and mutual respect.

5. A heavily restored image of Songtsen Gampo, missing his characteristic moustache. The photographs of the Dalai Lama are symbols of ordinary Tibetans' defiance and independent spirit.

# Labrang Tashikyil monastery

**The monastery of Labrang may well** have seen Marco Polo travel by on his way to Cathay, standing as it does in the far northeast of Amdo, which today means it is inside the Chinese province of Gansu. Polo was intrigued by the monks in the region, particularly because of their astronomical devotions and hard way of life. Founded in the early eighteenth century, it remains a tough environment because it lies at an altitude of 9,200 feet (2,800 m) and experiences the most severe winters.

Labrang Tashikyil is one of the great monasteries of the Gelugpa order, famous for its medical college and its library of 20,000 books. One of the largest Tibetan monasteries to have escaped destruction, it once housed 4,500 monks and today still has more than 1,500. A location close to the Silk Road and to China inevitably brings to mind the once-close bonds between the Mongol emperors of China and the Dalai Lamas, who were then the official spiritual heads of both China and Mongolia. Massive settlement of Chinese citizens around Labrang has made the local Tibetans into a minority in their own territory and transformed the monastery into something of an anomaly. Although the relative wealth of the Tibetan nomads of the region has enabled the monks to maintain the site's many fine buildings.

Pilgrims from China, Tibet and Mongolia still visit the monastery in their thousands. This recalls the ancient role of Tibetan monks as diplomats who for centuries helped smooth relations between the various Mongol factions and those established upon the Chinese imperial throne.

1. Labrang has a number of colleges and temples, as well as several large assembly halls that reveal the splendour of its awnings. Tibetan architects drape their buildings with awnings, canopies and exterior window frills. Many doors and windows are covered with exterior canvases offering reminders of the nomad origins of many Tibetans.

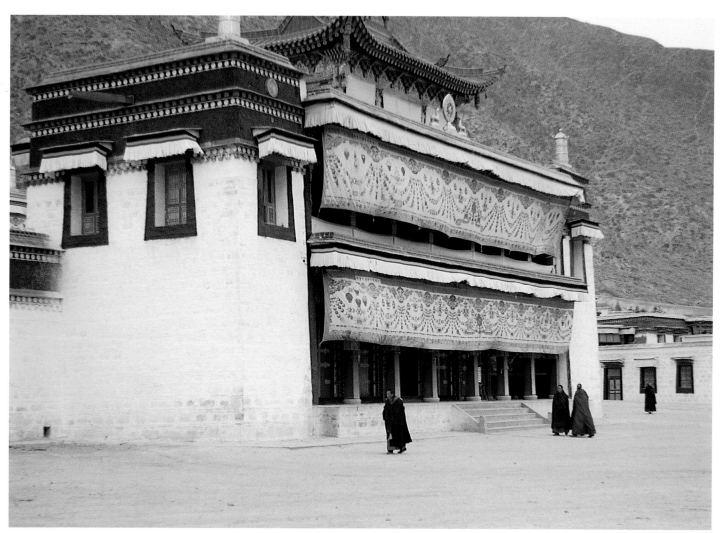

1

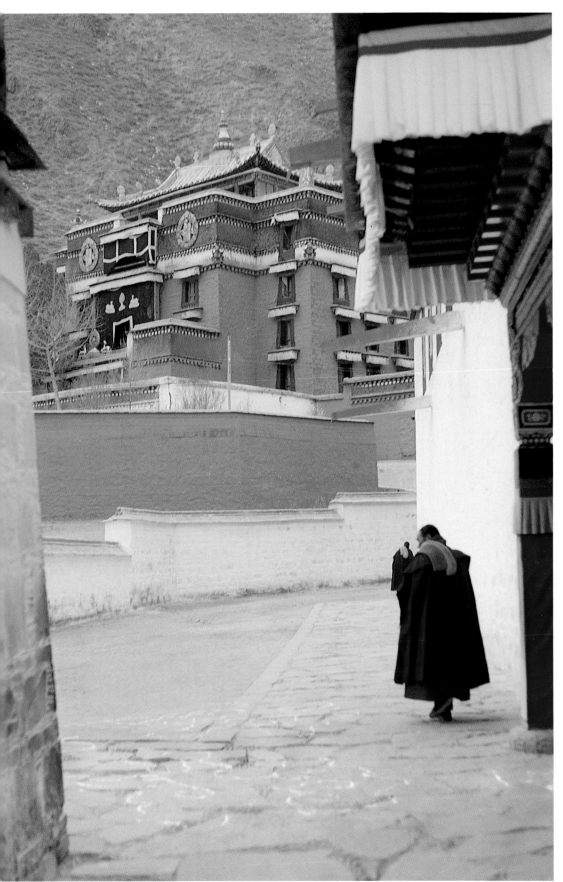

2

3

4

2. A police-monk, his shoulders padded, keeps an eye on what is going on from his position beneath the Golden Temple, one of the eight notable temples of this huge monastery.

3. Young novices carry water to the kitchens of the main assembly hall.

4. In the depths of winter, monks huddle before the door to their assembly hall, clad in their warm homespun gowns while they await the arrival of their abbot.

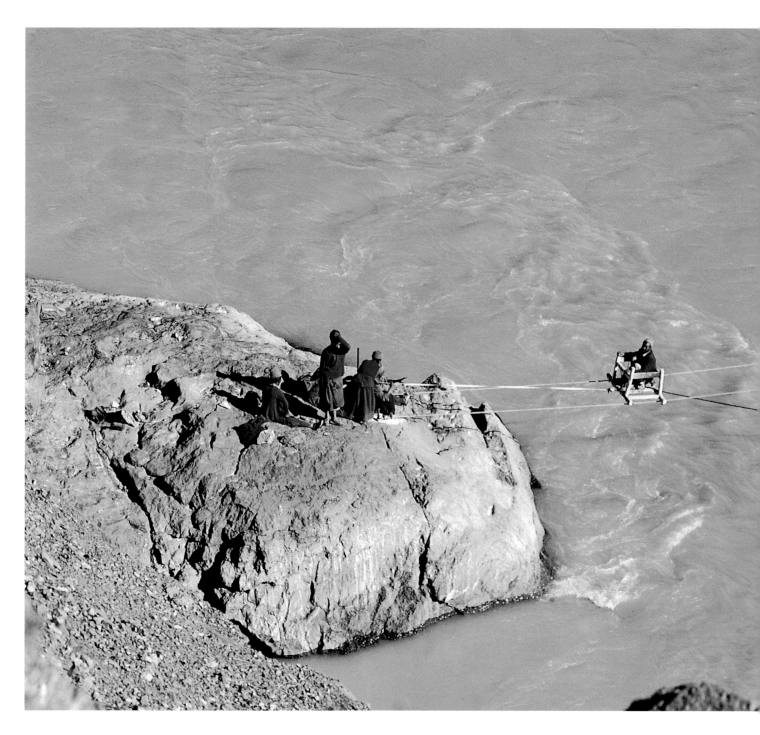

*Nothing will stop Tibetans who are determined to cross a river. These monks are experimenting with a semi-modern contraption that looks truly perilous — one would imagine the box would be safer if it were hanging beneath the steel cables.*

This was the first time ever that a Chinese military force had entered Lhasa uninvited but, although it succeeded militarily, the Chinese were unable to assert political control, because the following year, in 1911, revolution broke out in China and in 1912 the Manchu dynasty was overthrown. Seizing the opportunity afforded by the confusion in China, the Dalai Lama returned to Lhasa and reasserted Tibet's independence. He expelled all Chinese subjects from Tibet and formally reminded the new Chinese republic that Tibet was and always had been an independent state, and that even if the Mongol and Manchu emperors had been patrons of Tibetan Buddhism this in no way gave China any rights over Tibet's affairs, foreign or domestic. The Dalai Lama then began to look to the Western world, and particularly Britain, for help to modernize Tibet's army and administration.

## Tibet's mission to modernize

During his exile in Darjeeling, the thirteenth Dalai Lama had learned a lot about the West and the need for Tibet to enter the international community of nations. This was thanks to the efforts of Sir Charles Bell, a scholar of Tibet and Britain's political officer to Sikkim. As part of a modernization plan, the Dalai Lama appointed a brilliant young noble called Lungshar to accompany twelve, amply funded Tibetans to study in England. He then asked his favourite, Tsarong (who at just twenty-two had fought a rearguard action that had enabled the Dalai Lama to escape the invading Chinese), to proceed with a reformation of the Tibetan army, whose medieval equipment had been shown to be so inadequate against both the British and the Chinese.

The Tibetan government asked the British to supply them with rifles, machine guns and light artillery. This request was only partially granted because of the outbreak of war in Europe in 1914. Nevertheless, the rifles that were shipped permitted a sufficient enough improvement in Tibet's army to enable it to attack and drive out the Chinese from western Kham.

The British were then asked to mediate between the Tibetans and the Chinese in the settlement of territorial disputes over Kham. This eventually led to a joint, three-way conference in Simla, India, with the purpose being – apart from Kham's borders – to gain full recognition of Tibet's independence, to have Britain repudiate its Anglo-Chinese Convention of 1906 and to revise trade agreements with Tibet. This was a lot to hope to accomplish, and in this respect the conference was a failure. The Chinese refused to ratify the demands of the Tibetans. In the end, though, the British signed a separate agreement directly with the Tibetans, thus excluding China from whatever benefits they might have accrued had they signed something at Simla. In this agreement, Britain formally recognized Tibet as an independent state, a status it would later deny when British interests lay elsewhere.

The thirteenth Dalai Lama sought to fund his strengthening and enlarging of the army by raising more tax revenue. This met with strong opposition from conservatives, who were led by the heads of the principal colleges of the three great monasteries in Lhasa – Sera, Ganden and Drepung. These monasteries had more than 15,000 monks, almost half the population of the Tibetan capital. Each institution was an independent fiefdom with its own arsenal and an army of *dobdob*s or warrior-monks, so naturally they frowned at any increase in size for the regular army under the leadership of Tsarong.

Most of the initiatives to modernize Tibet failed to find favour with the majority of monks. Already there had been considerable opposition to the sending of students to study in England, where it was believed they would be contaminated by Christian thought and modern ideas. The favour the reformist figure of Lungshar curried with the Dalai Lama caused considerable jealousy (as was later to become apparent in a tragic way), and as the years passed any opposition to 'progress' was equated with anti-British attitudes, while China was felt to stand for conservatism.

Eventually, this bipolarization was to have disastrous consequences, with the Chinese quick to use it to their advantage, mainly by backing the Panchen Lama and trying to set up him and his followers as a rival force to the Dalai Lama. In 1923, the ninth Panchen fled to China where he formed a cloud on the horizon of the thirteenth Dalai Lama's otherwise strongly independent rule – for the danger lurked that the Chinese might invade Tibet yet again under the pretext of backing the Panchen Lama.

Lhasa, with only 35,000 inhabitants, was a hive of intrigue akin to Byzantium or the Vatican during the time of the Borgias. In this complex world, meshed by intricate alliances that set rival religious institutions and court factions against one another, the pivots were the Dalai Lama, the Panchen Lama, the regents, the heads of the great landowning aristocratic families, the various religious hierarchs and the heads of the colleges of the three main monasteries at Sera, Ganden and Drepung.

In addition to successfully criticizing Lungshar's initiatives (to the extent that the schoolchildren in England were recalled and never allowed to put into practice what they had learnt abroad), the monks attacked Tsarong not only for having modernized the army but also for wearing European clothes and introducing to his household, and eventually Tibet, modern technology such as electricity and a steel-girder bridge. As a result of these critics, in 1924 Tsarong fell out of favour and was relieved of his functions.

Earlier, in 1922, an attempt to set up a school in Gyantse to be run on British lines by British teachers was sabotaged by the conservative, xenophobic monks in Lhasa and closed. After this little or nothing was done to help Tibet join the twentieth century. A closed-door policy was maintained, although Lhasa did retain a small diplomatic community composed of a British representative, an embassy from Nepal and a Chinese *amban*. Yet visitors were few and far between, with most of them uninvited and then promptly expelled. The thirteenth Dalai Lama could only dream of a modern, independent, united Tibet.

Relations with China remained tense because of the drawn-out dispute over China's claims to the regions of Amdo and Kham, both of which were incorporated, on paper at least, in the mid-1920s into the two largely fictitious Chinese provinces of Qinghai and Kanting, tyrannized rather than ruled by opium-smuggling warlords over whom the central Chinese government had little or no control.

Interestingly, it was in Kham and Amdo that Mao Ze-Dong sought refuge at the start of his famous Long March in 1936, a journey on which he was assisted by the Tibetan Khampas and even aided by the head of one of Kham's large monasteries, all only too pleased to help fight the corrupt Chinese warlords. In 1929, the Pandatsangs, a rich merchant family, led an uprising against the Chinese presence in the Litang area of Kham in which the Chinese were forced back to the border of Sichuan. In spite of these successes, the situation in Tibet remained precarious, with rival religious factions and political weakness the products of theocratic rule.

The Dalai Lamas were generally more preoccupied with religious affairs rather than secular, political issues. Furthermore, the doctrine of Buddhism in general, and Tibetan Buddhism in particular, emphasized the importance of spiritual over material values. The latter were considered to be of little importance to those seeking to attain *nirvana* and achieve perfection. It could be argued that Tibetan potentates invested with both spiritual and temporal authority were easily swayed by their own personal causes rather than the welfare of the nation, and that it was this preference that led them to invite in Tibet's traditional enemies, be they Mongols, Manchus or Chinese. The ordinary citizens had little or no voice in matters of state. The Dalai Lama exercised power without any popular, political endorsement in the liberal democratic sense, but rather as a result of the military might of their foreign 'patrons'.

## Death and intrigue among the Dalai Lamas

In spite of these weaknesses, under the energetic rule of the thirteenth Dalai Lama, Tibet had gained the recognition of *de facto* and *de jure* independence, at least from Great Britain, at Simla. Then, suddenly, the Dalai Lama died in 1933 after the briefest illness. This was a tragic loss that plunged Tibet into yet more medieval intrigues. The revenge of the conservatives began with Lungshar, the progressive aristocrat. He was singled out because of his desire to overhaul the basic structure of the Tibetan government. After inscriptions of secret *mantra*s were found in his boots, he was accused of black magic and witchcraft and in 1934 his eyes were gouged out. It was a clear warning for those who might feel inclined to encourage reform and modernization.

To oversee the search for a new Dalai Lama, the twenty-four-year-old incarnate *lama* of Reting was named as the all-powerful regent. Much admired for miracles he had performed in his youth, Reting was a popular congenial figure. After consultation with the state oracle, the fourteenth Dalai Lama was located more than 1,000 miles (1,600 km) from Lhasa in a little village called Takster, situated less than 30 miles (50 km) from the great monastery of Kumbum Jampaling, the original seat of Tsongkhapa who founded the Gelugpa order, to which the Dalai Lamas belonged.

Ma Pu Feng, the Muslim warlord governor of Amdo-Qinghai who ruled from Xining, just 30 miles (48 km) northwest of Takster, refused to allow the young Dalai Lama to go to Lhasa until he had received payment of 100,000 Chinese silver dollars. When this sum was promptly handed over, the dishonourable warlord requested 300,000 more. Thus it was only in 1941 that the fourteenth Dalai Lama, Tenzin Gyatso, entered Lhasa with his large, recently ennobled family.

Today, the Dalai Lama (a Mongol term, for which the Tibetan is actually Gyelwa Rinpoche) is a familiar figure in the West, but what is less well known is the context in which he was raised as a child, surrounded by courtiers and the representatives of conflicting pressure groups. On the one hand there was the lay aristocracy, while on the other was the religious hierarchy, dominated by the heads of the three major monasteries. In between stood the *kashag*, the Tibetan state council, overseen by the regent who controlled the young Dalai Lama. Murder was not unknown.

The Dalai Lama was only partially shielded from these intrigues by Reting, his regent. Reting was then obliged to resign in 1941 because of apparent womanizing, something that conferred on him an impure status and rendered him unable to receive the vows of chastity of the young Dalai Lama. Reting handed over power to a friend, the respected sixty-two-year-old *lama* Takdra. Reting expected more favours from Takdra and decided to try to eliminate him when these failed to materialize. The plot failed and Reting was jailed, where he was mysteriously assassinated in 1947 when the present Dalai Lama was but thirteen years old.

## Violent and divided land

Such events served to show that life in Lhasa was complex, feudal and often cruel. Intrigues and ghastly, untimely ends provided an uncomfortable backdrop for the intensively meditative Dalai Lamas, who abhorred violence. Lhasa was the stage where all the conflicts of a divided land were played out; a land divided geographically by distance and mountain ranges, and rent further by politics into innumerable factions and by religion into a variety of orders. Sectarian influences in Tibet fuelled constant internal conflicts. Tibet needed a Cavour or Bismarck to reunite the once great nation of Songtsen Gampo; alas there arose no great leader, and Tibet's young Dalai Lama sought refuge in religious study rather than political reform.

Tibet's legal system remained archaic. To punish transgressors there were three courts of justice: the royal court, the religious tribunal and the village councils. In Lhasa during the nineteenth and twentieth centuries, the religious tribunals were the most important. Crimes were punished by the amputation of limbs: for example, a finger if one had pointed out and derided monks, the removal

of a hand for theft, which also required the restitution of 100 times the value stolen if the offence was against the head of state, eighty times if it was against the monasteries and only nine times the value of the money or object stolen if the victim was a layman. The gouging-out of eyes was also a traditional punishment, although one rarely enacted, less so at least than the crippling of hands or feet by encasing them in wet leather mittens that crushed bones and tendons when they shrank. The death penalty was never applied to monks, but highway robbers and cattle-rustlers were usually beheaded on the spot. Imprisonment with little or no food and water was a convenient way of disposing of one's enemy without openly taking life.

Such severe sanctions had a strong deterrent effect. Daily violence and rampant habitual criminality was alien to Tibet, with the possible exception of the highway robbers who abounded in the remote regions. These brigands were often tribesmen defending their territory or levying from caravans what they saw as a tax, one that provided their only means of acquiring arms and other goods. The Golok had the worst reputation for this behaviour and to cross their land one had either to be armed or to be ready to pay up. Travel in Tibet had always been a slightly dangerous affair, so caravans united and went accompanied by a military escort when possible. This state of affairs prevailed in Tibet until 1950.

The grip of the anti-modernizing lobby of conservative, pro-Chinese monks was such that when the Second World War broke out, the young Dalai Lama was surrounded by retrograde

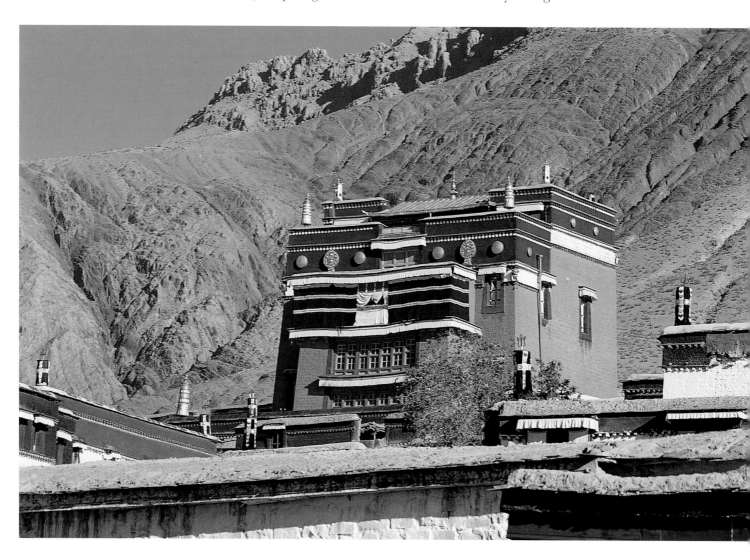

advisers and Takdra, an ageing conservative regent. Even so, Takdra had the sense to ensure Tibet was not drawn into the war, for although it offered Britain troops to help fight the Germans (an offer politely declined), the regent turned down President Roosevelt's appeal to the Dalai Lama, which was delivered in Lhasa in 1943 by Lieutenant Brooke Donovan and Captain Ilyia Tolstoy of the Office of Strategic Services (OSS), that arms to relieve Chiang Kai-shek be allowed to transit through Tibet. Tibet thus remained neutral, even giving asylum to Peter Aufsneiter and Heinrich Harrer, two Austrian mountaineers who had escaped from a British camp in Dehra Dun to which they had been confined at the outbreak of the war.

While the young Dalai Lama studied, prayed and passed his examinations in Lhasa, Mao was gaining ever more followers in China. After a brief alliance with the forces of Chiang Kai-shek in order to fight the Japanese, Mao's struggle continued after the end of the world war until he emerged in October 1949 as the uncontested leader of China. Lhasa, still under the shock of the assassination of Reting, seemed oblivious to the impending crisis. When the Tibetans did suddenly realize the gravity of the new situation, efforts were made to acquire modern arms (mortars and shells) from India and the army was enlarged and given improved training. It proved too little, too late.

### Communist threat

*The tantric college of Labrang monastery is a fine example of Tibetan religious architecture. The dark-coloured roof borders are a decorative motif representing the brush wood stored upon the roofs of common farmhouses. The gilt victory banners dominate the pagoda-shaped roof, which is originally of Nepalese rather than Chinese inspiration. The traditional latticed windows have been replaced by small panes of glass.*

Speaking from Tiananmen Square in October 1949, Mao proclaimed that China's first duty was to liberate Taiwan and Tibet. This reflected China's historic fear of the 'barbarians' at its gates, be they Mongols, Manchus or Tibetans. Theocratic Tibet had escaped annexation – by either the Mongols or imperial China – by dint of having converted the leaders of the threatening states to Buddhism, but now that China was controlled by a communist, atheist regime there would clearly be fewer obstacles to seizing Tibet by force. All China needed was an excuse.

Why would China want to possess a land that had long been regarded as poor and barren? The truth of the matter was that Tibet possessed an abundance of most of the resources China lacked: wood and cattle, not to mention gold and other precious metals – as well as, of course, land. Half of Tibet is covered by forests similar to those found in North America's Rocky Mountains, while an estimated 40 million yak and sheep roam its high grasslands. More important still is the strategic value of Tibet, which lies at the heart of Asia. There was also considerable prestige to be derived from the takeover of Tibet if Mao could be seen to accomplish what all the emperors of China had failed to do and control the 'last barbarians of the west'. Anticipating an invasion, the Tibetans belatedly decided to send a delegation to travel to the West, to Europe and America, to negotiate assistance and try to ward off what seemed to be the inevitable.

After the fall of Chiang Kai-shek the Tibetans expelled all Chinese subjects from Lhasa in an assertion of independence, as well as to remove potential communist sympathizers from the capital's community of ex-Nationalist Chinese. The Tibetans then sought to send a delegation to China via India and Hong Kong. The British refused to issue visas, which the members needed to travel to Hong Kong where it had been hoped they would negotiate with China on 'neutral ground'. The delay lasted several months and ultimately the Tibetans had to content themselves with talking in Delhi to the newly appointed Chinese ambassador. In the meantime, both Britain and the United States rejected Tibet's appeal for help. Now alone, Tibet hurriedly prepared to defend its eastern frontiers while at the same time the peace mission lobbied unsuccessfully for assistance from India and Nepal, and continued to try to get to Hong Kong in order to meet a Chinese emissary.

The communists claimed that their policy towards Tibet was but a continuation of that assumed by Sun Yat Sen, who desired to incorporate it into the Chinese motherland. What had previously

Having been sacked by the Red Army and later set on fire, the royal monastery of Nanchen Gar is in the process of being rebuilt. It is one of approximately seventy monasteries in this little-known region of Tibet, most of them belonging to the Kagyupa order.

been despised minorities – the Mongols, Turkic Muslims and Tibetans – were suddenly being acclaimed as part of the great Chinese family. Mao knew full well that India remained a formidable obstacle, so he opened negotiations with Nehru. Mao was also aware that he must be careful not to offend the Dalai Lama, for he knew better than to underestimate the power of religion. Mao was cognizant of the existence within China of the 100-million-strong Chinese People's Buddhist Association (out of a then population of 500 million), which was headed by a pro-Mao Tibetan *lama* from Amdo.

Mao understood that Tibet was split between the pro-British Tsarong faction, who were open to modernization, and the conservatives, who were generally favourable to China. Officially, Mao sided with the conservatives, declaring that China's only desire was to liberate Tibet from Western colonial influence and power. As had been done in the past, though, he also decided to play off the Panchen Lama against the Dalai Lama.

Mao made his invasion appear to be a campaign of liberation of Tibet from foreign imperialism, irrespective of the fact that in 1949 there were only eight Westerners in inner Tibet – two radio operators, Reginald Fox and Robert Ford; a missionary in Kham, Geoffrey Bull; Hugh Richardson, a Briton representing India in Lhasa; David Macdonald, a half-Tibetan trade agent in Dromo; the two Austrians, Peter Aufsneiter and Heinrich Harrer, who had escaped into Tibet; and an American student who had fled from the communists in Xinjiang – hardly what one could call a foreign occupation force.

To provide an appearance of legality and to further confuse the issues, Mao announced that the Panchen Lama – or rather the Chinese candidate to the post of Panchen Lama (there were other contenders and it was up to the Dalai Lama to decide which was the true reincarnation) – had sanctioned the Chinese plan to 'liberate' Tibet.

### Abandoned to its fate

Faced with the imminent prospect of an invasion, the Tibetans recalled the prophecy of the thirteenth Dalai Lama, which warned that if Tibet was not on its guard it would, like Mongolia, see its monasteries desecrated, its aristocracy banished and its land invaded. In a last-minute desperate effort to secure assistance against a Chinese invasion, a plea was made to Britain, the United States and the United Nations. The British washed their hands by repeating that the treaty obligations towards Tibet entered into by Britain had transferred to the Indian government. The United States was likewise non-committal. India, which should have been Tibet's ally against China, was ruled at the time by Jawaharlal Nehru, who saw himself as the leader in the making of the emerging, non-aligned third power in the world that would act as a buffer between the United States and the Soviet Union. Nehru's rival for this mantle was Mao, so Nehru was keen to strike a bargain in his and India's favour, even if it was at Tibet's expense.

Nehru's vision was a grand one and he began working on convening the Badung 'third world' conference. Naturally, Mao too wished to lead such a bloc and subsequently China's foreign minister, Chou en Lai, made Nehru an offer: if India endorsed China's claim to Tibet, Mao would allow Nehru to preside over the Badung conference as the spokesman for the so-called 'third world'. Nehru agreed. So it came to pass that in October 1950, certain that no international powers would object, the Chinese began to mass troops along the last semi-official border of eastern Tibet, near Denkhok, a village northeast of Chamdo, the capital of Kham.

Alarmed at the potential expansion of communism, the United States, through its ambassador in New Delhi, now secretly advised the Tibetans that it would help them with arms and even an offer of asylum for the Dalai Lama. This came too late, but even if it had been made earlier it is unlikely that Tibet would have been able to react as required to such an offer of assistance, because

with an old conservative regent in power and a Dalai Lama who was still a teenager it remained too hopelessly committed to its past ways.

Despite knowing that the Khampas were excellent warriors and, suitably armed and supported, could offer credible resistance to the Chinese, the Tibetan government decided not to arm them. It considered military opposition to be hopeless, although it perhaps revealed the distrust of the elite in Lhasa of their own eastern tribespeople. To negotiate with the Chinese, the Tibetan government sent Ngabo Ngawang Jigme to Chamdo, where he was to relieve the local governor, Lahu, who was busy raising and arming a Khampa militia with which to fight the Chinese. Lahu, the son of the deceased Lungshar, was seen by some as too belligerent and progressive, just as his father had been.

Shortly after Ngabo reached Chamdo, on 6 October, the Chinese attacked Denkhok. It was revealed that Lin Biao, the Chinese Minister of Defence, had planned the operation once he had received confirmation from Chinese agents in Kalimpong that neither Nepal nor India would come to Tibet's rescue. Following initial setbacks at Denkhok, Tibetan forces under the command of Muja fought back courageously and their determination brought some minor victories, sufficient to encourage the local population to clamour for arms and ammunition with which to offer further resistance.

Elsewhere in Kham and Amdo – regions of Tibet not under the rule of Lhasa – the Chinese People's Liberation Army (PLA) had been made relatively welcome. Not only did the communist troops not plunder and rape, as the rearguard Nationalist soldiers who sought refuge in eastern Tibet had done, but they also paid in silver dollars for every mule they hired or the barley they purchased. It was Mao's intention to win over the Khampas, whom he knew from experience distrusted the citizens of Lhasa. Assurances were given that monasteries would be respected, and many Khampas were impressed by the good behaviour of the PLA. The policy was one of divide and rule. The king of Nangchen, a vast land of nomadic herders to the south of Amdo, actually offered the PLA 1,000 mounted soldiers to help the Chinese rid Amdo of the warlord Ma Pu Feng. The Golok, however, fought the Chinese no matter how overwhelming the odds. Thousands of Golok died, leaving the route open for the Chinese to attack from the north as well as the east.

Meanwhile, to the dismay and disgust of those people in eastern Tibet who were calling for arms, Ngabo, the Dalai Lama's emissary, ordered the arsenal of Chamdo to be blown up. Ngabo then abandoned the city to give himself up to the Chinese troops who had entered from the north. To most Tibetans today, Ngabo Ngawang Jigme is considered a traitor, yet he was much favoured at the time by the young fourteenth Dalai Lama. Born into the nobility, Ngabo had always had pro-Chinese leanings, in common with many other high-ranking members of the conservative clergy. This elite ignored the prophecy of the thirteenth Dalai Lama, who had warned of the menace communism would pose for Tibet; it naively believed that China would continue to respect Tibet in the same way its emperors had done in the past.

When the news of the invasion reached Lhasa, the sixteen-year-old Dalai Lama was made to assume full power in the hope that he alone could rally around his person the full support of all the different Tibetan religious and political factions. It was then decided to send hundreds of mules loaded with silver and gold from the Tibetan treasury to Kalimpong. Also part of the plan was that the young Dalai Lama and his key ministers should travel to the border with India and thus evade possible capture by the Chinese. Yet the Dalai Lama did not enter India, setting up camp in Dromo, close to the border. He anxiously awaited the outcome of Tibet's appeal to the United Nations and the news from the delegates he had sent to join Ngabo to reach some sort of negotiated peace agreement with China.

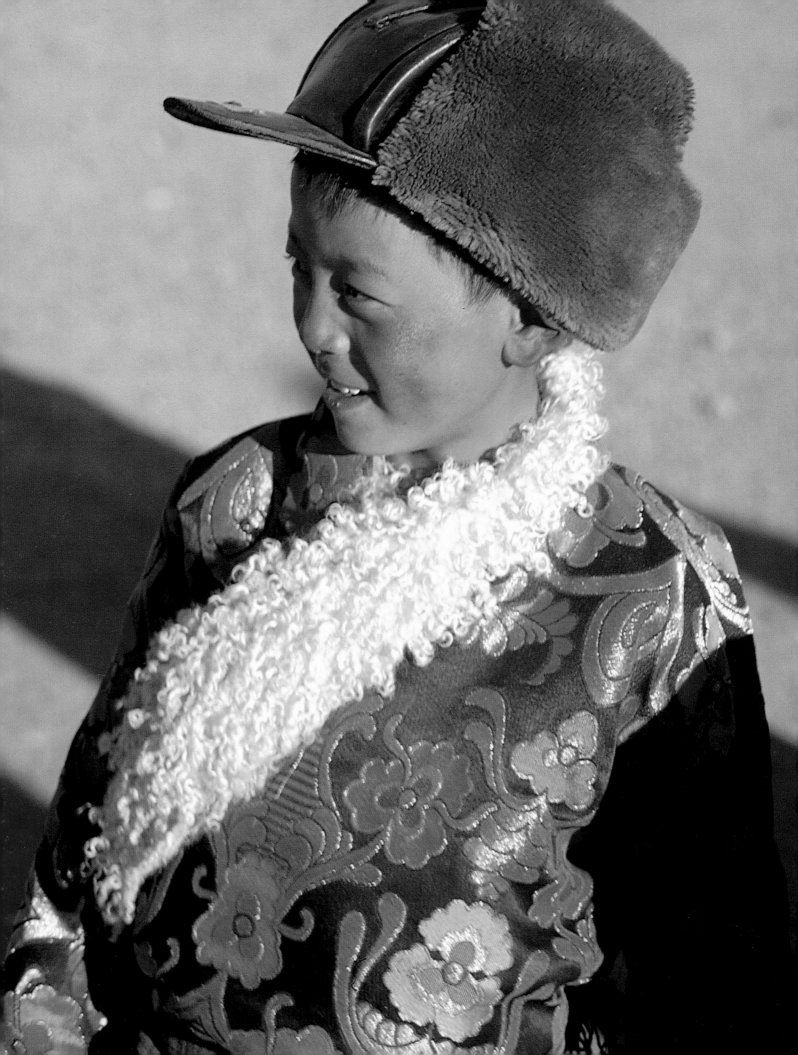

# 9 Tibet and its Future

THE UNITED NATIONS HESITATED before deciding to act on the Tibetan appeal put forward with much energy and merit by Hector David Castro, El Salvador's ambassador. Despite his country's formal dealings for more than a century with Tibet as an independent state, the British representative confused the issue by declaring that his government was unsure as to the exact status of Tibet. India's delegate then muddied the waters further by repeated pronouncements that his government was certain the differences between Tibet and China could be settled peacefully, in spite of what the Indians knew to be a state of war between Tibet and China. The United States, the Soviet Union, the United Kingdom, France and India all agreed that there should be no debate on the subject and that the 'Tibetan question' be adjourned. The world's major powers had washed their hands of the plight of Tibet. To quote Hugh Richardson: 'The conduct of the Indian and British Governments amounted to an evasion of their moral duty to make plain what they alone had special reason to know – that there was no legal justification for the Chinese invasion of Tibet'.

The Tibetans were shocked and could hardly believe that the British, whom they admired, could have let them down in the same way that their historic rivals, the Indians, had. Despondent, the Tibetans lost their will to fight because they now knew they could rely on no one. Not surprisingly, they also turned down the belated secret offer of the US government to send arms to the Tibetans and offer the Dalai Lama asylum. So it was with reluctance that the Tibetans sent four officials to join the controversial Ngabo in China and sue for peace. In Beijing, the Tibetan delegation, headed by Ngabo, was coerced into signing what became known as the 'seventeen-point agreement' for the 'peaceful liberation of Tibet'.

In Dromo, the Dalai Lama impatiently awaited a copy of the agreement that had been signed without his direct approval or that of the *kashag*, his government. For a moment the Dalai Lama contemplated flight into exile, then after consultation with the state oracle it was decided that he should return to Lhasa. This was a courageous move indeed.

Tibet, stripped of Amdo and most of Kham, had formally lost its independence yet, in communist-speak, it was declared to have maintained its autonomy. The revenues of the monasteries and of the nobles, according to the agreement, were not to be affected. In view of these assurances, the Dalai Lama and his entourage reluctantly accepted the agreement; of course, they really had no other choice.

Thus it was that thirteen centuries after the death of Songtsen Gampo the dismemberment of the Tibetan empire he had established was completed. China, India, Pakistan, Nepal and Bhutan (independent since the seventeenth century) had all shared in the spoils, holding on to Tibetan territory and quite determined, as India later declared in respect of Ladakh, 'to wean these territories away from Tibetan culture'. The Muslims of newly created Pakistan held Baltistan and the western extremity of Ladakh; the Hindus of newly independent India held Lahaul, Spiti, Zanskar, Ladakh, Machel and Sikkim, along with Towang and the Darjeeling and Kalimpong districts; and Nepal had incorporated Mustang and Solu Khumbu. It was small comfort but, in contrast to India and Pakistan, the Chinese had at least recognized the ethnic and cultural identity of the Tibetan areas, which, if not part of the Tibetan Autonomous Region, were classified, in former Kham and Amdo, as Tibetan prefectures. Hollow names perhaps but names nevertheless.

## China's takeover of Tibet

The Chinese appointed General Jang Jin-wu to be their all-powerful representative in Lhasa. To reach his new post, however, the general was obliged, due to the lack of roads between China and Tibet, to travel there via India like a tourist. Reliant on the goodwill of Nehru, the general and his entourage duly drove from Calcutta across India to reach the border with Tibet. All that Nehru could advise the young Dalai Lama was that he try to get along with the Chinese.

Unknown to the Dalai Lama, and much to the surprise of the Tibetan delegation itself, prior to the signing of the 'seventeen-point agreement' it had been presented with and bullied into endorsing another document that recognized the Chinese candidate for Panchen Lama as being the true Panchen Lama. Once this had been done it mattered little to the Chinese whether the Dalai Lama fled to India or not, for with the Panchen Lama on its side, China's takeover of Tibet could be formally legitimized. This small detail was very important for the Chinese. Tibet could be claimed as part of China because the Panchen Lama had sanctioned its 'liberation' from the forces that had impeded it from joining 'the motherland'. It should also be stated that many Chinese believed that they were bringing the benefits of civilization to what was seen as a backward corner of the motherland that had been separated from it by foreign, imperialist nations. This viewpoint appeared to be confirmed in 1954 when Chairman Mao, looking every bit the imperial patron himself, was photographed alongside the Panchen Lama and Dalai Lama, attired in their full regalia, as he received them in Beijing – the city of the emperors.

For the young People's Republic, the acquisition of Tibet salvaged national pride, gained territory and sent a warning to the international community not to interfere in Chinese affairs. For the Greater Tibetan nation, from Ladakh to Kham and from Gannan to Mustang, it was a time of invasion, dismemberment and rule by foreigners. In addition to seizing the heart of Tibet, the Chinese now controlled all the principalities and kingdoms of Amdo and Kham, along with the territories frequented by the nomads of Amdo. In short, the whole empire of Songtsen Gampo lay in foreign hands, while the religious leadership of the Panchen Lama and Dalai Lama were the hostages and puppets of an atheist Chinese state.

As a result, much of the rest of the world believed that Tibet had been eradicated before it could find a new place for itself among the modern community of nations. This, of course, was a great mistake, for while 1951 did indeed mark the end of a Tibet ruled by its religious leaders, it

*Wearing modern clothing and wrapped up well to protect against the cold, these two children with their open and friendly smiles remind us of the enduring Tibetan spirit that lies beneath the surface trappings of Western culture.*

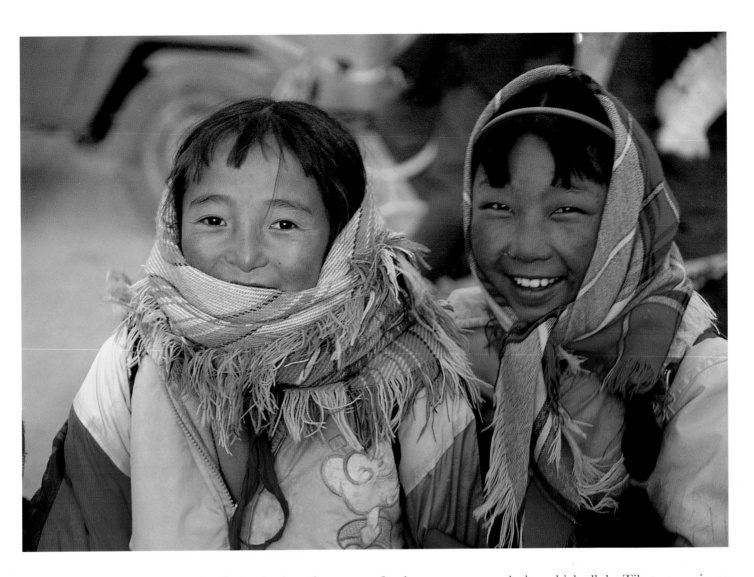

was also the beginning of a new era for the country – one during which all the Tibetan provinces slowly became aware of the many bonds that united them. Only after the Chinese had assumed control did the Tibetan people begin to realize once more that they in fact formed one large nation united by language, religion, customs and traditions. Once again, the memory of the holy kings who had first forged Greater Tibet was revived .

Tibetans also began to appreciate that their identity did not lie solely in religion. Modern media, such as the radio and, increasingly, television, made them more aware of how widespread their common heritage was. Broadcasts in Tibetan from as far apart as Lhasa, India, Ladakh and Bhutan echoed from the portable radios throughout the remote Himalayan and Tibetan hamlets. While the Dalai Lama in Lhasa was surrounded by Chinese advisors and troops, the Tibetan people were slowly catching up with technology and information about the outside world. Films, radio broadcasts and the first Tibetan language newspapers stoked the fires of political awareness throughout the plateau. This in a land with a sophisticated culture, but one that had lacked electricity, wheeled transport, clocks, modern appliances and facilities, and had no knowledge – the nobility apart – that such things existed in the world beyond its own rocky eyrie. Tibet's self-imposed isolation, more than anything else, had made it the secretive 'world apart' that it was.

From 1951 to 1959, Tibet underwent a deep metamorphosis. The Chinese busied themselves building a network of strategic roads, considered essential to exert their authority over the vast

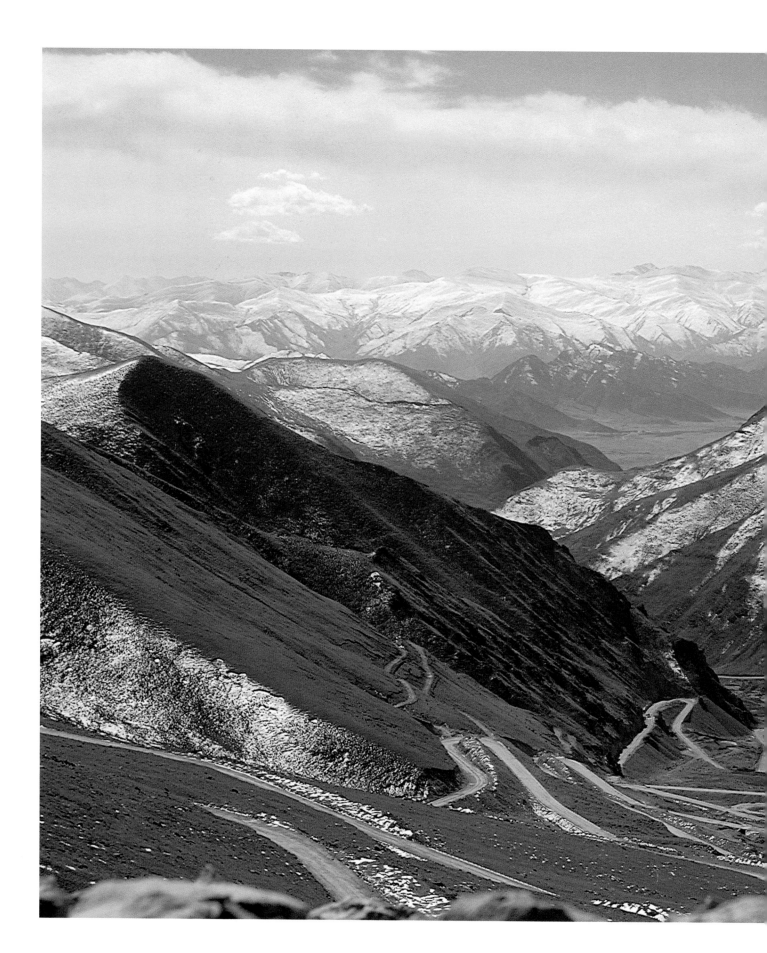

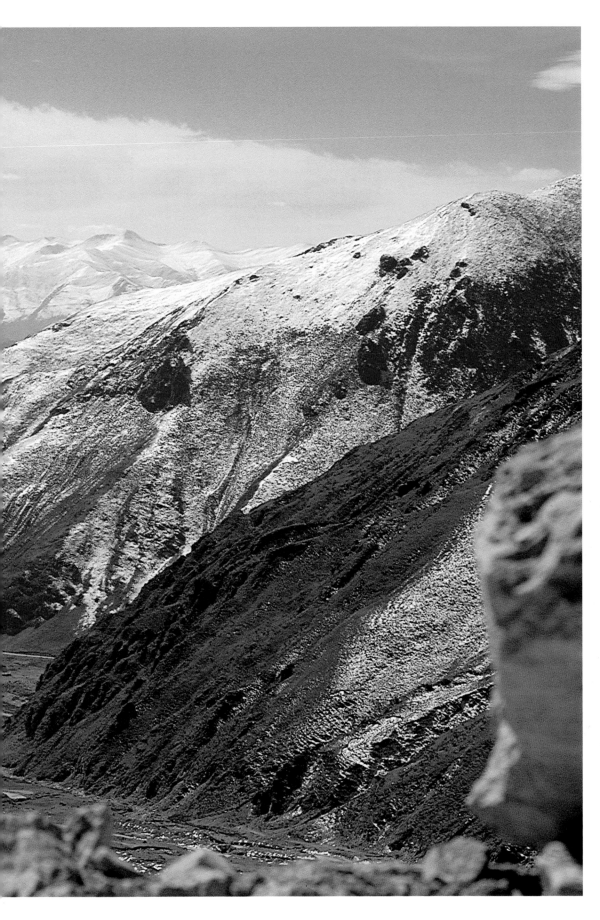

Tibet's immensity and the inaccessibility of its mountainous terrain have in the past guaranteed its independence. Today, overland communications remain difficult and fragile, although road-building has increased and other infrastructure links, such as train lines, are constantly being constructed.

expanses of central Tibet. The Tibetans themselves then began to travel over these roads, further increasing their own political awareness. For a while all was peaceful, then in 1953 when the first strategic roads had been completed China decided to impose on Amdo and Kham its idea of so-called 'democratic reforms'. These measures called for the abolition of private property, the creation of communes and, more importantly, the slow but sure elimination of religion. The aristocracy was identified as the enemy of the people, as were the abbots and *lama*s. In other words, the eastern Tibetans were asked to turn against everything that was perceived by them as specific parts of their cultural heritage rather than things that were, as the Chinese claimed, retrograde and feudal. The Chinese could not understand why the Tibetans were opposed to the 'enlightened reforms' they were trying to implement.

The Tibetan people loved their monasteries and the monks therein were the sons of families rich enough to be able to afford to maintain them in celibacy and prayer, but they were not big landowners by any means – many, in fact, were too land-poor to enable them to marry. As for the noble families in rural areas far from Lhasa, these were generally loved and admired, especially in Kham where they were respected for their martial courage and ability. In such places, the local aristocracy was not very much wealthier than the average land-holding farmer and it did not possess the vast estates that the upper class of Lhasa did. In contrast, businessmen such as the Pandatsangs were very rich indeed, but they were heroes for having fought against the Chinese in 1929. The Khampas, like the Tibetans in general, were proud of their institutions, their religion and their social values, and, pride notwithstanding, they did not need to be given lessons by an old enemy in the form of China's bureaucratic state.

### Revolt: the War of Kanting

When the Chinese began to send political commissars into the countryside to order indoctrination sessions in which the rich were singled out and beaten into confessing their 'crimes against society', nearly everyone was outraged. Then when the Chinese openly ridiculed religion a revolt erupted. It came to pass in 1954 that in Kham there broke out what the Chinese called the War of Kanting. This escaped the attention of the Western media, which knew little or nothing of Kham or the Khampas, but it did attract the attention of the Central Intelligence Agency (CIA) and the Pentagon in the United States. They had monitored the ever-increasing discontent of the eastern Tibetans, who had been the first to appeal to the United States for help in 1950.

This appeal had been made by the Pandatsang brothers. To seek backing for their cause they had sent George Patterson, a Scottish missionary, to Kalimpong as their emissary. Patterson had contacted Ambassador Loy Henderson, a firm supporter of Tibet, who did not react immediately to the Khampa cause – this was because he was busy in late 1951 drafting, with the approval of Washington, D.C., a letter to the Dalai Lama explaining that the United States would stand by Tibet if the Dalai Lama fled Lhasa, repudiated the agreement and stood up against communism. The Dalai Lama had not responded, preferring to oppose the Chinese from Lhasa. With silence from the Dalai Lama, the United States did not react to the Khampas, thus only once the war had broken out three years later and guerrillas had taken to the hills, was a bold and daring plan hatched. The Americans would train Tibetans (preferably Khampas) in the use of modern arms and radio-sets after which they would be parachuted back inside Tibet to direct the local resistance.

The risks of such an operation were considerable; it meant flagrant US interference into what the United Nations had come to consider as an internal Chinese problem. Furthermore, it involved violating Chinese air space, which was tantamount to an act of war. Implementation of this plan was postponed until late 1957 for political reasons and, as a result, the Khampas began their struggle alone.

*Jyekundo in northwest Kham is a region of Tibet where the Sakyapa and Kagyupa traditions are predominant. Links with China go back many centuries, and several places in the area have associations with the Chinese princess Weng Cheng who is linked with some of the earliest Buddhist activity here, when the Bon faith was still strong. These monastic cells form part of the hillside monastery of Jyekundo Dondrubling, a Sakyapa institution dating from the late fourteenth century.*

In the meantime, the Chinese sent in a Russian-built Ilyushin bomber to destroy the monastery of Litang, where the first rebels had barricaded themselves. Chinese reprisals against eastern Tibet, whose peoples included the Khampas and the Golok of Amdo, were ferocious. Repeatedly the Khampas made desperate appeals to Lhasa for help, but to no avail. The Dalai Lama shunned all forms of violence and the only advice he could give the beleaguered Khampas was that they should lay down their arms and seek to live with the Chinese. The indifference of those in central Tibet to the plight of the Khampas was perhaps due to the ancient fear some of those in Lhasa entertained of the 'warlike' people within Tibet's own borders. As for the young Dalai Lama, he still lacked the necessary maturity, energy and willpower to oppose simultaneously the Chinese and his complex Tibetan entourage – particularly the more self-seeking courtiers within it.

As he himself wrote years later, these were terrible times for the Dalai Lama because the political situation in Tibet was in direct contradiction to his religious teachings. An advocate of non-violence, the Dalai Lama was in an impossible position – while the Khampas and a small but strong faction of central Tibetans clamoured without success for him to stand up to the Chinese, the Chinese were accusing him of obstruction. The situation was extraordinarily complex. Here was revolutionary and atheist China confronted with the most flamboyantly traditional society, a feudal theocracy, a situation quite sufficient to bewilder any statesman, let alone a quiet, contemplative young man.

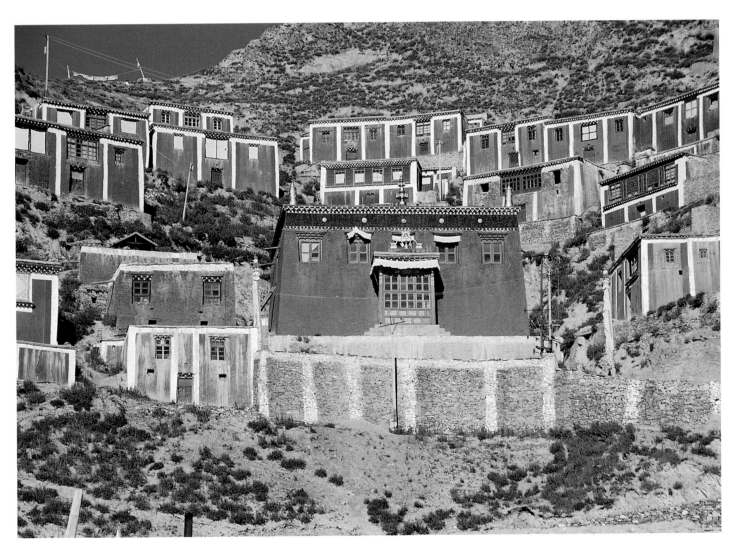

Matters were further complicated by the fact that several members of the Dalai Lama's cabinet, particularly Ngabo and several abbots, seemed to be favourably disposed towards the Chinese. The most prevalent argument for being pro-Chinese was that few could imagine how five or six million Tibetans who had been abandoned by the rest of the world could ever hope to oppose the 600 million-plus Chinese. Still today there are those who are convinced that numbers alone make Tibet's situation hopeless, but elsewhere in the world many small nations have courageously and successfully stood up to larger states, from Cuba to Switzerland. The brave inhabitants of Kham and Amdo engaging in guerrilla warfare felt they had a chance. They knew that even a small, reasonably armed guerrilla force with popular support, especially in mountainous terrain, could defeat the greatest of armies. Mao himself had proved that.

In 1957, the Americans – motivated by anti-communism and a desire to please Nationalist China– belatedly gave the Khampas their backing. Some 260 rebels were smuggled across the border with India and taken to the United States, via Bangladesh, Thailand and Saipan, to be trained in modern warfare and communications in Colorado. Afterwards they were parachuted into Tibet by planes flown from Takhli air base in Thailand. Naturally, the US actions were shrouded in mystery. Then in 1960 the shooting down of Gary Powers in his U-2 spyplane resulted in a high-profile controversy, which culminated in the termination of the parachute drops.

In the meantime, China had amassed such numbers of troops in Amdo and Kham that in 1958 the guerrilla fighters were obliged to retreat westwards into central Tibet. Their intention was to regroup in the Lhokha area of southern Tibet. As they crossed Tibet, the Khampas presented a mixed force: some were armed with modern weapons and commanded by compatriots trained in Colorado; others carried matchlock muskets and huge swords, wore leopard-lined sheepskin coats, and rode under the direction of their traditional local lords. There were also red-robed warrior-monks with rifles and swords. By autumn 1958 Lhasa was filled with these armed refugees.

Although the Dalai Lama protested to the Chinese commander about the bombings and massacres in eastern Tibet, he refused to lend his support to guerrilla warfare and was unwilling to advocate passive civil disobedience, believing it would lead only to the inflicting of pain upon the pacifists. As a non-violent man – indeed, one who is the reincarnation of the essence of compassion – the Dalai Lama was persuaded that, ultimately, virtue will triumph over vice and compassion over evil.

## Tibetan Government of National Liberation

To the Khampa leaders it was apparent that the Dalai Lama should not be involved, but he also remained an attractive 'prize' for the Chinese and those seeking Tibet's freedom wished to coax him to flee from Lhasa and the Chinese stranglehold. The Khampas, meanwhile, began to score some successes, including the seizure of the key Chinese garrison of Tsetang, the capital of Lhokha district, situated some 112 miles (180 km) southeast of Lhasa on the southern route to Kham. Tsetang was a particularly emotive place, for it was among the mountains and caves here that, according to legend, a monkey and an ogress begot the ancestors of the Tibetan people. Here, too, stood Songtsen Gampo's ancient fortress of Yambu Lakhang.

By January 1959 the Khampas controlled most of southern Tibet and were urging an open confrontation. In Lhasa the situation was tense, for in February the New Year celebrations (*Losar*) were due to commence and the town was full of pilgrims, creating a potentially large and volatile crowd. The spark that ignited the conflict was the 'theatre incident'. The Dalai Lama had been invited to attend a theatrical performance within the Chinese military compound and had been told to come without his customary bodyguards. As a consequence, rumours spread that the Chinese wanted to abduct him. At the same time, the Chinese had begun to attempt a census of

the Khampas and it was feared that this might be a prelude to reprisals, for the Chinese were well aware of the CIA's involvement with elements of the Khampas.

Rumours of an imminent abduction swept the town and crowds rushed to stop the Dalai Lama from leaving his summer residence at the Norbulingka Palace. One of his aides whom the crowd identified as a China sympathizer was murdered and his bloodied corpse was paraded through the city. The Chinese issued an ultimatum to the Dalai Lama's ministers that they pacify the Khampas, but there was little or nothing they could do. The Khampa leaders now marched with other opposition figures at the head of a huge procession to the village of Zhol at the base of the Potala Palace. At the site there stood an obelisk that was a symbol of Tibet's longstanding independence. The leaders then declared a new Tibetan Government of National Liberation. Upon the crowd's return to the summer palace with the members of the 'new government' the Dalai Lama's bodyguards, the Kusung Regiment, discarded their uniforms for Tibetan dress and joined the Khampa leaders.

From that point on, the Dalai Lama and his cabinet were no longer in control and Tibet had, momentarily and symbolically at least, re-established its independence and declared war on China. The Khampas were determined to fight – but not in Lhasa, surrounded as it was with Chinese garrisons. Their immediate concern was to stop the Dalai Lama, Tibet's head of state, from falling into Chinese hands and it was decided to get him to nearby Lhokha. The Khampas were optimistic that they could hold this part of southern Tibet for a long time.

On returning to the summer palace, Tibet's new leaders discovered that Ngabo had fled to the Chinese. Consequently, they placed the three ministers then in the palace under house arrest. The Dalai Lama convened the new leaders and tried one last time to have them renounce their struggle. The Khampas explained their cause and withdrew from Norbulingka back to the foot of the

*The gardens and pavilions of the Dalai Lama's summer palace in Lhasa, the Norbulingka. Today, it lies empty and overgrown with weeds, as if in lament, awaiting his return.*

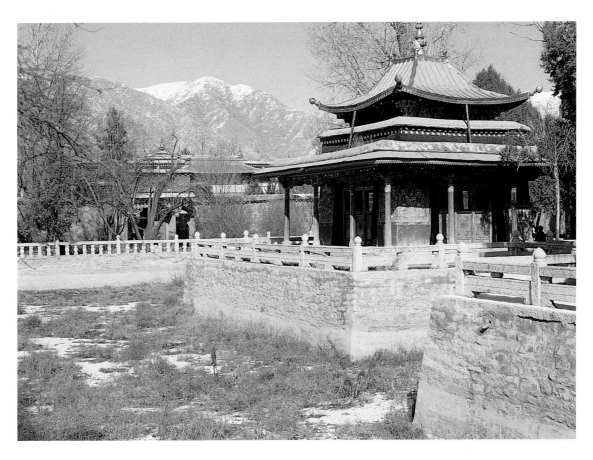

Potala, from where they sent notice that they would continue to request the departure of the Chinese. They further advised that they would protect His Holiness as necessary, but all the while crowds continued to surround the Norbulingka complex, forming a massive human shield to protect their country's spiritual and temporal leader.

The Chinese made no secret of their intentions when they wrote to the Dalai Lama and asked him to pinpoint in which building he would be, for they planned to attack the site. In a last coded message to the Chinese smuggled out of the palace on 16 March, the Dalai Lama and his ministers asked Ngabo to try to find a way to transfer them all to the Chinese camp. A few hours after receiving the reply from Ngabo, two mortars were fired not far away. This triggered a panic and people begged the Dalai Lama to escape. He duly convened the new leadership and his escape under protection of the Khampas was arranged.

That night, dressed as a Khampa with a rifle slung over his shoulder, reminiscent of his flight to Dromo nine years previously, the Dalai Lama slipped out incognito through the door in the thick wall of the summer palace gardens and pushed his way unnoticed through the crowd, camping there in the hope of it protecting him from a Chinese attack. He was followed by his mother and sister, then in separate small groups by his remaining cabinet ministers and several abbots. A detachment of soldiers had earlier been sent down to guard the river and it was dusk as the Dalai Lama clambered aboard one of several yak-skin coracles, which were paddled across the broad swift waters of the Kyi-Chu. On the other side, the Dalai Lama's party was reunited and met by a group of Khampa soldiers. The Dalai Lama formally exchanged *khata*s – the white traditional silk scarves of welcome – with the military commanders, Kunga Samten and Tenpa Dargye. He was then escorted to the first pre-arranged meeting place at Lhuntse Dzong by the very soldiers from eastern Tibet whose struggle he had for so long tried to forestall.

*A yak-hide coracle. It was in a boat similar to this one that the Dalai Lama crossed the Kyi-Chu River in March 1959 on his way south to the stronghold of the Khampa guerrillas and then on to India and into the exile in which he has remained since.*

### Exile and resistance

At Lhuntse Dzong, the Dalai Lama, fully robed and with the traditional ceremonial attendant, sanctioned the new government. In his book *My Land and My People*, he recalled: 'We went into the *dzong* (fortress) for a ceremony of thanksgiving for our safety. After that we held the religious ceremony to consecrate the founding of the new temporary government. Monks, lay officials, village headmen and many other people joined us on the second floor of the *dzong*, bearing the scriptures and appropriate emblems'.

Thus was formally proclaimed a new, united Tibet composed of Kham, Amdo and central Tibet, just as the freedom-fighters had wished – a Tibet joined together in resistance against China. At long last, there was hope that Tibet could regain its independence. A few days later, after the sighting of a Chinese reconnaissance plane overhead, it was felt sensible for the Dalai Lama to travel to India where he would be better able to help the Khampa soldiers by securing more assistance from abroad. As the Dalai Lama was taken in good order to the border, the main body of freedom-fighters who had accompanied him on his journey headed back towards Lhasa to fight the Chinese, most of them feeling certain that a new era for Tibet had begun.

Little did they expect the disaster that awaited them. Lhasa had been ravaged. The holy city's finest monuments, with the exception of the Potala Palace, had been violated. The streets were littered with the bodies of men, women and children caught in the gunfire from armoured cars. The gates of the Jokhang Temple, the Tibetan holy of holies, had been battered down by tanks and its sanctity desecrated. A long agony followed as thousands of prisoners were jailed for up to twenty years for partaking in the popular uprising. The Khampas retreated and escaped into India, then transferred secretly to Mustang, which is located north of the Dhaulagiri and Annapurna ranges and forms a peninsula-shaped enclave into Chinese-held Tibet, south of the Tsangpo River.

It was in Mustang in 1964 that I met the disheartened Tibetan soldiers who were to rot away in their high-altitude camps, where they were supplied by the CIA for eight years until 1971, when Nixon and the United States abandoned them. Many were then tracked down and slaughtered during a search operation conducted by the Chinese and Nepalese. They had served their purpose as a minor thorn in Mao's flank but were then disowned by their erstwhile supporters in the outside world. Of those that survived, several committed suicide in disgust at the missions to track them down. They felt they had been let down during the Dalai Lama's exile, believing their own Tibetan government had done little or nothing to help their cause and was unable or unwilling to secure any military support for all those committed to the forceful liberation of Tibet. Meanwhile, the Dalai Lama was obliged by his hosts to make no statements which might embarrass India.

Too much focus has been given to the Dalai Lama's escape and not enough has been said about the situation inside Tibet and those who had led the uprising there. The history of Tibet for more than half a century has been the story of the sheer courage of the inhabitants of Greater Tibet, simple Tibetans, men and women, raised far from the court intrigues of Lhasa. In Dharamsala, a hill station in India, a clean, smart world of sophisticated Tibetans in exile was created, a significant number of them descendants of the aristocracy, which was as much to blame for the situation in Tibet as were those monks that for centuries had enmeshed Tibet in constant webs of intrigue. Such people tended to have a greater concern for power and fortune than for prayer, and in the past they had taken their services to the highest bidders, be they Mongol, Manchu or Chinese. The monastic theocracy had lost Tibet, partially to Mongolia and then to China, from a lack of foresight and for not having established sufficient links with the international community.

As for the institution of the Dalai Lamas, in all of Tibet's history only two of them had ruled effectively: the great fifth and the thirteenth. Discounting the young libertine sixth Dalai Lama, who was murdered in his early thirties, several others had been murdered before their coming of age and the present fourteenth Dalai Lama ruled only under Chinese tutelage from the age of

*The dark façade of Nechung monastery, the traditional residence of the Tibetan state oracle, who now lives in exile in Dharamsala. The medium would enter into a violent hypnotic trance to communicate with Dorje Drakden, the protector of the Gelugpa order, who was himself believed to be possessed by Pehar, the protector deity. The oracle made pronouncements on natural disasters and political appointments, but today, in Nechung at least, all is silent.*

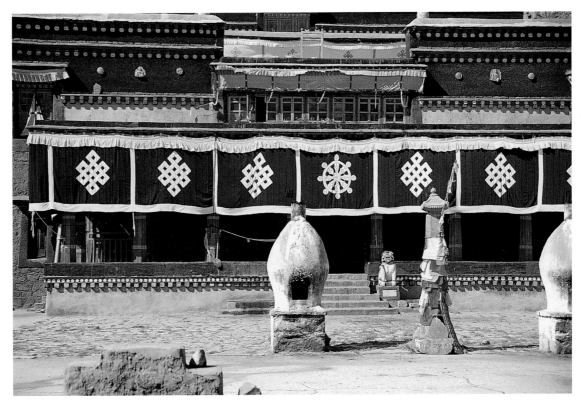

sixteen to twenty-four until he was forced into exile. Now, significant numbers of people have tired of what were seen as the accommodating tactics of some government ministers, whom it was felt were too keen on maintaining their privileges at the expense of the mass of the Tibetan people.

The dominance of the Dalai Lamas had barely lasted 300 years – a short time in the history of a nation 1,400 years old. In these three centuries, there were many great literary and artistic achievements, though few of them equalled those of the more distant past when Tibet produced some of the greatest poets, philosophers, engineers and medical doctors Asia has ever seen. Yet the Tibet the Dalai Lama left behind was and remains a vital, young and dynamic nation imbued with a strong sense of identity – a people as fully aware of the importance of social and material matters as they are of the role of philosophy and Buddhist ethics in daily life.

Neither Chinese indoctrination nor palace intrigues have turned the heads of the millions of Tibetans who continue to struggle to oppose Chinese, Indian, Pakistani and Nepalese dominance throughout the far-flung corners of the plateau. The fourteenth Dalai Lama is a pious and kind man, but he appreciates that the duties of running a modern state should not be entrusted to religious men. Perhaps the Dalai Lama should have done what his predecessors had done before him and found a strong patron beyond Tibet ready to help, but His Holiness has not ceased to fight to see righted what remains one of the great political injustices of our times. One of the greatest handicaps Tibet has had to suffer, however, is that the Dalai Lama was for a long time ill-advised by an entourage that prevented His Holiness from assuming what can be his only true duty: the welfare of all those inside Tibet who look to him as their only hope of liberating their homeland.

## Communist repression and hopes for a new generation

After the departure of the last of the freedom-fighters, a nightmarish fate befell the Tibetans thanks to the mismanagement of those responsible for the poorly named Great Leap Forward. A famine struck China and so food was taken from Tibet, an act that induced shortages estimated to have killed many thousands of people. This was a disaster of the worst kind, because there had been no crop failure in Tibet – food was rationed and withheld. Only in recent years has the truth come out about this terrible famine that also killed tens of millions of Chinese.

Matters were only just improving when in 1966 the Red Guards were unleashed. As with the famine, because of the heavy military presence in Tibet, the ravages of the Red Guards were worse than elsewhere. Many of the monasteries were systematically destroyed by forced labour gangs of Tibetans. In many places there was nothing left to record that this had been the site of a chapel or a monastery. Libraries were put to the torch while religious treasures were melted down or sold to foreign collectors through Hong Kong. The Dalai Lama in exile in India was not allowed to make 'political' statements and more often than not he was impeded from travelling abroad. When he did travel it was the host governments who ensured there were no such statements.

Matters did not improve for Tibet until 1982 when the Chinese themselves realized the extent of the atrocities and mistreatment committed against the Tibetans. As a result there was a respite, and that year religion was tolerated, some monasteries were rebuilt and Tibet was opened to tourism – and a sad sight it was. Villagers had been displaced; wheat had been planted where only barley could grow; and nomads had been tied to the land, with disastrous results for their cattle.

Matters continued to improve slightly until 1987 when protest marches in Lhasa were savagely put down. The worst repression came in March 1989 when nearly 400 Tibetans were killed in Lhasa, most of them shot by the People's Armed Police, the same force that was called into Beijing's Tiananmen Square a few months later to confront the pro-democracy students. The Dalai Lama then received the Nobel Peace Prize and at last, after thirty years in exile, His Holiness was allowed to talk.

Today it is fashionable to meet the Dalai Lama and he is acknowledged as a good, wise man. Yet during the decade that has elapsed since the massacres, China has emerged as a powerful, industrialized country and Lhasa has boomed into a huge, modern city with nearly 400,000 inhabitants, over half of them Chinese. There are nightclubs, banks, bars, hotels, taxis and department stores; meanwhile, gold, leather, wool, wood, herbal medicines, lithium, rare metals and other materials are removed from Tibet to fuel multi-million-dollar businesses in China.

But what of the Tibetans? Educational standards remain low and most government posts of any importance are held by Chinese. The countryside is as miserable as ever, for the Chinese still ship out grain and oblige the farmers to cultivate state-owned acreages in return for little remuneration, while nomads are forced to sell their cattle at prices set below market rates.

Even with business booming in Lhasa, Tibet remains a miserable colony of China. Just as they were before, political parties are banned, as is the photograph of the Dalai Lama. Increasingly, the Chinese are exploiting every aspect of Tibet they can, not to mention what some call 'the final solution' – namely the slow, inexorable drowning of the Tibetan population in an influx of Chinese immigrants. Fortunately, humankind is so made that oppression does not weaken faith or make people lose their identity. On the contrary, Tibetan identity has never been stronger. All over the high plateau, television, satellite phones and cyber-cafés link Tibetan youths with each other and the rest of the world.

At long last there is a new generation inside Tibet that is aware of the state of the world and the injustice of its own plight. It is with these Tibetans and not with the exiles that the future of the country lies. For those who are disheartened about Tibet's future it is as well to recall those Central Asian republics that were part of the Soviet Union and are now independent after being under Russian rule for nearly 150 years. Today the Russians are finally leaving these territories, so there is hope yet for Tibet. Perhaps once again Greater Tibet will become a political reality and the Dalai Lamas can then continue, free from political intrigues, to preach tolerance to the rest of the world.

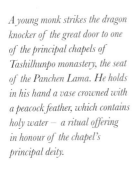

*A young monk strikes the dragon knocker of the great door to one of the principal chapels of Tashilhunpo monastery, the seat of the Panchen Lama. He holds in his hand a vase crowned with a peacock feather, which contains holy water – a ritual offering in honour of the chapel's principal deity.*

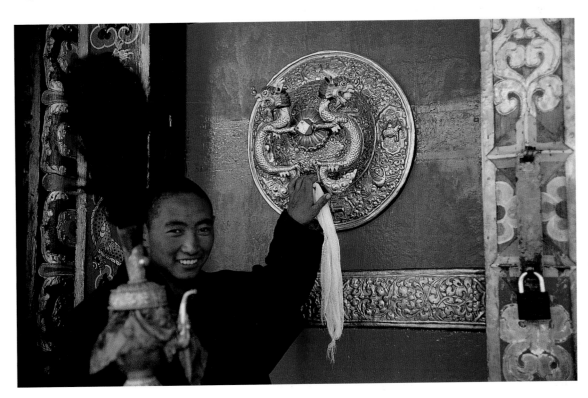

# The wild Changtang

**The word Changtang refers to Tibet's 'northern plains'**, the treeless, high-altitude regions of the plateau that stretch all the way from Ladakh in the west to Gansu and China in the east. The western half is home to large herds of wild yaks, *kyang* and Tibetan antelopes, which survive on the light covering of grass. Dotted with startling salt lakes, the region can seem an enchanting paradise when the weather is fair. Those regions below 16,400 feet (5,000 m) are inhabited by nomadic tribes of herders who tend large herds of yaks, sheep and keel goats.

Keen to observe wild yaks, in the late 1990s I set out in search of these fascinating animals. Early in October 1998, at an altitude of 18,700 feet (5,700 m), panting and with my heart pounding from the thin air and excitement, I peered over a snow-crested ridge and saw my first herd of the great wild yak of northern Tibet. I was thrilled and impressed that any creature so big could roam the flanks of mountains so steep – they scrambled up snow slopes that a skier would hesitate to descend. The wild yaks did not, of course, appear very much different from tame ones. It was only a few days later that I was able to get near to a solitary bull, which on several occasions turned to face me, snorting menacingly before continuing on its way. Gingerly I pursued it, hoping it would not turn around and charge. There was something amazing about the animal's slow-paced dignity and strength, and for the first time I understood why so many people once considered bulls to be sacred. I came to appreciate why to dominate one was the goal of legendary Greek heroes and why crowds still flock to see matadors.

1

1. Aru Lake's white beaches of salt mirror the distant snow-topped mountain peaks and are typical of the hundreds of landlocked lakes that cover the Changtang.

2. Of the lakes to be found in the Changtang, several are dozens of miles long, such as lakes Tso-ngon and Namtso Chukmo. Of them all, arguably the most beautiful is Memar Lake, seen here.

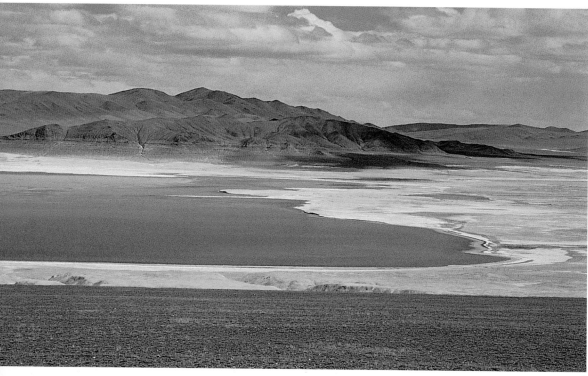

2

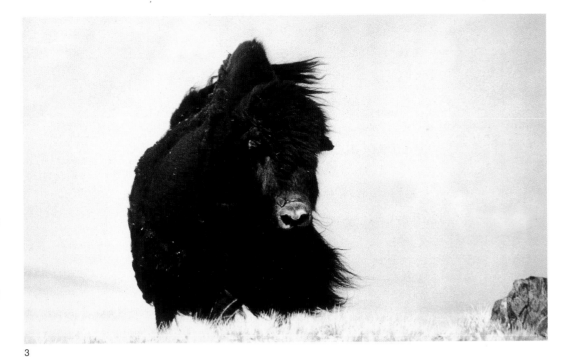

3. The king of the Changtang is the wild yak, a most unusual animal. Its herds once covered the whole of Tibet, but today the animal is getting rarer and is to be seen mostly in the highest reaches of the wilds of northwest Tibet. To hunt wild yaks was the sport of kings in ancient Tibet and to kill one was considered an act of bravery – one that is much lauded in the great Tibetan epic of Gesar of Ling.

3

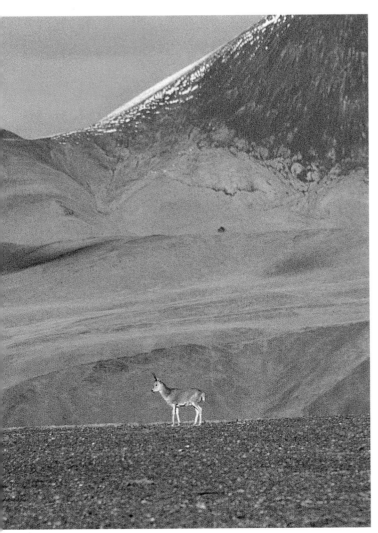

4

4, 5. Young buck antelopes on the great plain. The males stick together, both young and old, with seemingly little to do, because one dominant male breeds with a large herd of females. Although there are an estimated 200,000 or more antelopes in Tibet, considerable concern has been expressed about their future. Worries began in 1982 when poachers started using machine guns to kill large herds for their wool. This wool is world famous as *shatoosh*. The poaching seems to have diminished as a result of an international crackdown on the sale of shawls made using the wool, as well as competition from fake *shatoosh* shawls, woven from extra-fine cashmere wool, which is difficult to distinguish from real *shatoosh* in the absence of certified samples. It takes up to five antelopes to make a single shawl.

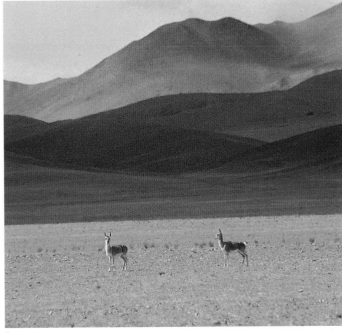

5

# Rebuilding for the faithful

**What makes Tibetan art, architecture and culture** so fascinating is that it is still, despite everything its people have endured in recent decades, a dynamic living tradition. Today, all over Greater Tibet, houses, chapels and monasteries are still being built and decorated along traditional lines. While artisans in central Tibet are busy restoring monasteries destroyed during the Chinese occupation, there are others who are busy building wholly new chapels and assembly halls. This activity refutes the general belief that foreign military occupation destroys beliefs and traditions. This has certainly proved to be the case in places such as Ladakh, although Bhutan has demonstrated that it is possible for cultural identity to be preserved in the face of exposure to Western influences.

Although these are encouraging signs, it is nevertheless an uncomfortable fact that few of Tibet's great monasteries, important historic places and monuments have survived unscathed. Regional craft traditions, such as painting, have somehow managed to endure and are now being transmitted to new generations of artists, many of whom are using their skills to redecorate temples in the exquisite style they exhibited originally. Painting finds its expression in murals, manuscript illumination and cloth-painted scrolls (thangka). Sculpture is practised in metal, clay, stucco, wood, stone – and even butter. The modern availability of man-made materials has, if anything, made the process of revitalization and restoration easier to accomplish, and it has boosted other skills such as blanket- and carpet-weaving.

1. The building of a new temple at Tashilhunpo in 1986 utilized modern technology and materials (for example, steel-reinforced concrete) to construct a building with a traditional appearance. It demonstrated the ability of Tibetan architects to reconcile the old and the new. The strong faith of Tibetans is the principal motor behind the preservation of the land's artistic traditions, yet even in lay constructions the Tibetans show a deep attachment to their native styles and forms.

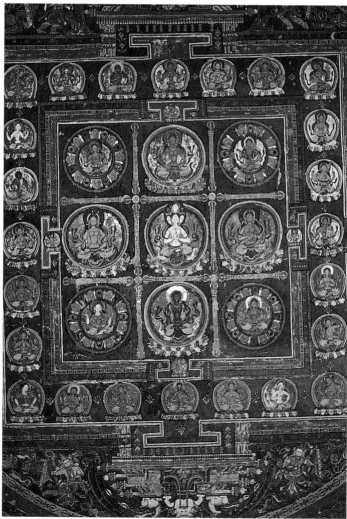

1    2

3

4

2, 3, 4, 5 and 6. Seven centuries separate the remarkable painted ceiling (3) and portico (2, 5) of Alchi from the modern windows (4) and construction site (6) evident here. Even if the talents of past great masters are not always matched today by their modern counterparts, the methods of blending elegant paintings and sculptures into functional doors and windows have remained the same over the centuries. In Tibet practically all artisans, other than blacksmiths, are simple farmers rather than professionals. Such people have been encouraged to develop their talents as painters, sculptors, carpenters, architects, or builders. These talents they then place at the service of their faith or fellow farmers. Houses, like monasteries, are built as communal endeavours with neighbours each providing a different skill and receiving only food in return for their efforts.

5

6

# Elemental power of prayer flags

1

**Flags are universal, yet no land** makes better use of their charms than Tibet, where they are the visible, tangible incarnation of the air – the elemental force that animates all living creatures. This force is represented by the 'horse of the winds' printed on cotton flags and shown surrounded by symbols of the four quarters: a blue dragon representing the south; an eagle, or garuda, for the north; a lion for the east; and a tiger for the west.

These flags are planted on or around buildings, tents, monasteries or outstanding geographical features. They can be found near springs, strung across gorges, or above cairns on the summits of passes. They are attached to poles, strung like garlands to ropes, or sometimes hung from eaves. As with most objects of a religious nature in Tibet, prayer flags obtain merit for those who make them or set them up. The *mantra*s printed on the flags are recited to the wind when they flutter. Prayer flags are renewed annually during festivals in which houses and monasteries are repainted.

2

1. Prayer flags crest the monastery of Lo Gekar in Mustang, a fine example of a small, traditional Tibetan temple.

2. Torn to shreds, a few solitary prayer flags mark a lonely pass on the high road that links Zanskar with Ladakh.

3. Unusual *chorten*s surround this chapel on the road to Riwoche in the distant northeastern corner of Tibet.

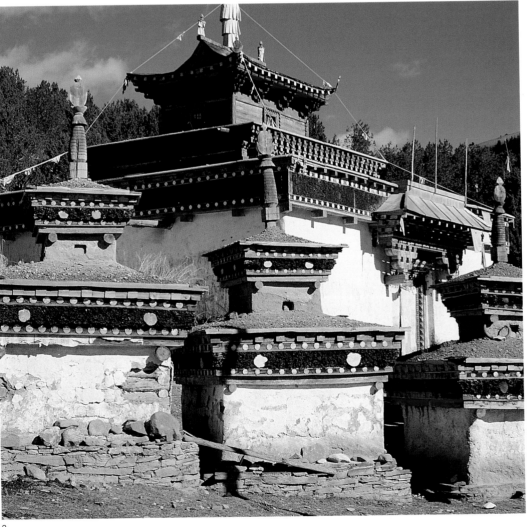

3

4. For the weary traveller upon the rugged trails of Tibet, the sight of prayer flags is always a welcome one because it announces the end of one's climb is near. The beating of prayer flags in the cold winds blowing over a pass is also a sound never to be forgotten – the very voice of the invisible spirit of Tibet.

5. A pyramid of prayer flags stands out on the bleak pastures of the Golok people at the foot of the Amnye Machin range – an unusual fluttering monument to the gods of the winds. The different colours of the flags reflect the basic elements of which man is said to be composed.

4

5

# Bibliography and further reading

Andrugtsang, Gompo Tashi. *Four-Rivers-Six Ranges: A True Account of Khampa Resistance to Chinese in Tibet.* Information Office of His Holiness the Dalai Lama, Dharamsala, India, 1973.

Avedon, John F. *An Interview with the Dalai Lama.* New York: Littlebird Publications, 1980.

Barber, Noel. *The Flight of the Dalai Lama.* London: Hodder & Stoughton, 1960.

Barber, Noel. *From the Land of Lost Continent.* Boston: Houghton Mifflin Co., 1970.

Bell, Sir Charles. *Tibet Past and Present.* Oxford: Oxford University Press, 1968 (first published 1924).

Bell, Sir Charles. *The People of Tibet.* Oxford: Oxford University Press, 1968 (first published 1928).

Bell, Sir Charles. *The Religion of Tibet.* Oxford: Oxford University Press, 1968 (first published 1931).

Bell, Sir Charles. *Portrait of the Dalai Lama.* London: Collins, 1946.

Bell, Sir Charles. *Grammar of Colloquial Tibetan.* New York: Dover Publications, 1977.

Bull, Geoffrey T. *When Iron Gates Yield.* London: Hodder & Stoughton, 1964.

Burman, Bina Roy. *Religion and Politics in Tibet.* New Delhi: Vikas Publications, 1979.

Carrasco, Pedro. *Land and Policy in Tibet.* Lexington: the University Press of Kentucky, 1976.

Choedon, Dhondrub. *Life in the Red Flag People's Commune.* Information Office of His Holiness the Dalai Lama, Dharamsala, India, 1978.

Choepel, Gendun. *The White Annals.* Library of Tibetan Works and Archives. Dharamsala, India, 1978.

Clark, Leonard. The Marching Wind. London: Hutchinson, 1955.

Dalai Lama, the Seventh. *Songs of Spiritual Change.* New York: Gabriel/Snow Lion, 1962.

Dalai Lama, the Fourteenth. *My Land and My People.* New York: McGraw-Hill, 1982.

Dorje, Gyurme. *Footprint Tibet Handbook.* Bath: Footprint, 1999.

Dreyer, June Teufel. *China's Forty Millions.* Cambridge: Harvard University Press, 1976.

Ford, Robert. *Wind Between the Worlds.* New York: David McKay, 1957.

*Fundamentals of Tibetan Medicine.* Tibetan Medical Centre, Dharamsala, India, 1981.

Ginsburgs, George, and Michael Mathos. *Communist China and Tibet.* The Hague: Martinus Nijhoff, 1964.

Gould, B. J. *The Jewel in the Lotus.* London: Chatto & Windus, 1957.

Harrer, Heinrich. *Seven Years in Tibet.* New York: E. P. Dutton, 1954.

Hopkirk, Peter. *Trespassers on the Roof of the World.* London: Oxford University Press, 1982.

International Commision of Jurists. *The Question of Tibet and the Rule of Law.* Geneva, 1959.

International Commision of Jurists. *Tibet and the Chinese People's Republic of China.* Geneva, 1960.

Jackson, David. *A History of Tibetan Painting.* Vienna: Verlag der Osterreichischen Akademie der Wissenschaften, 1996.

Karan, Pradyumna P. *The Changing Face of Tibet.* Lexington: the University Press of Kentucky, 1976.

Lang-Sims, Lois. *The Presence of Tibet.* London: Cresset Press, 1963.

Ling, Trevor. *The Buddha.* London: Temple Smith Ltd, 1973.

Matthiessen, Peter. *The Snow Leopard.* London: Vintage, 1998.

Mele, Pietro Francesco. *Tibet.* Oxford and Calcutta: IBH Publishing Co, (no date).

Migot, Andre. *Tibetan Marches.* London: Rupert Hart Davis, 1955.

Mitter, J.P. *Betrayal of Tibet.* Bombay: Allied Publishers Private Ltd, 1964.

Moraes, Frank. *The Revolt in Tibet.* New Delhi: Sterling Publishers, 1966 (first published 1960).

Norbu, Dawa. *Red Star Over Tibet.* London: Collins, 1974.

Norbu, Jamyand. *Horsemen in the Snow.* Information Office of His Holiness the Dalai Lama, Dharamsala, India, 1979.

Norbu, Thubten Jigme and Heinrich Harrer. *Tibet is my Country.* New York: E.P. Dutton, 1961.

Patterson, George N. *Tragic Destiny.* London: Faber & Faber, 1959.

Patterson, George N. *Tibet in Revolt.* London: Faber & Faber, 1960.

Peissel, Michel. *Mustang A Lost Tibetan Kingdom.* London: Collins and Harvill Press, 1969.

Peissel, Michel. *Lords & Lamas: A Solitary Expedition Across the Secret Himalayan Kingdom of Bhutan.* London: William Heinemann Ltd, 1972.

Peissel, Michel. *The Cavaliers of Kham, the Secret War in Tibet.* London: Little, Brown & Co and Heinemann, 1973.

Peissel, Michel. *Himalaya, the Secret Continent.* Paris: Flammarion, 1978.

Peissel, Michel. *Zanskar: The Hidden Kingdom.* London: Collins and Harvill Press, 1979.

Peissel, Michel. *The Ant's Gold.* London: Collins and Harvill Press, 1984.

Peissel, Michel. *Himalayan Kingdoms.* Paris: Bordas & Fils and Perlinger, 1989.

Peissel, Michel. *The Last Barbarians: The Discovery of the Source of the Mekong in Tibet.* London: Souvenir Press, 1997.

Rahul, Ram. *The Government and Politics of Tibet.* New Delhi: Vikas Publications, 1969.

Rato, Khyongla Ngawang Losang. *My Life and Lives.* New York: E.P. Dutton, 1977.

Richardson, H.E. *Tibet and its History.* Oxford: Oxford University Press, 1962.

Rockhill, William Woodville. *Notes on Tibet.* New Delhi: Asian Publication Services, 1977.

Rowland, John. *A History of Sino-Indian Relations.* Princeton: D. Van Nostrand, 1967.

Shakabpa, Tsepon W.D. *Tibet: A Political History.* New Haven: Yale University Press, 1967.

Snellgrove, David and Hugh Richardson. *A Cultural History of Tibet.* Boulder: Prajna Press, 1980 (first published 1968).

Stainton, Adam and Oleg Polunin. *Flowers of the Himalayas.* Oxford: Oxford University Press, 1997.

Stein, R.A. *Tibetan Civilization.* Stanford: Stanford University Press, 1972 (first published 1962).

Strong, Anna Louise. *When Serfs Stood up in Tibet.* San Francisco: Red Sun Publishers, 1976 (first published 1959).

Tada, Tokan. *The Thirteenth Dalai Lama.* Tokyo: The Centre for East Asian Cultural Studies, 1965.

Taring, Rinchen Dolma. *Daughter of Tibet.* London: John Murray, 1970.

Thomas, Lowell Jr. *Out of this World.* New York: Greystone Press, 1950.

*Tibet.* New York: McGraw-Hill, 1981.

Topping, Audrey. *The Splendours of Tibet.* New York: Sino Publishing Company, 1980.

Tsongkhapa, Je. *Compassion in Tibetan Buddhism.* Ed. Kensur Lekden and Jeffrey Hopkins. New York: Gabriel/Snow Lion, 1980.

Tsongkhapa, Je. *The Yoga of Tibet: The Great Exposition of Secret Mantras Numbers 2 and 3.* London: George Allen and Unwin, 1977 and 1981.

Tucci, Giuseppe. *To Lhasa and Beyond.* Rome: Instituto Poligrafico Dello Stato, Libreria Dello Stato, 1956.

Tucci, Giuseppe. *The Religions of Tibet.* London: Routledge and Kegan Paul, 1980.

Tung, Rosemary Jones. *A Portrait of Lost Tibet.* London: Thames and Hudson, 1980.

Van Walts Van Praag, M.C. *Tibet and the Right to Self-Determination.* Information Office of His Holiness the Dalai Lama, Dharamsala, India, 1979.

Wadell, Austine L. *Tibetan Buddhism.* New York: Dover Publications, 1972 (first published 1895).

Wangdu, Sonam. *The Discovery of the Fourteenth Dalai Lama.* Bangkok: Khett Thai Publications, 1975.

Willis, Michael. *Tibet: Life, Myth, and Art.* London: Duncan Baird Publishers, 1999.

# Expeditions

*Michel Peissel's expeditions to Greater Tibet:*

**1959** Anthropological survey of Solu Khumbu (Everest district); study of Sherpas communities.

**1964** Exploration and study of the Kingdom of Mustang, discovery of first 'Mollas'; historical chronicles, proving the region's long standing independence of both Tibet and Nepal.

**1966** and **1967** Research in Nepal on Mustang and the survival of the 'animal style' in Tibet.

**1968** Anthropological exploration of Eastern Bhutan.

**1972** Expedition by Hovercraft through the Great Himalayan Breach between Annapurna and Mount Dhaulagiri.

**1975** Expedition to Ladakh.

**1976** First anthropological study of Zanskar.

**1977** Trans-Himalayan expedition from Kitchwar to Leh.

**1978** Filming expedition to Zanskar with BBC TV.

**1980** Expedition to the Ralagong valley and the discovery of Minaro settlements in Zanskar.

**1980** (winter) Expedition to the source of the Ganges via Machel.

**1981** Study of Minaro of upper Indus, recording of an extensive vocabulary of archaic Shina.

**1982** Expedition in disguise into the no-man's-land along the Indo-Pakistan cease fire line in search of the gold fields of Herodotus.

**1982** (winter) Expedition around Mount Minya Konka in Kham (eastern Tibet).

**1986** Expedition to tropical Tibet, Pemako and Tsari along the great bend of the Brahmaputra.

**1991** Second expedition to Mustang, investigation of cave sites.

**1992** First expedition to study horse breeds and horse care in Tibet.

**1993** Expedition to southern Qinghai to study the distribution of the Nangchen thoroughbred horse.

**1994** (spring) Journey to Lhasa to translate a treaty on equine pharmacology.

**1994** (sept) Discovery of the principal (historical) source of the Mekong.

**1995** Expedition to northern Tibet leading to the identification of an archaic breed of horses at Riwoche.

**1996** Expedition to Baltistan to establish the Dansar plateau as the origin of the account of the 'Giant gold-digging ants' (marmots) of Herodotus.

**1997** Expedition to Guge and western Tibet in search of cave sites and salt routes.

**1998** Expedition to Aru Tso in the heart of the Western Changthang; filming of the Tibetan grizzly, blue sheep, and wild yak.

**1999** Trans Changthang expedition financed by the LGRF to study the Sengo nomads and film local wildlife.

**2000** Journey to Amdo in North Tibet and to the Towers of Pasung in Kongpo, Eastern Tibet.

# Index

## AUTHOR'S ACKNOWLEGEMENTS

I wish to thank my editor Nikki Sims for her kind assistance, Chris Westhorp for his in-depth corrections amendments and additions to this book and Fréderique Darragon for the use of certain of her photographs, in particular those taken in the Changtang. I am also grateful to the Kalpa Group for assistance in the course of my 1999 expedition to the Aru Lake region of northwest Tibet. I would also like to thank all those who accompanied me over the years in the course of my many journeys to Greater Tibet, in particular: Missy Allen, Alain Thiollier, Sebastian Guinness, Jean François Vezies, Jacques Falck, Tashi Karmay, Lesley Powell, Caroline Puel and Jane Blunden.

All photographs © Michel Peissel, 2002 except the following:
Missy Allen (back flap of jacket)
Fréderique Darragon (page 28 top; pages 40–41; all on page 207)
Jean François Vezies (page 37 bottom left).

First published in the United Kingdom in 2002 by Cassell Illustrated

A CIP catalogue record for this book is available from the British Library

ISBN 0304354104

Design Director David Rowley
Designed by Nigel Soper
Project managed by Nikki Sims
Copyedited by Chris Westhorp
Map by ML Designs
Indexed by Sue Lightfoot
Printed at Printer Trento and bound at LEGO in Italy

Cassell Illustrated
2–4 Heron Quays
London  E14 4JP